HARLEM

HISTORICAL STUDIES OF URBAN AMERICA

Edited by Timothy J. Gilfoyle, James R. Grossman, and Becky M. Nicolaides

Additional series titles follow index.

HARLEM

The Unmaking of a Ghetto

CAMILO JOSÉ VERGARA

Foreword by Timothy J. Gilfoyle

THE UNIVERSITY OF CHICAGO PRESS ✳ *Chicago and London*

CAMILO JOSÉ VERGARA *is a photographer and writer, a MacArthur Fellow, a recipient of the National Humanities Medal, and the author of many books. To see more of his work, visit www.invisiblecities.com and www.camilojosevergara.com.*

The University of Chicago Press, Chicago 60637
The University of Chicago Press, Ltd., London
© 2013 by Camilo José Vergara
All rights reserved. Published 2013.
Printed in China

22 21 20 19 18 17 16 15 14 13 1 2 3 4 5

ISBN-13: 978-0-226-85336-9 (cloth)
ISBN-13: 978-0-226-03447-8 (e-book)
DOI: 10.7208/9780226034478

Library of Congress Cataloging-in-Publication Data

Vergara, Camilo J., author, photographer.
 Harlem: the unmaking of a ghetto / Camilo José Vergara; foreword by Timothy J. Gilfoyle.
 pages cm — (Historical studies of urban America)
 Includes bibliographic references.
 ISBN 978-0-226-85336-9 (cloth : alk. paper) — ISBN 978-0-226-03447-8 (e-book) 1. Harlem (New York, N.Y.)—Pictorial works. 2. Urban renewal—New York (State)—New York—Pictoral works. 3. Street photography—New York (State)—New York 4. Harlem (New York, N.Y.)—Buildings, structures, etc. 5. Urban renewal—New York (State)—New York. I. Gilfoyle, Timothy J., writer of added commentary II. Title. III. Series: Historical studies of urban America.
 F128.68.H3V47 2013
 974.7'1—dc23
 2013013418

♾ This paper meets the requirements of ANSI/NISO Z39.48–1992 (Permanence of Paper).

CONTENTS

FOREWORD

CAMILO JOSÉ VERGARA's *Harlem: The Unmaking of a Ghetto* provides a visual history of one of the most famous neighborhoods in any American city, with an accompanying narrative that is part history, part sociology, and part memoir. Harlem offers a graphic exposé of the dramatic social and physical changes that have transpired in that community since 1970, and in doing so, it illustrates some of the most important themes of American urban life over the past half century.

Camilo Vergara is often described as "the Jacob Riis of our time." Riis and Vergara share an interest in exposing the differences between segregated and marginalized urban communities and those of "normal America." Both present images absent or rarely found in middle-class or stable working-class neighborhoods. Vergara's photographic archive includes graffiti-covered structures, storefront churches, second-rate facilities, a different commercial streetscape, an underground economy, and homelessness. His photographs sometimes depict windowless, doorless, fence-topped factories; community and retirement centers surrounded by chain-link or iron fences topped with razor wire; homes and clubhouses absent windows and visible entrances.[1] These are landscapes marked, in part, by fortress architecture.

This inner-city vision is upsetting to many. The message, at first glance, speaks to the physically destructive results of racial and social segregation, economic disinvestment, and the abandonment of urban communities. Buildings and structures in any city landscape are physical links to the past, the tangible expression of history, our shared urban memory. They often embody the intangible recollections in the most personal way. For current and former residents, buildings and streetscapes are not just brick and mortar or wood and asphalt, but memories of walking to school, shooting basketballs in an alley, jumping rope on a sidewalk, playing in a front yard, caring for a sick child or parent, laughing with a next-door neighbor. Abandoned buildings represent the opposite. When social forces determine that no functional use exists for a neighborhood's buildings, when structures are discarded and transformed into ruins, the message is that those memories are unimportant, are not worth preserving, and have no greater value than their real estate appraisal. If those memories, like the buildings, are finite, maybe ours are as well.

Vergara's work, however, is more than a chronicle of urban decay. A careful observer of these photographs will notice at least three themes and methods rippling through them. The first might best be labeled "scientific" (although Vergara himself

sometimes resists this categorization). In these images Vergara employs a time-lapse approach, returning to the same structures and vantage points over periods of three or four decades. Many of these pictures are taken from high-rise rooftops or immediately in front of specific buildings. This more clinical approach embodies a form of visual sociology in which Vergara visually documents when and how the urban fabric decayed, frayed, vanished, and sometimes reappeared in new forms. The shock-and-awe effect is reminiscent of Jacob Riis.

A second theme focuses on the street. These images document ground-level vistas and communities that might be labeled "forgotten spaces," "vanishing spaces," or "barely surviving spaces"—neighborhoods, streets, sidewalks, lots, and interiors often marginalized and ignored during the late twentieth century. These repetitive images of structures, streets, and urban landscapes may prove to be Vergara's most important historical legacy. Contemporary historians suffer from an absence of visual images of the interiors of Lowell boarding houses, Bowery flophouses, or the skid rows of most American cities. Vergara's photography, by contrast, represents an archive full of images of forgotten or ignored communities, structures, streets, and spaces. He is the unpaid friend of future historians.

Finally, Vergara's treatment of people is explicit and biased. These images are more controversial. He dispenses with any notion of "objectivity" or "scientific" methodology. Indeed, he frequently describes his conversations, even arguments, with his subjects. In his portrayal of people, Vergara stands in marked contrast to Jacob Riis. The latter manipulated his subjects into certain postures and poses but never revealed such methods to his audiences; Vergara adopts a transparent pose, openly injecting the personal, the emotional, the sentimental in his treatment of people. Riis photographed intensely for only four years; Vergara has been at it ten times longer. Riis was frequently

accompanied by police officers; Vergara is always alone. Riis was primarily concerned about the immediate subject in front of him; Vergara observes change over time. Riis was a reformer seeking the correction and improvement of present conditions; Vergara provides images that map the development of those conditions.

Vergara's oeuvre resists easy classification. The photographer's gaze most noticeably focuses on the physical city, but a careful reading of his photography reveals a more complex interpretation of urban change in the late twentieth century and at the turn of the second millennium. Parts of the landscape decline, even disappear. Yet other areas are revitalized and transformed. What emerges are dramatic contrasts. Development and physical change do not form a linear narrative of decline and destruction. Rather, these neighborhoods exhibit contradictory and paradoxical elements of renewal alongside examples of decline. Most powerful are Vergara's images of people who, more often than not, evoke a sense of humanity, perseverance and dignity in surroundings that frequently epitomize the opposite.

In explaining an earlier work, Vergara stated that he was interested in "the debris of history." He was motivated not as a historian or social scientist but, rather. as a human being. "We picked whatever moved us the most," he wrote. "It is easy to think of that as a selfish motivation, but it was not." Here, too, Camilo José Vergara's *Harlem* documents the complexity of this community, telling us that it is much more than a ghetto full of abandoned ruins, that beside the poverty are people laughing, playing, working, living.

Timothy J. Gilfoyle

INTRODUCTION

STREET PHOTOGRAPHY
OF HARLEM, EARLY 1970S

*Harlem is a base for more than Hughes, Malcolm X, and Ellison. It is the symbolic base of the Negro American and his culture. Harlem pulled Arthur Schomburg from Puerto Rico, Josephine Baker from St. Louis, A. Phillip Randolph from Florida, Thelonius Monk from North Carolina, Duke Ellington from Washington, D.C., and Roy Wilkins from Minnesota. *EBONY, JET, THE CHICAGO DEFENDER, *and *THE PITTSBURGH COURIER *have all covered Harlem for years. When there is a small demonstration at the local school (I. S. 201) it is reported to the entire country. Even Adam Clayton Powell was not just another Congressman. He represented Harlem and Harlem represents the Negro America.*

ALEXANDER GARVIN, URBAN PLANNER, CA. 1967

I BEGAN DOCUMENTING Central Harlem and the northern half of East Harlem above East 110th Street in 1970, six years after the riot of 1964 that lasted two days and resulted in widespread destruction. I was attracted to the neighborhood because Harlem was a gritty, tough, militant place, as evidenced in the large murals painted on the side of burntout shells encouraging black people to break the chains of oppression, to be born again, to be free. I saw anger and mistrust on the faces of young people. Sometimes I received looks from total strangers as hateful as I had experienced

once, inexplicably, while visiting the South Side of Chicago. The vibrant street life, the rebellious spirit, the absence of white people, the scenes of destruction all around me, and the constant fear of being mugged made my visits unpredictable and memorable.

Harlem was like a run-down version of Paris where life was lived on the streets, amid the fading glory of its grand boulevards. Once imposing and elegant buildings were now derelict; the streets were dirty; parks were semiabandoned; decrepit-looking schools evoked a culture, different and separate from mainstream America that thrived in Harlem's many nooks and crannies. Harlem was a decaying, depopulated, dangerous, mysterious, and exciting neighborhood.

The Harlem Renaissance seemed to have never happened. To imagine Harlem "as the site and symbol of Afro-American progress and hope," as Ralph Ellison wrote in 1986, was to deny what one could see all around.[1] Harlem celebrities in the 1970s were heroin kings Frank Lucas of *American Gangster* fame and Leroy "Nicky" Barnes. Most of those able to leave left; Central Harlem's population went from a 1950s total of approximately 237,000 to 101,000 in 1990.[2] Only 1.5 percent of that population was white. Proposals to rebuild Harlem included grand plans of local politicians to construct an international trade center as well as plans by the city, which would have reserved the renovated structures for an AIDS hospice, drug treatment centers, and housing for the homeless.

I was an audio-visual technician for a Park Avenue advertising agency in 1970. Lunch hours ran usually about two hours, which gave me enough time to travel to Harlem and back on the East Side IRT (Interborough Rapid Transit) express train. I exited at 125th Street and walked in a radius of about twelve blocks from the subway stop, photographing as I went along. On holidays and weekends I returned for longer visits.

Since I admired the work of photographers Henri Cartier Bresson, Roy De-Carava, Helen Levitt, and Aaron Siskind, I was delighted to see Harlem street scenes similar to those captured by these masters: black children playing with white dolls, jumping on discarded mattresses, and opening fire hydrants to spray friends and passersby. I photographed people walking up and down the stairs to the subway, men playing dominos, naïve commercial signs, torn and faded advertisements, and, of course, graffiti. Sometimes I joined family members photographing weddings as they spilled out onto the streets. I went inside tenement buildings to make portraits of elderly ladies sitting in the dark looking at the street.

My choice of film was High Speed Ektachrome. High Speed Ektachrome, because its rapid speed let me photograph quickly and without the images looking blurred, allowed me to be a street photographer and to observe Harlem through its people and signs. I carried several lenses with me: wide angle lenses to capture panoramas and a telephoto in order to better record scenes undetected. During my early documentation I neglected to record names of people and addresses of buildings. What was the point of recording such information when the masters of photography themselves seldom included it with their work? All Henri Cartier-Bresson did was label a photograph "Family, Mexico 1934."[3] Like them I was simply trying to capture essences that transcended urban time, personal names, and physical space.

Without a doubt, fear was part of my photographic ventures. I had once been robbed and beaten up in Roxbury, Massachusetts. But Harlem proved to be somewhat safer for me. I learned to walk fast and to cross the street so as to avoid groups of menacing youths loitering on the other side. Several times I was told to clear out of the neighborhood; otherwise my camera would be taken or broken.

Once I was punched in the face. My glasses fell in front of an unlicensed "gypsy cab." Face on the ground, I watched the cab run over them.

In the early 1970s I witnessed the stabbing of a young man from the Metro North commuter train platform at East 125th Street and Park Avenue. It was a sunny afternoon, and I never thought of photographing the event. I remember the assailant carrying the knife, first running slowly away, looking back several times as if not wanting to break his link with his victim, then running faster until he disappeared around the corner onto Madison Avenue. In the 1980s, from a passing bus, I saw a man lying on a table in a pool of blood inside Cincinnati Fried Chicken on West 125th Street. And at the height of the drug epidemic in the late eighties, I saw the bare toes of an executed Puerto Rican youth protruding from under a blanket as he lay on the back of an ambulance parked on Lexington Avenue.

I became an eavesdropper and a voyeur because I believed that the spirit of Harlem would reveal itself through random bits of overheard conversation. I situated myself near public phones, listening intently to what people said and writing it down. In one long conversation I heard a man describe how his girlfriend had thrown all his belongings out of the apartment window into the street below. Another time on East 125th Street, a man walking briskly by the side of a young woman on a mission to buy drugs kept imploring her to go back home. He said repeatedly to her: "I know you are going to buy crack," while she walked quickly and silently ahead of him.

I am fond of my earliest pictures of Harlem. Once upon a time, I rejected them as sentimental and unoriginal. When I showed my early photographs to gallery and museum curators they were disinterested. Now I see them as unique

historical artifacts, images of people who stayed behind and documents of the decrepit buildings they inhabited. Among these is the photograph of a black man driving his horse-drawn carriage full of junk north toward Harlem, along what seems to be Park Avenue. Another photo shows an elderly woman sitting on the sidewalk; on the wall behind her is a painted mural of the skyscraper city. Another one depicts young black girls sitting on a tenement stoop carefully arranging their white Barbie dolls on the steps.

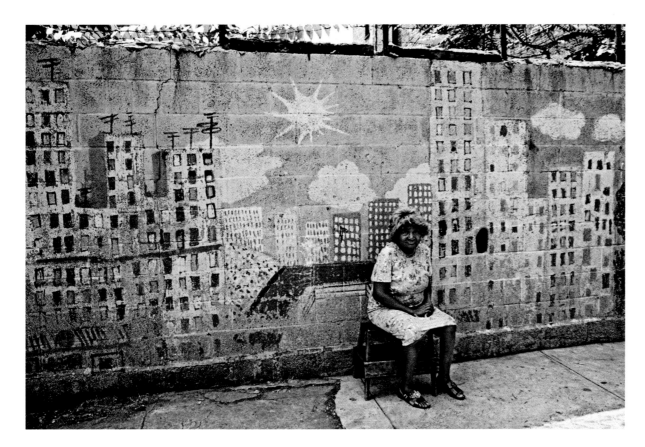

East Harlem, 1970

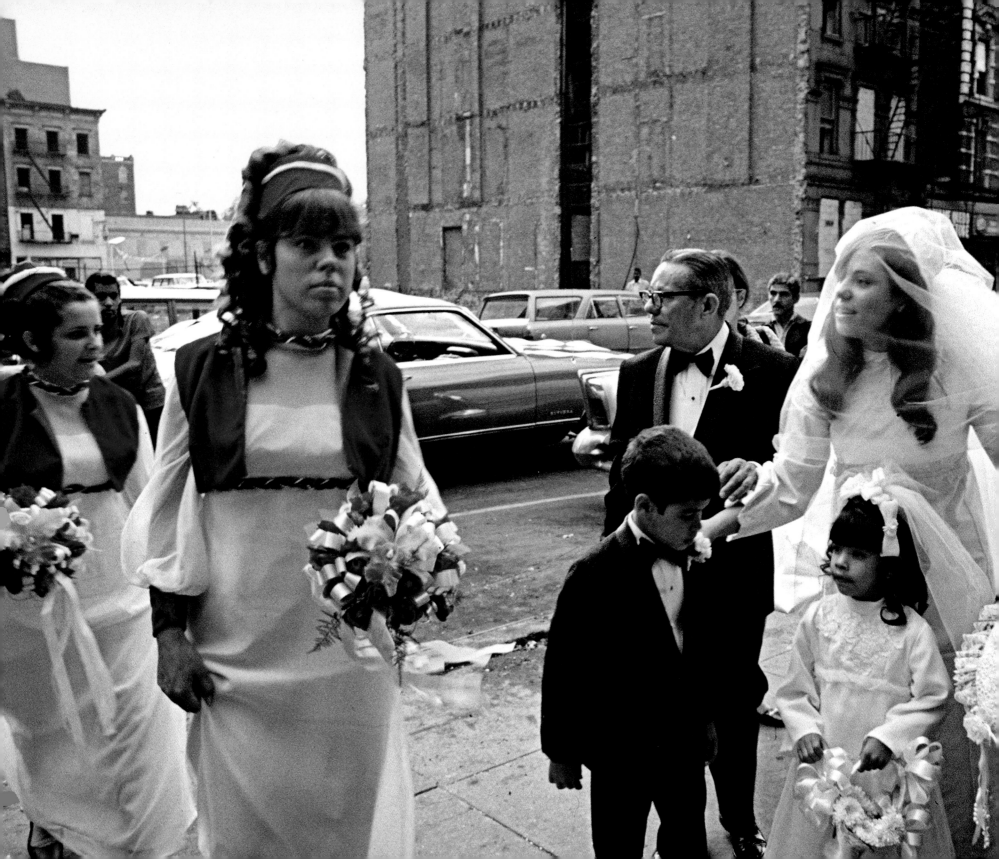

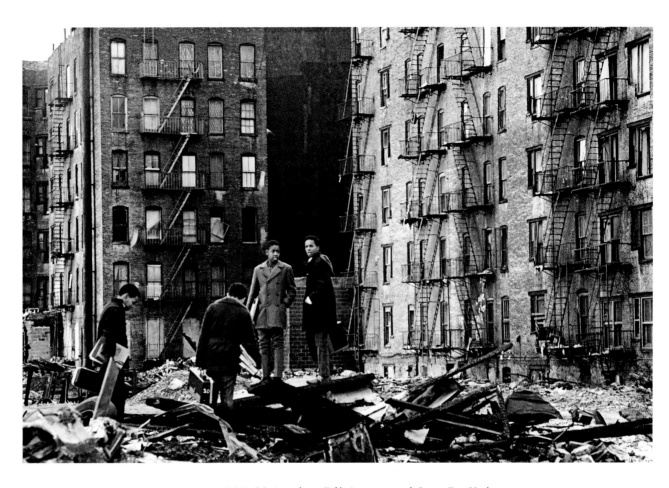

Music students, Fifth Avenue at 110th Street, East Harlem, 1970

Puerto Rican wedding, East Harlem, 1970

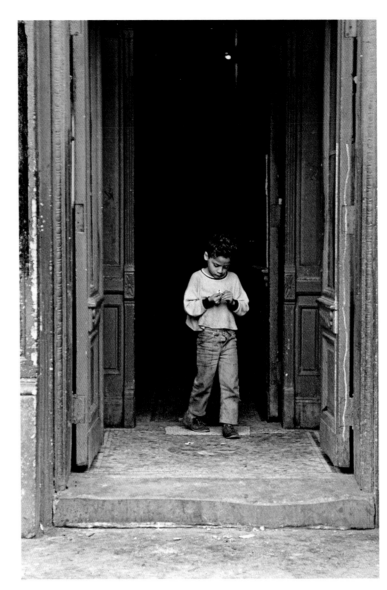

Boy, East Harlem, 1970

Entrance, East Harlem tenement, 1970

9

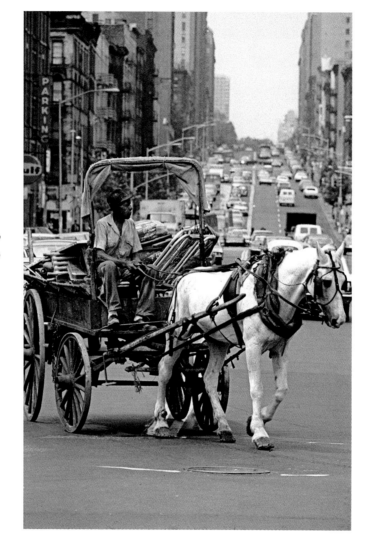

RIGHT *Scavenger on the way to Harlem with a load of metal, 1970*

OPPOSITE *Cadillac Fleetwood, Harlem, 1970*

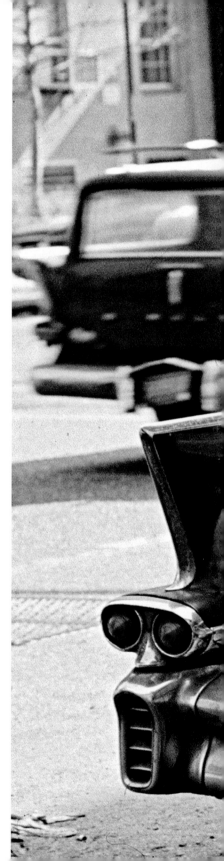

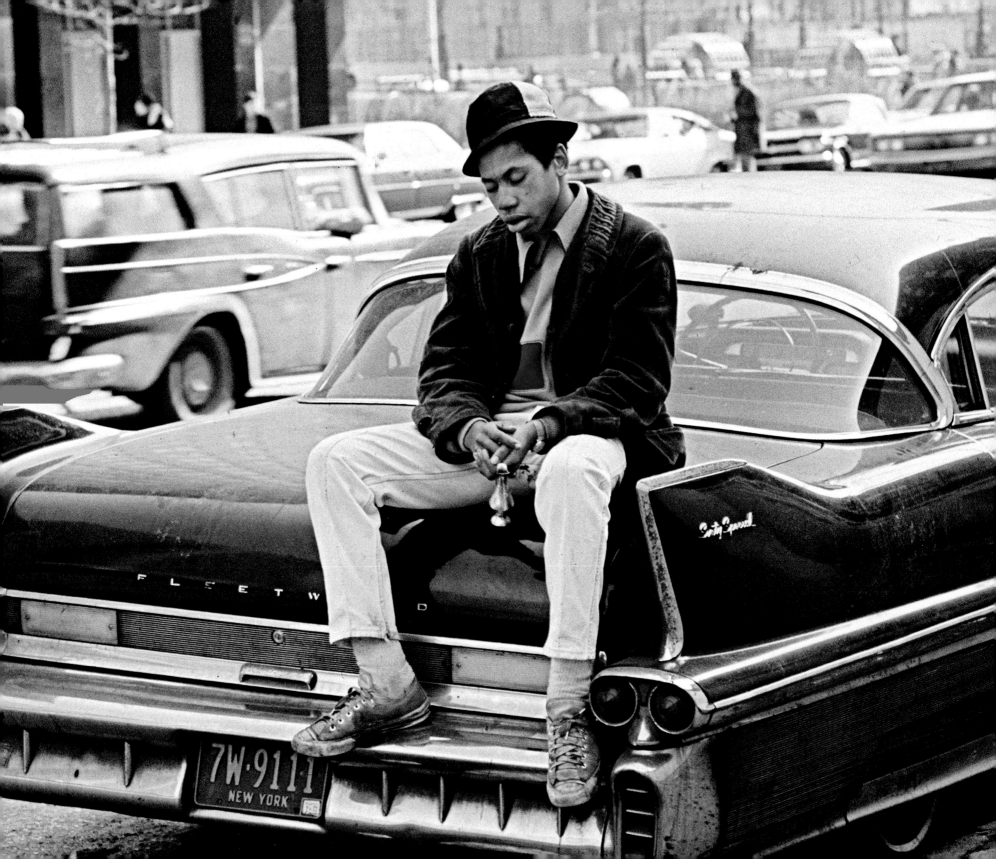

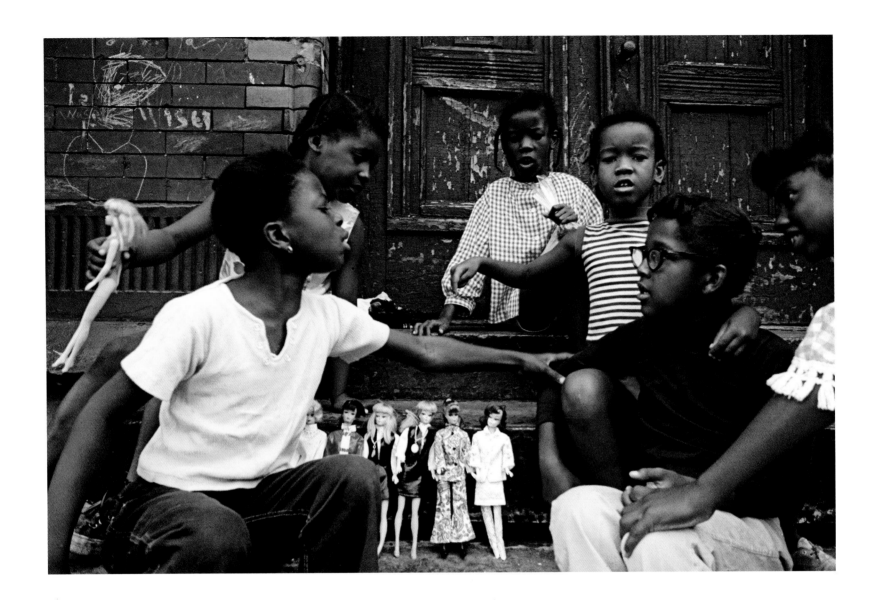

12 *Girls and Barbies, East Harlem, 1970*

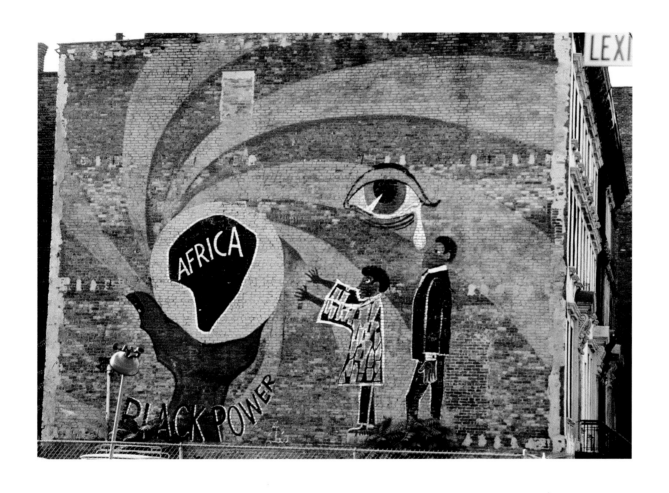

Black power mural on the side of a brownstone, Lexington Avenue, Harlem, 1970

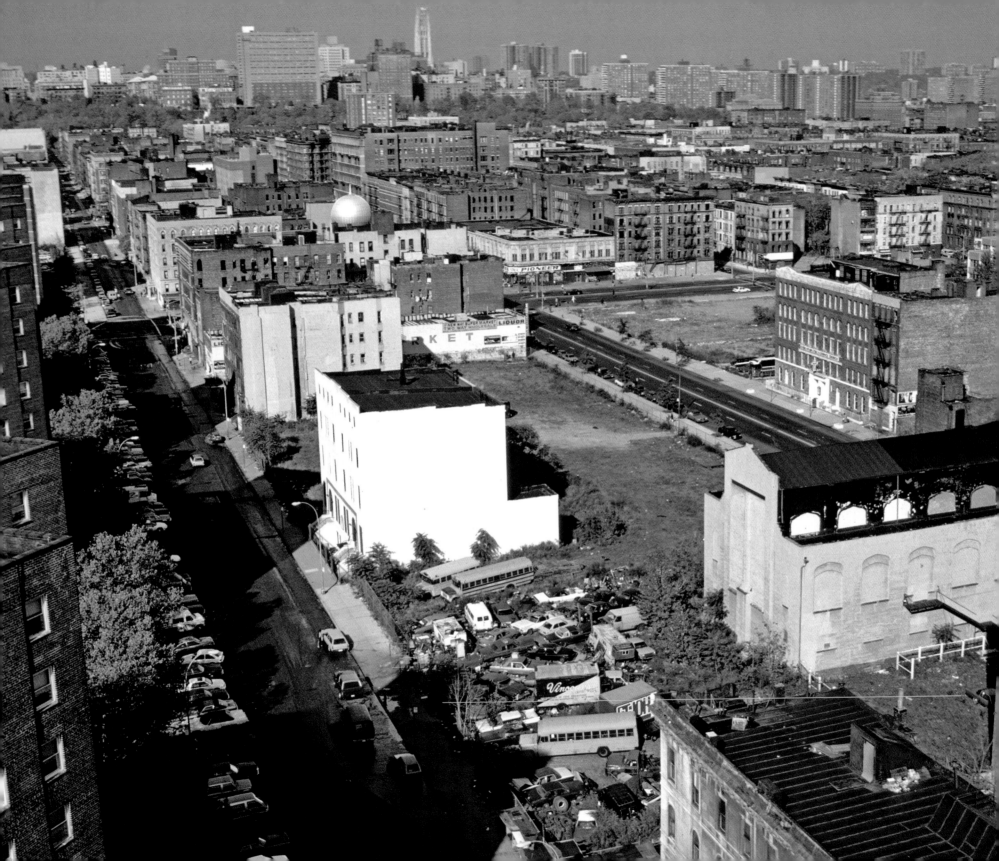

SINCE 1977, EXPLORING HARLEM
THROUGH TIME-LAPSE PHOTOGRAPHY

BETWEEN 1973 AND 1976 I was a graduate student in sociology at Columbia University. In my struggle to be an objective observer, I did not want to limit the scope of my documentation to places and scenes that captured my interest merely because they resonated with my personality. In 1977, relying on sociological methodology as well as intuition, I began to photograph again, this time intending to make a complete and objective portrait of the American inner city not only to illustrate urban issues but to discover them as well. I changed the main focus of my documentation from people to the physical city. I stopped taking just single photographs that captured my imagination; instead I rephotographed the same places over time and from different heights, creating images of entire neighborhoods to the point of saturation. I believed my photographs taken from different levels and angles would eventually form a dense web of images, a visual record of these neighborhoods over time.

I included places such as empty lots, which seemed at the time to be a waste of film but might, as segments of a sequence, become revealing. Studying my growing archive I discovered fragments of stories in need of elaboration and

15

urban themes in need of definition and further exploration. To enrich my narratives I wrote down observations, interviewed residents and scholars, and made comparisons with similar photographs I had taken in other cities. Since the turn of the millennium I have made extensive use of Google to do research.

No longer burdened with the belief that I had to capture moments that "seem blessed, harmonious, and eternal," to quote photography critic Sally Eauclaire, I embarked on the more prosaic undertaking of using images as a tool for recording and understanding the changing city.[1] Someone informed me, none too kindly, that what I was doing was little more than real estate photography. But I saw my mission as compiling a record of the destruction and violence done to New York City and to other cities at the height of America's urban crisis, a period when "planned shrinkage" was being implemented and when schools, fire stations, and hospitals were closing in Harlem and its vacant buildings were left to decay.

In retrospect, I was photographing the end of an urban era in a clear and simple fashion. My photographs showed how cities declined and how residents and city officials tried to stop it. I was creating a photographic record that one day would be useful to historians, planners, architects, and people interested in understanding and explaining urban America.

Until 2010 I used Kodachrome 64, a stable color film that came out in the mid-seventies. It provided me with the medium speed, fine-grain emulsion appropriate for creating a lasting archive using a small 35 mm camera. I have photographed urban America systematically using perspective-corrected lenses, covering entire inner cities and returning to rephotograph the places I had previously visited. Along the way I became a historically conscious documentarian, an archivist of decline, a photographer of walls, buildings, and city blocks. Bricks, signs, trees,

and sidewalks: these were the subjects that spoke most truthfully and eloquently about urban reality. I felt a people's past—their accomplishments, failures and aspirations—were not reflected in their faces but in the material world in which they lived and which they helped to shape. Rather than capture decisive moments when "form and content, vision and composition merged into a transcendent whole," I found that the decaying urban fabric would wait; if I did not get an image right the first time, I returned the following week.[2]

My photographic archive of Harlem as well as that of other poor, minority communities across the country evolved over decades. The stages can be divided according to the film and type of camera used: High Speed Ektachrome in the early 1970s, Kodachrome 64 from 1977 to 2010, used concurrently with digital photography since 2005. Kodachrome 64, now discontinued, was a fine-grain film very good for photographing buildings and city blocks. After 2010, I have continued storing time sequences in slide sheets arranged according to place in binders. This allows for easy access to images and information since I don't have to mix transparencies with digital files and I write field observations on the slide cardboard frame. My present film of choice is Fujichrome Provia 100, a slide film.

Most photographs of people were taken surreptitiously without asking permission—not out of disrespect but because I wanted to capture life as it was happening in front of me. Asking for permission would have made people turn into their favorite pose and destroyed the manner in which they were presenting themselves.

Using a cable release I keep in my pocket and a quiet setting, a digital SLR (single lens reflex) enables me to take pictures of people, without them being aware of being photographed, inside subways and buildings at night. In the 1940s and 1950s, Helen Levitt photographed in Harlem using a camera that ap-

peared to take pictures through its regular lens while instead she was capturing a different scene from a hidden lens on the side of the camera.[3] In the tradition of Levitt's surreptitious picture taking, I made portraits of people on the street, demonstrating just how style-conscious residents and tourists were as they strolled Harlem's main avenues, particularly 125th Street. Indeed, on weekends Harlem's main streets had a crowded, festival-like atmosphere, wide sidewalks providing the space to promenade and be seen. The expressive, colorful attire of African American strollers contrasts strongly with the more tame and conventional fashions worn by Japanese and European tourists who now feel safe enough to visit the "Capital of Black America."

I see myself as a builder of a virtual city. The photographs are arranged according to time and location as connectors linking hundreds of stories, telling how Harlem evolved and how it was shaped by the recent economic boom, by its following recession, and by its former greatness and present aspirations. I think of my images as bricks that, when placed next to each other, give shape and meaning to the neighborhood.

Harlem is a dense environment with many tall buildings. The neighborhood offered an ideal place to work. I photographed the community from a variety of easily accessible high vantage points. Foremost among these were the high-rise buildings of the New York City Housing Authority and, in the nineties, the hundreds of tenements undergoing renovation, their entrances wide open and their roofs unlocked and unguarded. In addition I repeatedly visited stations on the elevated rail lines that cross 125th Street for panoramic perspectives.

My photographs included more than the physical city. I documented the fashionable hats worn by elderly women on their way to church and the latest

sneakers and newest jackets worn by the young and recorded, as well, the statements about slavery, racism, gentrification, God, and salvation on walls and on people's clothing. I also photographed the new immigrants from places like Africa as they attracted customers to their nail and braiding salons. Even two decades of rebuilding, gentrification, and population growth, Harlem continues to be a poor community, and I photographed the homeless, the drug addicts, and the newly released prisoners who gather on the north side of Lexington Avenue at East 125th Street and underground, inside the East Side IRT subway station.

I experienced Harlem with my body, through smells, noises, voices, the faces of people, the buildings, and the trees. What I feel goes to my memory and gets recorded with my camera and in notebooks. I consider myself privileged to carry with me present-day Harlem as well as that Harlem I first saw forty-two years ago and all the Harlems in between.

While in the field there was always a Harlem in my head in addition to the one in front of my eyes. Of course this approach limits, but does not rule out, personal choices since, unlike a place you see fresh and new, where the photographic approach has not yet been defined, Harlem is a well-known place. Yet these are made by a person deeply involved in a neighborhood and guided by an evolving mental image of the place.

After 2000 my documentation entered a new phase. I began "Googling" words, themes, and addresses. With a simple search on Google for a particular location, I was able to find newspaper and magazine articles, religious pamphlets, student papers, announcements for conferences, and political meetings that enriched the context of my research and prompted me to ask fresh questions and take new photographs. I discovered information about people who lived in these locations

19

**SINCE 1977, EXPLORING
HARLEM THROUGH
TIME-LAPSE PHOTOGRAPHY**

I photographed, read about events such as crimes, fires, stores, and institutions coming in or abandoning the area and learned about historical events that had taken place nearby.

YouTube, Vimeo, and Google are where I found my archives. I saw great parades, dancers at the Savoy doing the Lindy Hop, preachers and politicians in online documentaries, and newsreels from the Depression. In rap videos, I observed places that performers had selected to show as the "real Harlem."

After 2005 and then after 2007, Google Maps and Street View, respectively, became important research tools allowing me to revisit the locations of my photographs and to go beyond the frames of the images and explore the streets around them. Whenever in doubt about the location of an image, I searched for the correct address with Google Satellite or Street View. And thanks to Google Satellite I was able to observe backyards and roofs, adding to or correcting my impressions.

The selection of images chosen from thousands taken over more than four decades has been influenced by issues and places central to the Harlem Renaissance, by efforts to make Harlem into a cultural destination, and by a desire to look for the neighborhood's unique identity during a period of increasing gentrification and globalization.

Five years ago I made Harlem part of my website Invinciblecities.com. Since the photographs on the website are arranged geographically as dots on the Harlem map, I could see the areas where the documentation was weak or falling behind and was then able to compensate for it. In addition, since the images were placed in sequences according to date, I could observe the changes taking place in the neighborhood. The website images were arranged thematically, and many of those themes became sections and chapters of this book.

Invincible Cities drew diverse responses from the audience, as viewers posted questions and comments to the site. Others simply took my images and used them in their own projects. The way images from the website were used, the comments to these postings, and the requests I received for commercial uses of the images made me reflect on how and why these images resonated. In forty-two years of documentation I gathered stories, voices, and images; now this material has become part of the way people interpret the neighborhood.

The most popular use of my photographs was "Harlem—1980s: Images Taken by Camilo Vergara" posted on YouTube by "dtoronto." In that video, seventy-six images of the neighborhood in ruins were downloaded from Invincible Cities and arranged to the rhythms of Bobby Womack's song "Across 110th Street," and in the four years since 2008, the video has been seen by 172,000 viewers. Among the 764 comments on the site many are from people who, appalled by the devastation, call the Harlem of the 1980s a "ghetto," "a slum," and even "the shithole of all shitholes." One bewildered viewer wrote "My God! Glad it's not like that anymore! Nothing but white men with babies strapped to their chests and white women jogging all over the place now." Among those posting are those who miss "the grit and grime" and "the way the city was" and believe that the neighborhood was more authentic when it was "the real ghetto hood." One viewer went so far as to remark: "1980s WAS TOO REAL, FAKE SHIT HADENT EVEN BEEN INVENTED YET." Many of those commenting placed the blame for the destruction of Harlem either on blacks or on Caucasians.[4]

21

SINCE 1977, EXPLORING
HARLEM THROUGH
TIME-LAPSE PHOTOGRAPHY

View northwest along West 115th Street from Fifth Avenue, Harlem, 1997

View northwest along West 115th Street from Fifth Avenue, Harlem, 2008 **23**

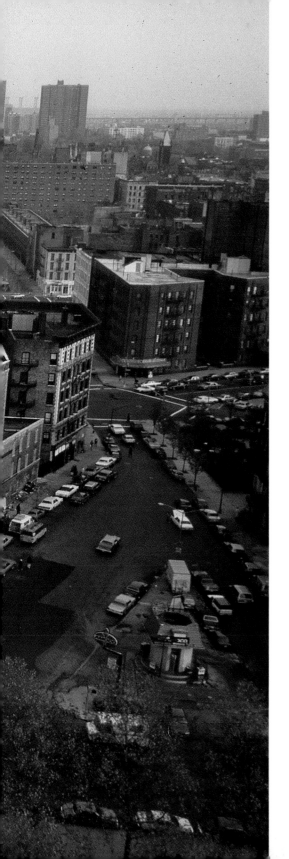

View northeast along West 125th Street, from Morningside Avenue, Harlem, 1988

25

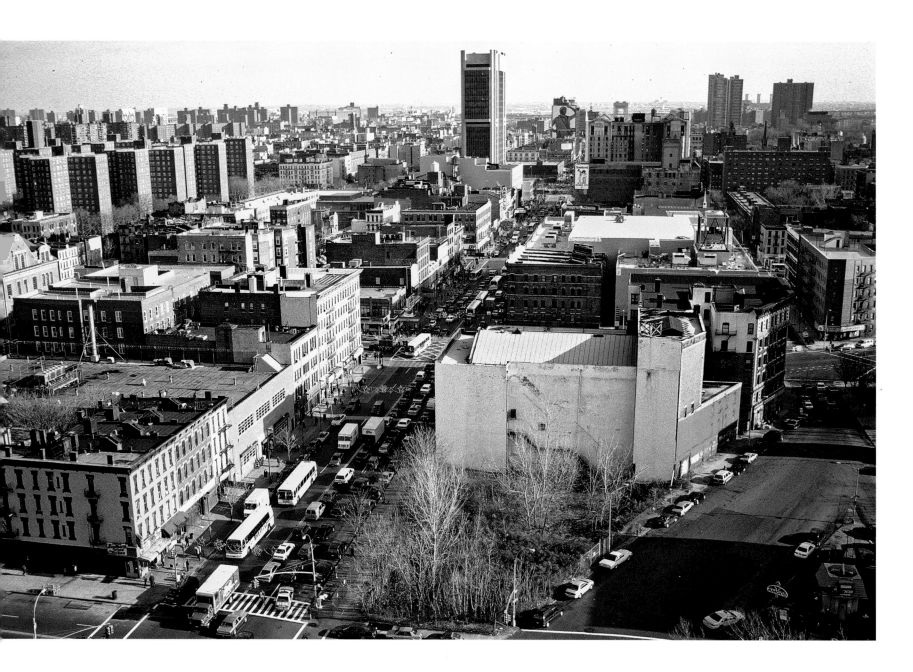

View northeast along West 125th Street, from Morningside Avenue, Harlem, 2000

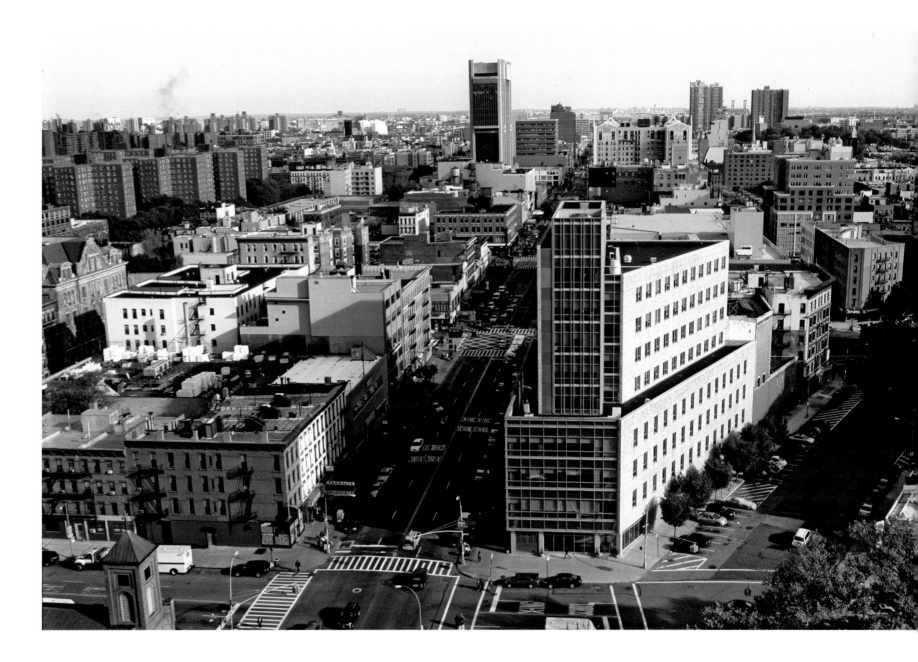

View northeast along West 125th Street, from Morningside Avenue, Harlem, 2011

THE URBAN
FABRIC

MANY HARLEMS, ONE CULTURAL CAPITAL OF BLACK AMERICA

So much goes on in a Harlem air shaft. You hear fights, you smell dinner, you hear people making love. You hear intimate gossip floating down. You hear the radio. An air shaft is one great big loudspeaker. You see your neighbors' laundry. You hear the janitor's dogs. The man upstairs' aerial falls down and breaks your window. You smell coffee. A wonderful thing, that smell. An air shaft has got every contrast. One guy is cooking dried fish and rice and another guy's got a great big turkey. Guy-with-fish's wife is a terrific cooker but the guy's wife with the turkey is doing a sad job.…I tried to put all that in "Harlem Air Shaft."

DUKE ELLINGTON, 1944

ELLINGTON'S EVOCATIVE DESCRIPTION of apartment life as experienced through a Harlem air shaft still rings true. In 2012, however, the aerials have long been replaced by dish antennas and cable. I never met Ellington, who died in 1974. I could not claim that "sometimes I run into Duke Ellington on 125th Street," as did Langston Hughes's everyman character, Simple.[1] By 1970 the talented and sophisticated members of the Harlem Renaissance I read about in books and saw in portraits were dead or, like most other middle-class residents, had left the neighborhood for better

29

places, such as Brooklyn, Saint Albans in Queens, or the suburbs. Today's famous African Americans rarely live in Harlem.

Now, five generations removed from the Harlem Renaissance, Harlem is no longer either the citadel of black achievement and culture or the most brilliant black "city" in the world. No second Harlem Renaissance has attracted exceptional artists and performers from across the country. Celebrated black performers seldom play in the neighborhood because there aren't venues large enough to accommodate the enormous crowds they can attract. The music of the great jazz musicians and singers—like Duke Ellington, Billie Holliday, and Miles Davis—are seldom heard on the streets of Harlem. (Though their music is sometimes played in the summer during free open-air concerts, sponsored by Jazzmobile, a not-for-profit arts and cultural organization that reaches out to communities where jazz was born to remind them of their history.)

Instead, what people regularly listen to is rhythm and blues, rap, and, on Sundays, preachers and religious music. Kim, a middle-aged resident of the Saint Nicholas Houses, a public housing project in Central Harlem, explains, "The old good music, the classics, musicians such as Count Basie and Dinah Washington, are what is played at the Apollo Theater. When I was growing up I heard all that shit. Young people, they never hear it, theirs is a different style." When I asked Kim about religious music, she tells me, "People like my age, our age, on Sunday, if they are cooking, they put on church music, they sing and dance. You hear people hollering and stomping."

On West 128th Street I hear Anita Baker's voice coming out from an apartment. At another building, also at the Saint Nicholas Houses, I asked a Latino caretaker what music is popular among her tenants and she listed bachata, merengue, and

salsa, all Latin rhythms. Her answer reminded me that the Hispanic population of Central Harlem grew 27 percent during the first decade of the twenty-first century.[2] In 2011 more than one in five residents of Central Harlem was Latino.

A popular urban experience that captures another of the Harlems in Harlem is that of the heavily guarded basketball tournaments that take place at night in courts surrounded by looming high-rises. Rucker Park near the thirty-five-story Polo Grounds Houses is legendary; Wilt Chamberlain, Julius Erving, and Kareem Abdul-Jabbar are among the greats that played there. Other popular basketball games are located along Malcolm X Boulevard and West 145th Street and at the Grant Houses on West 125th Street.[3]

Particularly in summer, Harlem lives by night, and Harlemites socialize in large numbers, looking at others in the crowd, smoking, cooling off, and playing. Sidewalks are an extension of their confined living spaces. Men sitting on plastic chairs play dominoes and cards; a few stand against a wall, rolling dice. Churches keep their doors open for ventilation as they conduct Bible-study programs, choir practices, and board meetings. Church members sit on the sidewalk in front of their houses of worship. Under the floodlights from the high-rise public housing projects, parents keep an eye on their children while chatting with their neighbors.

I expected to see people working during the day and having fun or resting at night. Instead I saw large numbers of families for whom the night seemed to be a continuation of the working day, as they washed their clothes at laundromats and bought food in stores or from street vendors. At supermarkets, women took their children along while they grocery shopped. They pushed loaded carts, their sleepy children hanging from the carts. Men and women congregate in liquor stores, barbershops, and beauty salons. The light from store windows and doors

renders those hanging out on the sidewalk into silhouettes while those inside, lit from behind and framed by the entrance, seem ghostly. Groups of people stand on street corners waiting for the bus. Scavengers push their carts and stop to open garbage bags searching for bottles and cans. The proverbial Harlem rats scurry silently between buildings or run from one garbage bag to another.

The area of Central Harlem between the statues of Frederick Douglass and Harriet Tubman, along Frederick Douglass Boulevard north of 110th Street and south of 125th Street, once the epitome of a ruined commercial neighborhood, is now Harlem's most gentrified stretch. Renamed SoHa (short for South Harlem), these fifteen blocks of restaurants, wine stores, pet shops, and a large Best Yet supermarket have Morningside Park to the west and Central Park to the south, fantasy landscapes with lakes, castles, and waterfalls. Above the hill on Morningside Heights are Columbia University and the Cathedral of Saint John the Divine. A sign on The Livmor, a new condo building on Frederick Douglass, invites you to move to SoHa to live more actively and be more adventurous. Since 20 percent of the residents in the area are white, many consider the neighborhood to be an extension of the affluent Upper West Side of Manhattan, its character enhanced, but not defined by, black culture.[4]

Neither Harlem's icons nor African imagery are visible in the lobbies of new buildings or in most restaurants along the boulevard. African Spears, a "cultural village and meeting place" that served coffee from Kenya and Ethiopia and sold African statues, closed two years ago. Minton's Playhouse, the cradle of Bebop on West 118th Street received a neon sign and a plaque placing it in the National Register of Historic Places. After being closed for more than two decades Minton's reopened in 2006, only to close again in 2010.

Gentrified SoHa is a stark contrast to Harlem's hypersegregated northern tip, the location of the Polo Grounds Houses, the Ralph Rangel Houses, and a Doe Fund homeless shelter. The area lies north of West 155th Street and is bounded to the east and north by the Harlem River and on the west by the promontory Coogan's Bluff. The American Community Survey for 2005 to 2009 reveals that the population of this section of Harlem is 1 percent white and, surprisingly, 38 percent Latino.[5] At the Ralph Rangel Houses located beside the Harlem River, street-level drug trade is still a daily event witnessed by families and elderly residents.

One such resident asks of me, "Do you have a key? Don't you know where you are? They see you with that camera. You have a lot of problems with people, not with me," he warns as I try to get inside a locked building at the Rangel Houses. Posted in the lobby of some of the public housing buildings in the complex is a wanted poster for a three-hundred-pound armed robbery suspect. At Rucker Park across from the Polo Grounds Houses, the site of the aforementioned renowned basketball tournament, spectators are searched for weapons and the police stand guard at the entrance. Having to submit to a search, however, does not diminish the spectator's enjoyment of the games.[6]

As Big Marl, a maintenance man at the Rangel Houses, explained: "It is the people that make it Harlem. Everybody in Harlem has a certain swagger, people in Brooklyn and the Bronx can tell." He sees the existence of this particular neighborhood character threatened because "the people who made this place real popular have to move out because they can't afford it." The newcomers look down on things like "sagging," that is, wearing pants like they are falling down.

Batik, a street vendor and a resident of the Saint Nicholas Houses, is grateful

to Bernard Madoff, "the man who ran off with all those hundreds of billions," for saving the neighborhood from being completely gentrified. "In 2008, pictures of 125th Street full of skyscrapers like Midtown were circulating and people thought they would be pushed out. But many of the people who wanted to invest in Harlem lost their money to Bernie Madoff. This is how Madoff saved Harlem."

Searching for continuity between pre–World War II Harlem and the present, I tried to look at the neighborhood through the eyes of its writers, poets, visitors, and photographers such as James Weldon Johnson, Langston Hughes, Claude McKay, Zora Neale Hurston, Nancy Cunard, James Van Der Zee, and Roy De-Carava. For the period after World War II and the beginning of my documentation in 1970 I read Harlem-born James Baldwin, as well as Ralph Ellison and Langston Hughes.

I am aware that Dutch farming communities in Harlem date from the seventeenth century, yet I didn't run into any marker, store name, or institution with Dutch references. Dutch settlements as well as the nineteenth- and early twentieth-century German, Italian, and Jewish immigrant neighborhoods that followed them have had little influence in shaping the present development of the neighborhood or its identity except in its built environment. It is not out of romanticism that I chose the Harlem of its Renaissance heyday as a basis of comparison with that of the period covering 1970–2012 but, rather, because of increasing references to that past in the neighborhood. The only Harlem to become world famous is "The Capital of Black America," the African American community of the 1920s and 1930s. Memories of the black struggle and of the Harlem Renaissance give names to streets, are represented in statues and buildings, and help shape Harlem's economy.

My search for persistent remains of the past led me to the last bastions of family-owned independent businesses—each bearing the personal imprint of the owner: barber shops, coffee shops, bars, and funeral establishments, places where people eat, socialize, escape from family problems and troublesome bosses, or where they go to pay their respects to the dead. Employees and owners of these businesses, because of their roots in the community and their knowledge of local traditions, turn into arbiters deciding what is authentic and what is fake.

On Malcolm X Boulevard I found Ralph & Son Barbershop. An 1859 framed newspaper clipping advertising "Negroes for Sale" was displayed on the window inside the shop. Another picture showed a young slave in chains. I listened to an elderly barber as he spoke about his dislike of the way youngsters in Harlem today eat watermelon as they walk along the street. He assessed the quality and price of the smoked ham hocks on sale in the store across the street. While waiting for a haircut, a vendor came into the shop to sell jeans and shorts, which he displayed on his arm.

Guided by Claude McKay's descriptions of Aunt Hattie's chitterlings joint on 132nd Street in his *Home to Harlem*, I embarked on a search for today's version of this famous dish made with pork intestines.[7] I found chitterlings for sixteen dollars on the menu at Sylvia's Restaurant—but only from Friday to Sunday and everyday for thirteen dollars at Manna's, a Korean soul food chain. Kim of the Saint Nicholas Houses informed me that chitterlings is a dish people cook at home. "I made some the other day, with potato salad and collard greens," she said.

The former H. Adolph Howell Funeral Church was a well-known neighborhood funeral home. When the performer Florence Mills died in 1927, more than ten thousand people came to this small Gothic revival establishment located on

Adam Clayton Powell Jr. Boulevard and West 132nd Street to pay their respects to Harlem's "Queen of Happiness."[8] The establishment was later named the Rodney Dade Funeral Home. By 2011 it was closed.

Death, in grassroots Harlem, is a community affair. On bus stops, bars, and newspaper stands and in community gardens, elevators, and lobbies of public housing projects, one often encounters fliers announcing someone's death and giving the names of their immediate family members. Neighbors are encouraged to pay their condolences to the family of the deceased and are invited to attend memorial services. Names of dead family members and their dates of birth (sunrise) and death (sunset) are often spray-painted on the rear windows of vehicles. Roadside memorials made up of flowers, candles, cards, stuffed animals, and pictures are placed at spots where people have been killed. And the owner of A Touch of Dee Lounge on Malcolm X Boulevard at 143rd Street placed portraits of her deceased father and mother on the window of the bar facing the Boulevard. When I asked why she responded, "I wanted to do it, I did it for myself." In a card attached to a memorial to someone named Tony placed on a wall at a corner of Malcolm X Boulevard, his family thanked the neighborhood for "whatever you did to console our hearts."

Local heroes and celebrities are likewise informally celebrated. Bobby Robinson, Harlem's soldier, singer, and producer, died in January of 2011 at the age of 93.[9] Almost immediately, handwritten notes appeared on the facade of his former store, Bobby's Happy House on Frederick Douglass Boulevard. Robinson was hailed as a "great human being" and an "icon." His old store was decorated with red roses arranged to spell "BOBBY." Condolence notes came from near and far: the Saint Nick Projects, 131st Street, the Hood, the Zulu Nations, and even Dallas,

Texas. Addressed to Bobby, the notes expressed sentiments such as "Thanx 4 the music"; another note, signed "The Cat," read: "Bobby U Ran W/the Starz, Now you're A STAR to 4ever shine in heaven."

Continuing in my search for the real Harlem, I asked a maintenance man at the Polo Grounds Houses about nearby landmarks; he listed Jimbo's Hamburger Palace among his favorite local authentic places. Was it possible for a part of a local restaurant chain to be "authentic"? I checked the place out several times and saw no Caucasians among the patrons. While the workers were Latinos, most of the customers were black and poor; the menu included grits, eggs, sausages, home fries, and bacon as well as hamburgers. Harlem hip-hop artist ASAP Rocky selected a Jimbo's to shoot a scene for his popular video "Peso": rappers, barbers, funeral directors, public housing employees, and saloon keepers are authoritative sources when it comes to authenticity.[10]

Jimbo's restaurants are clean and cheap. The service is fast, the food greasy and tasty. Clients often ask the prices of items such as a melted cheese sandwich or want to know how much they can save by skipping the tomato slice in their hamburger. They may order one item and share it with their child. Customers can stay for as long as they like, despite the sign that reads "Maximum time at the table is 25 minutes." Posters of Louis Armstrong, Billie Holliday, and Dizzy Gillespie underscore that the clientele is black, while a hidden altar to the Virgin of Guadalupe makes the workers feel at home.

In a Jimbo's on West 145th Street, I overheard a Mexican cook call an elderly black lady "abuelita" (grandma) while serving her a cup of coffee. Street vendors come to Jimbo's to sell steaks at bargain prices, as well as DVDs. The chain is four decades old and thriving, showing that Harlem still creates authentic places,

that such places can evolve even from franchises, and that the patrons are what give an establishment its character.

But corporate and municipal attempts to celebrate Harlem's uniqueness and culture are also evident all along 125th Street. A newly arrived Applebee's fast food franchise spares no expense in showcasing the history and local character of the community. Posters of Gordon Parks, W. E. B. DuBois, Billie Holliday, and Muhammad Ali grace the walls. Nearby, a customized McDonald's is decorated with the faces of black and Latino musicians surrounded by an effervescence of painted and carved musical notes.

"Why, in this capital of the Negro world, is there no centre, however small, of Africanology?" asked Nancy Cunard in 1934.[11] More than seventy-five years later, Cunard's question is being answered: in 2012 the Museum for African Art is being completed on Fifth Avenue at 110th Street. More than any other place, Harlem, with its research institutions, performing arts centers, museums, and statues of famous African Americans is in the business of preserving, mythologizing, and celebrating black culture.

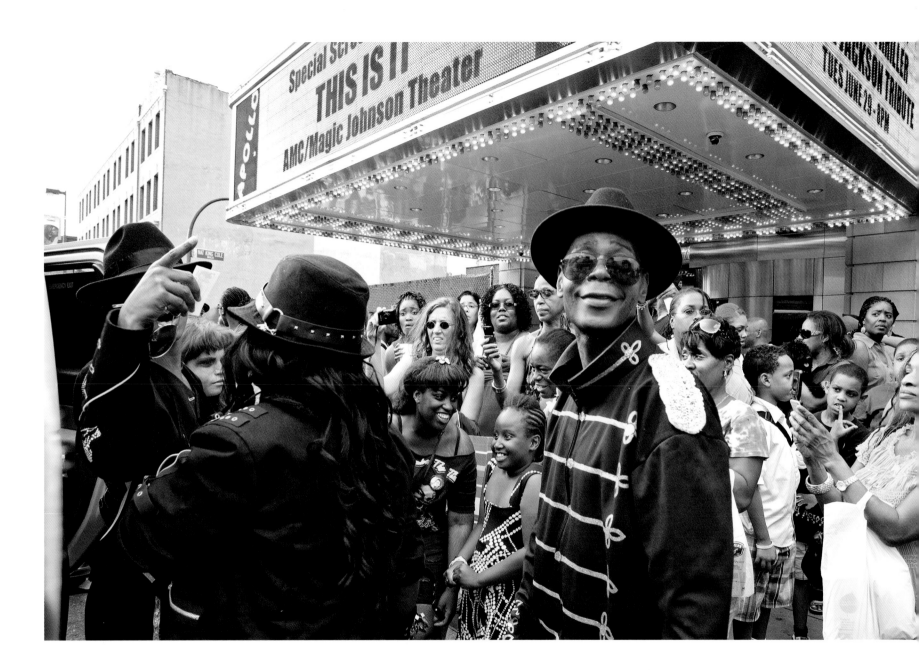

Michael Jackson's look alike, Apollo Theater, 253 West 125th Street, Harlem, 2010 **39**

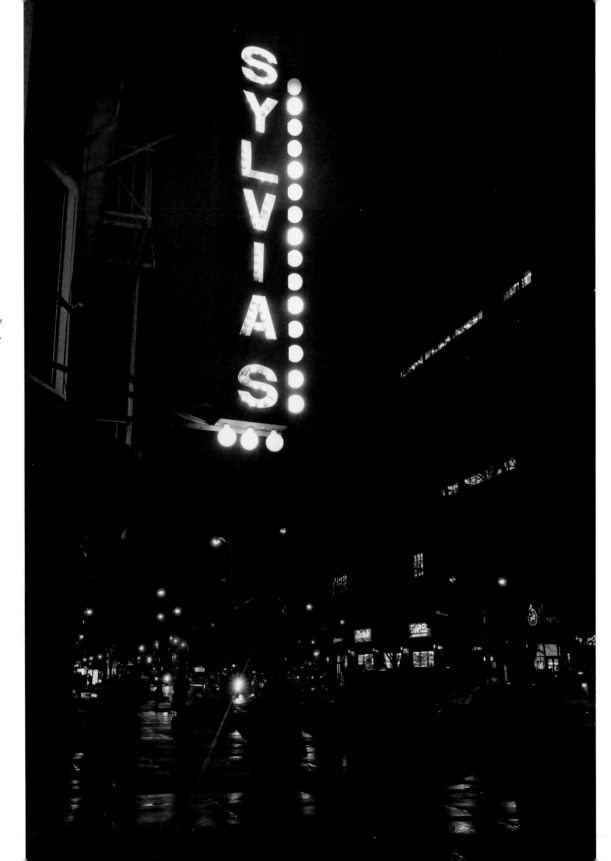

Sylvia's, Malcolm X Boulevard view south from West 127th Street, Harlem, 2011

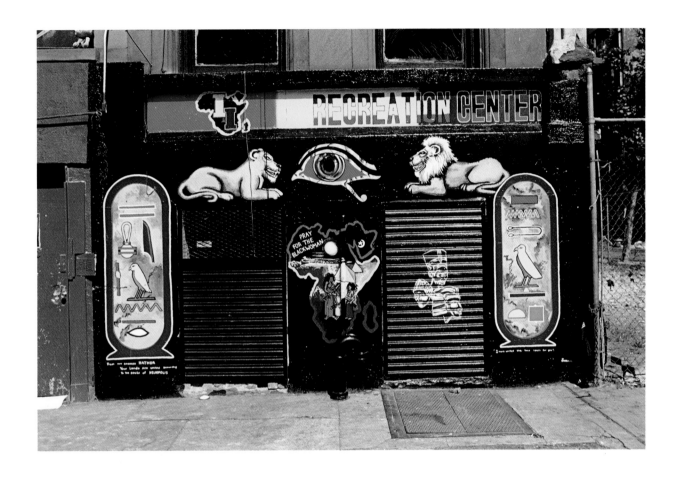

West Indian recreation center, 2038 Fifth Avenue, Harlem, 1992

42 *Record shop, 2038 Fifth Avenue, Harlem, 1996*

African hair braiding, 2038 Fifth Avenue, Harlem, 2007 **43**

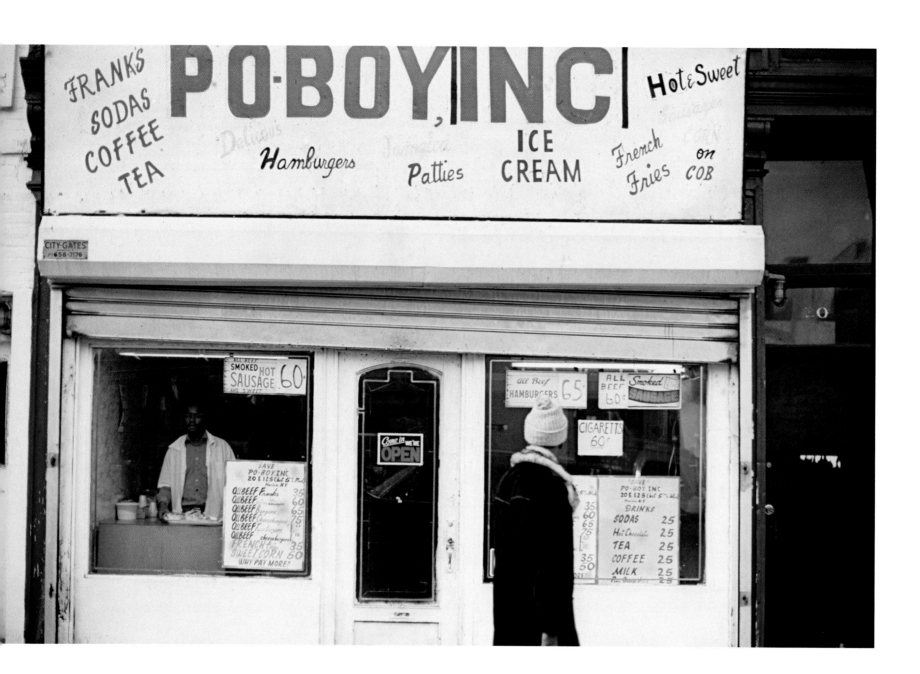

44 *Jamaican restaurant, 20 East 125th Street, Harlem, 1977*

Harlem Underground Clothing Company, 20 East 125th Street, Harlem, 2009 **45**

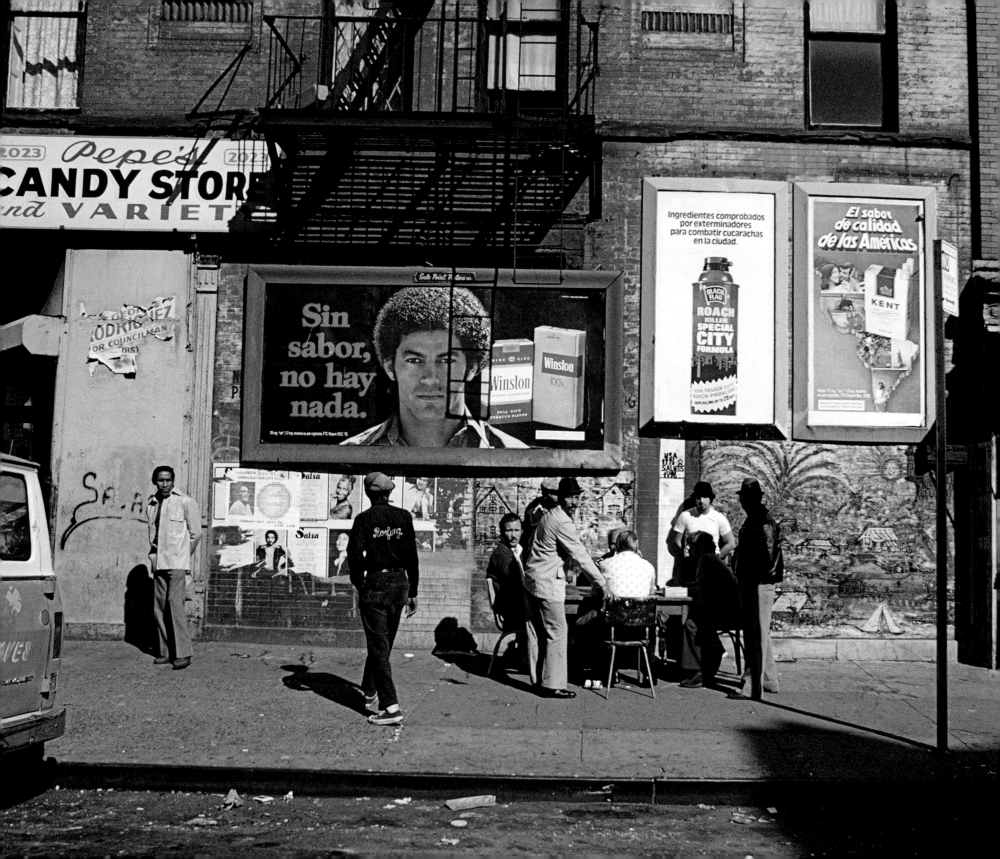

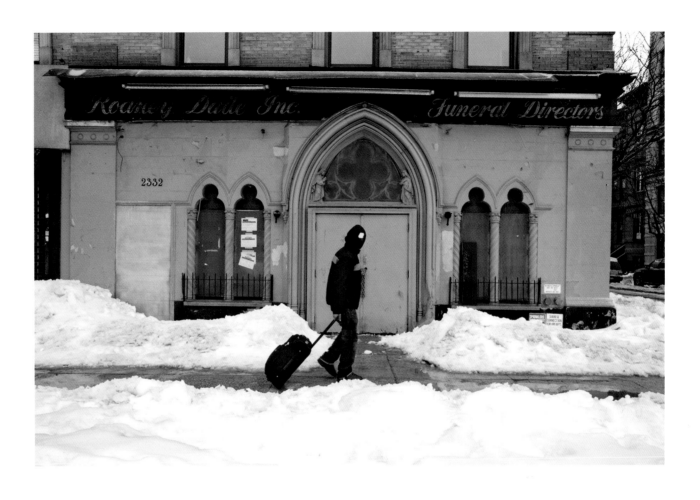

Former Rodney Dade Funeral Home, 2332 Adam Clayton Powell Jr. Boulevard, Harlem, 2011

East Harlem street scene, East 123rd Street at Lexington Avenue, Harlem, 1977 **47**

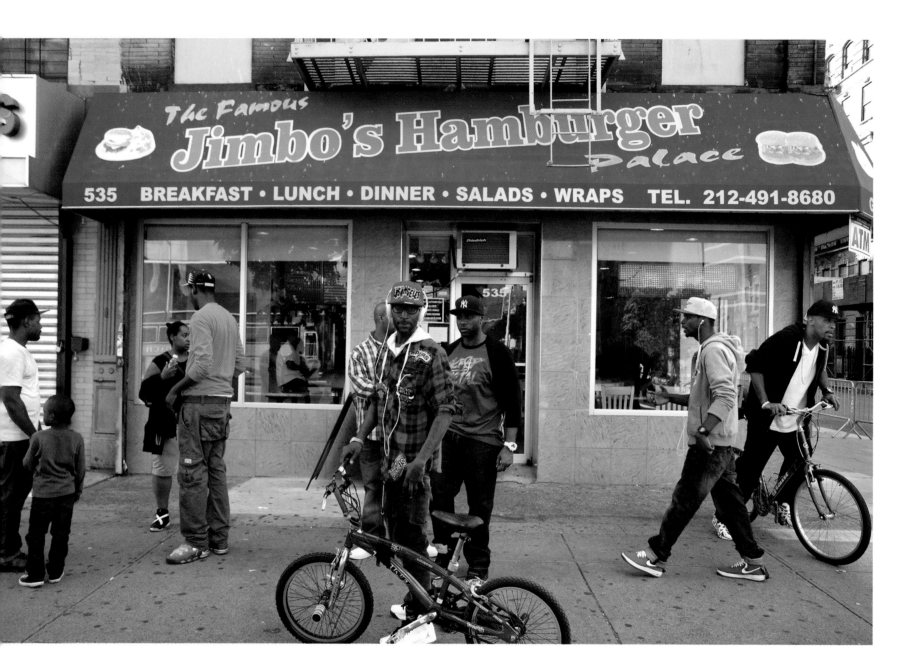

Jimbo's Hamburger Palace, 535 Malcolm X Boulevard, Harlem, 2012

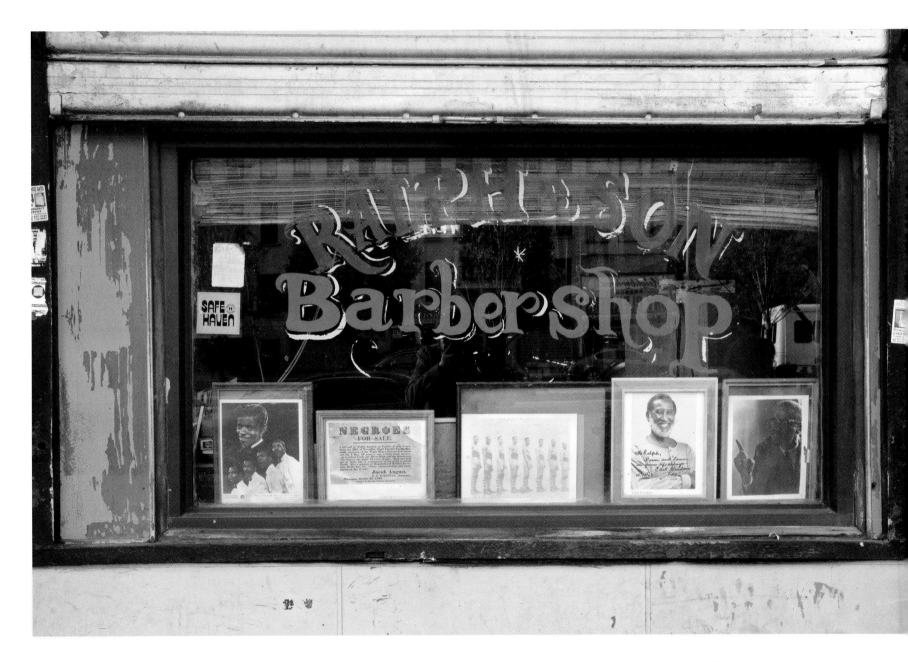

Former Ralph and Son Barbershop (now closed), 431 Malcolm X Boulevard, Harlem, 2010

Bus stop death announcement, Frederick Douglass Boulevard at West 155th Street, Harlem, 2008

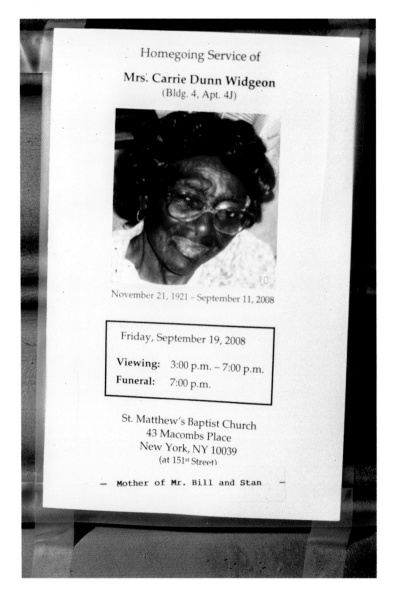

Homegoing Service of

Mrs. Carrie Dunn Widgeon
(Bldg. 4, Apt. 4J)

November 21, 1921 – September 11, 2008

Friday, September 19, 2008

Viewing: 3:00 p.m. – 7:00 p.m.
Funeral: 7:00 p.m.

St. Matthew's Baptist Church
43 Macombs Place
New York, NY 10039
(at 151st Street)

— Mother of Mr. Bill and Stan —

Waiting by the liquor store, 469 Malcolm X Boulevard, Harlem, 2011

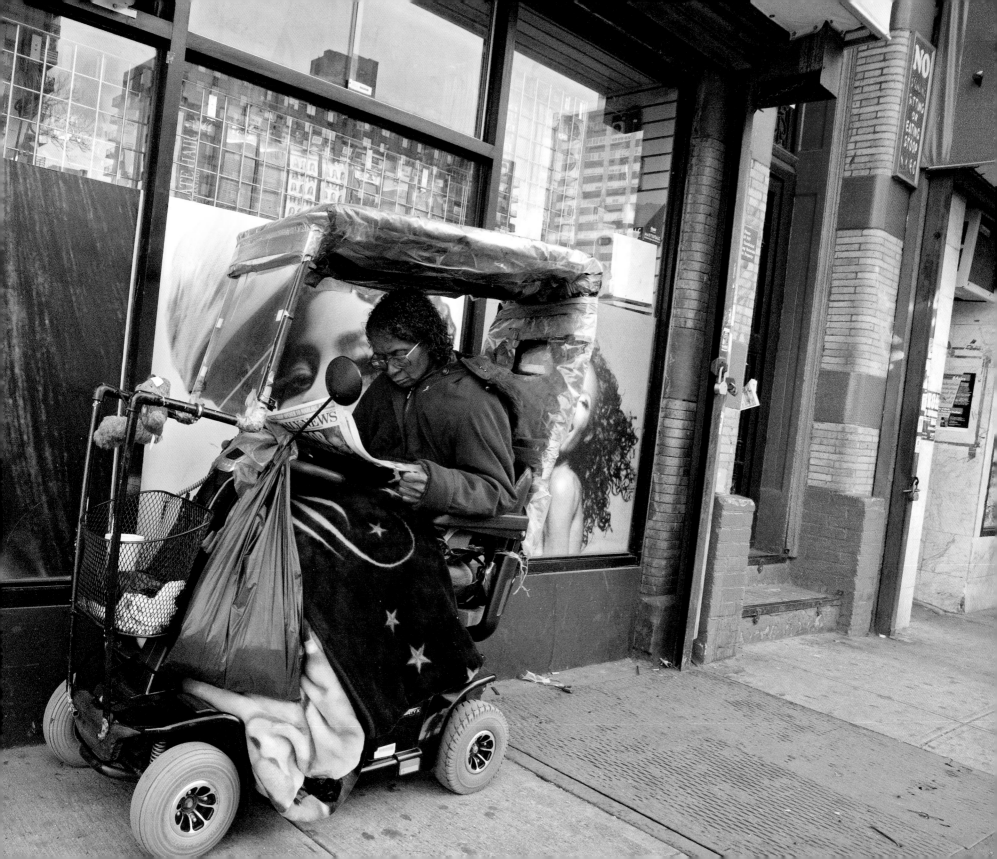

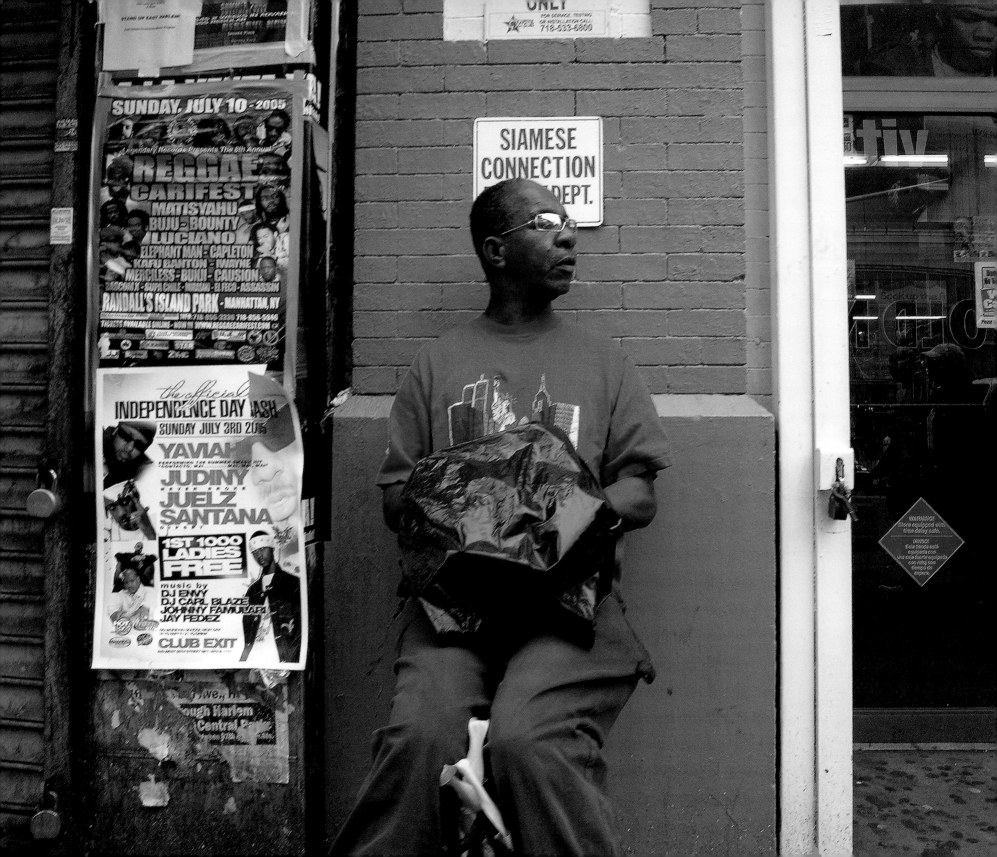

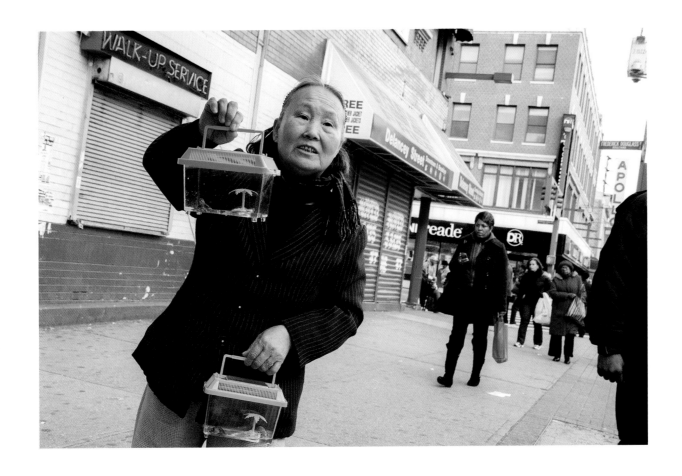

TOP *Selling baby turtles at the bus stop, Frederick Douglass Boulevard at West 125th Street, Harlem, 2010*

OPPOSITE *Video salesman, West 125th Street by Frederick Douglass Boulevard, 2005*

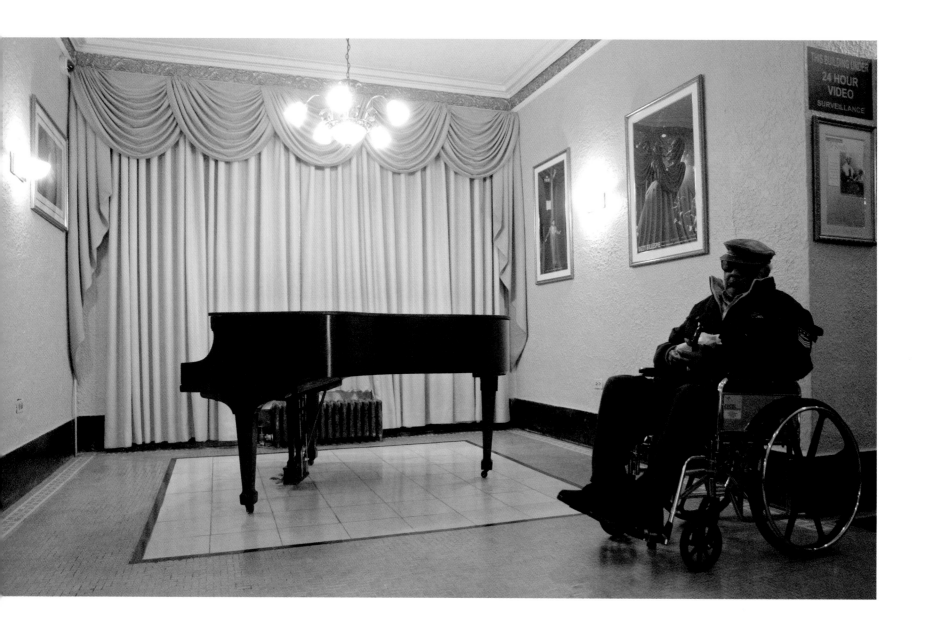

Lobby, 112 West 138th Street, Harlem, 2011

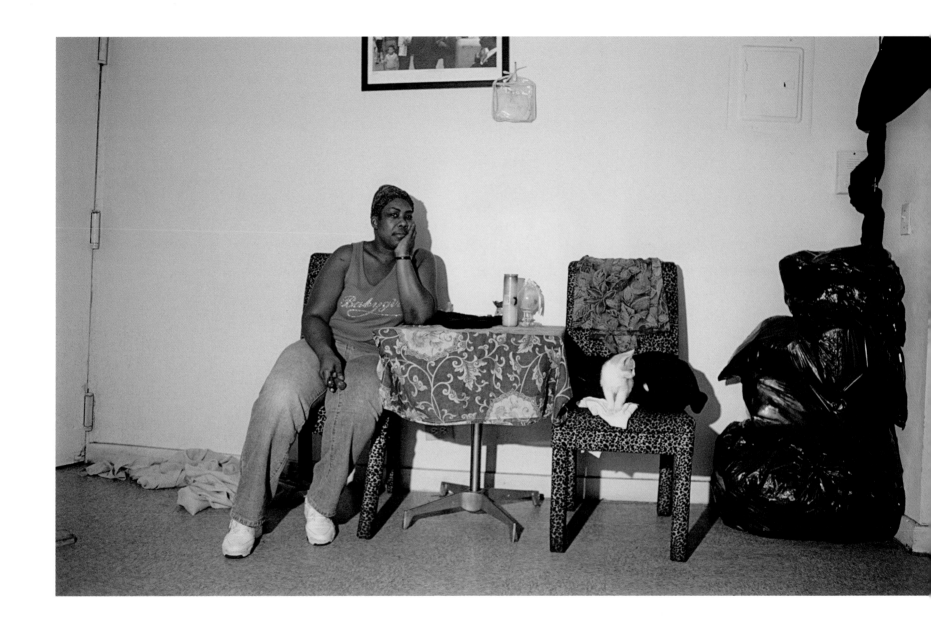

Woman evicted from condemned building, 2807 Frederick Douglass Boulevard, Harlem, 2008

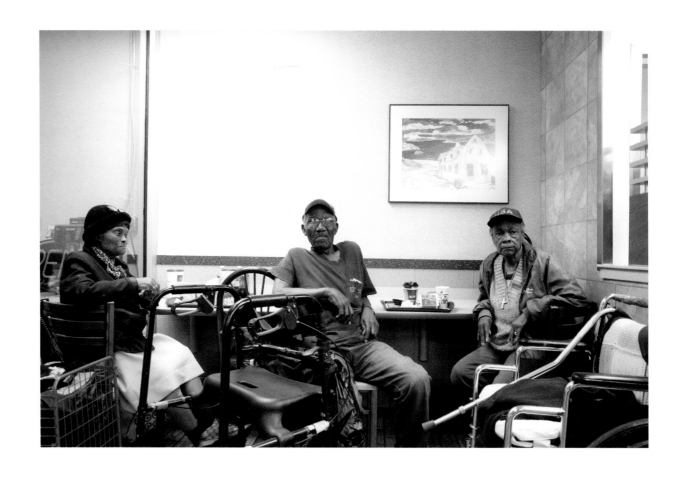

TOP *Old folks, McDonald's, Malcolm X Boulevard at West 132nd Street, Harlem, 2010*

OPPOSITE *Seville Lounge (now closed), 126th Street at Adam Clayton Powell, Harlem, 2011*

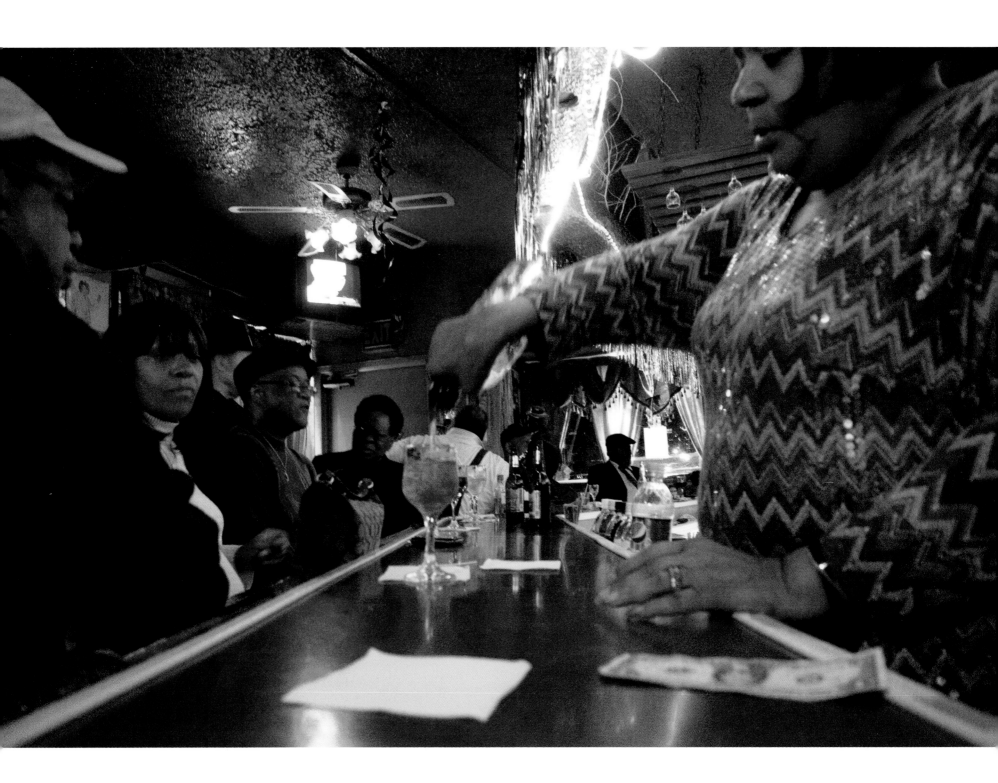

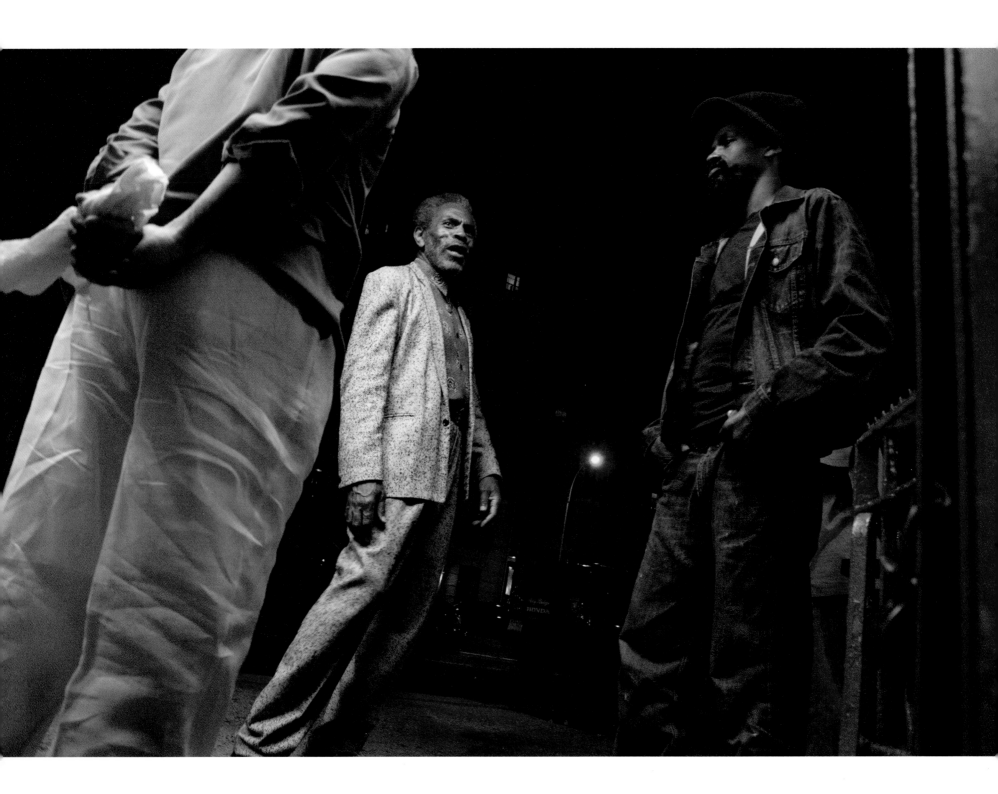

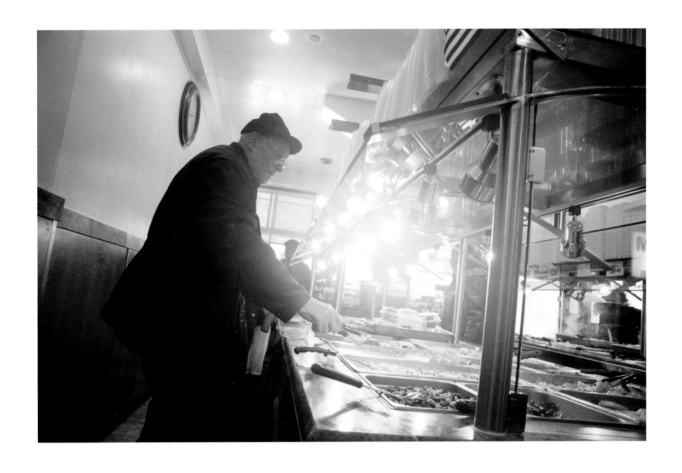

TOP *Jacob Restaurant, 2695 Frederick Douglass Boulevard, Harlem, 2011*

OPPOSITE *Smokers outside Saint Nick's Pub (now closed), 773 Saint Nicholas Avenue, Harlem, 2010*

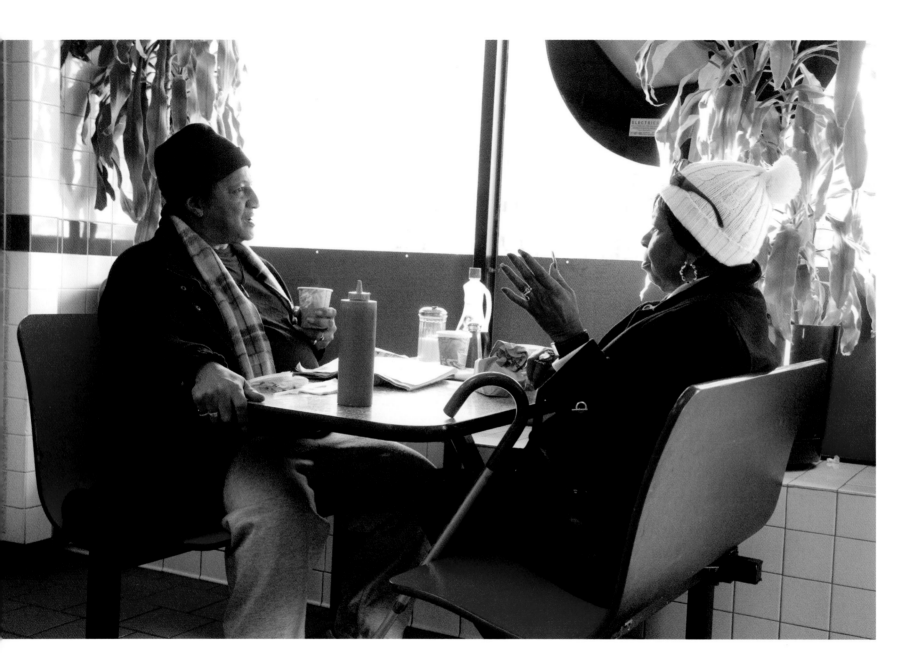

Jimbo's Hamburger Palace, Malcolm X Boulevard at West 124th Street, Harlem, 2011

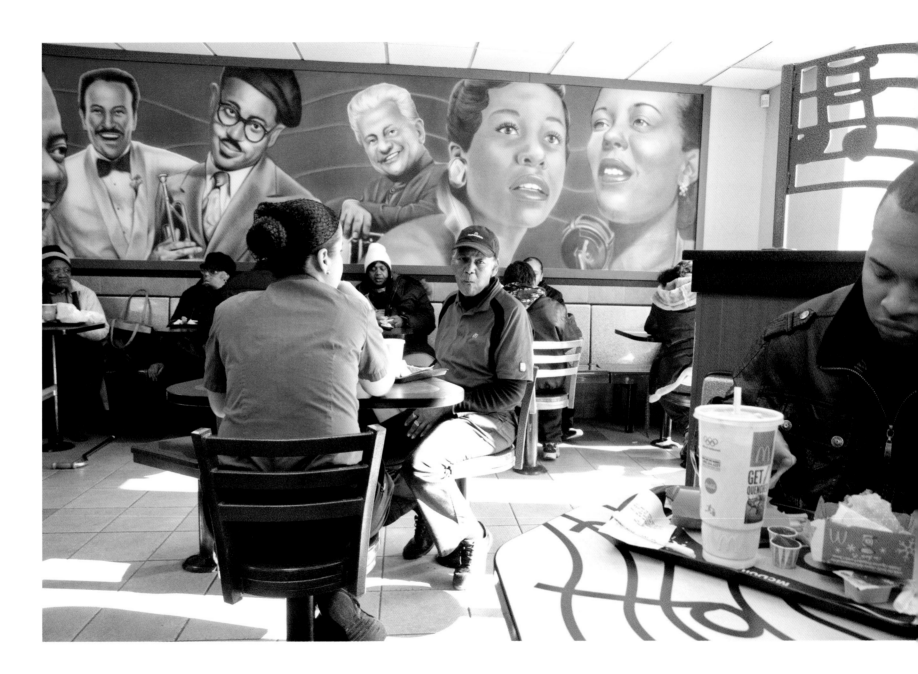

Music-themed McDonald's, East 125th Street at Lexington Avenue, Harlem, 2011

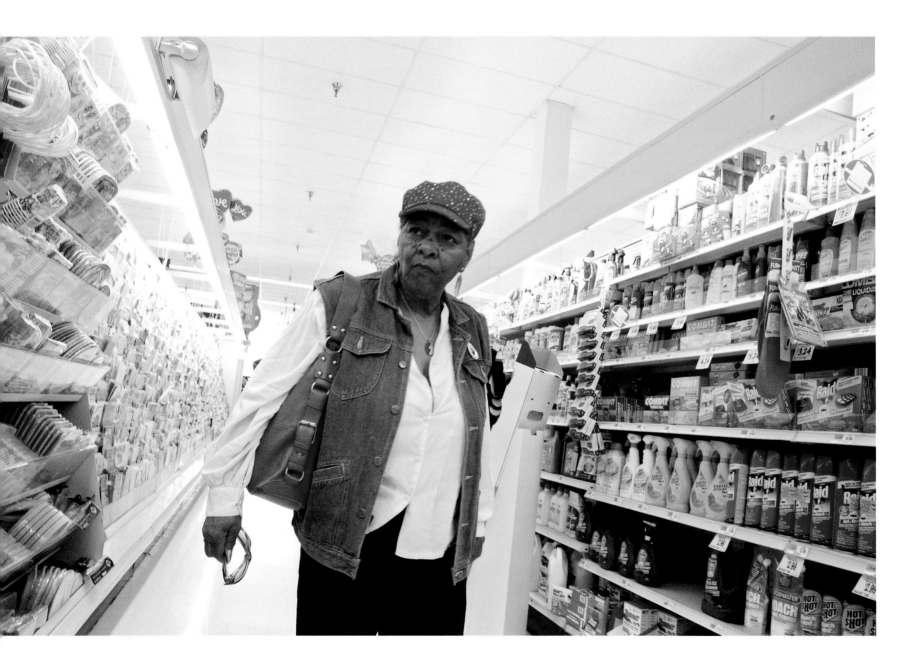

Pathmark, the largest supermarket in Harlem, Lexington Avenue at East 125th Street, Harlem, 2010

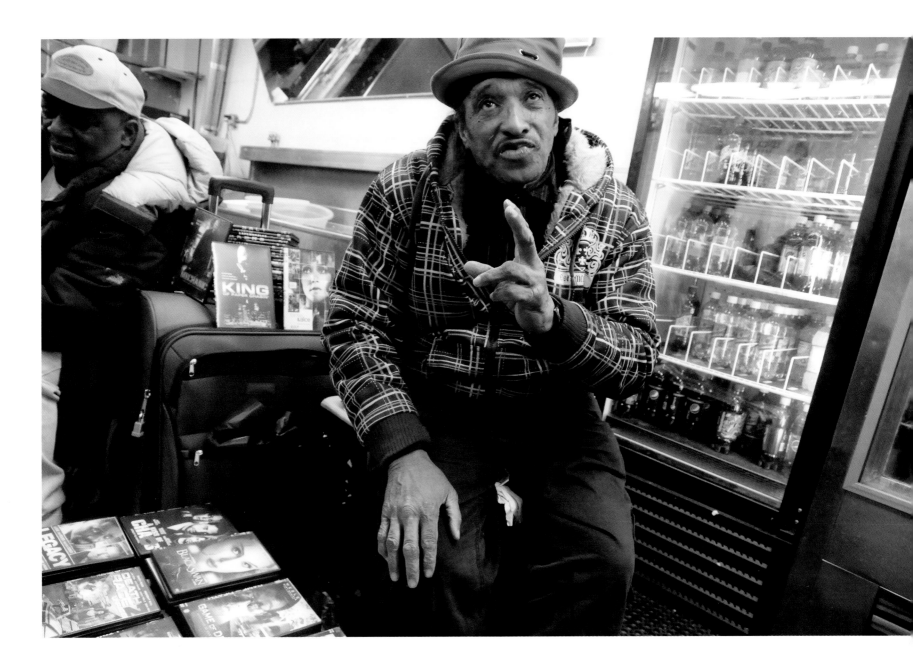

Video salesman, Lenox Fish Market, 480 Malcolm X Boulevard, Harlem, 2011 **63**

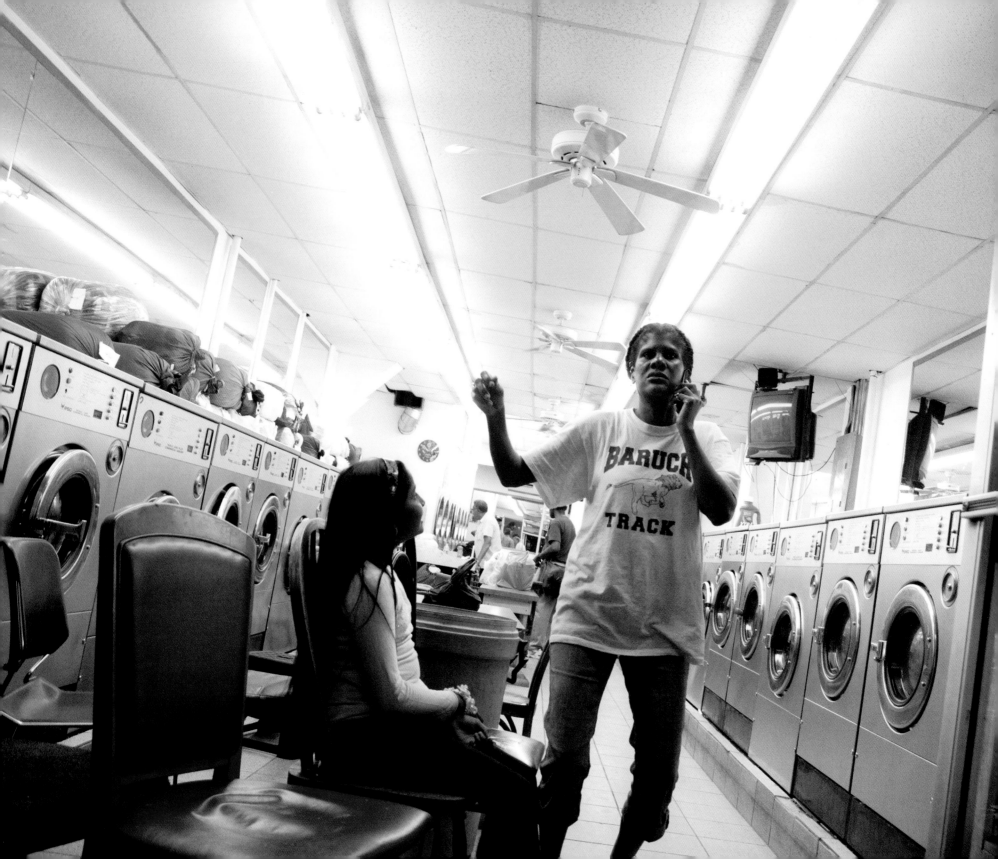

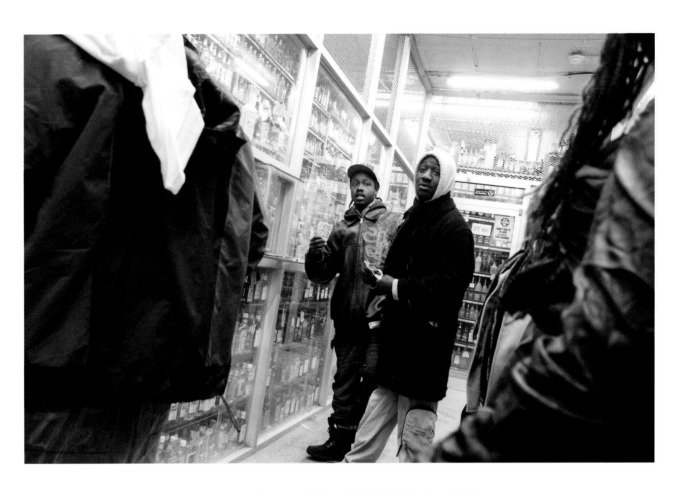

TOP *Liquor and Wines, 467 Malcolm X Boulevard, Harlem, 2011*

OPPOSITE *Dancing while talking on the cell phone, Flash Cleaners and Laundromat, 2707 Frederick Douglass, Harlem, 2010*

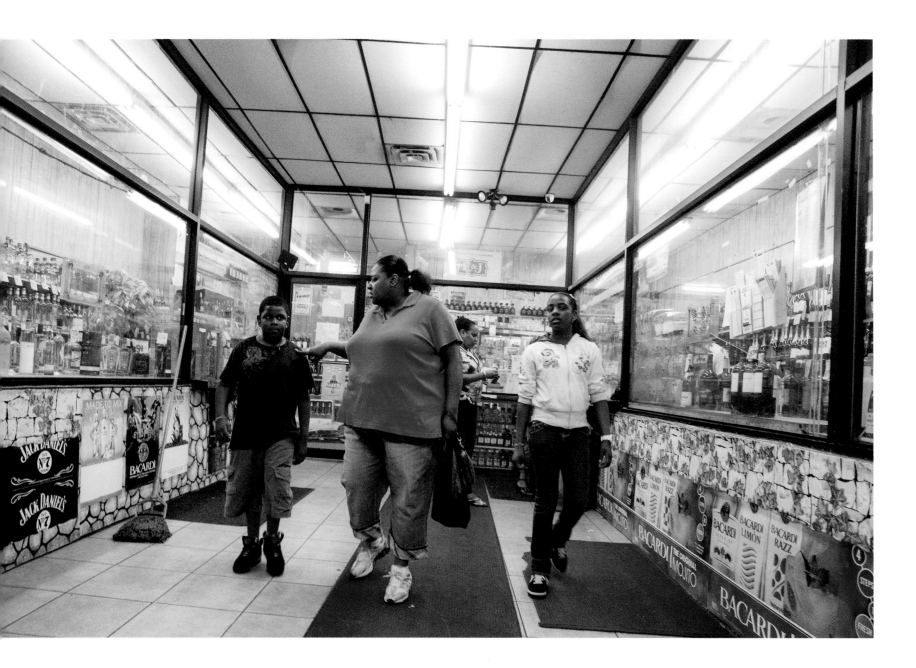

Louis Liquor Corporation, 108 West 145th Street, Harlem, 2010

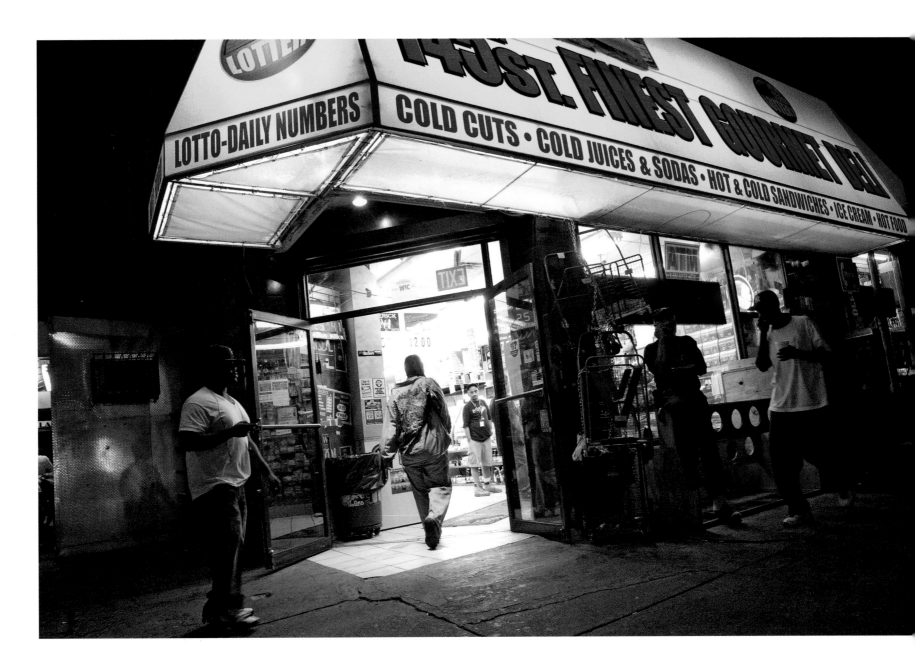

145st Gourmet Deli, West 145th Street at Frederick Douglass Boulevard, Harlem, 2010

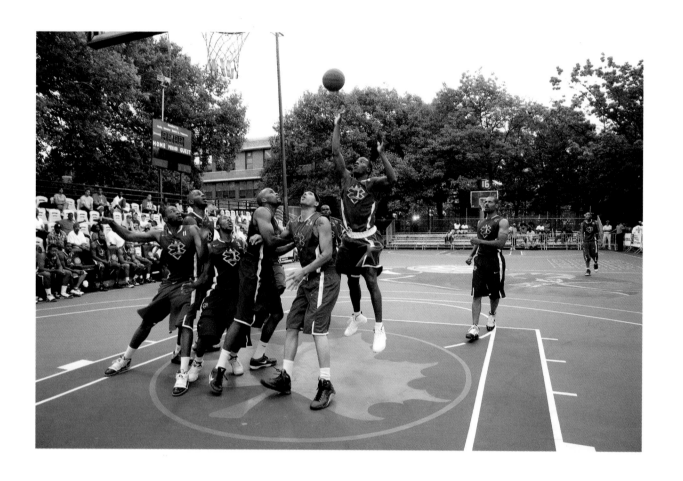

Entertainers Basketball Classic, West 155th Street at Frederick Douglass Boulevard, Polo Grounds, Harlem, 2010

OPPOSITE *Harlem noir, view east along West 125th Street from 700 West, Harlem, 2011*

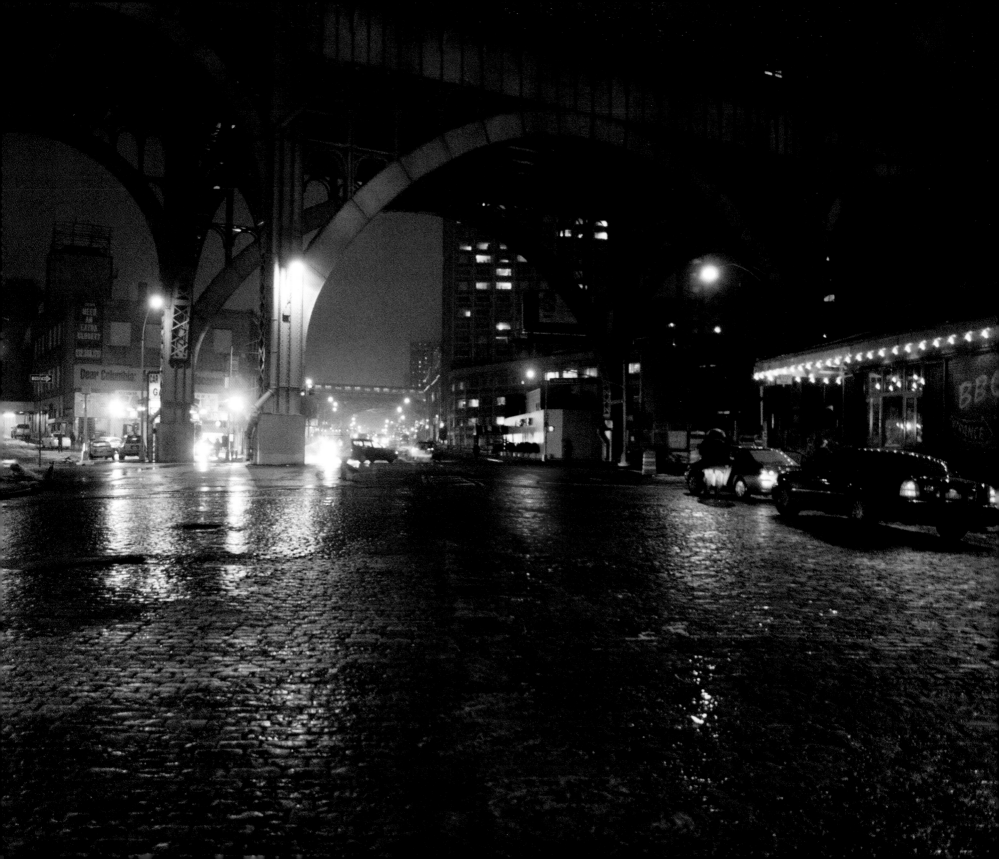

LOST HARLEM

The people in Harlem know they are living there because white people do not think they are good enough to live anywhere else. No amount of "improvement" can sweeten this fact. Whatever money is now being earmarked to improve this, or any other ghetto, might as well be burnt. A ghetto can be improved in one way only: out of existence.

JAMES BALDWIN, *Esquire*, 1960

OPPOSITE *21 East 125th Street, Harlem, 1977*

IN THE 1972 MOVIE *Across 110th Street*, Bobby Womack sang "Harlem is the capital of every ghetto town." Located in the world's media capital, the neighborhood was a convenient destination for reporters looking for the worst in ghetto living during the second half of the twentieth century. Movies about drugs, gangsters, and killing such as *New Jack City* (1991) by Mario Van Peebles, Gordon Parks Jr.'s *Superfly* (1972), and Shirley Clarke's documentary *The Cool World* (1964) are a few examples of films shot in Harlem.

The economic crisis of the mid-seventies, which hit Harlem particularly hard, forced the closing of the Apollo Theater in 1976. It remained closed, except for special events, until 1984.[1] Like the Savoy Ballroom and the Lafayette Theater once were, the Apollo Theater was an incubator of talent.

According to *New York Times*, in the 1980s, approximately 65 percent of the buildings in Central Harlem were con-

trolled by the city, the landlord of last resort.[2] Harlem was depopulated. Vacant lots were home to junkyards, where used cars, trucks—even boats—as well as kitchen appliances such as stoves and refrigerators were spread out for prospective customers. Often these junkyards were located next to tire and auto repair shops or used appliances stores. Some dumpsites were so large they covered almost the entire block, while others occupied no more than the footprint of a demolished tenement.

Zoning laws were revised in 2007.[3] Several large and prominent buildings were demolished to make room for even larger ones. The Eisleben—named after the city where Martin Luther was born in 1483, for example, and representative of the strong German presence in Harlem once located on the southwest corner of West 125th Street and Malcolm X Boulevard—is gone. Other impressive surviving structures—such as the six-story former Corn Exchange Bank, a Victorian landmark on East 125th Street, which, after a succession of fires, has been reduced to a two-story shell—will most likely be demolished.

As for the arts, a few of the larger institutions have grown and thrived, while many smaller venues are gone. On the one hand, the Apollo Theater experienced a revival after being rehabilitated. On the other, Smalls Paradise, a celebrated venue for music and dancing, is now the Thurgood Marshall Academy and an International House of Pancakes. A classic example of the corporate takeover of Harlem is the transformation of the Baby Grand Bar—first into the King Party Center (a Korean toy store) and recently a Radio Shack outlet. Another club, The Lido, became a Rite Aid Pharmacy.

The merchants and traders have also changed. Entrepreneurial Koreans and West Indian immigrants replaced an earlier generation of Jewish storeowners.

Now they are being displaced by corporate franchises and chain stores. Many of the Korean toy, fruit, and clothing stores have closed, as have West Indian variety shops and restaurants. McDonald's, KFC, and Blimpie franchises are their replacements. This transformation coincides with the community's loss of most local organizations, clubs, associations, and stores that historically linked residents with the rural South or the Caribbean.

The large murals condemning racism and colonialism are no longer part of the street scene. Peaceful reminders of country life in the rural South, the place of origin of many older Harlem residents, have vanished. On the facade of the Carolina Meat and Vegetable Market on Lenox Avenue, for instance, there used to be a large painting in which playful cows, horses, pigs, ducks, chickens, turkeys, and rabbits took precedence over the tiny humans depicted by the farm buildings in the background. But the market and its painting have disappeared. A Wachovia Bank branch occupies their place.

Although Harlem is home to more than three hundred religious congregations, many of the smaller ones have closed or moved to poorer areas. Harlem, like the Lower East Side, is no longer an incubator of struggling churches. Several of the most famous neighborhood churches, however, such as the Abyssinian Baptist Church and First Corinthian Baptist Church, both historical and cultural landmarks with large congregations celebrated for their choirs and pastors, are thriving. On Sundays these houses of worship, now part of the tourist circuit, attract bus loads of visitors from the world over.

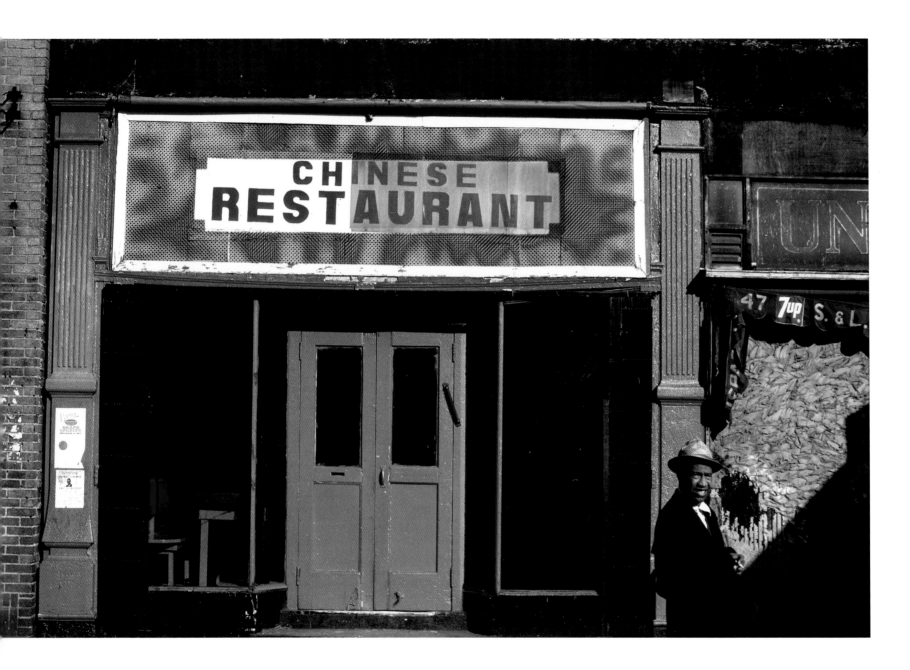

47 East 125th Street, Harlem, 1977

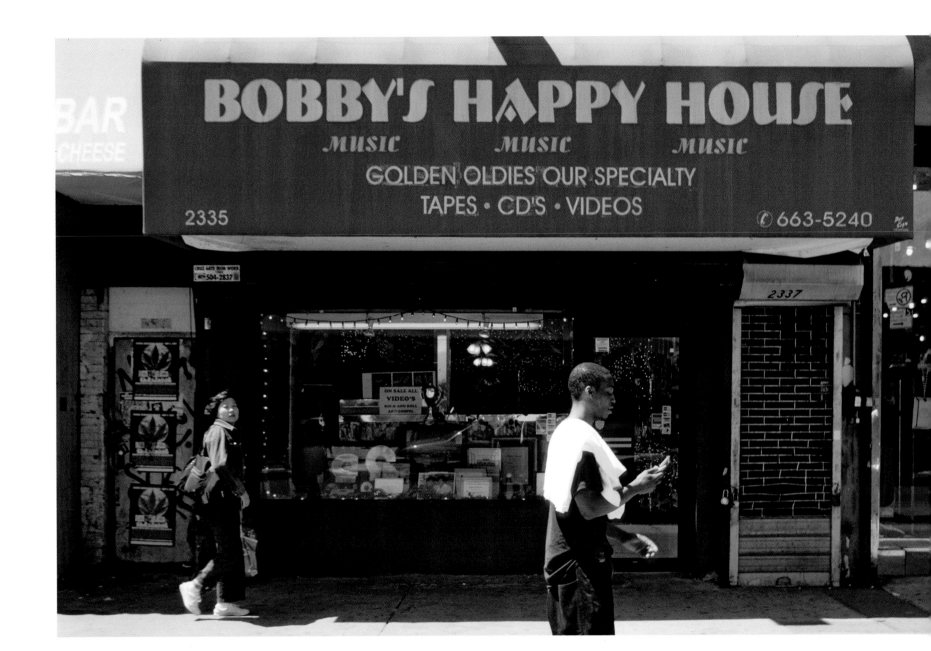

Bobby's Happy House, a bygone Harlem landmark, 2335 Frederick Douglass Boulevard, Harlem, 2007

75

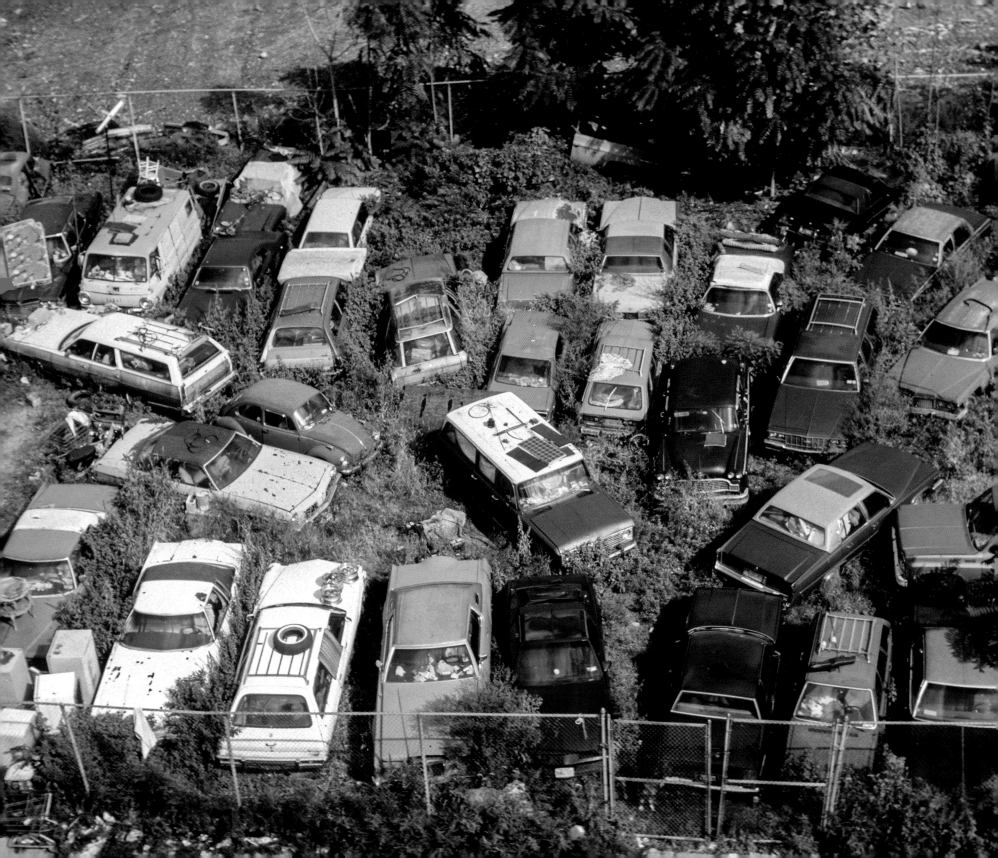

TOP *Ruins of the Renaissance Ballroom and Casino frame the Abyssinian Baptist Church, West 137th Street at Adam Clayton Powell Jr. Boulevard, Harlem, 2011*

OPPOSITE *Doc Singleton's lot, 118th Street at Frederick Douglass Boulevard, Harlem, 1990*

77

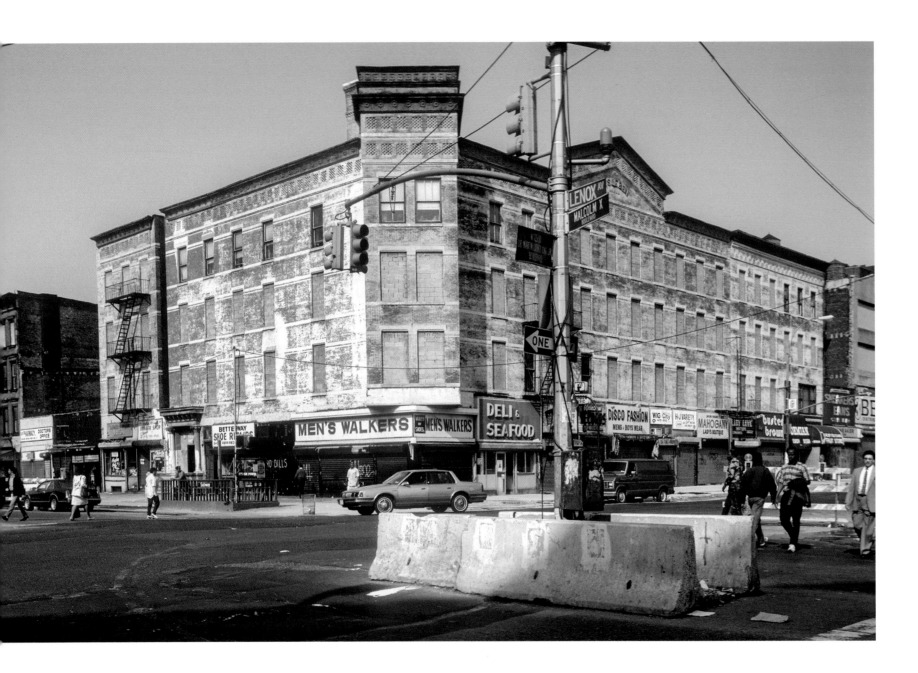

The Eisleben Building, southwest corner of Malcolm X Boulevard at West 125th Street, Harlem, 1989

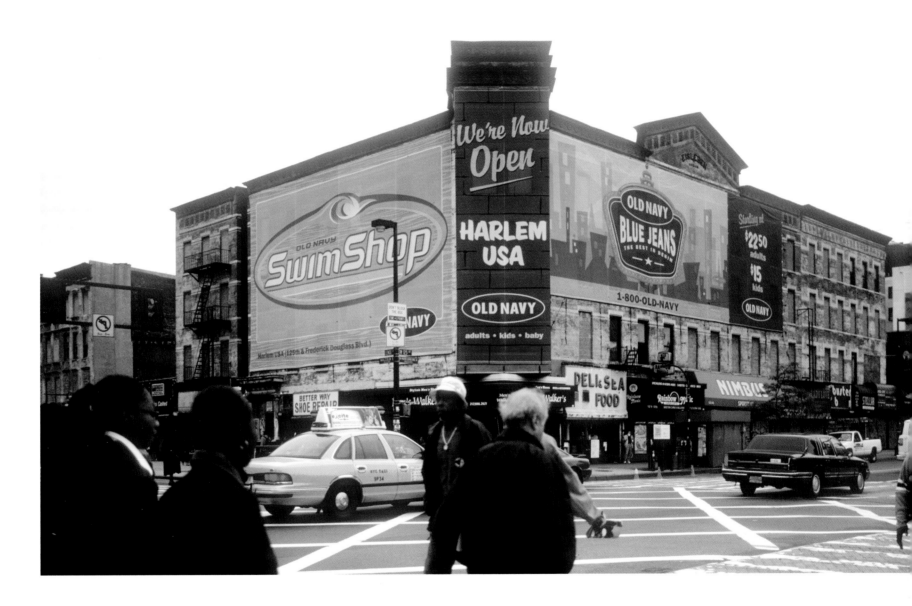

The Eisleben Building, southwest corner of Malcolm X Boulevard at West 125th Street, Harlem, 2000

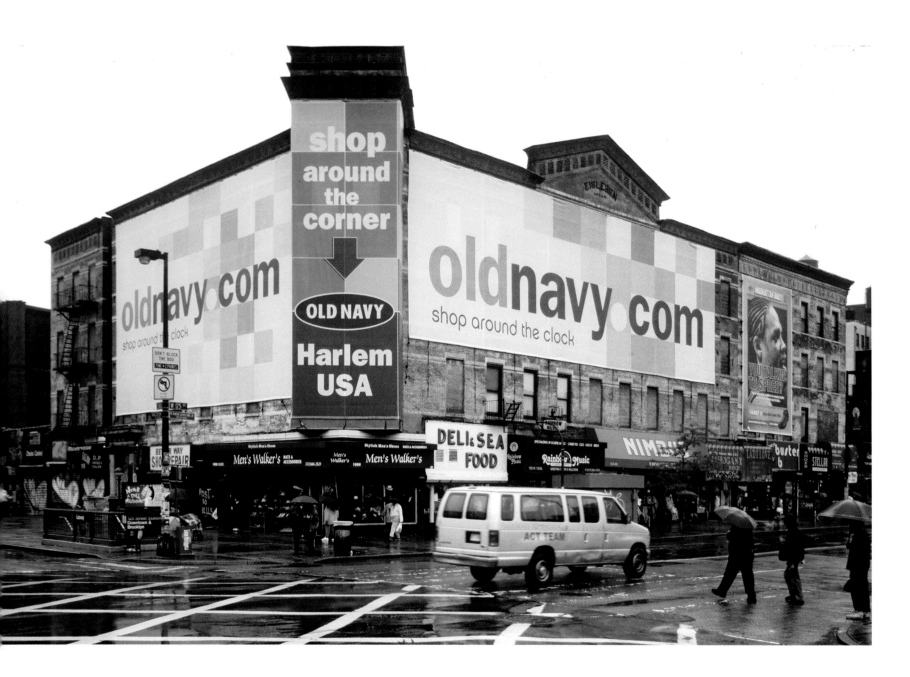

The Eisleben Building, southwest corner of Malcolm X Boulevard at West 125th Street, Harlem, 2001

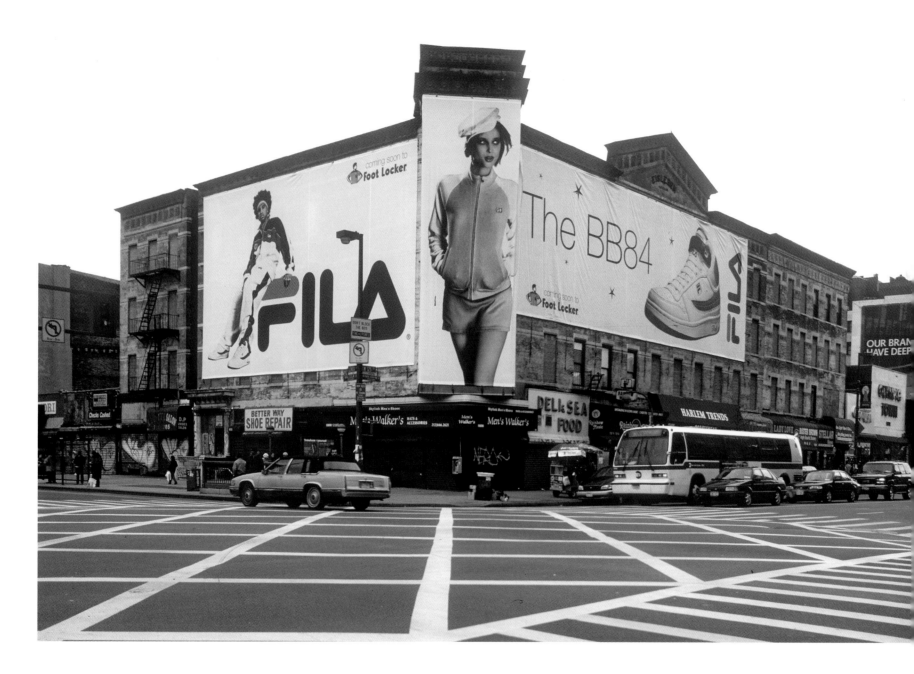

The Eisleben Building, southwest corner of Malcolm X Boulevard at West 125th Street, 2003

The Eisleben Building, southwest corner of Malcolm X Boulevard at West 125th Street, 2005

The Eisleben Building, southwest corner of Malcolm X Boulevard at West 125th Street, Harlem, 2006

Vacant lot, southwest corner of Malcolm X Boulevard at 125th Street, Harlem, 2013

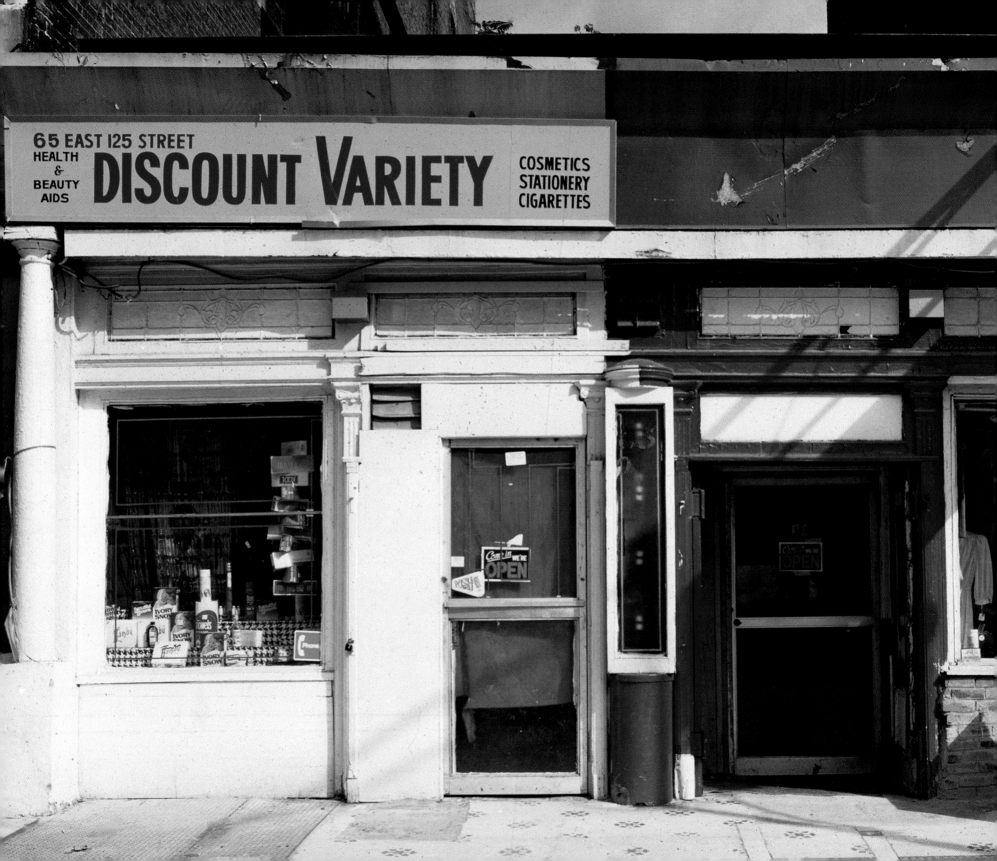

GLOBALIZATION TAKES OVER

From Sugar Club to Global Church

Sadness, drugs and depression were part of my life.
Allison.

<div align="right">

SIGN ON JESUS CHRIST IS THE LORD,
THE UNIVERSAL CHURCH, 2011

</div>

IN 2012 THE FACADE of buildings in Harlem advertise gin, beer, Old Navy, BMW sports cars, sneakers, black TV shows, schools, and popular music. In some ways this reflects how the level of alienation and anger has ebbed dramatically. Young black men now rarely give hateful looks to white strangers. Even people who are not obviously members of some minority group are accepted on the main streets and avenues of Harlem today. As for the elderly, they are not much a part of any street scene, except on Sundays, when they are out and about to attend church.

OPPOSITE *65 East 125th Street, Harlem, 1981*

A decade and half ago, the word "Harlem" was rarely included in the name of local stores. Today, however it is incorporated into the names of many commercial establishments as if it will produce magical effects. This transforma-

87

tion ironically coincides with the community's loss of many local organizations, clubs, associations, and stores. Vernacular names such as Mity Fine or De Paree Beauty Products went out of fashion, replaced by franchises. Gone are all but one of the shops specializing in old, rare 78 rpm records as well as most members-only social clubs.

Tourist buses now line up outside Sylvia's Restaurant, while simpler, friendlier, and less expensive neighborhood places such as the restaurant/jazz club 22 West on West 135th Street, a favorite hangout of Malcolm X, have closed. The Apollo Theater, the Abyssinian Baptist Church, the Studio Museum in Harlem, and Red Rooster Restaurant are some of the area's important destinations now, and their influence is growing.

I miss many ghosts from the old days: pizzerias with one-of-a-kind names like Ronzzo and Zewege. And what tourist now would want to shop for t-shirts portraying Haile Selassie "the Lion of Judah," in a mini-mall run out of shipping containers located in a vacant lot, a scene from the third world? Who needs a Peaches Variety store? And Tot Tot Bar—a unique establishment—was replaced by a McDonald's, one of more than thirty-three thousand in the world.[1] And who can match today the tempting smell of Pig Foot Mary's legendary food stand selling pigs feet, fried chicken, and hot corn?[2] The New York City Planning Department, in its tour of Lenox Avenue, includes the spot on West 135th Street where her business stood. And in the thirties, Black Herman, a performing magician, fondly remembered by artist Romare Bearden, sold roots and strange potions in his Lenox Avenue drugstore.

Another Harlem institution, the cabaret Purple Manor, was promoted in a 1961 advertisement in *Ebony* as offering drinking, dancing, and live jazz. Inside

this air-conditioned "sugar club," the visitor could meet "stars of the stage, screen and radio and dance."[3] The famous drug dealer Leroy "Nicky" Barnes was one of its frequent patrons.

In 1977 the Purple Manor was a rare survivor of a vanishing Harlem music scene. By 1980, the bar was two separate businesses, its western part struggled unsuccessfully twice as a fish and chips establishment, once as a doctor's office, once selling the unlikely mix of kitchen cabinets and clothes. It was also a boutique, a beauty shop, and again a clothing store. Much more stable was the store on the eastern part—the twenty-four-hour Smoke Shop, which remained unchanged for thirteen years until the building was demolished and replaced in 2002 by a cinderblock building hosting Sleepy's: The Mattress Professionals, a national retailer. I always suspected, though, that the clothing store was a "numbers place" and its neighbor, the Plexiglas-protected smoke shop, a drug location.

As of 2009, even Sleepy's had been replaced—by a global church with roots in Brazil and branches in major American cities: Jesus Christ Is the Lord, the Universal Church. In its newest incarnation, the former Purple Manor helps those willing to stop by for five minutes to heal their illnesses, empower beliefs, and in one of their spiritual cleansing meetings, remove evil spirits and receive help with other spiritual issues. The Universal Church assists those with immigration problems via the "foreigner's prayer" and improves people's finances with special prayers and teachings.

In my frequent visits to this site over the years, I was often confronted and ordered to stop photographing lest I be punched and have my camera broken. An advantage of the businesses changing so frequently was that the new owners did not recognize me.

89

GLOBALIZATION TAKES OVER

In a Manhattan constantly in flux, this late Victorian building kept its original appearance until 1980. The Purple Manor saw disappear its carved doors, stained glass windows, golden depictions of champagne glasses among stars, and the tiled sidewalk that led to the entrance, images that made it fun to linger a little longer. The facade slowly disappeared. Some fragments of the original building remained until it was rebuilt completely to house a Sleepy's. Later additions were also eventually replaced, until finally a new two-story cinderblock structure and a disability access ramp was constructed in front. Why did the Purple Manor resist the passage of time so long, then change so rapidly, only to finally disappear?

Harlem, the capital of black America, is largely another of New York City's globalized districts, joining Williamsburg, Wall Street, and Times Square. Tourists can go to Harlem USA and shop at The GAP or at the plentiful sneaker and sporting goods stores to purchase the same commodities as back home but at a good price. Harlem in 2012, with a more varied population and a significant middle class, is not as tough and colorful as it was two or three decades ago. Visitors feel comfortable here, the landmarks are clustered together, and the streets and neighborhoods reflect a new relaxed and friendly atmosphere.

As yet globalization has not fully penetrated Spanish Harlem north of East 110th Street. Lacking the history of slavery in the United States and of the Civil Rights struggle, the Hispanic experience in New York is quite different from that of African Americans. The Catholic Church has played an important role in homogenizing cultural influences from places such as Cuba, Puerto Rico, and more recently Mexico. Tour buses seldom bring visitors to Spanish Harlem. Here, economic development and gentrification have not significantly affected its Latino character.

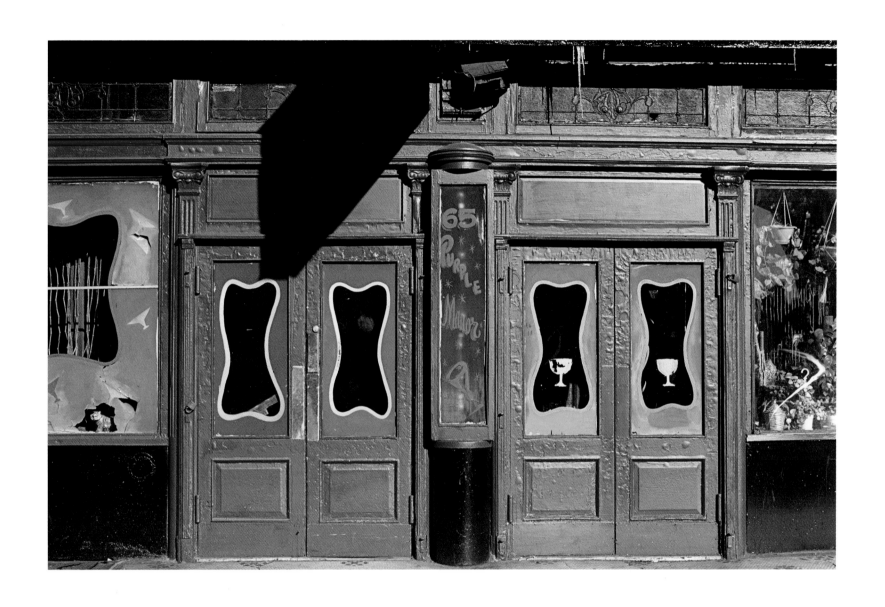

65 East 125th Street, Harlem, 1977

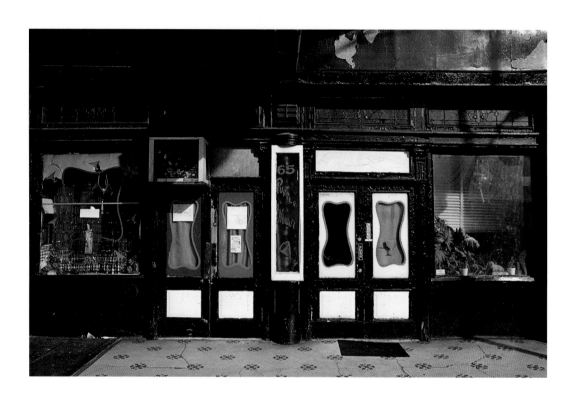

65 East 125th Street, Harlem, 1978

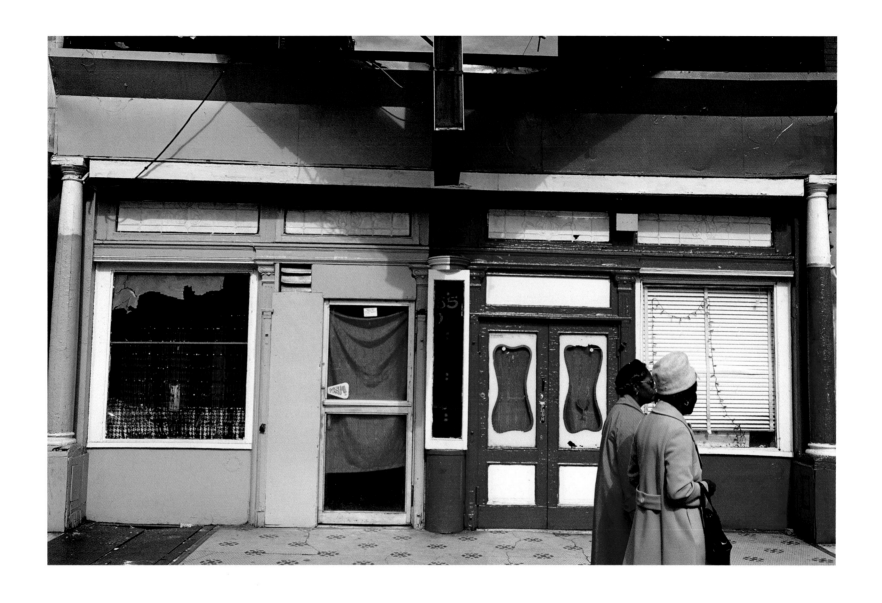

65 East 125th Street, Harlem, 1980

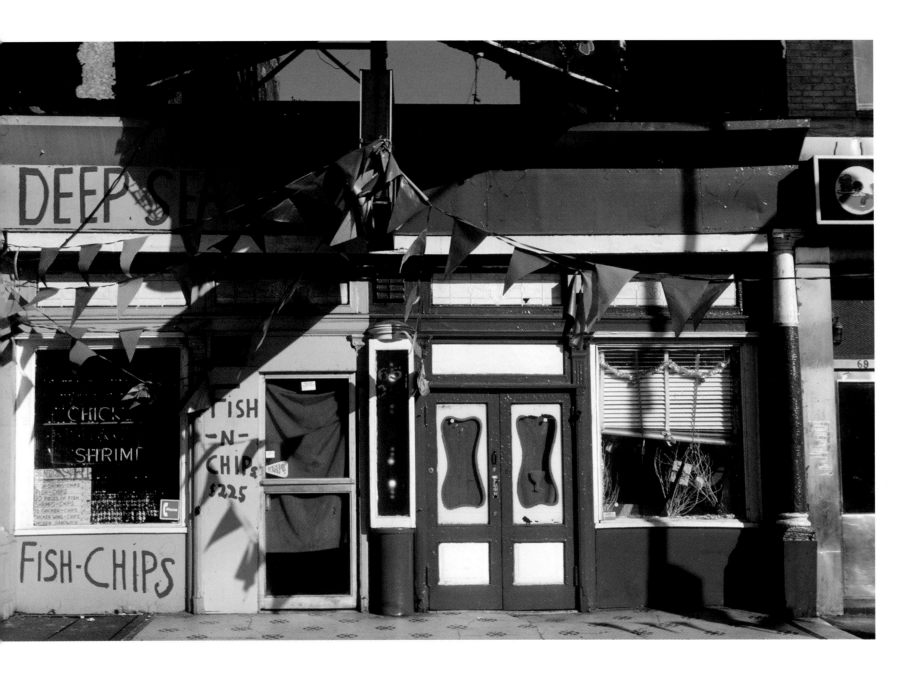

65 East 125th Street, Harlem, 1980

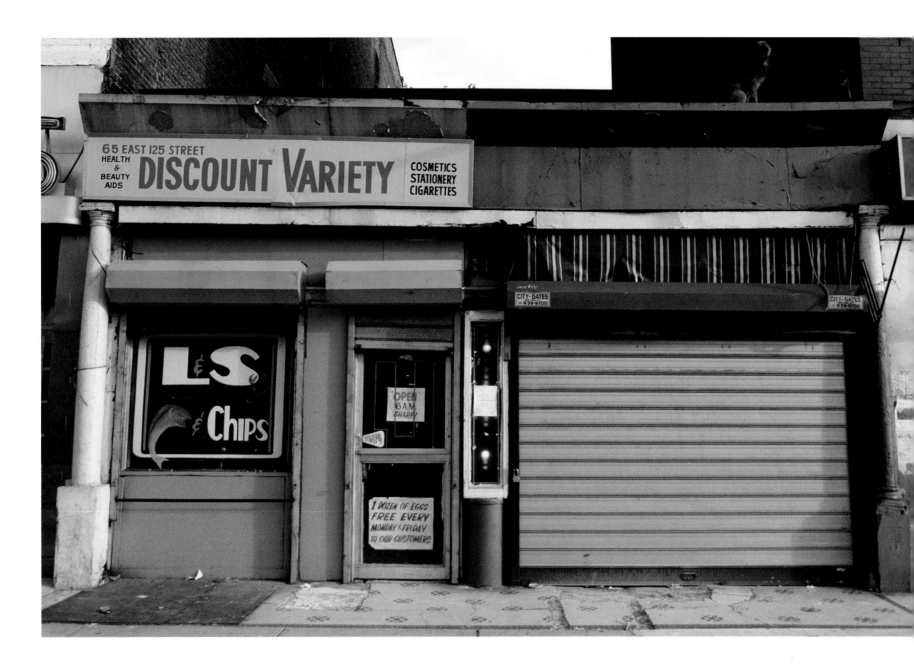

65 East 125th Street, Harlem, 1983

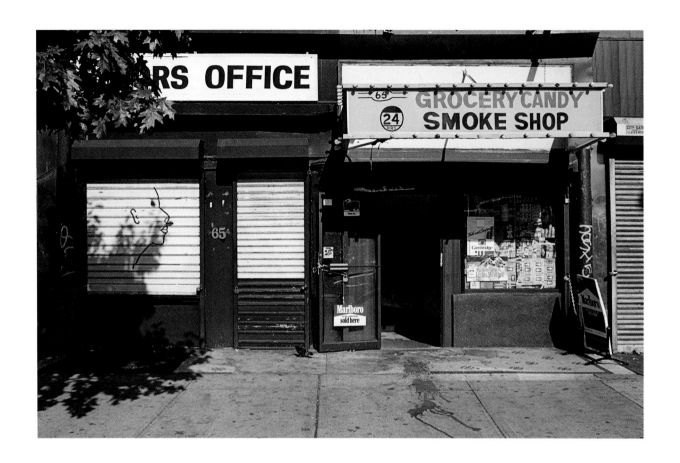

TOP *65 East 125th Street, Harlem, 1988*

OPPOSITE *65 East 125th Street, Harlem, 1990*

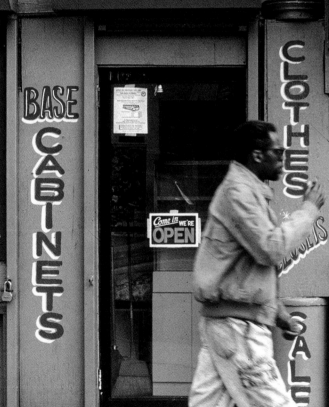

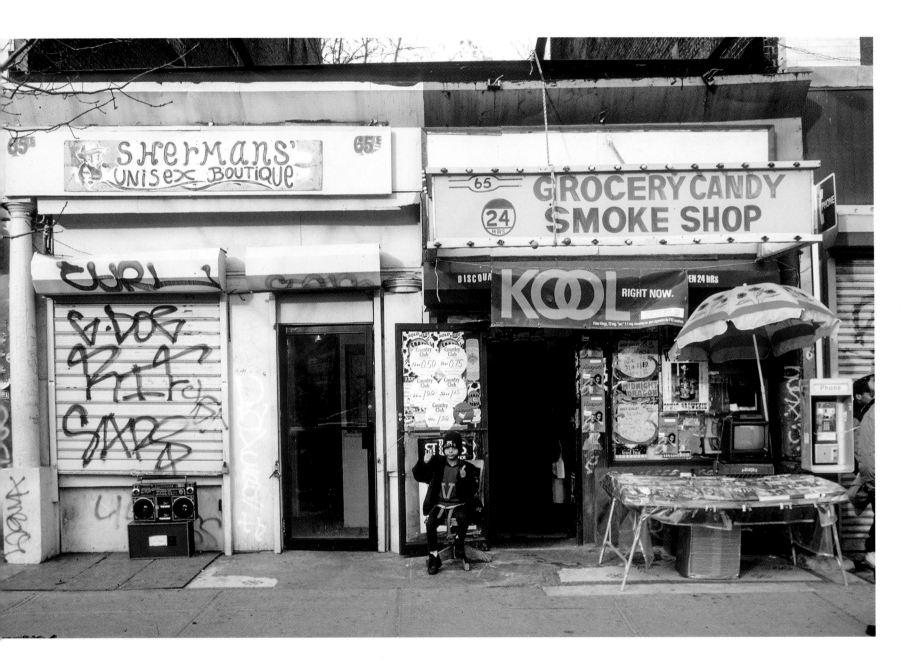

98 *65 East 125th Street, Harlem, 1994*

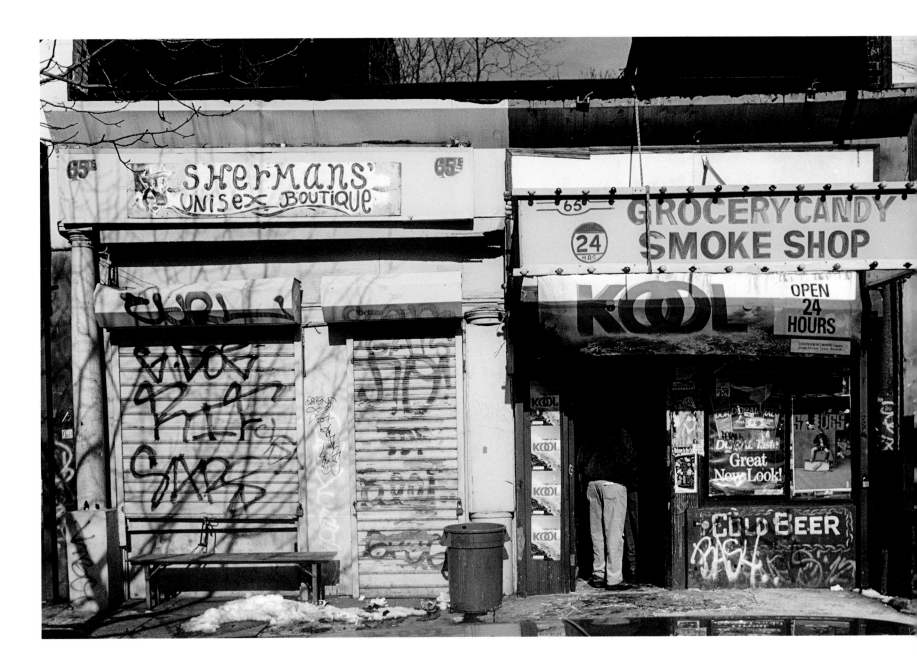

65 East 125th Street, Harlem, 1996

99

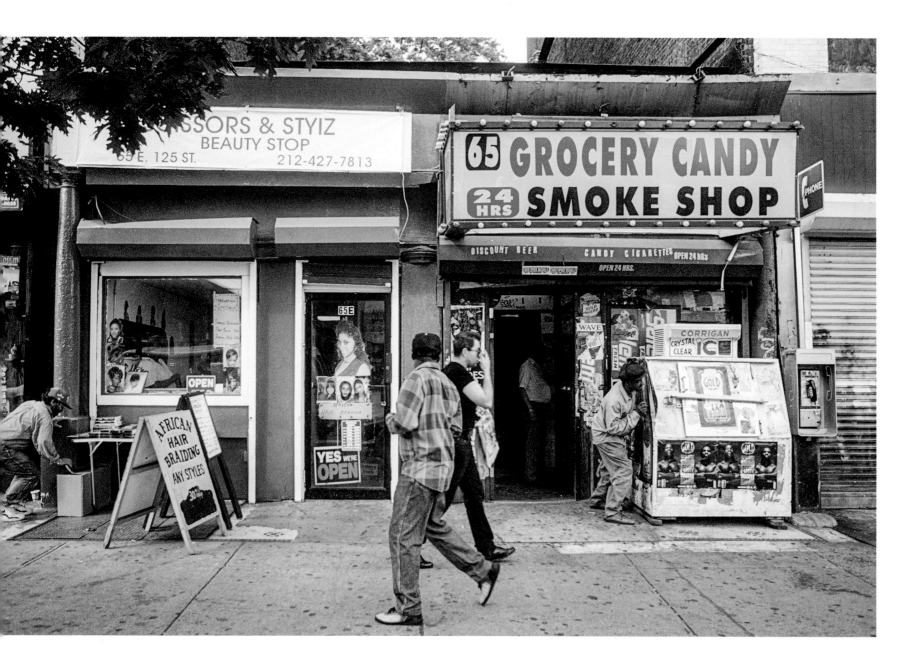

100 *65 East 125th Street, Harlem, 1997*

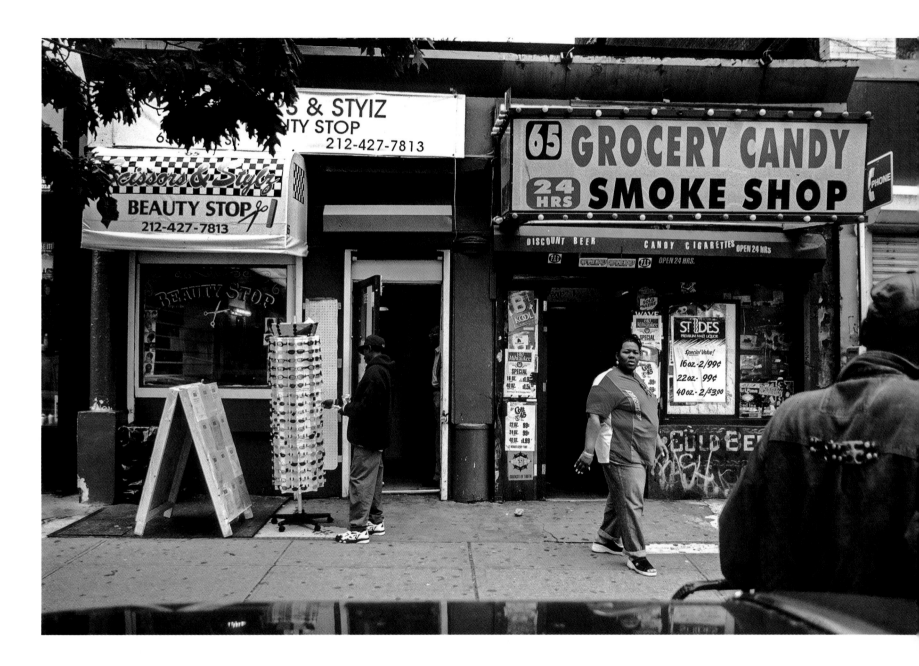

65 East 125th Street, Harlem, 1998

101

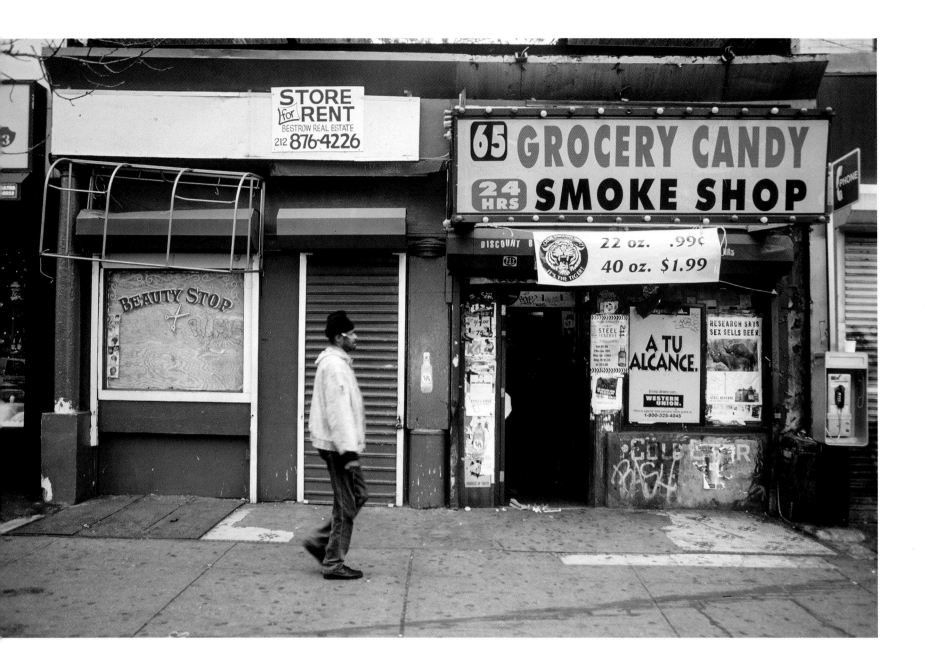

102 *65 East 125th Street, Harlem, 1998*

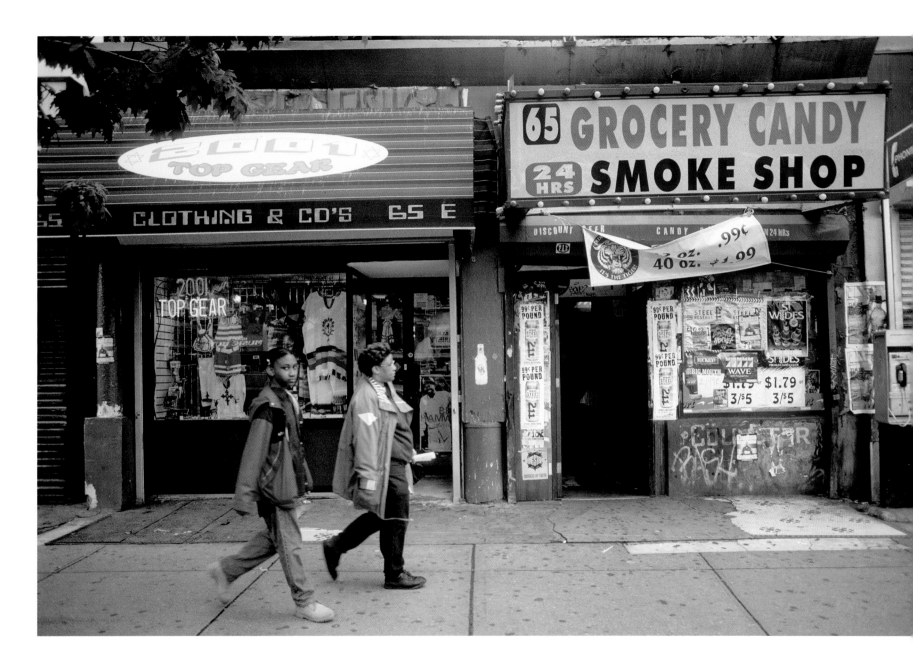

65 East 125th Street, Harlem, 1999 **103**

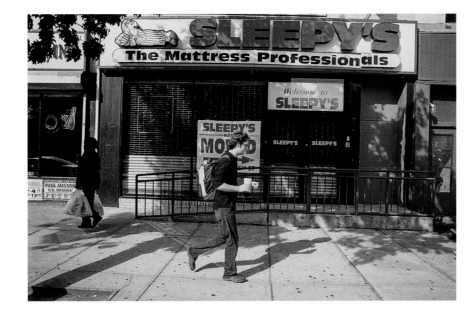

LEFT *65 East 125th Street, Harlem, 2007*

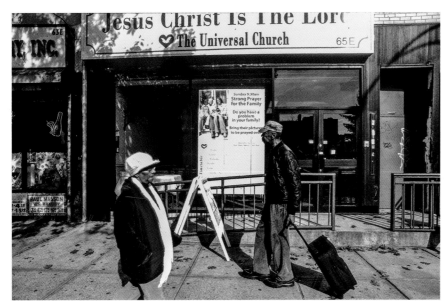

LEFT *65 East 125th Street, Harlem, 2009*

OPPOSITE *65 East 125th Street, Harlem, 2001*

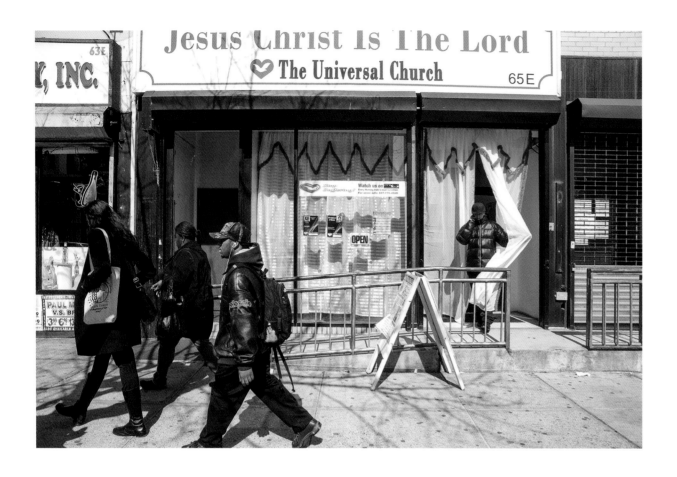

TOP *65 East 125th Street, Harlem, 2011*

OPPOSITE *The Baby Grand, once a hot bar, 319 West 125th Street, Harlem, 1977*

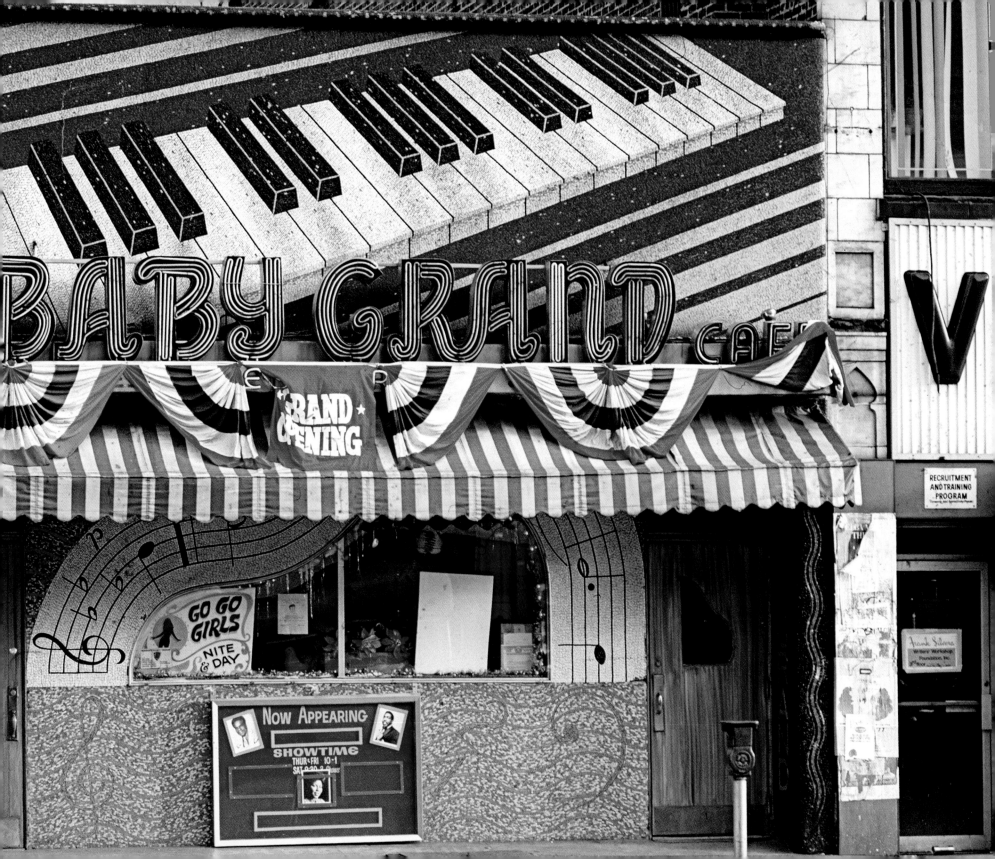

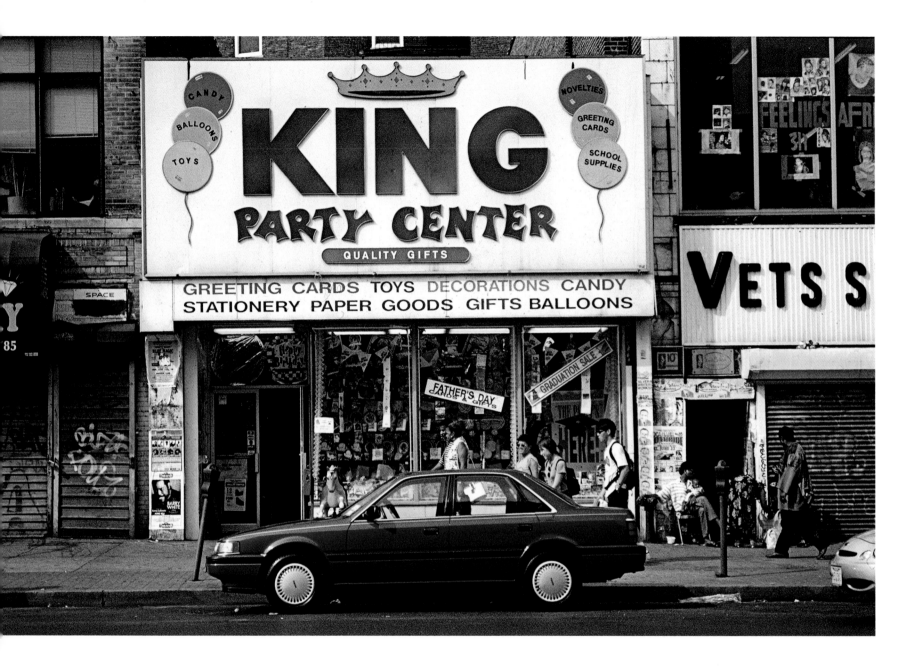

319 West 125th Street, Korean toy store, Harlem, 1996

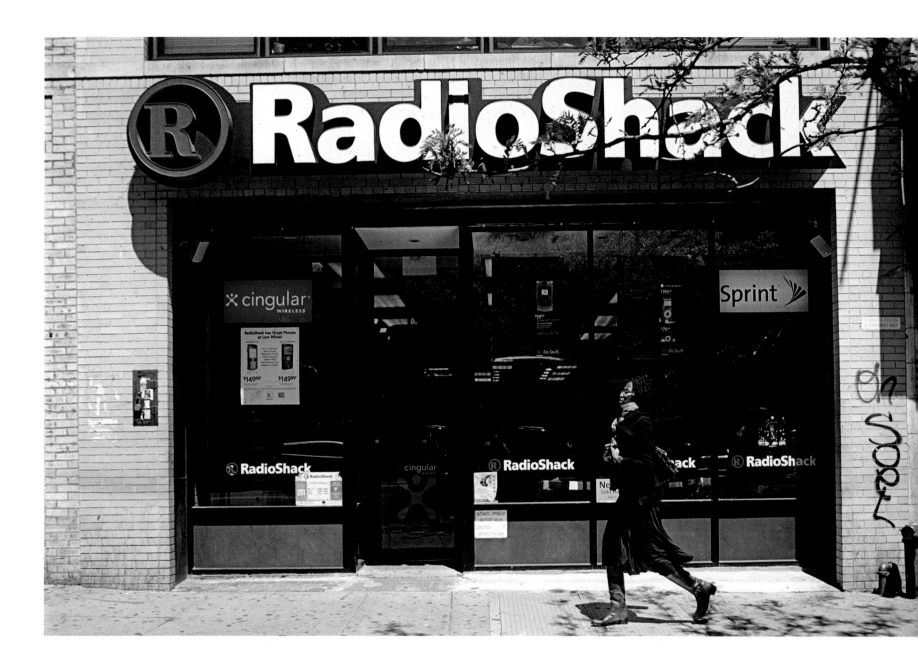

319 West 125th Street, franchise, Harlem, 2007 **109**

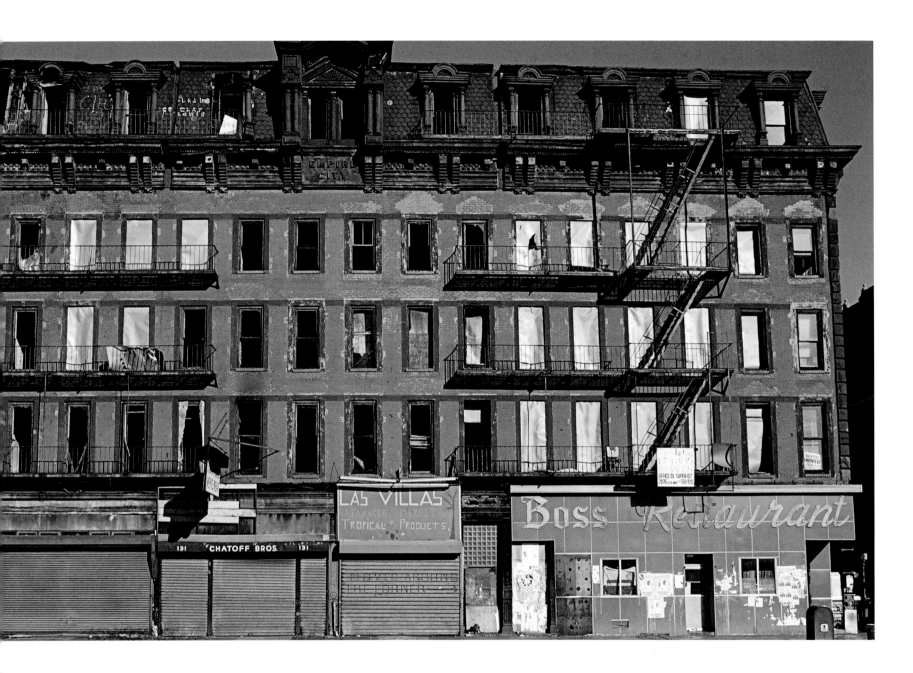

110 *135 East 125th Street, Harlem, 1980*

135 East 125th Street, Harlem, 2002

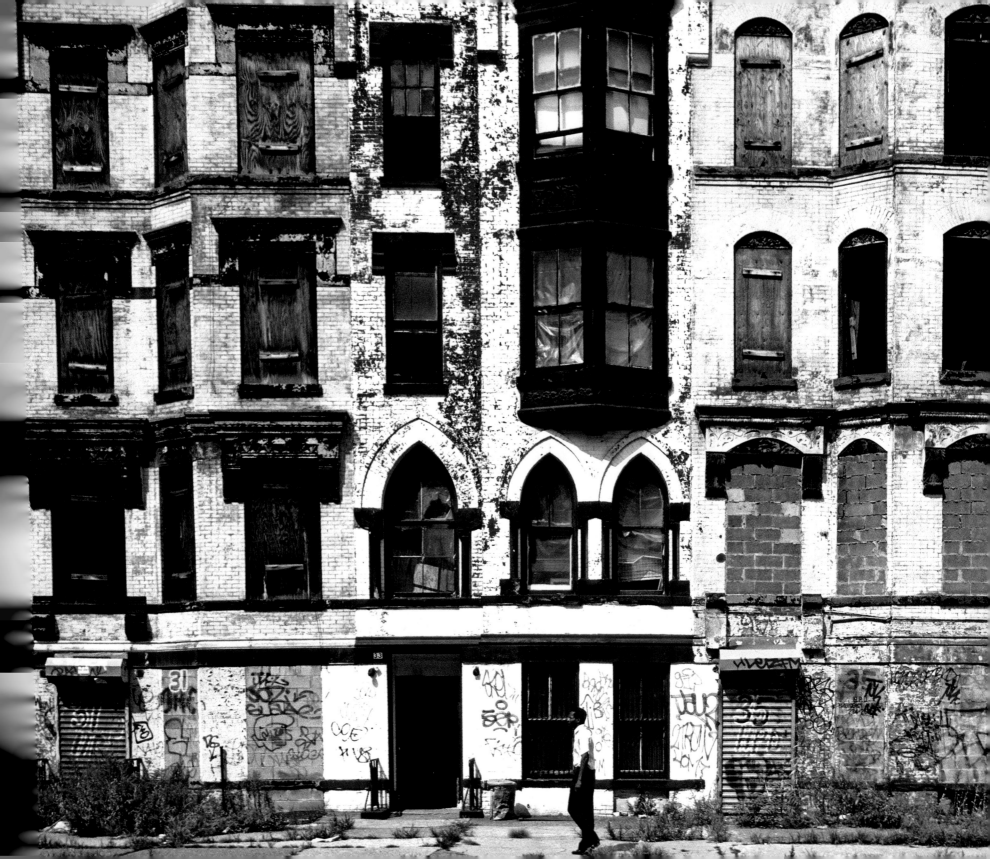

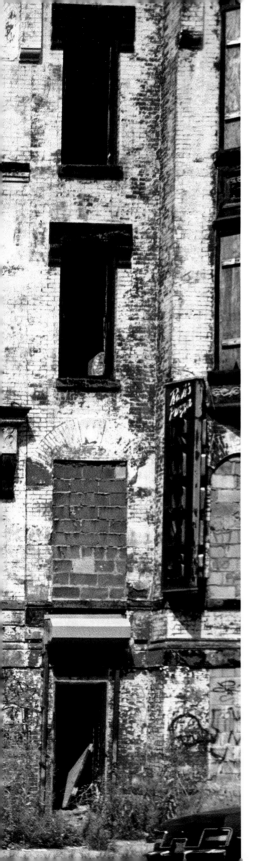

RUINS AND SEMI-RUINS

Physically, Harlem has been a symbol of urban ruin. Its decline over 70 years from a masterpiece of urban elegance and lucid city planning to a ruinous array of broken buildings and garbage-strewn lots could not have been more complete if it had been legislated or decreed. Yet the paradox of Harlem is that even in the midst of what has become a physical wasteland, there is a creative energy that is alive and palpable.

<div align="center">MARY SCHMIDT CAMPBELL (NYC COMMISSIONER OF CULTURAL AFFAIRS, 1987–91), 1989</div>

OPPOSITE *31–33 Bradhurst Avenue; since this photo was taken these buildings have been refurbished, Harlem, 1996*

UNTIL THE TWENTY-FIRST CENTURY, Harlem's ruins spread along the grand boulevards, evoking a grandeur second only to the derelict skyscrapers of Detroit. During the 1980s and 1990s Harlem's built environment worsened as the population declined. Few new buildings were erected or refurbished. Abandoned buildings decayed; trees grew on their roofs. Squatters forced open doors and made holes in the walls. They removed boards from the windows to allow for light and ventilation, transforming empty buildings into homes for the homeless, places to sell drugs or serve as "shooting galleries." Waiting for commuter trains to Westchester on East 125th Street, for example, commuters witnessed a steady stream of purchasers converging on

113

the shell of a tenement on Park Avenue to buy drugs through a hole in the wall.

Danger and decay peaked along Frederick Douglass Boulevard between West 116th Street and West 145th Street. At those intersections were two of the most active street drug markets in the city. At times it was hard to believe Harlem was part of Manhattan. On the rare occasion when I encountered a police car on these blocks, policemen usually suspected I was in search of drugs. After asking if I was lost, they advised me to leave, warning me that if I stayed I would be robbed.

Vacant lots between buildings were often turned into gardens, car repair shops, or junkyards from which cars, appliances, and other viable items were sold. Others were regularly used for dumping mattresses, tires, wrecked cars, appliances, and building materials. Sometimes the trash formed small hills, which in time became overgrown with trees and bushes. The city tried to prevent dumping by fencing off vacant lots. But people cut holes on the fence or stole it to sell for scrap.

On several corners, buildings managed to remain partially functioning with only their ground floors in regular commercial use. The upper floors were abandoned, sealed off, and, if located on a busy street, used for advertising.

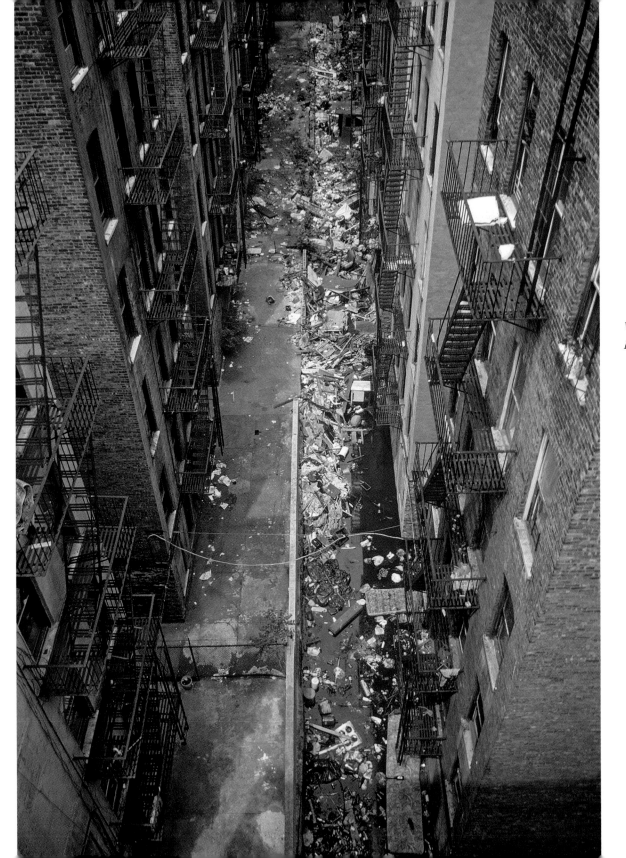

View west from 127th Street and Frederick Douglass Boulevard, Harlem, 1992

115

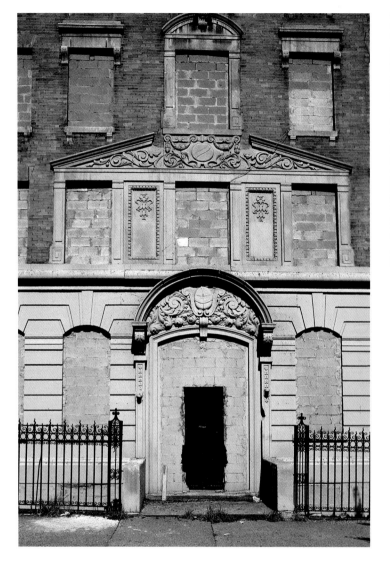

209–232 West 110th Street; since this photo was made these apartment buildings have been refurbished, Harlem, 1980

Window decal designed to create the illusion that abandoned buildings were occupied, 2371 Frederick Douglass Boulevard, Harlem, 2001

214 West 122nd Street, Harlem, 1995

117

Classic liquor store sign, southwest corner of Adam Clayton Powell Jr. Boulevard at 149th Street, Harlem, 1998

118

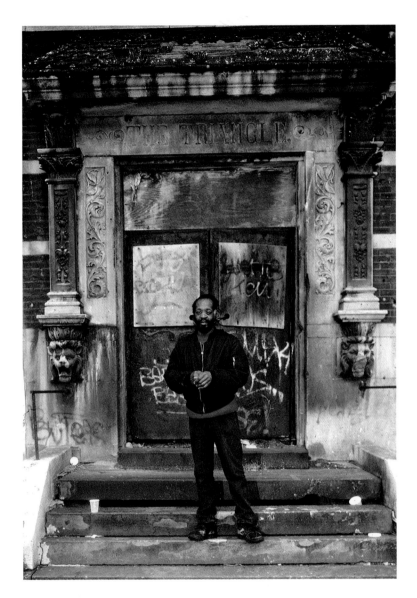

The Triangle Building, 2230 Frederick Douglass Boulevard, Harlem, 1996

119

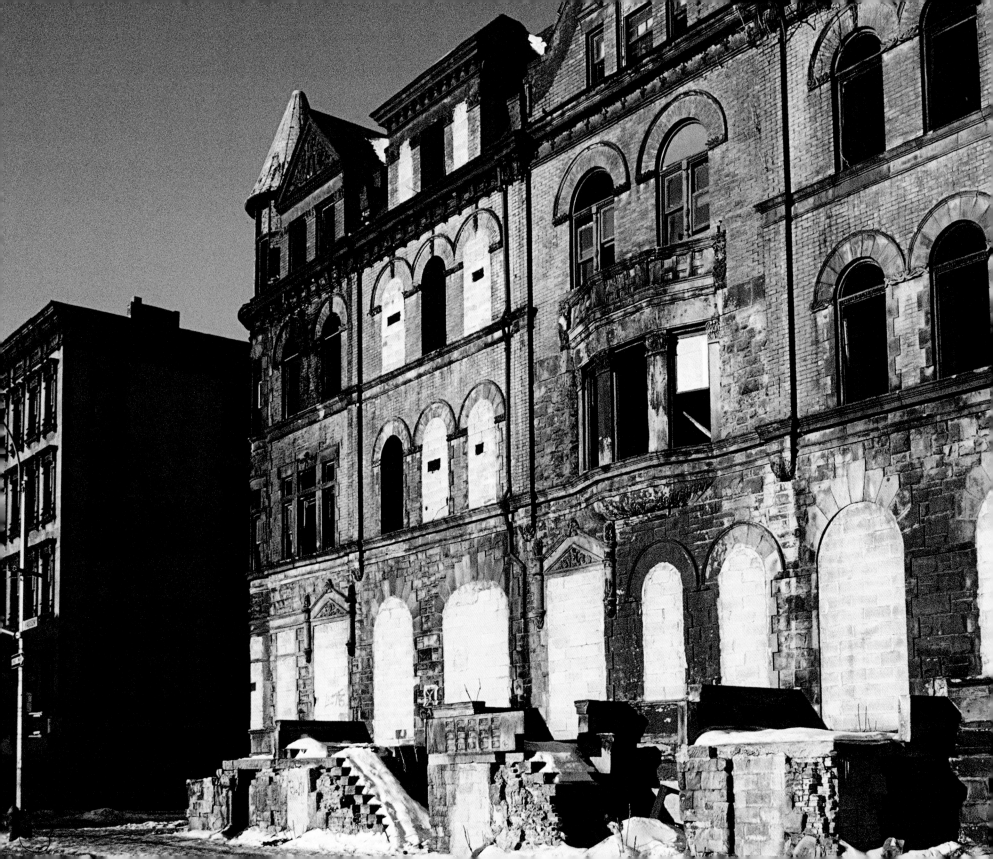

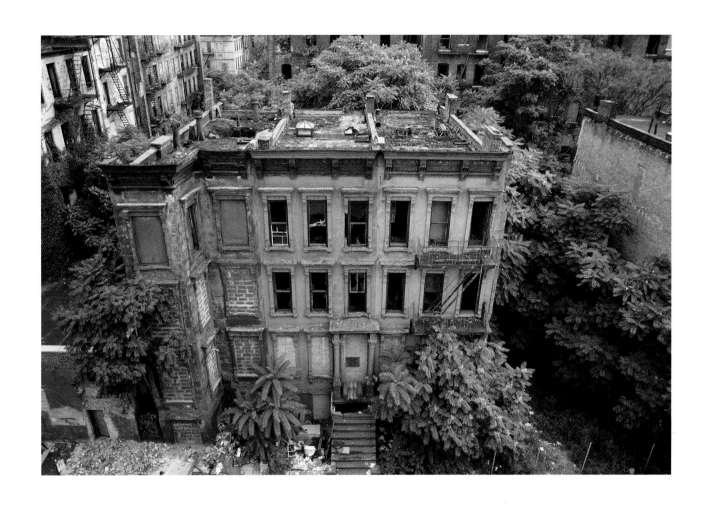

TOP *269 West 121st Street, now rehabilitated, Harlem, 1989*

OPPOSITE *Stately buildings long demolished, view southwest
along Madison Avenue toward East 127th Street, Harlem, 1982*

121

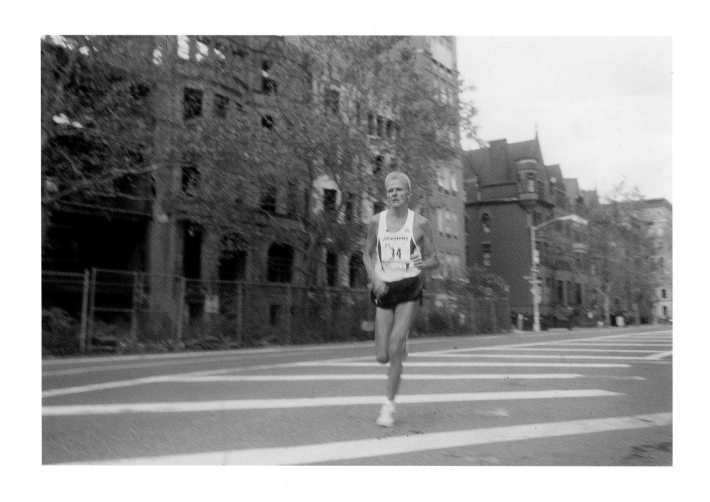

View northwest along Mount Morris Park west from West 120th Street, New York City Marathon, 1994; the background buildings have since been rehabilitated

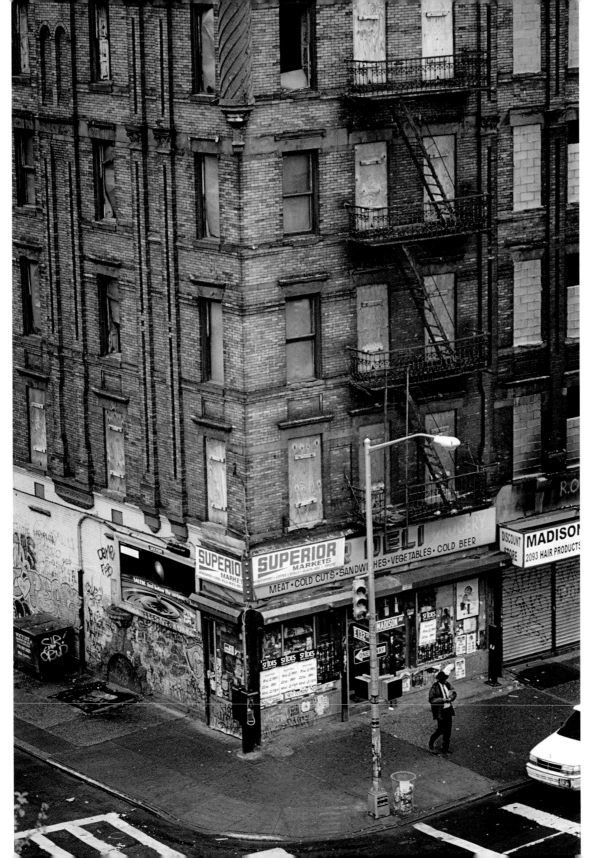

*Madison Avenue at East 132nd
Street, Harlem, 1998*

123

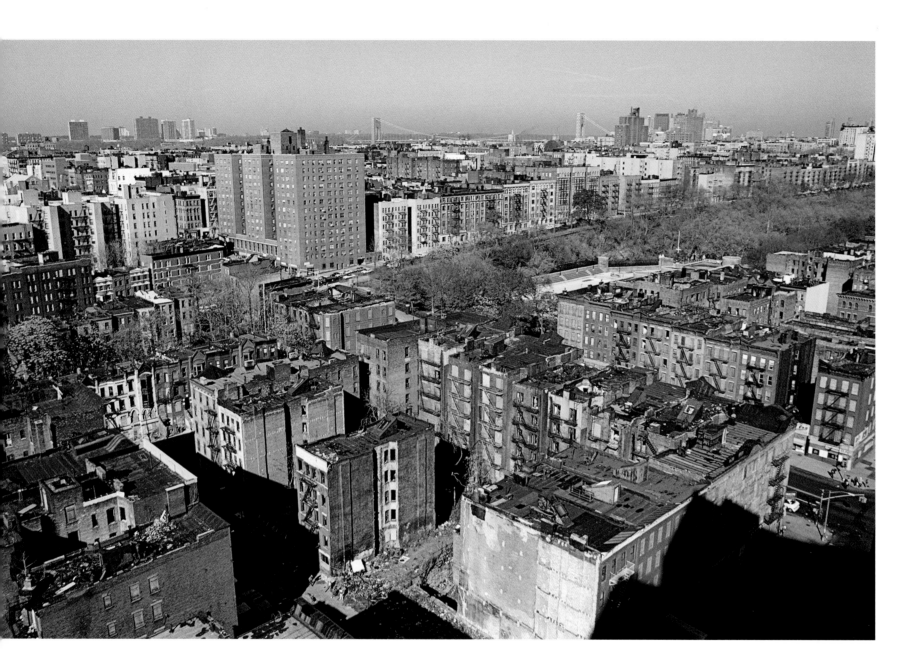

124 *View northwest from West 143rd Street at Frederick Douglass Boulevard, Harlem, 1988*

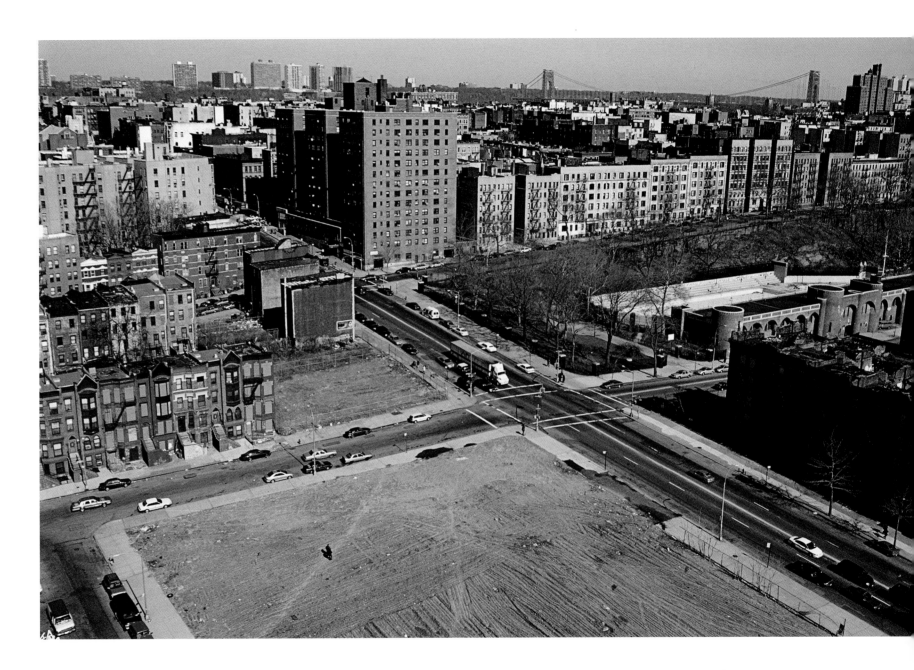

View northwest from West 143rd Street at Frederick Douglass Boulevard, Harlem, 2001 **125**

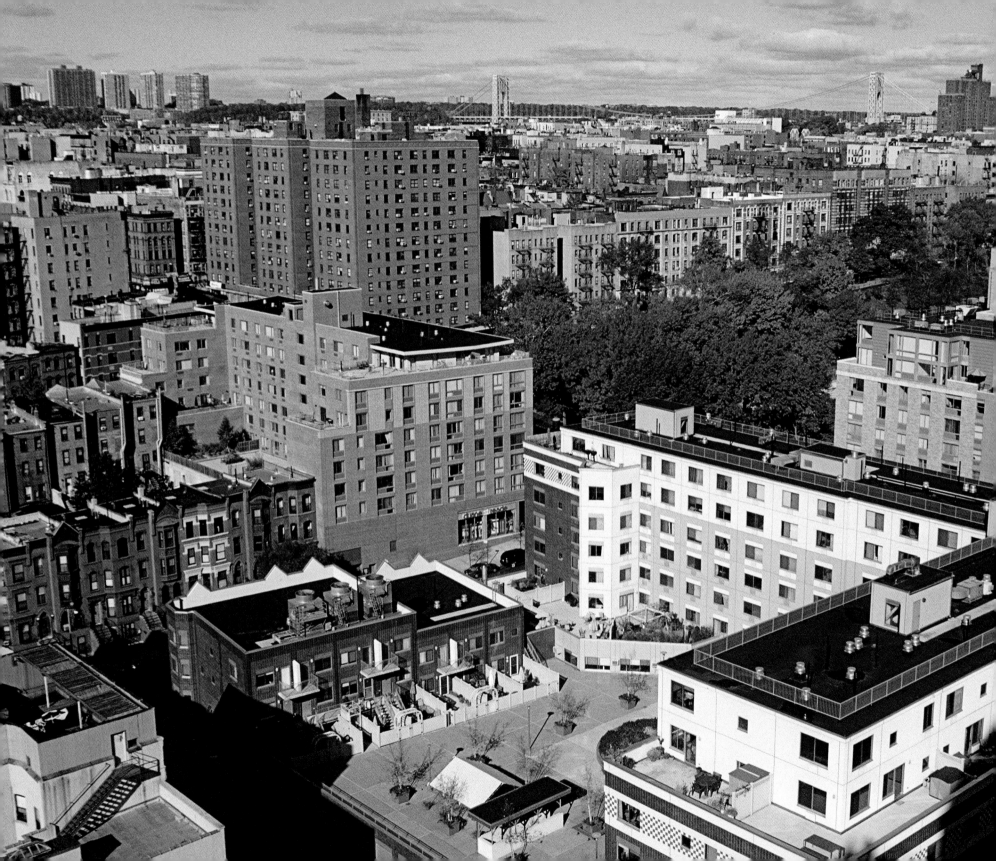

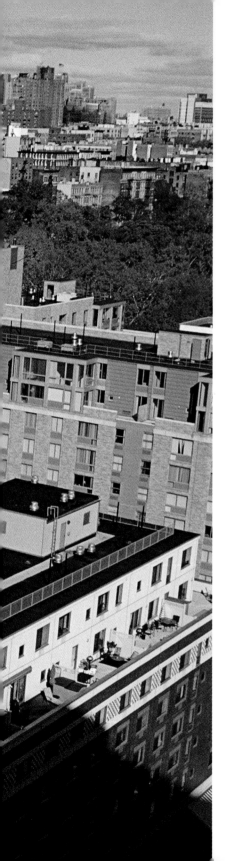

View northwest from West 143rd Street at Frederick Douglass Boulevard, Harlem, 2007

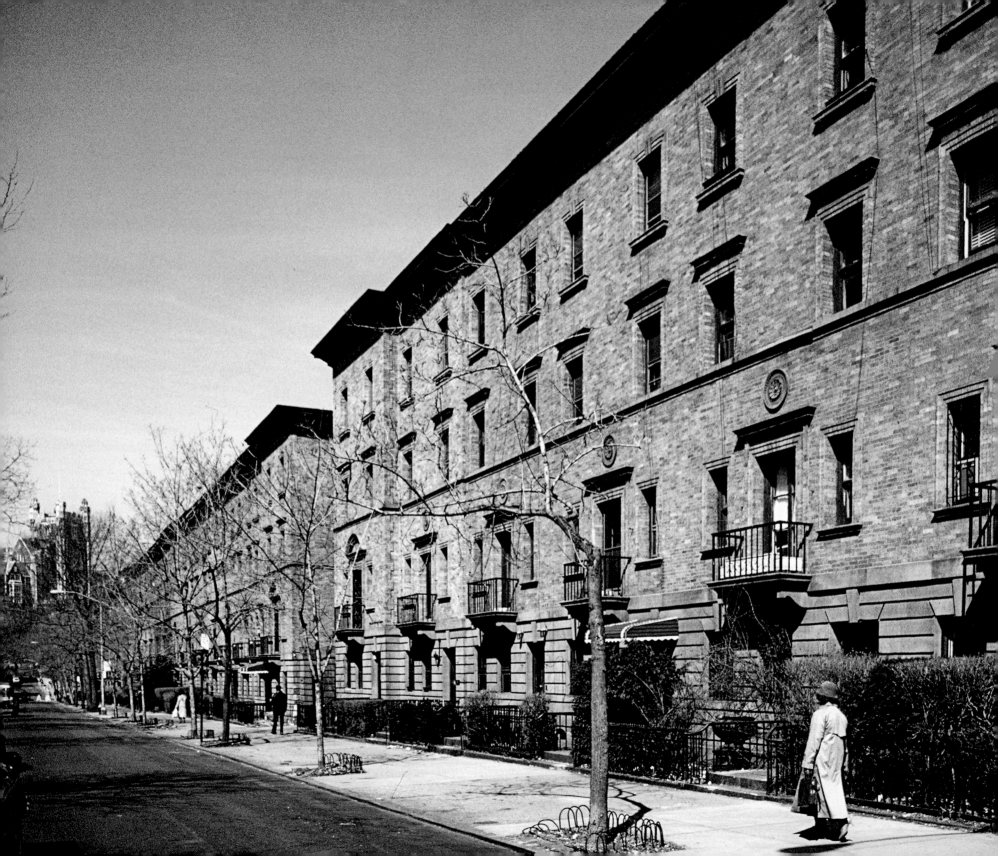

LANDMARK HARLEM AND
HARLEM LANDMARKS

Negro Harlem covers the most beautiful and healthful sites in the whole city. It is not a fringe, it is not a slum, nor is it a quarter consisting of dilapidated tenements. It is a section of new law apartments and handsome dwellings, with streets as well paved, as well-lighted, and as well-kept as any in the city.... The question inevitably arises: will the Negroes of Harlem be able to hold it? Will they not be driven further northward? Residents of Manhattan regardless of race, have been driven out when they lay in the path of business and greatly increased land values. Harlem lies in the direction that path must take; so there is little probability that Negroes will always hold it as a residential section.

JAMES WELDON JOHNSON, 1930

JAMES WELDON JOHNSON PROVED to be a wise soothsayer. Johnson's physical Harlem still presents a striking visual prospect. Wide, tree-lined boulevards are bordered with five or six stories apartment buildings with facades of red, dark brown, or light brown brick and with many sporting richly ornamented facades, bay windows, and entrances flanked by classical columns. Side streets remain home to distinctive buildings and brownstones. Entire blocks have managed to survive fires, urban renewal, and decades of disinvestment. And boulevards such as Frederick Douglass, which once had

OPPOSITE *Strivers Row, Italianate townhouses designed by Stanford White; view northwest along West 139th Street from Adam Clayton Powell Jr. Boulevard, Harlem, 1989*

129

a large numbers of empty lots, have been rebuilt over the years. In the rebuilding, however, the boulevard has lost much of its original character.

Charles "Ibo" Balton, director of Manhattan Planning for the city's Department of Housing, Preservation and Development, who lived and worked in Harlem for twelve years, commented in 2005, "Blocks I thought would never turn around are suddenly fashionable. People are buying private property and building their own brownstones—some very modernistic, some traditional. First we had to do our job in government. Now private buyers are taking over." Balton died in 2007; since then a new building has been named after him, on Saint Nicholas Avenue.[1]

Over the years, numerous blocks in Harlem were demolished to make room for new buildings—modern public housing projects, subsidized apartment buildings, and, more recently, luxury condos. Attractive buildings that could have been candidates for rehabilitation were demolished, leaving behind lots that remained vacant for decades. Of the buildings that were rehabilitated, about half lost their cornices, which were corroded and falling apart. Because the rehabbers didn't have the money or skilled workers to replace them, the building lost much of their elegance and distinctive character.

Theaters and banks, particularly those along 116th Street and 125th Street, have been converted into churches. A striking example of this sort of adaptive reuse is the Lafayette Theater, which in its heyday was known as "House Beautiful" and "Cradle of New Stars."[2] In 1912 it was among the first theaters in New York to desegregate audiences. Home of the Lafayette Players, a black stock company, this "sympathetic old hall" held two thousand people.[3] Here Bill "Bojangles" Robinson danced, Duke Ellington and his orchestra played, and Orson Welles presented his celebrated version of *Macbeth*, set in Haiti. In 1951, the Lafayette Theater be-

came the Williams Christian Methodist Episcopal Church, the original terracotta designs on its facade now covered with stone and decorated with church bells.

After the mid-1980s, the city planted trees in the neighborhood, landscaped the street medians, replaced cobra-head street lights with vintage-designed models, paved sidewalks, and removed unused trolley tracks along 125th Street. In collaboration with local community-development corporations, the city refurbished hundreds of the vacant structures it had acquired as tax liens. The declining crime rate, improved public services, and affordable prices and amenities attracted middle-class families to Harlem for the first time since the first half of the twentieth century. Although much has vanished, large parts of Harlem are still architecturally intact. Landmarks in Harlem include grand buildings such as Graham Court and 409 Edgecombe Avenue in the Sugar Hill section, where W. E. B. DuBois and Thurgood Marshall once resided.

Another important Harlem landmark, since 1939, was the Lenox Lounge, an art deco masterpiece that closed December 31, 2012. The Lenox Lounge, one of those magical places that gave the neighborhood its identity, is now lost. Its dark red facade presented a warm and inviting exterior to those walking by. It was one of the friendliest bars in the city; people bought each other drinks and seemed to glow as they talked or simply sat there. Even though it was restored at the turn of the millennium, the Lenox Lounge looked its age; decay only increased its allure: metal decorations were slightly dented, not all the lights worked, letters were missing from the signs, and the original zebra skins in the Zebra Room had long been replaced with wallpaper. A more accomplished restoration would have scared the ghosts of Malcolm X, John Coltrane, and Billie Holliday, all former patrons. In 2001, the Lenox Lounge was voted the best of the best by *New York*

Magazine. Scandinavians, Germans, and other tourists seemed delighted to find themselves welcomed in this seedy and beautiful place.

Less than twenty-four hours had passed, following its closing, before the neon sign bearing its name in large block letters was removed, thereby announcing that Harlem had suffered another indignity. A black woman standing nearby commented that white folks were taking everything from Harlem, while another passerby, a black man, optimistically predicted that another Lenox Lounge similar to the original one would rise very near the old one.

Judging by the number of tourists it attracts, the "world famous" Apollo Theater on West 125th Street, which for nearly eight decades was the heart of Harlem's cultural life, remains its most important landmark and the last of the popular entertainment palaces left in Harlem. "The Soul of American Culture," as the Apollo has proclaimed itself, has become a shrine honoring great entertainers of the past. When James "The Godfather of Soul" Brown died in 2006, his gold casket on the Apollo stage drew thousands of mourners.[4] After Michael Jackson, "The King of Pop," died in 2009, he was given a public tribute at the Apollo and, in 2010, was inducted into the Apollo Legends Hall of Fame. Aretha Franklin, "The Queen of Soul," became an Apollo Legend in 2010. On an impromptu memorial wall next to the Apollo, Whitney Houston was declared "Our #1 Diva, our singing angel," when she died in 2012. The Apollo continues, as of 2012, to attract audiences ranging from local residents to visitors from all over the world lured by its mythology.

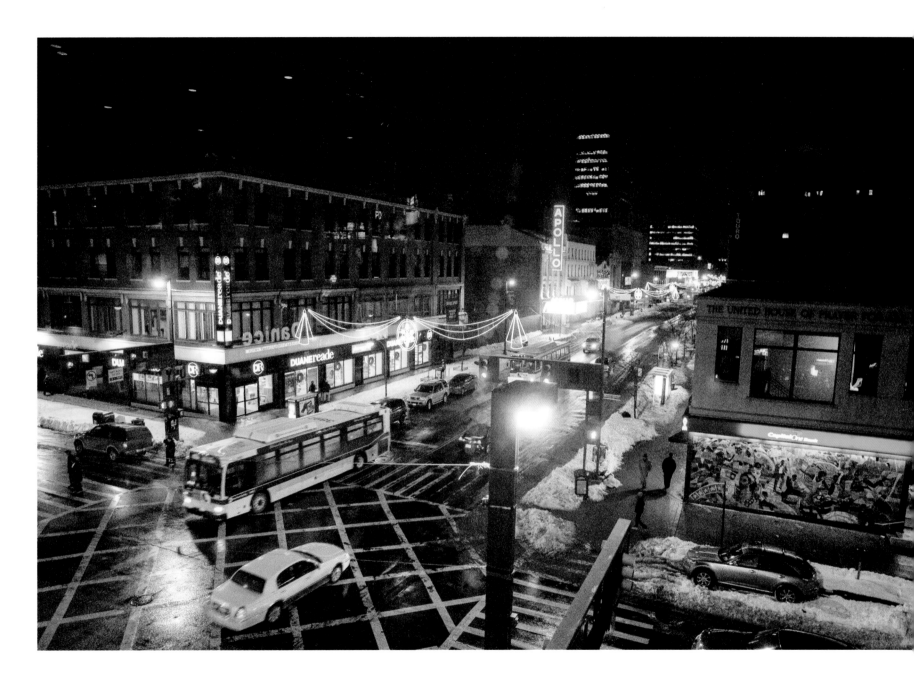

View east along Christmas-decorated West 125th Street from Frederick Douglass Boulevard, Harlem, 2010 **133**

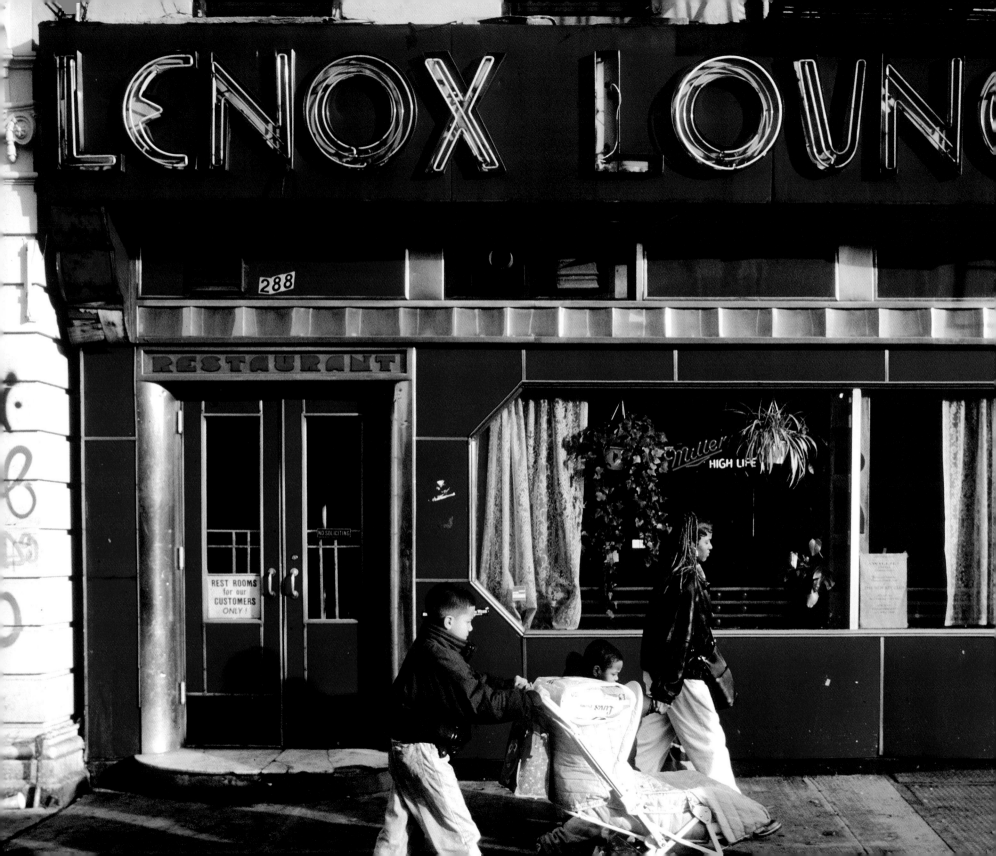

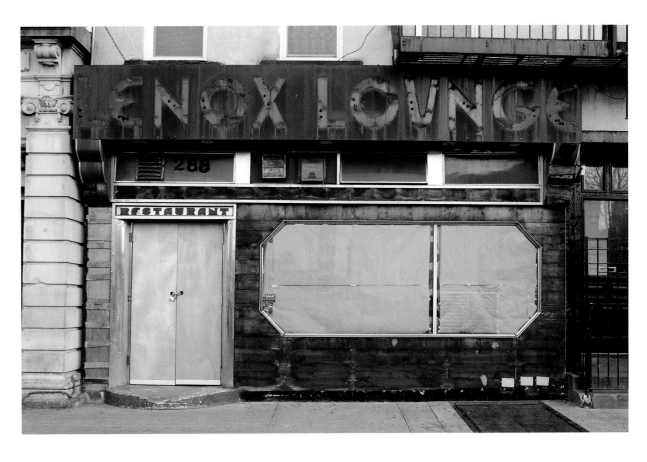

TOP *Lenox Lounge, 288 Lenox Avenue, Harlem, 2013. In December 31, 2012, "due to an insurmountable rent increase," the Lenox Lounge was forced to close. Mr. Alvin Reed, the owner, took the sign from the facade and "a truckload of interior fixtures" to 333 Lenox Avenue, where he plans to open a new Lenox Lounge to resemble the old landmark, according to an article by Al Barbarino in the* COMMERCIAL OBSERVER.

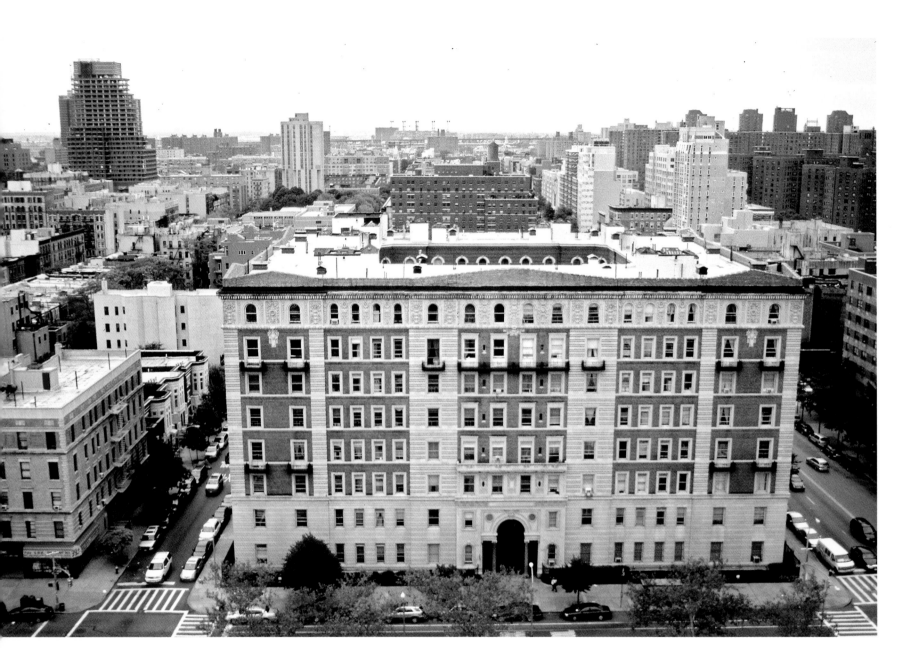

Graham Court, a New York City landmark, built in 1901, view east from West 117th Street at Saint Nicholas Avenue, Harlem, 2008

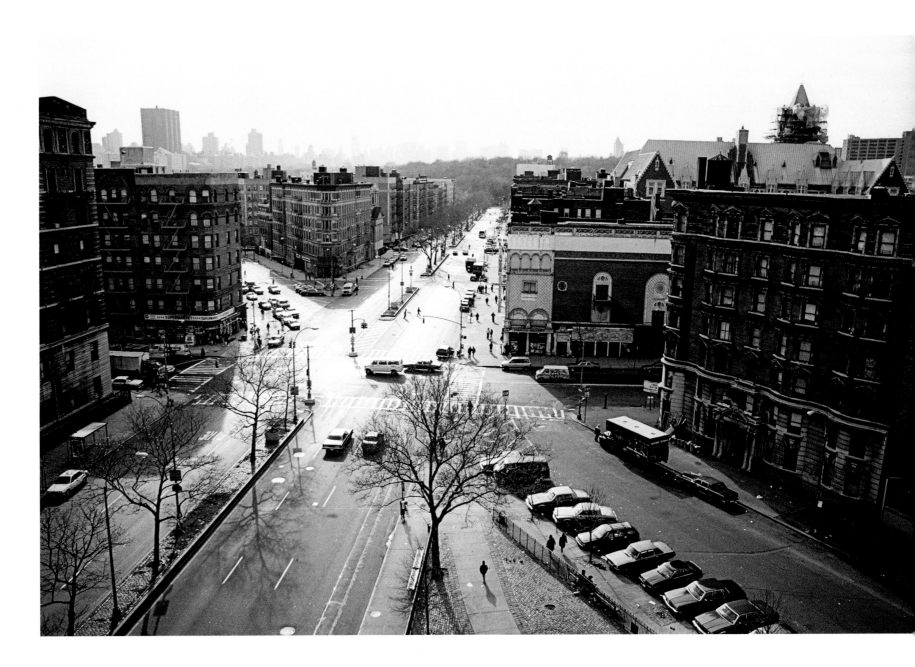

"Old Harlem," view south along Adam Clayton Powell Jr. Boulevard from West 117th Street, Harlem, 1992　　　**137**

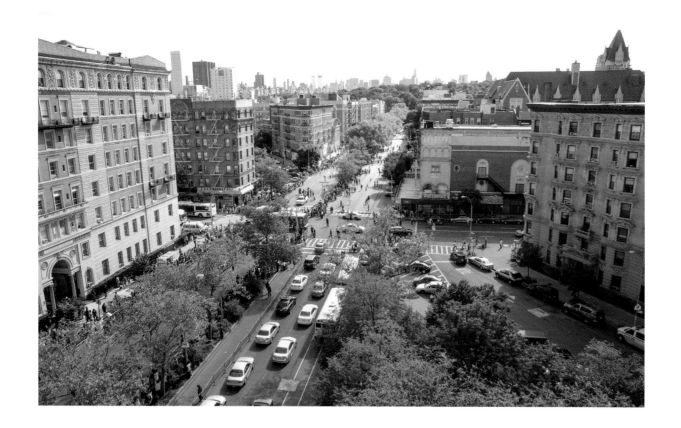

TOP *"There is never going to be the old Harlem. These may be the same streets, and the same buildings, but there is never going to be the old Harlem, I have lived here for forty-seven years; my family is all from Harlem," said the janitor of the building from which this photo was taken. View south along Adam Clayton Powell Jr. Boulevard from West 117th Street, Harlem, 2012.*

OPPOSITE *409 Edgecombe Avenue. During the Harlem Renaissance, this was the tallest and most exclusive apartment building in Harlem (2008)*

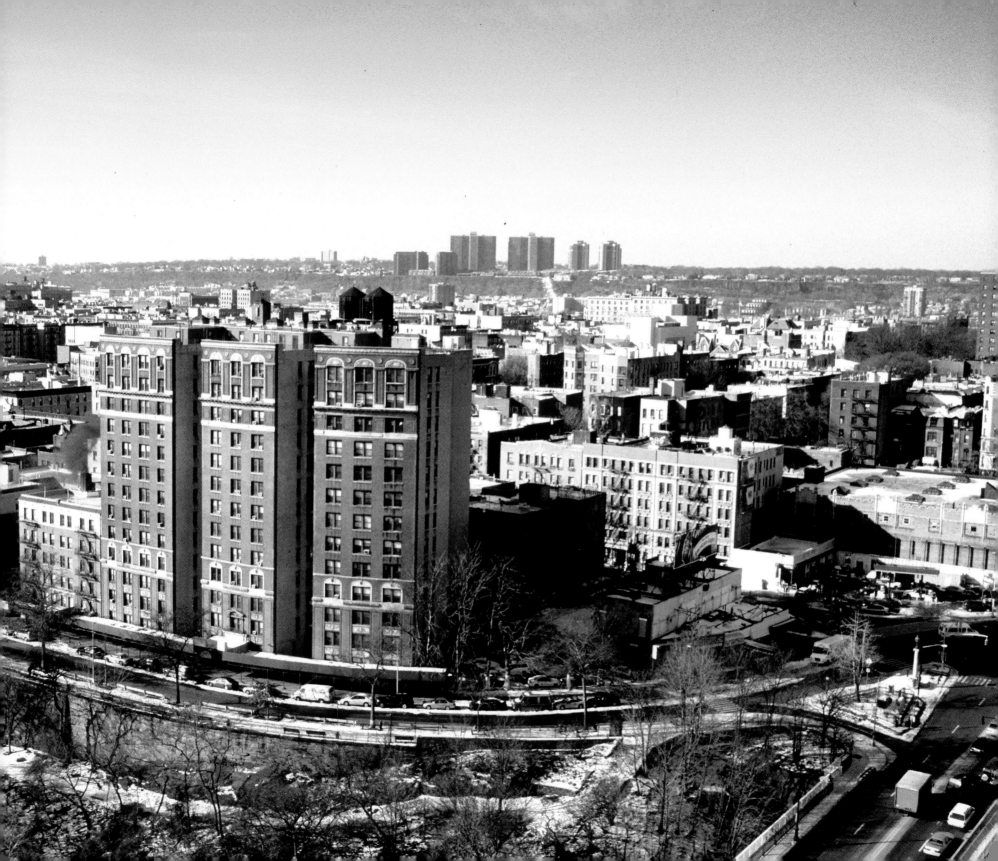

Astor Row, built in the 1880s; view southeast along West 130th Street toward Fifth Avenue, Harlem, 2009

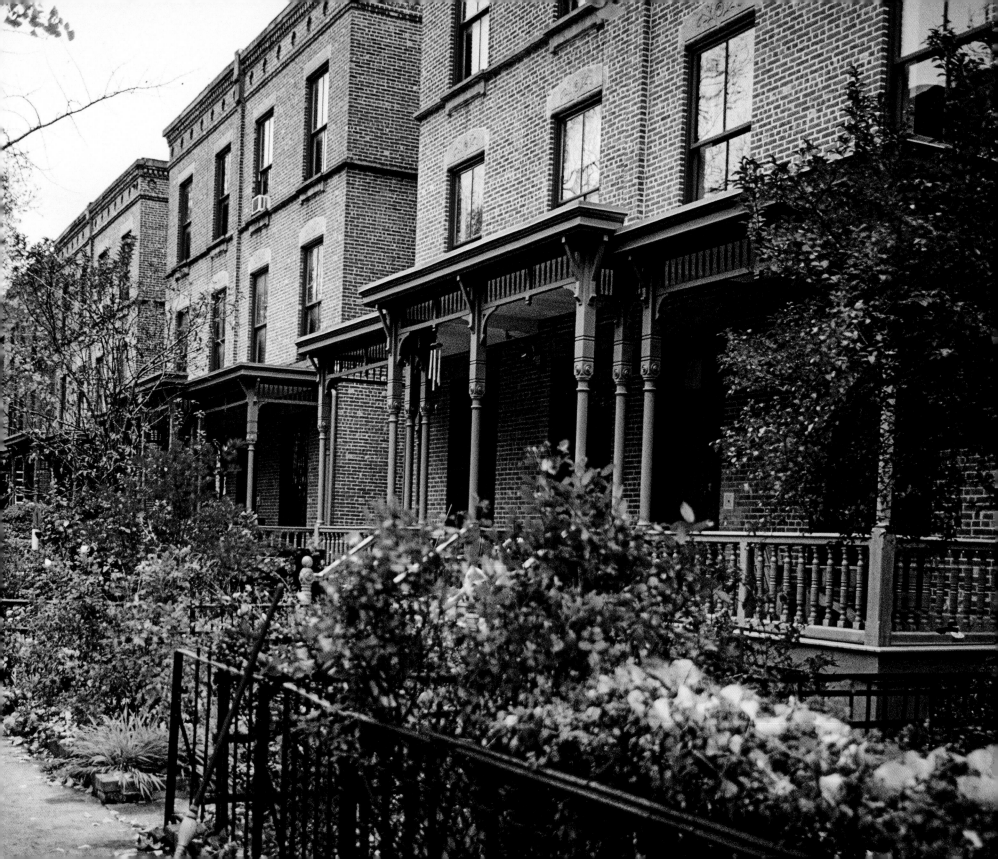

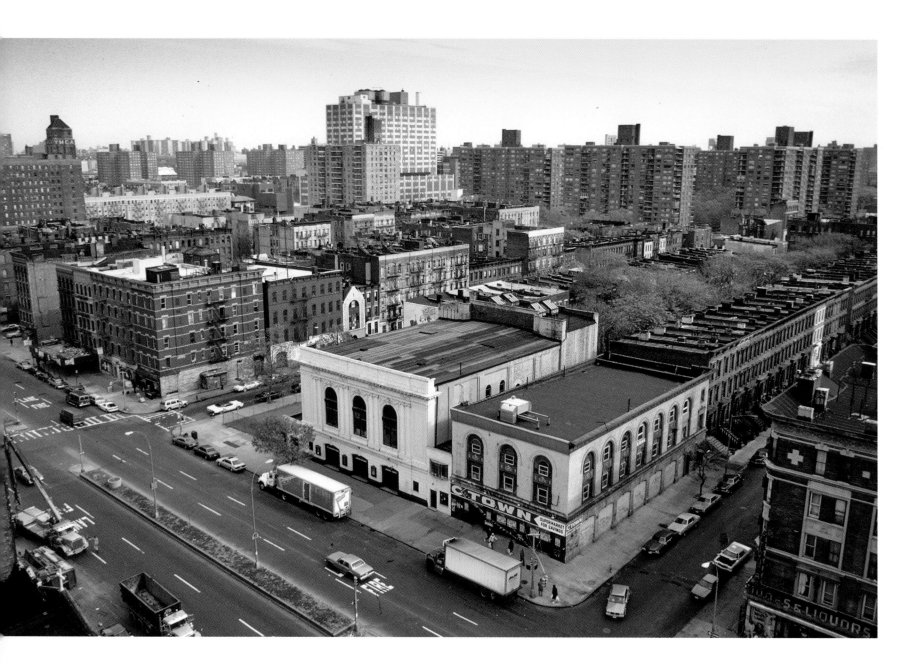

142 *View northeast along Adam Clayton Powell Jr. Boulevard from West 131st Street; at the center is the former*
Lafayette Theater before it was completely redesigned as a church; Harlem, 1988

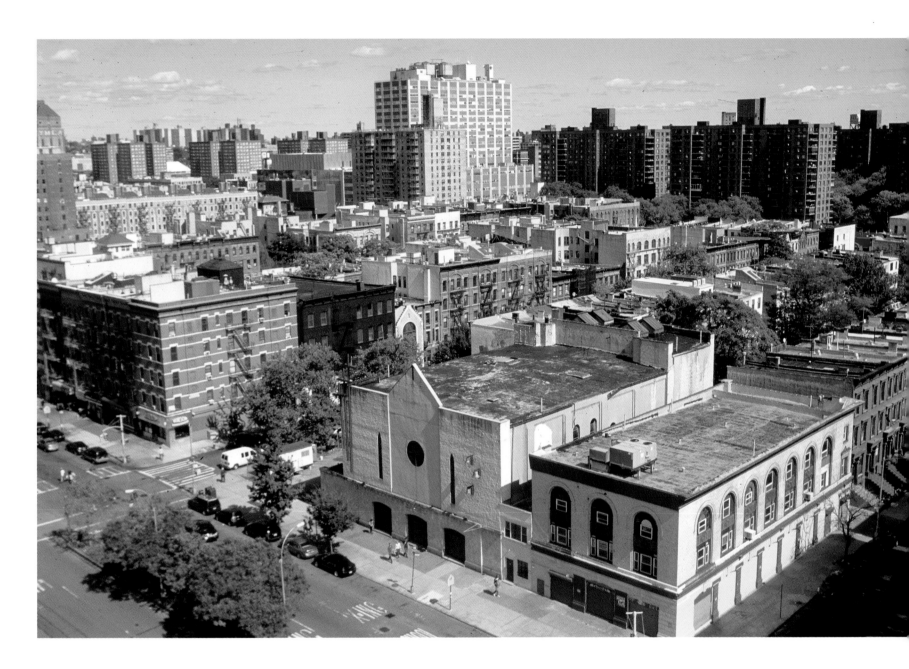

View northeast along Adam Clayton Powell Jr. Boulevard from West 131st Street, Harlem, 2012; at the center is the former Lafayette Theater after being redesigned as a church by the Williams Institutional Christian Methodist Episcopal Church, 2012

143

All Saints Roman Catholic Church, Madison Avenue at East 129th Street, Harlem, 1993

144

103 West 135th Street, New York Public Library Branch—a Carnegie Library designed by McKim, Mead and White; opened in 1905, it became a focal point of the Harlem Renaissance; Harlem, 2009

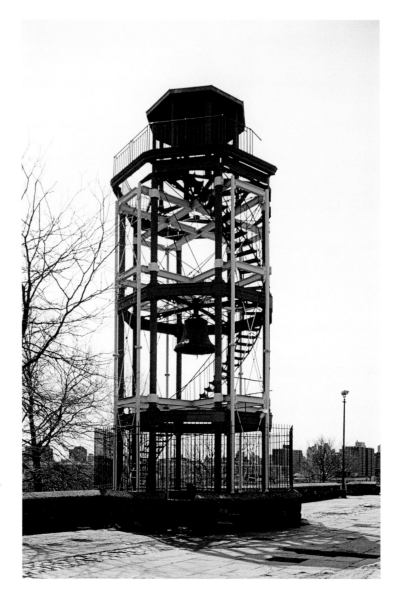

Fire watchtower built in 1857—the only one of its kind left in New York City—Marcus Garvey Park, 2007

146

Corinthians Baptist Church (detail), once the Regent Theatre, an "all picture house." Built in 1913 with a Venetian-style facade, the theater closed in 1964 (http://cinematreasures .org/theaters/6818); 1908 Adam Clayton Powell Jr. Boulevard, Harlem, 1997

147

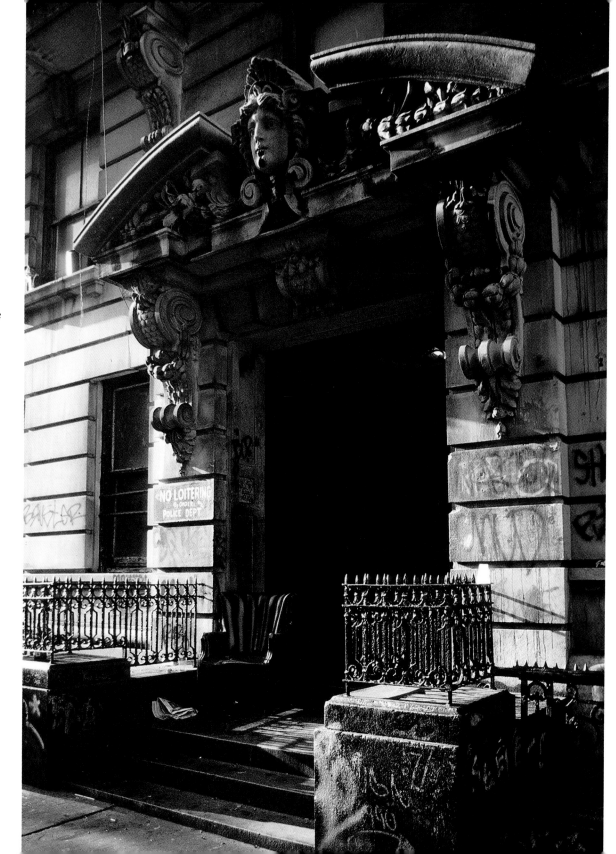

86 West 119th Street, Harlem, 1992

148

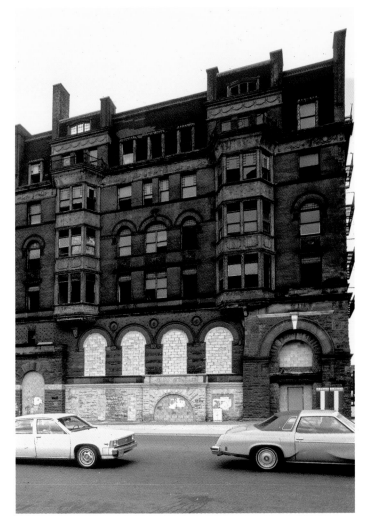

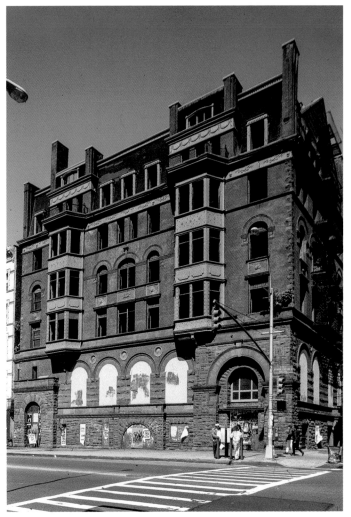

Former Corn Exchange Bank, northwest corner of
Park Avenue at East 125th Street, Harlem, 1982

Former Corn Exchange Bank, northwest corner of
Park Avenue at East 125th Street, Harlem, 1992

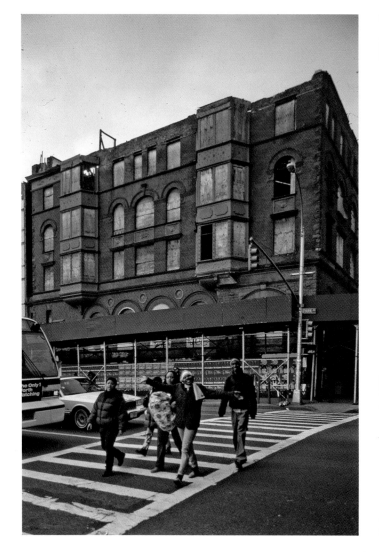

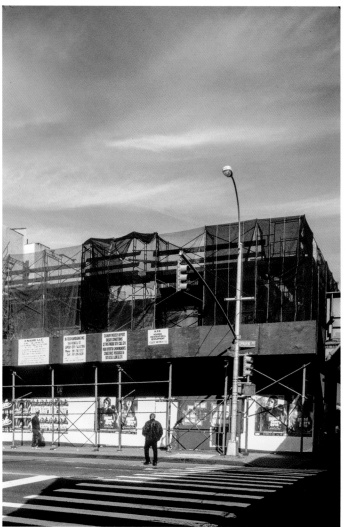

Former Corn Exchange Bank, northwest
corner of Park Avenue at East 125th Street, Harlem, 1996

Former Corn Exchange Bank, northwest
corner of Park Avenue at East 125th Street, Harlem, 2009

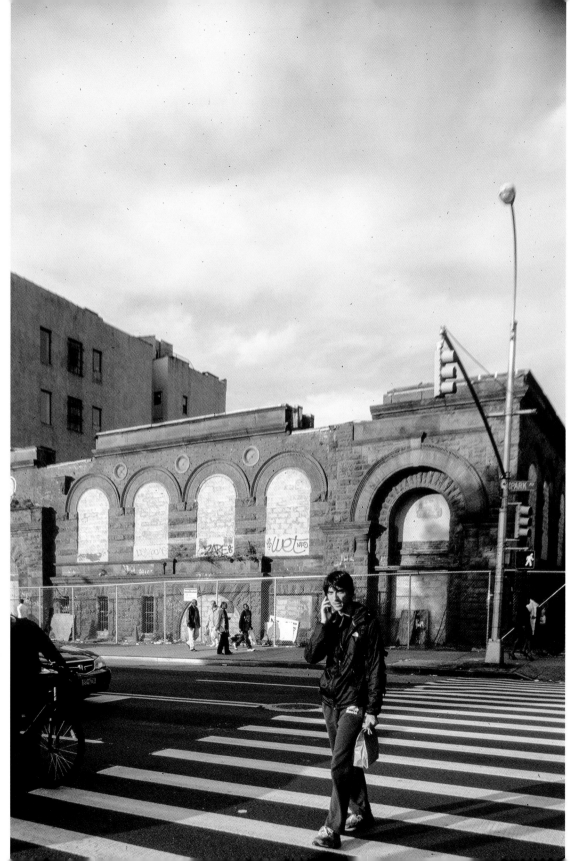

Former Corn Exchange Bank, northwest corner of Park Avenue at East 125th Street, Harlem, 2011

151

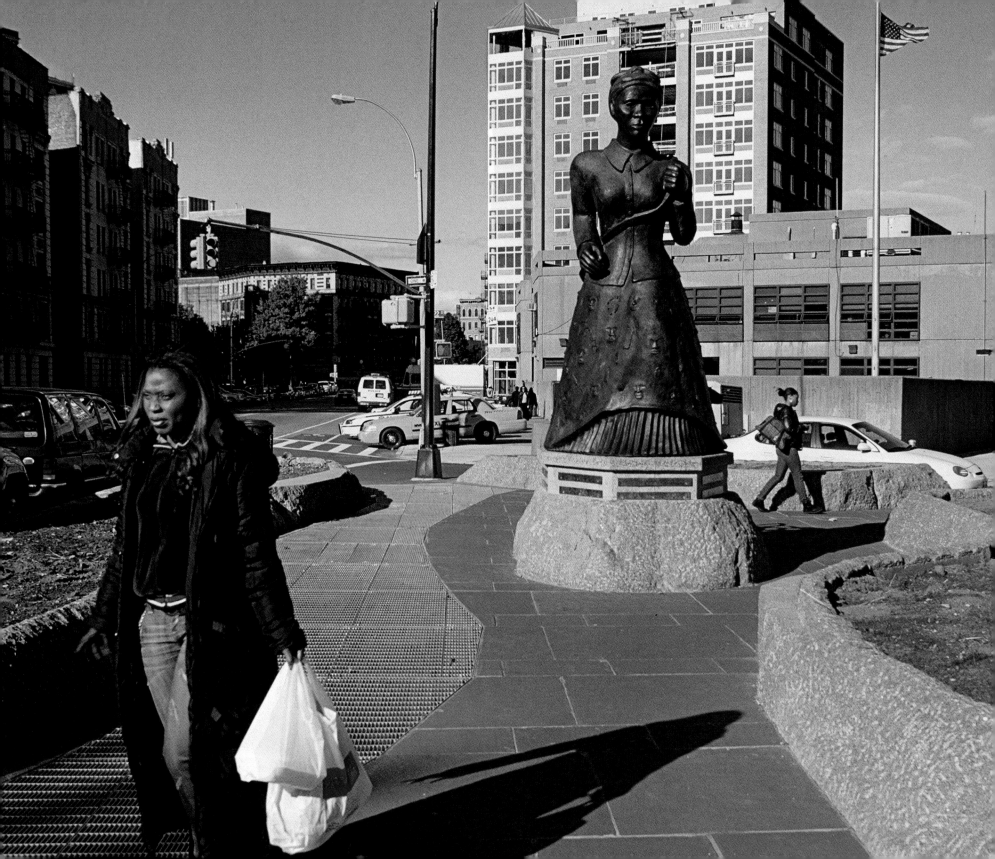

MEMORIALIZATION

There's not enough applauding of positive accomplishments in Harlem, and this is a positive step and deserving of applause.

KINSHASHA HOLMAN CONWILL, DIRECTOR OF THE
STUDIO MUSEUM, HARLEM, COMMENTING ON A PROPOSED
MONUMENT TO DUKE ELLINGTON, 1990

OPPOSITE *Harriet Tubman statue, view north from West 122nd Street at Frederick Douglass Boulevard, 2007*

BEFORE HARLEM BECAME the great center of black migration, its public statues honored historic figures such as Civil War general Winfield Scott Hancock along Saint Nicholas Avenue; or George Washington depicted with the Marquis de Lafayette, a 1900 copy of a large bronze Parisian statue by Frederic Auguste Bartholdi on West 114th Street.[1] Only much later—toward the end of the twentieth century—were monuments erected to famous black Americans.

Other cities honored the accomplishments of their black inhabitants earlier. For example, on the South Side of Chicago, on what is now Martin Luther King Jr. Drive, a 1927 memorial to black soldiers who served in World War I stands. The memorial, entitled *Victory*, depicts a black soldier from the Eighth Regiment of the Illinois National Guard and was erected by the state of Illinois.[2] Also in Chicago is the

153

1973 Benin-style bronze statue of Martin Luther King Jr. dressed as an African chieftain. In this statue by Geraldine McCullough, located on West Madison Street, King wears the Nobel Peace Prize medal and is portrayed as royalty. The statue was recently removed for repairs.

Facing the courtyard of the Harlem River Houses (built ca. 1937) is a statue of the legendary John Henry portrayed as a black man holding a hammer. "John Henry was a hard worker, a steel-driving man, a big man, a determined man, a slave," said Lenny, a retired Park Department employee who was born in the Harlem River Houses in 1947. Lenny remembers the statue of John Henry as always being there.

As early as 1941 there was a proposal to honor James Weldon Johnson, Harlem resident and the first black to become executive secretary of the National Association for the Advancement of Colored People, with a statue to be placed at the intersection of Central Park and Seventh Avenue. The proposal was delayed by Robert Moses, the city commissioner of parks, then approved in 1942 to be erected in a section of Central Park where "no white man or dicty [i.e., high-class] Negro has ever set foot." The project was eventually abandoned, ostensibly because of rising costs, in 1945.[3]

The shock of Martin Luther King Jr.'s assassination in 1968 spurred creation of a great many monuments to this civil rights leader across the nation. Harlem's most famous thoroughfare, 125th Street, was renamed after Dr. King. In 1969, a sculptural group created by John W. Rhoden representing an anonymous black family was placed above the entrance to the then-new Harlem Hospital building.[4] By the late 1990s statutes of other prominent African Americans followed, including a controversial statue erected in 1997 on Fifth Avenue showing Duke

Ellington sitting at a piano on a platform supported by his naked muses. The monument drew accusations of sexism and a call to withdraw $450,000 in city money. Manhattan Borough president Ruth Messinger called the monument "aesthetically suspect."[5]

Another, named *Higher Ground*, was installed in 2005 on West 125th Street and shows Adam Clayton Powell Jr. ascending a ramp. Statues were erected to honor Harriet Tubman and the Underground Railroad on Frederick Douglass Boulevard in 2007 and on the northwest corner of Central Park to honor Frederick Douglass—*The Prophet*—in 2010. Malcolm X was assassinated in 1965 in the Audubon Ballroom on Broadway; in 1987 Lenox Avenue was renamed after him.

In 2011 I rode the M4 bus along West 110th Street sitting behind a black woman and her small daughter. As the woman pointed at the Duke Ellington statue she said, "You see there, you see, that is Duke Ellington." When I asked her the reason for her interest in the monument she answered, "My daughter loved the statue of Harriet Tubman, she wants to know what all these statues are."

Harlem is now evolving as a principal destination for those interested in the African American experience; as such it is likely additional museums, monuments, and memorials will be erected in the neighborhood.

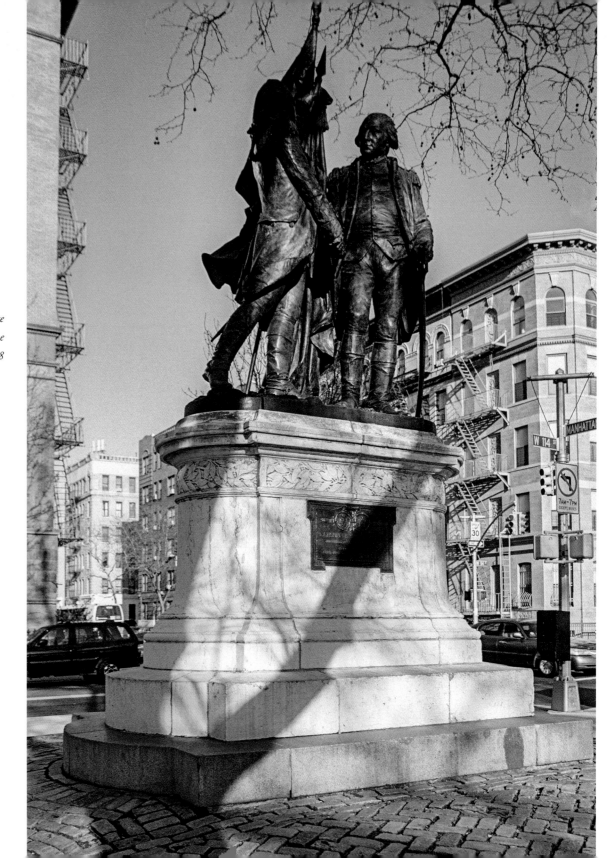

Statue of Washington and Lafayette by Bartholdi, Morningside Avenue at West 114th Street, Harlem, 2008

156

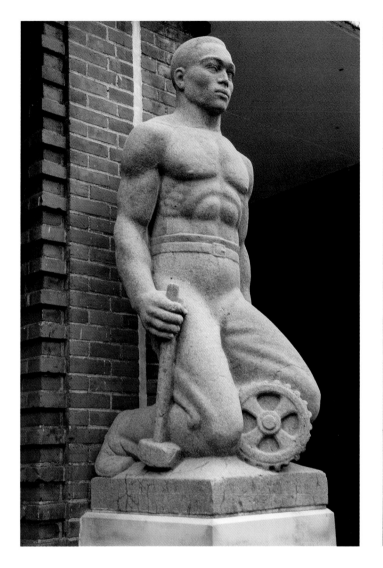

John Henry, Harlem River Houses courtyard, 2010

Black family sculptural group by John W. Rhoden, 1969, placed above the entrance to the then new Harlem Hospital Building, Malcolm X Boulevard at West 135th Street, Harlem, 2011

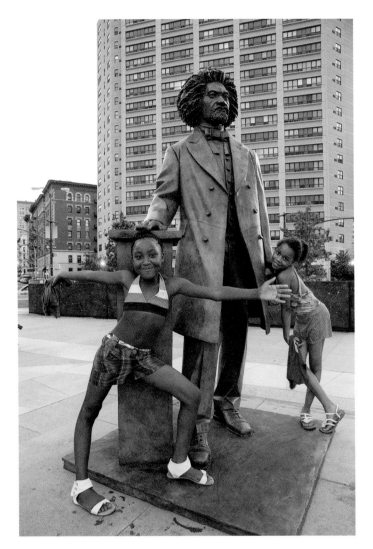

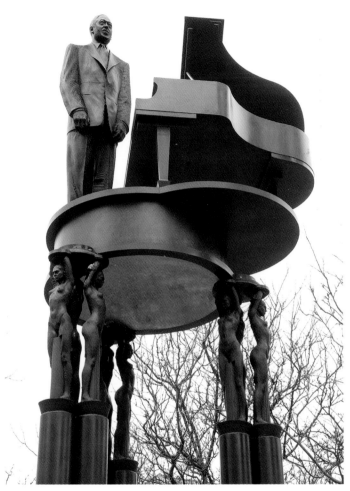

*"He escaped," the girls in the photograph told me when I asked for
the reason Douglass deserved a monument; Frederick Douglass statue,
West 110th Street at Frederick Douglass Boulevard, Harlem, 2010*

*"Aesthetically suspect" Duke Ellington statue by Robert
Graham, Fifth Avenue at 110th Street, Harlem, 2011*

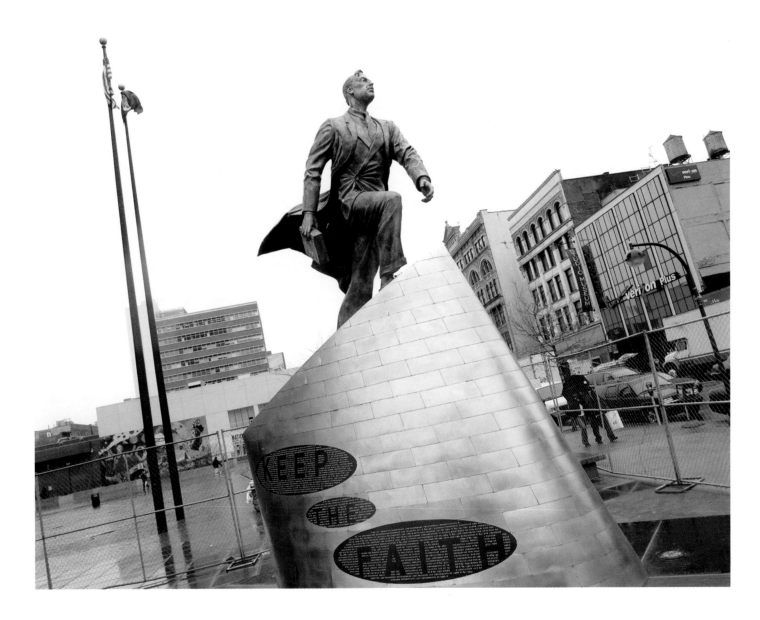

Higher Ground, Adam Clayton Powell Jr. statue, West 125th Street at Adam Clayton Powell Jr. Boulevard, Harlem, 2005

"SIMPLY MAGNIFICENT"

The New Apartment Buildings of Harlem

The Lenox is a 77-unit full-service luxury condominium development rising 12 stories at the corner of 129th street and Lenox Avenue. The opulent lobby, 24-hour concierge, valet service, attended underground parking, rooftop garden, residents only fitness center and upscale retail shops planned for the concourse level are the type of amenities that the Lenox Website declares, "defines the emerging lifestyle of today's Harlem."

STEVEN L. NEWMAN REAL ESTATE INSTITUTE,
"HARLEM IN OUR EYES," 2006

AT THE START OF THE twenty-first century, a new image of Harlem started to appear in the real estate advertisements for new buildings. Words such as "luxury sun filled," "duplexes," "penthouses" "with shiny wooden floors," "wood-paneled lobby," "high ceiling" and "African art" described a transformed housing market in Harlem. In slick videos, the surrounding neighborhood is displayed from penthouses using a telephoto lens making Central Park, Riverside Church, and the Midtown skyline appear nearby.

OPPOSITE *The Lenox, Malcolm X Boulevard at West 129th Street, Harlem, 2007*

An online promotion for the neighborhood south of 125th Street on the west side reads: "Artists and Musicians. Doctors,

lawyers and Wall Street investment bankers. Young families and college students. Longtime residents and global nomads. In an area teeming with **energy** in a way not seen since the Harlem Renaissance, nowhere is more vibrant than **South Harlem, or SoHa**." Located along Frederick Douglass Boulevard, an area that, according to its promoters, has "momentum" like no other in Harlem, can be seen its "restaurant row."[1] Surprisingly, SoHa does not make a strong connection to the Harlem renaissance in terms of its décor. The lobbies of its most important buildings and restaurants do not display Afrocentric art and their names are not those of famous blacks. The historic character of the neighborhood is just one more element adding to its desirability, but not its defining one.

An advertisement for the Lenox fantasized: "The city spreads out in front of you like an urban fairy tale."[2] The Lenox declared bankruptcy in 2010; at the time, eighteen of the apartments remained unsold and the ground floor commercial space, once occupied by Dancy-Powers, a luxury car dealership selling Rolls Royces and Bentleys, was vacant.[3] A barber that works in a nearby shop expressed his resentment of the Lenox and gentrification, saying, "The city is going to come and take them over. The homeless are going to live in the vacant apartments. I can see them bringing their shopping carts full of cans into that luxury apartment."

"Reparation Tower" is a cool and ironic image of an upturned black fist exhibited at the Studio Museum in Harlem in the 2004 architecture show *Harlemworld: Metropolis as Metaphor* organized by Thelma Golden. The proposal by the architect Ron Norsworthy for a forty-story luxury high-rise shaped like of the Black Power salute reads: "History. Destiny. Luxury."[4] Having lost its rage, the Black Power symbol entered the museum as a luxury apartment building and a work of art.

The Harlem described by real estate developers presents a different world from that seen in the videos of hip-hop artists. Absent are check-cashing places, twenty-four-hour convenience stores, drug treatment centers, crime scenes, welfare offices, or housing projects. In these promotional videos, the capital of black America is presented as an affluent neighborhood, "a community offering a vibrant scene with numerous restaurants, lounges, shops and services." Available shopping consists of boutiques, high-end food stores, pet stores, spas, pastry shops, landmark bars, and cultural institutions such as the Apollo Theater, the Cathedral of Saint John the Divine, Columbia University, and "Museum Mile." The website for 88 Morningside informs those interested in the outdoors, "The nearby Harlem Piers leads to the beautiful Hudson River bike paths and Riverside Park."[5]

In its moral and economic implications, the twenty-first-century vision of commercial developers breaks radically with the past. The neighborhood offers green technology, modern design, space, adventure, and consumerism in an ethnically and racially mixed middle-class community. Segregated old Harlem, the capital of black America, was a unique place where blacks could realize their potential. Multicultural Harlem offers those who can afford it an open neighborhood in which to live well, to enjoy diversity, and to live right.

Luxury apartment building with great views of Central Park, 111 West 110th Street, Harlem, 2011

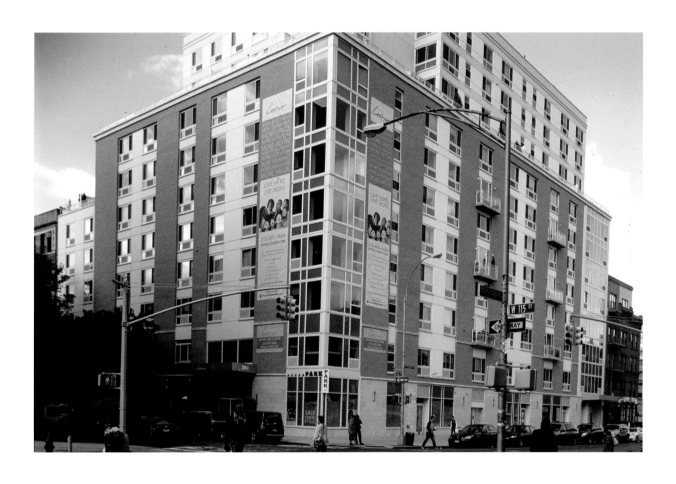

"More Value," Livmor Condominium, Frederick Douglass Boulevard at West 115th Street, Harlem, 2011

TOP *2004 Rolls Royce for sale at Dancy-Powers Automotive Group,*
northeast corner of Malcolm X Boulevard at West 129th Street, 2008

OPPOSITE "Green," *the Kalahari apartments, West 115th Street, Harlem, 2010* **167**

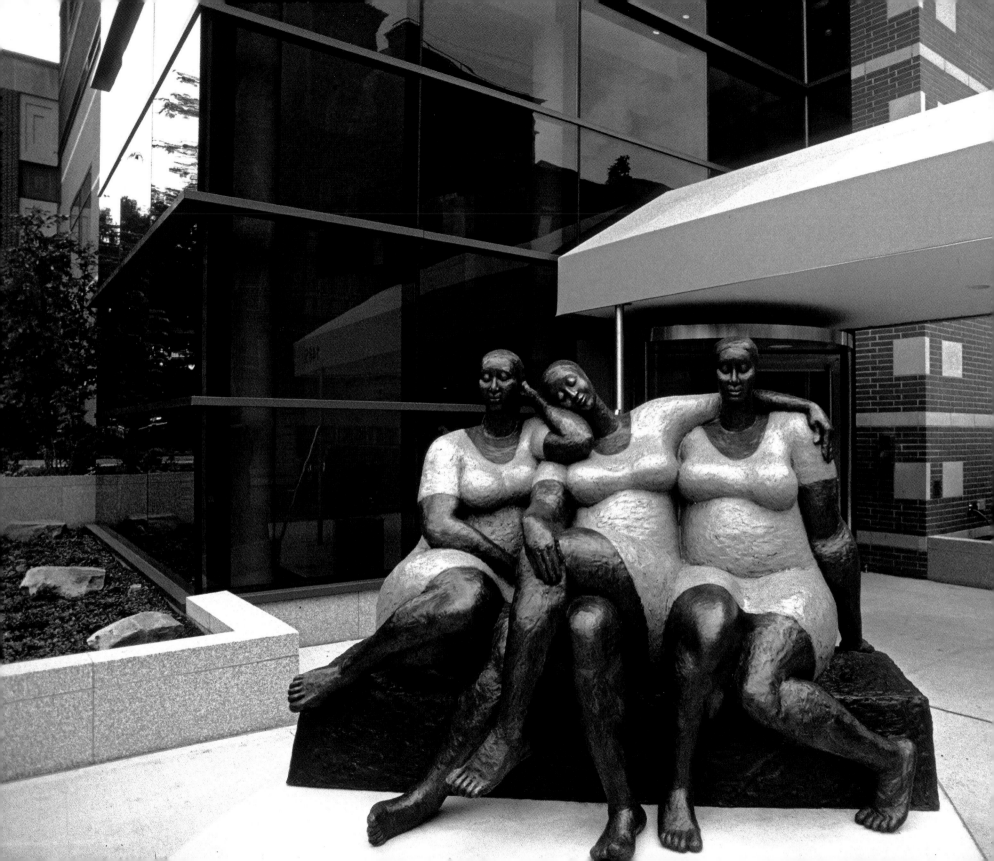

5th on the Park, 120th Street at Fifth Avenue, Harlem, 2010

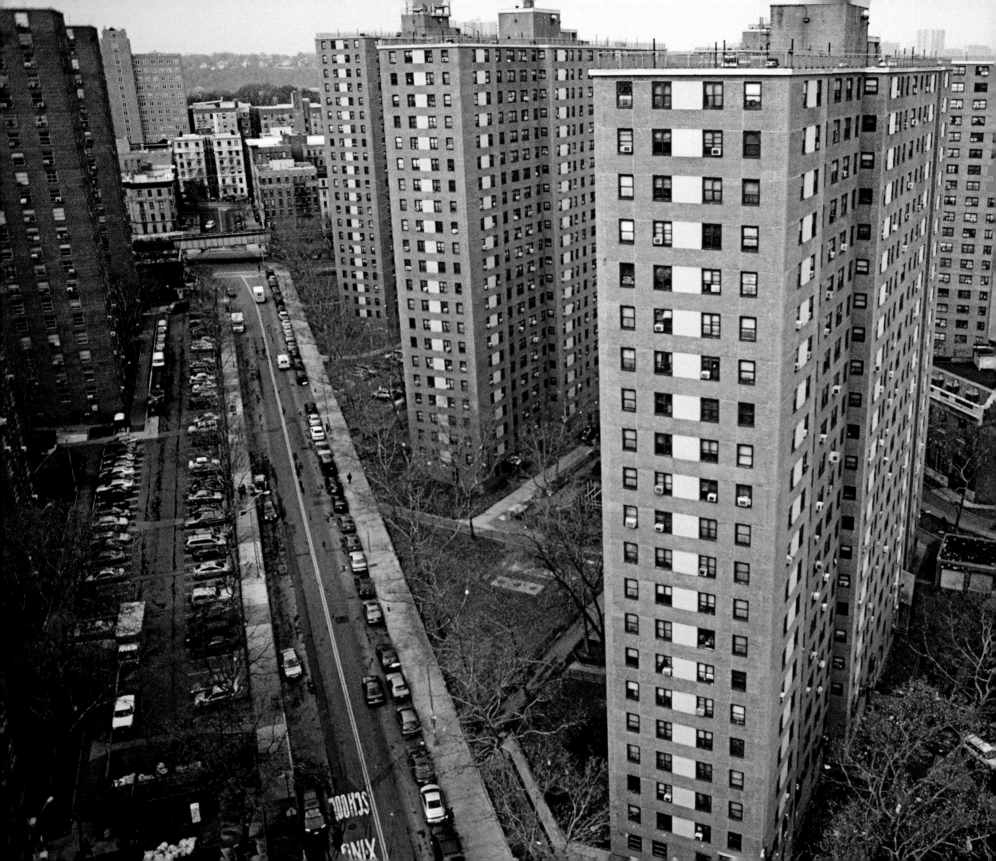

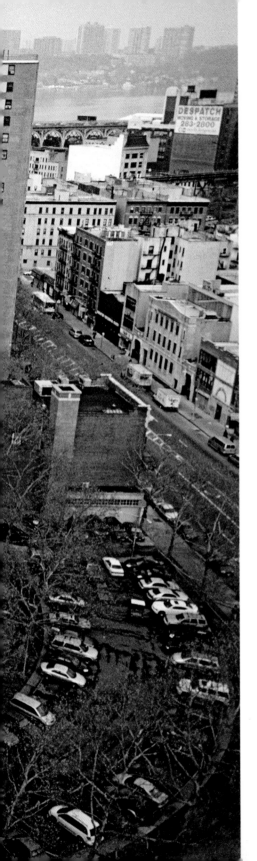

THE PROJECTS

Unlikely Bastions of Traditions

Nearing its 50th anniversary, the Harlem River Houses project wears its age softly. A veil of springtime green floats like a cloud over its courtyards, where the plane trees long ago grew higher than the seven small red-brick apartment buildings around them.

DAVID DUNLAP, *New York Times*, 1987

IT TOOK ALMOST TWO DECADES after the Harlem River Houses for additional projects to be built in the neighborhood. Nine public housing developments were built in Harlem during the 1950s and the 1960s. Today, approximately 15 percent of the community lives in public housing.[1]

In 1950, Lewis Mumford criticized New York City and the New York City Housing Authority's vast slum clearance and housing program for abandoning the model of the four- and five-story Harlem River Houses and building "bleak and uniform" high-rises at double or triple the density. By creating complexes lacking churches, synagogues, movie theaters, schools, or public markets, the Housing Authority was re-creating the massive damage that high-density housing has done, resulting in exchanging "slums for super

OPPOSITE *Grant Houses, view west from West 124th Street at Morningside Avenue, Harlem, 2007*

171

slums." Those living on the sites designated for public housing had to be evicted. The long years of construction necessary to complete new housing developments accelerated the exodus of the middle class and contributed to making Harlem the "super slum" the neighborhood became in the 1970s and 1980s.[2]

In Chicago, Baltimore, and Newark, high-rise family projects became housing of last resort. Many decayed along with the rest of the buildings in the neighborhood and were demolished. Mumford would have been surprised to discover that in 2011 these tall complexes, placed so intrusively into the urban fabric, played an important role in maintaining the character of Harlem. The many neighborhood housing projects shared in the poverty and crime of their surroundings, yet unlike the projects in other cities, in New York these towers survive fully occupied even though many of the buildings nearby were abandoned.

Developers in Harlem, unlike those in other cities, built expensive apartments across the street from projects. For example the Kalahari Apartments, "where luxury meets green," face the Martin Luther King Jr. Houses on West 115th Street.[3] And a new public high school to be managed by Harlem Children's Zone is being built on the grounds of the Saint Nicholas Houses.

Until recently, public housing developments with one thousand or more low-income families were large enough to shape their immediate surroundings. But with everything around public housing developments evolving, the ninety-nine-cent stores and coffee shops across the street are being replaced by new market-rate apartment buildings, banks, and upscale restaurants. Tenants feel disoriented as they lose the familiar institutions of their neighborhood.

The projects are "outside the market," thus limiting displacement. Because their rents are set to about 30 percent of the family's income, residents of modest

means, including those receiving social security and disability, can afford the rent. Among those who live in public housing are members of local churches, choirs, and sports and neighborhood clubs, as well as the patrons of nearby bars and restaurants. Ironically, intrusive public housing developments of the past, built with no regard for Harlem's building types, have become the keepers of traditions and bulwarks against gentrification.

173

THE PROJECTS

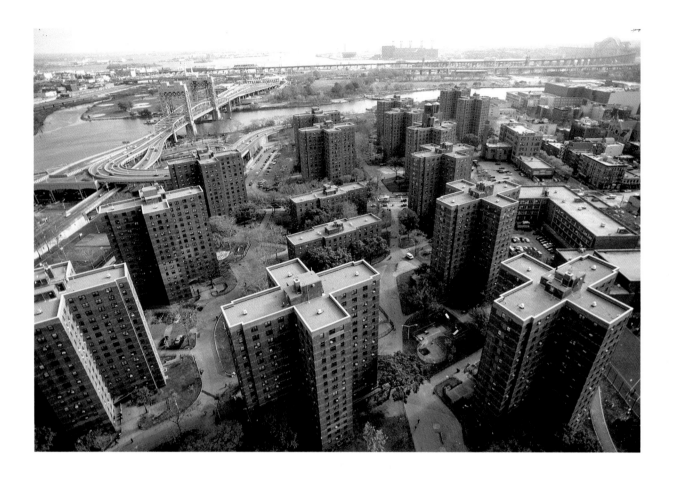

TOP *Robert Wagner Houses, view east from East 122nd Street at Second Avenue, Harlem, 2009*

OPPOSITE *"Sly," riding the elevator, Polo Grounds Towers,*
2931 Frederick Douglass Boulevard, Harlem, 2008

174

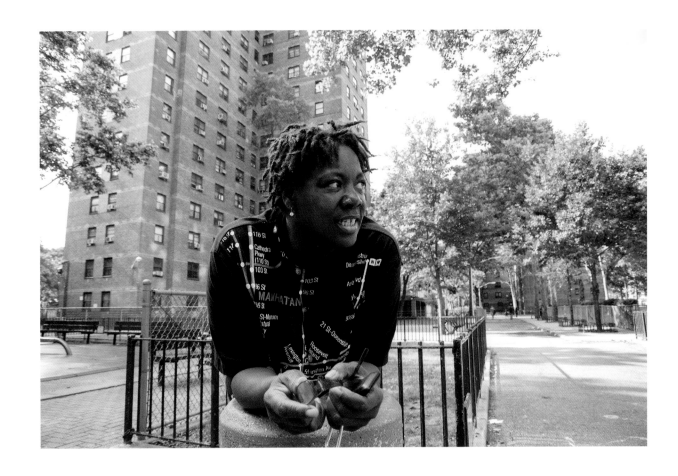

TOP *Joanne Tucker, Robert Wagner Houses, East 121st Street at First Avenue, Harlem, 2010*

OPPOSITE *Polo Grounds maintenance supervisor at his office,*
2975 Frederick Douglass Boulevard, Harlem, 2007

177

THE SUBWAY

I can never put on paper the thrill of that underground ride to Harlem.… At every station I kept watching for the sign: 135th Street…I came out onto the platform…and looked around. It was still early morning and people were going to work. Hundreds of colored people. I wanted to shake hands with them, speak to them. I hadn't seen any colored people for so long—

LANGSTON HUGHES, *The Big Sea*, 1926

IN A FAMOUS SCENE FROM the 1984 movie *The Brother from Another Planet* a card player going uptown on the D train tells the alien Brother that he can perform a magic trick and make all Caucasians disappear at West 59th Street, Columbus Circle. And before the doors close at 59th Street all whites leave the subway car, showing Manhattan's extreme segregation.[1] In the twenty-first century this situation has changed, as the numbers of Asian and whites visiting or living in Harlem continues to grow.

Harlem owes its recent development to the four subway lines that connected the neighborhood to lower Manhattan. Harlem grew as New York grew as railroad and subway lines reached what until then were sparsely populated, almost rural villages. Before the IRT line was completed in 1904

the trip from Wall Street to Harlem took longer than an hour; the underground, with its express line, made that trip in fifteen minutes. "City Hall to Harlem in 15 minutes!" became the slogan of the IRT.[2]

Subway stations along 125th Street and in other gentrified neighborhoods have now been renovated and decorated with images of the old neighborhood and its famous residents. Faith Ringgold decorated the number 2 and 3 lines West Side IRT station at 125th Street with playful portraits of famous black artists and activists flying above local landmarks. While inside the 110th Street number 6 line IRT station, in El Barrio (i.e., Spanish Harlem), James de la Vega created a set of lively murals depicting Latino musicians, dancers, and fruit vendors dressed in traditional attires.

The desolate 155th Street station for the B and the D lines and the unkempt 148th Street station on the number 3 line IRT, located in the segregated northern fringes of Harlem, are barely maintained. Running the length of Harlem, the C line, with the oldest cars in the system, is rated the worst of the city lines.[3] Young and homeless people wait at subway stations ready to jump the turnstiles as soon as the train arrives. Others ask fellow travelers to give them "a swipe" from their fare card. People use the subway as an inexpensive way for transporting large boxes, mattresses, and pieces of furniture such as tables.

Harlem subway stations are not the busiest in the city. The East 125th Street IRT station on Lexington Avenue ranks thirty-fifth in the city and the IND station on West 125th Street at Saint Nicholas Avenue forty-first, far behind stations such as Times Square and Grand Central, which rank first and second, respectively.[4] Yet the dreary but lively IRT station on East 125th Street was ranked fifth among the most dangerous subway stations in the entire city.[5]

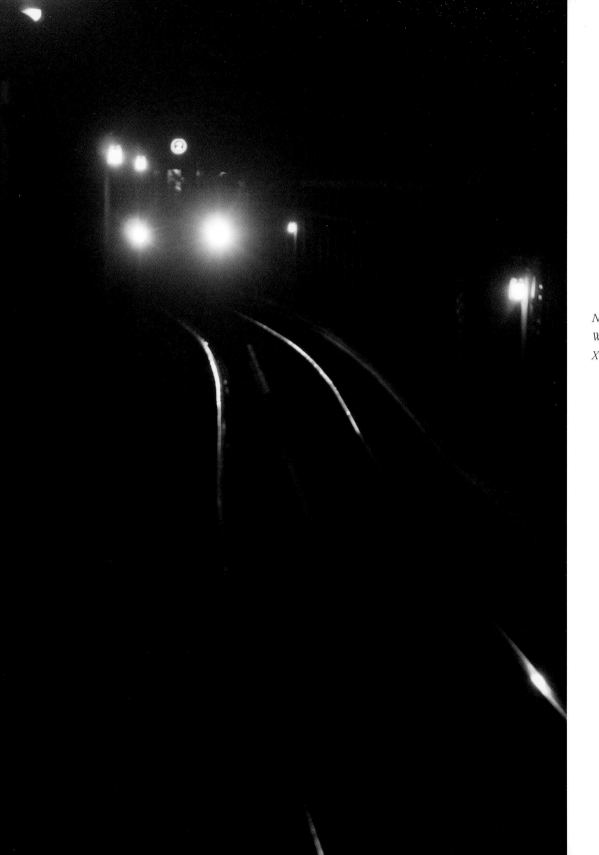

Number 2 express approaching the West 125th Street Station on Malcolm X Boulevard, Harlem, 2011

181

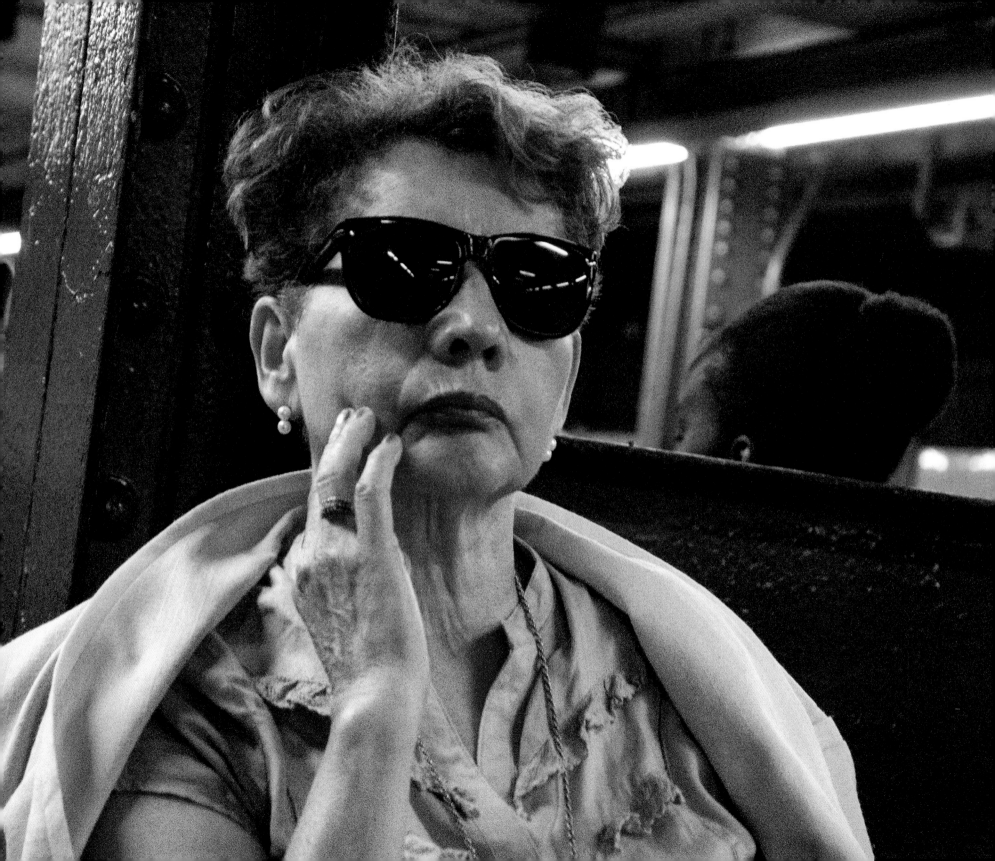

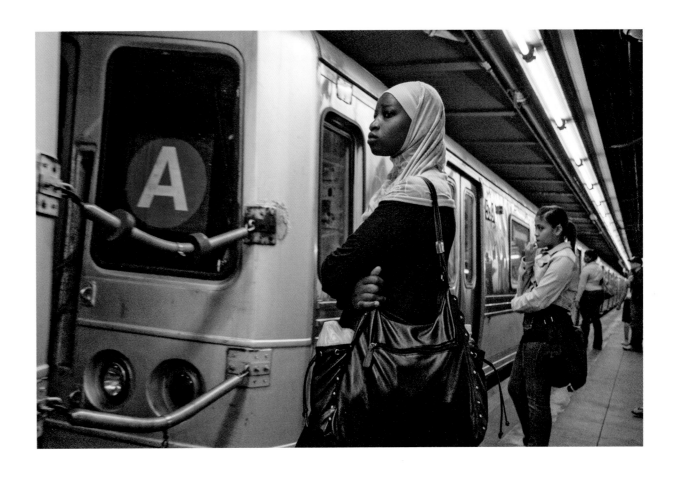

TOP *145th Street, IND subway station, Harlem, 2010*

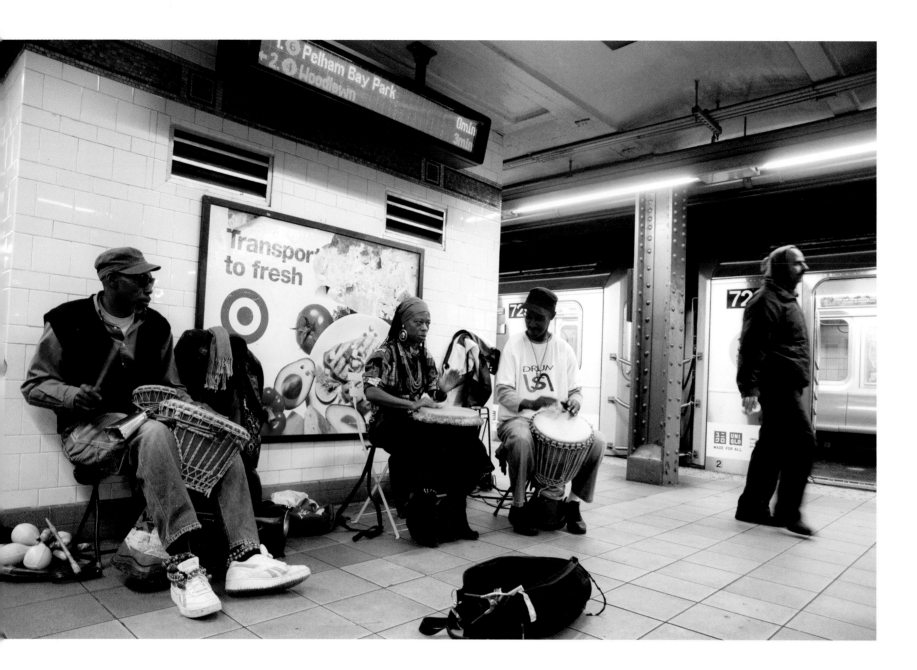

Saka, Niyyirrah, and Raheem, healing drums, IRT station, Lexington Avenue at East 125th Street, Harlem, 2011

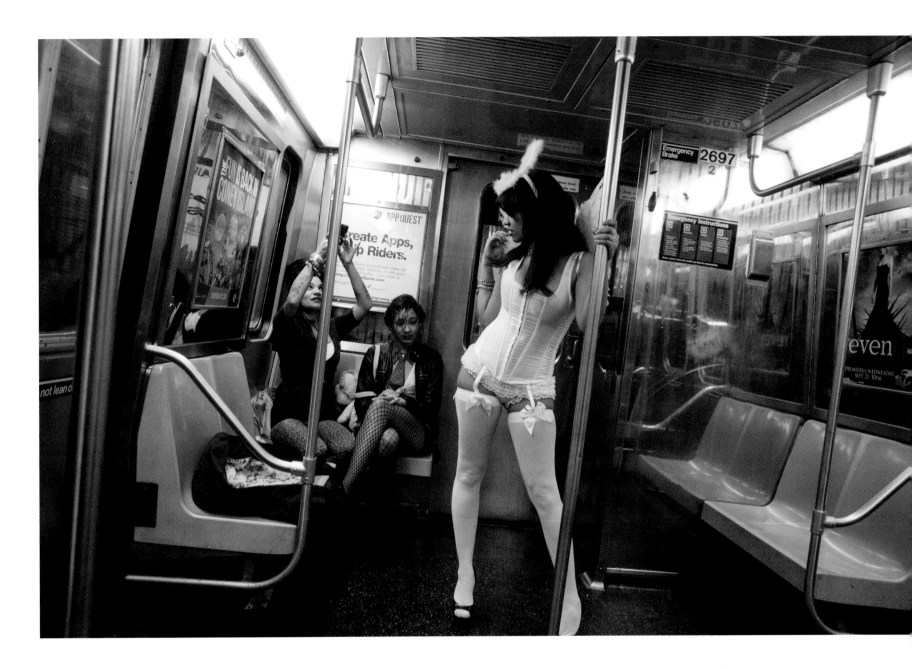

Halloween, IND Line, 155th Street at 8th Avenue, Harlem, 2011 **185**

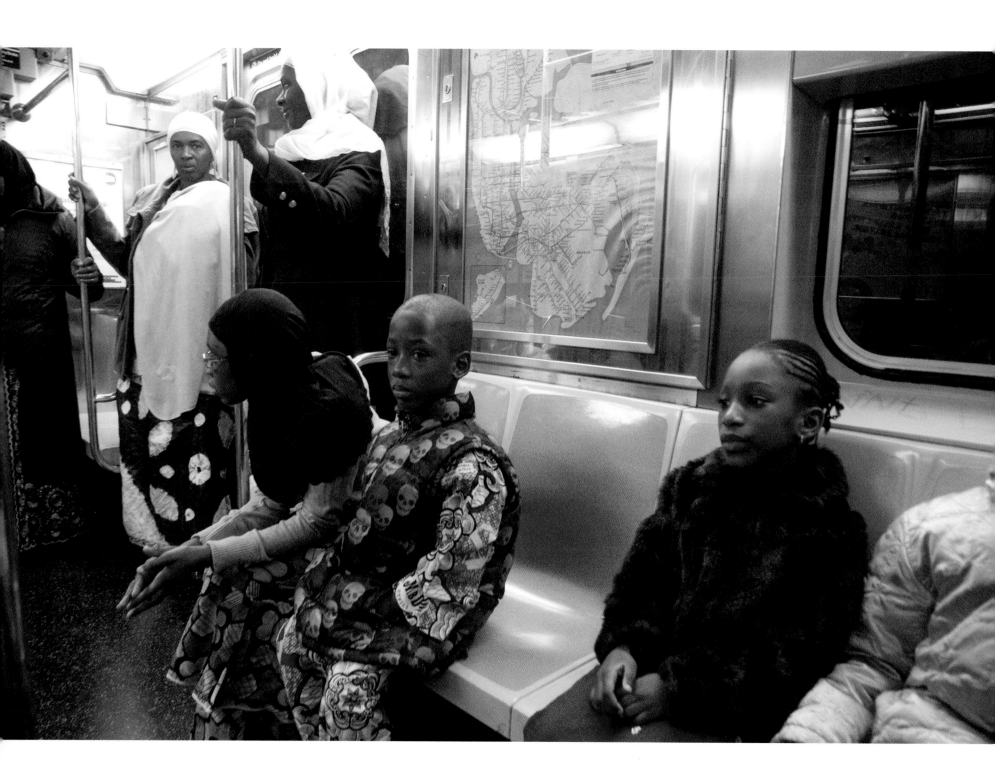

TOP *Malcolm X and Martin Luther King fly over the Theresa Hotel, by Faith Ringgold, 1996, West Side IRT station, 125th Street, Harlem, 2011*

OPPOSITE *Number 3 line IRT, West 135th Street, Harlem, 2011*

187

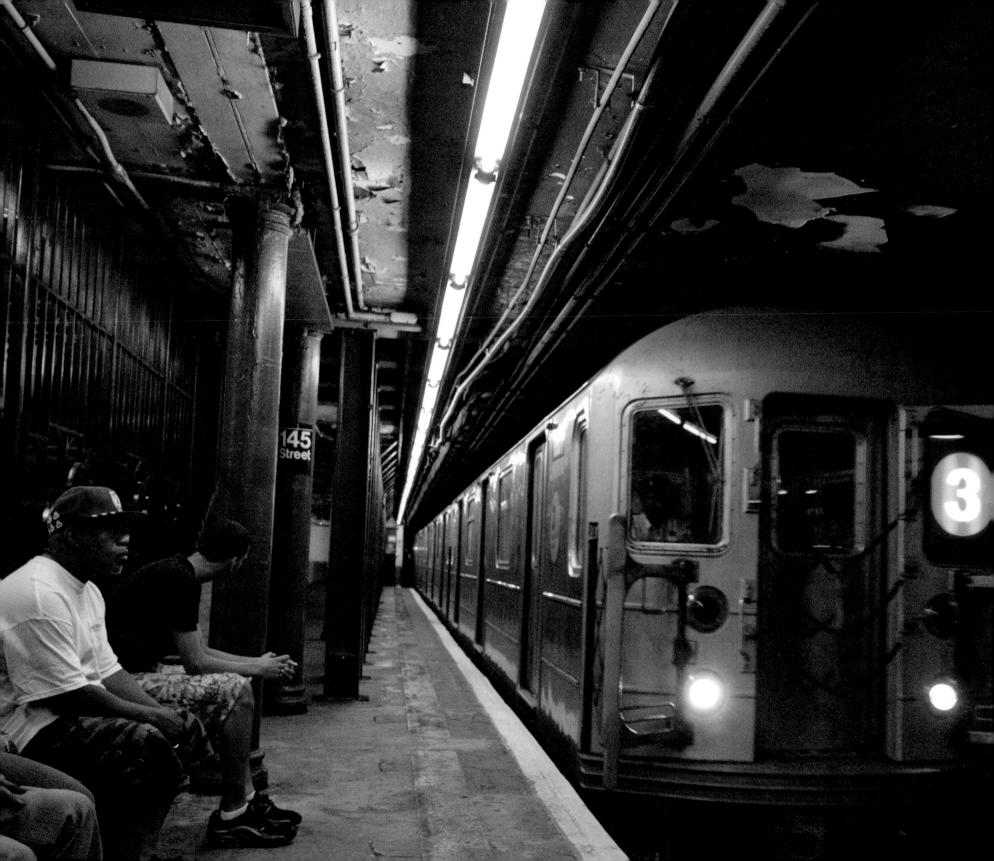

West 145th Street IRT subway station, Harlem, 2010

189

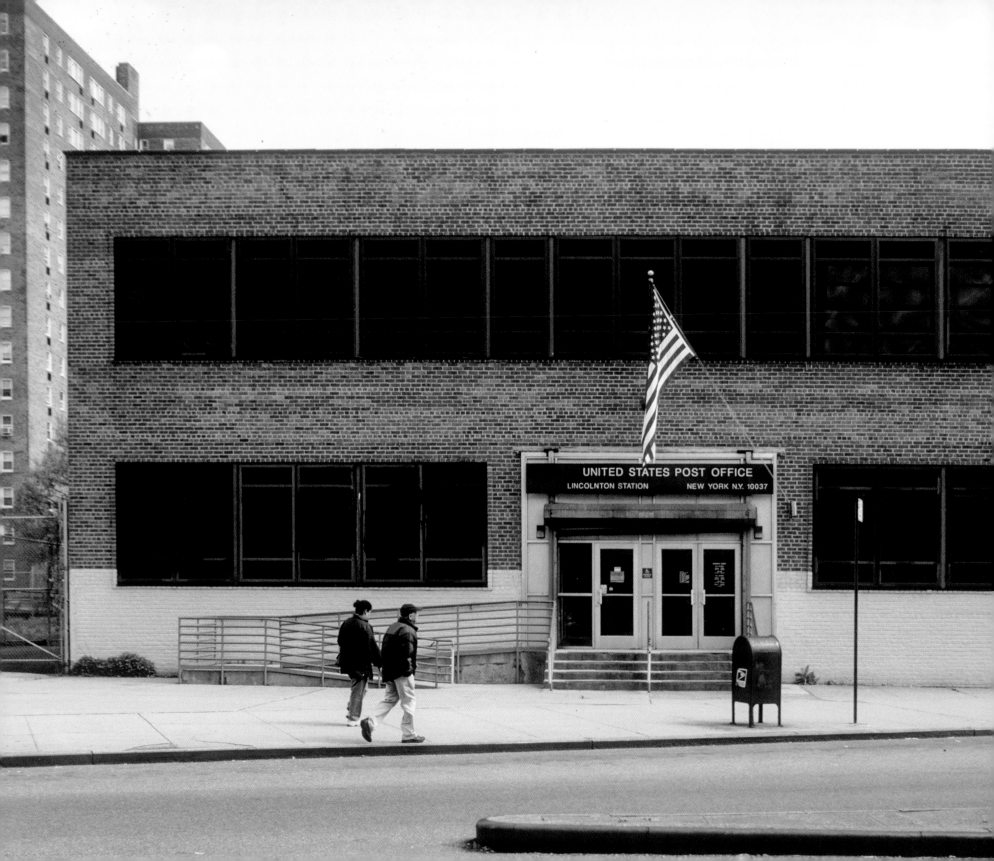

DEFENSES

You see it [SkyWatch]; it says there was a shooting.

<div align="right">

POLICEMAN ON MALCOLM X BLVD.
AT WEST 128TH STREET, 2011

</div>

OPPOSITE *Lincolnton Station,
US post office stripped of its metal
covering, northwest corner of Fifth
Avenue at 138th Street, Harlem, 2005*

IN HARLEM, VIOLENT CRIME HAS declined to approximately a third of its early 1990s peak. Police presence in Harlem has increased dramatically, and their tactics have become more aggressive under Mayor Michael Bloomberg. In 2009 there were 580,000 "stops and frisk" in the city, almost all young males believed to be armed and dangerous. In 2010 the numbers of suspects stopped and searched by the police increased to 600,000; 85 percent were African Americans and Hispanics. Manhattan Borough president Scott Stringer blamed the New York City Police Department for creating a "wall of distrust" between officers and the black and Latino communities.[1]

In 2009 while walking home at night along Frederick Douglass Boulevard I saw three policemen at the corner of West 112th with their guns drawn and pointed to the head of a black teenager. A few months later the same scene was repeated with one of the teenagers breaking loose and an undercover policeman running after him. Since then youths have stopped hanging out at this corner, located at the heart of restaurant row.

191

Petty street crime lets tourists know they are in a real tough place, one that is not completely "Disneyfied." While sipping a drink in a restaurant, patrons often have a chance to see the New York Police Department in action. Violent crimes, however, bring an immediate response from outraged residents, local politicians, and the police. Witness, for example, the widespread anger resulting from a shooting incident in the summer of 2011 in which three bullets were fired across from a playground in Morningside Park at dusk. Fortunately nobody was hurt. Yet the incident mobilized the community, which was fearful that the old Harlem was reappearing.[2]

A decade and half ago, the eyes on the street were often those of youthful drug dealers, and defenses included dogs, metal doors, window bars, and razor wire. In 2010 Harlem began to rely mostly on surveillance cameras, security guards, doormen, shopkeepers, and the police for security. Scenes of crimes are captured in video and posted on YouTube. If viewers recognize the perpetrators they are asked to report them to the police.

In 2005 the group Surveillance Camera Players mapped 316 video cameras in Harlem, which was up 300 percent since 2003. The commercial strip of West 125th Street has the highest density of cameras in the neighborhood.[3]

The most sinister of the security devices are the mobile surveillance platforms with high-powered sensors, cameras, microphones, and spotlights operated by the police department. "The SkyWatch tower is designed with darkened windows so those below cannot tell if an officer is present" and is often seen at corners such as Malcolm X Boulevard and West 137th Street or in places where a murder has taken place or where crime is spiking. SkyWatch, frequently seen parked near the improvised altars made in memory of those killed, has itself become a funeral monument.[4]

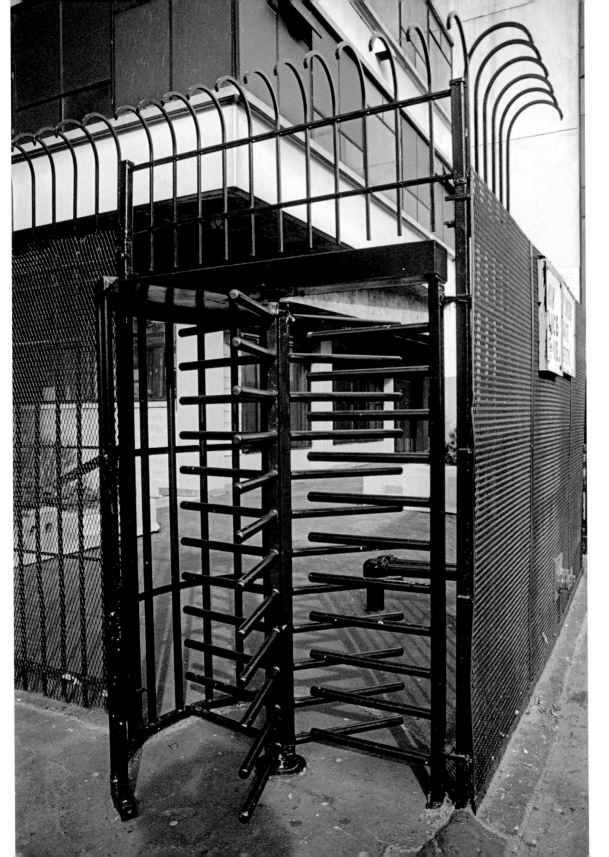

Defended entrance to Taino Towers,
2383 Second Avenue, Harlem, 2007

193

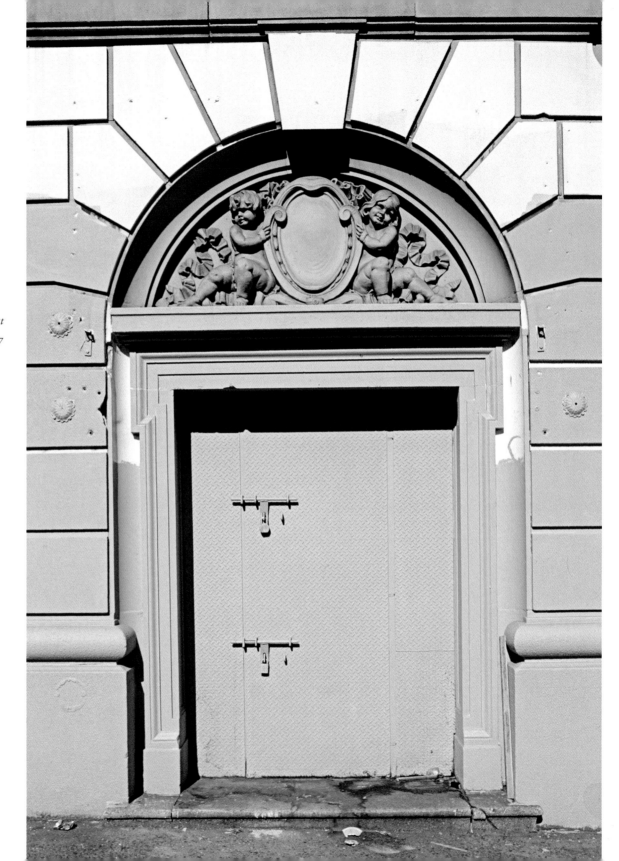

Northwest corner of West 110th Street at
Malcolm X Boulevard, Harlem, 1987

194

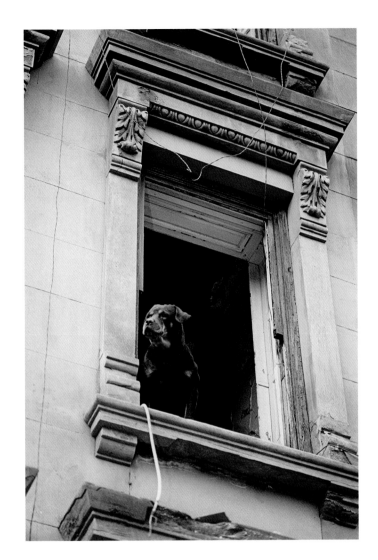

Guard dog, 257 Malcolm X Boulevard, Harlem, 1998

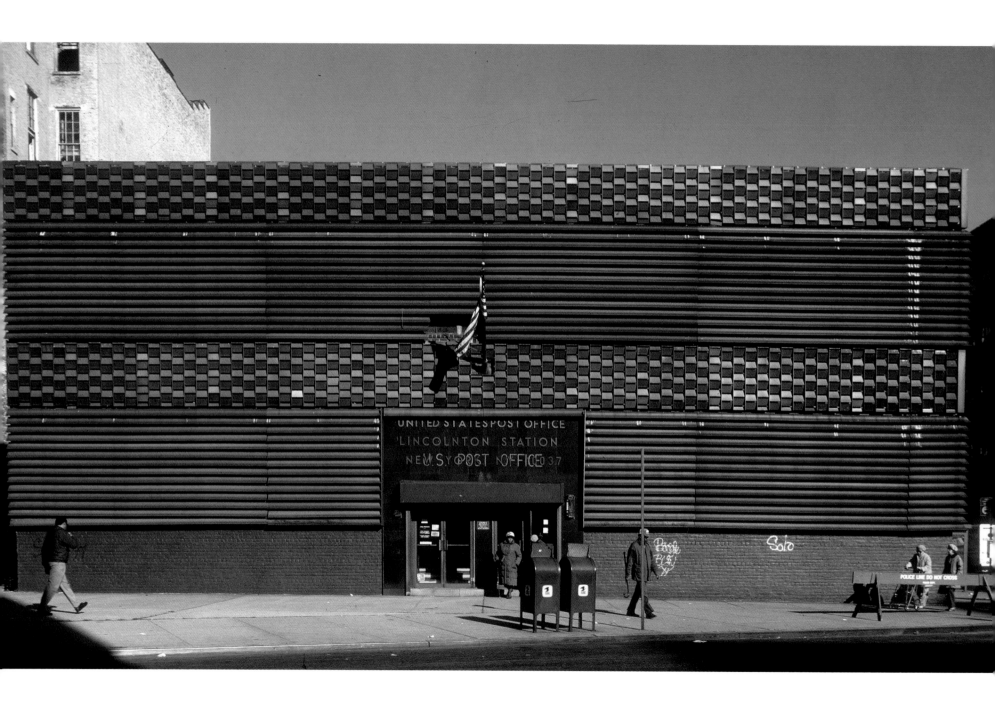

TOP *Lincolnton Station, US post office stripped of its metal covering,
northwest corner of Fifth Avenue at 138th Street, Harlem, 2005*

OPPOSITE *Fortified Lincolnton Station, US post office, northwest corner of Fifth Avenue at 138th Street, Harlem, 1990*

Northwest corner of Second Avenue at East 126th Street, Harlem, 2008

SkyWatch tower, New York Police Department, Malcolm X Boulevard between West 137th Street and 138th Street, Harlem, 2008

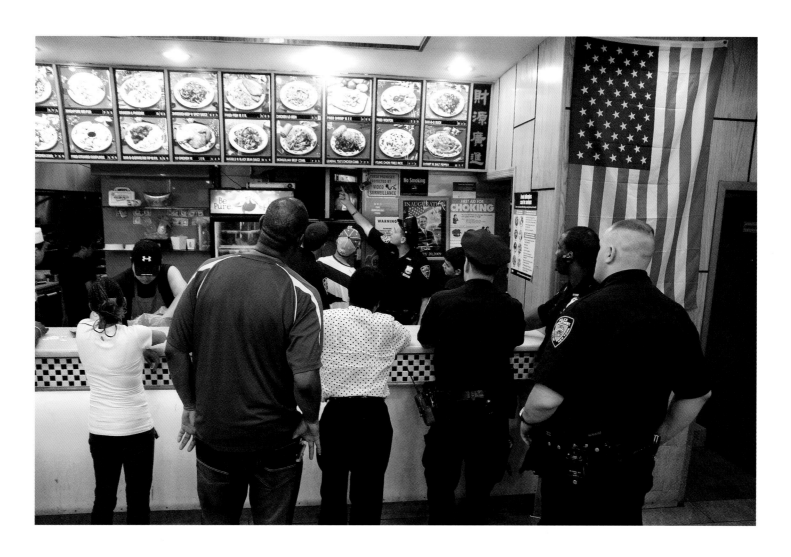

Policemen looking at the surveillance tape at Empire Chinese III, 1902 Adam Clayton Powell Jr. Boulevard,
Harlem, 2012. A worker at the restaurant explained: "A crazy woman attacked somebody working down
here." People commented: "Some lady had a complication with somebody." "It is like a reality show."

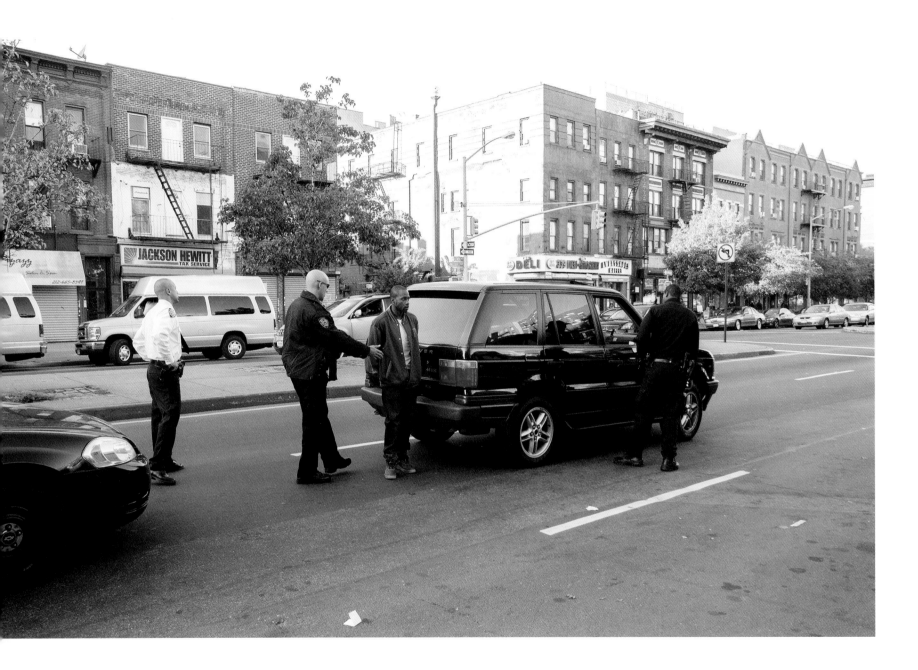

Arrest, Malcolm X Boulevard at West 126th Street, Harlem, 2011

Woman being arrested in front of Red Rooster Restaurant, Malcolm X Boulevard at West 125th Street, Harlem, 2011 **201**

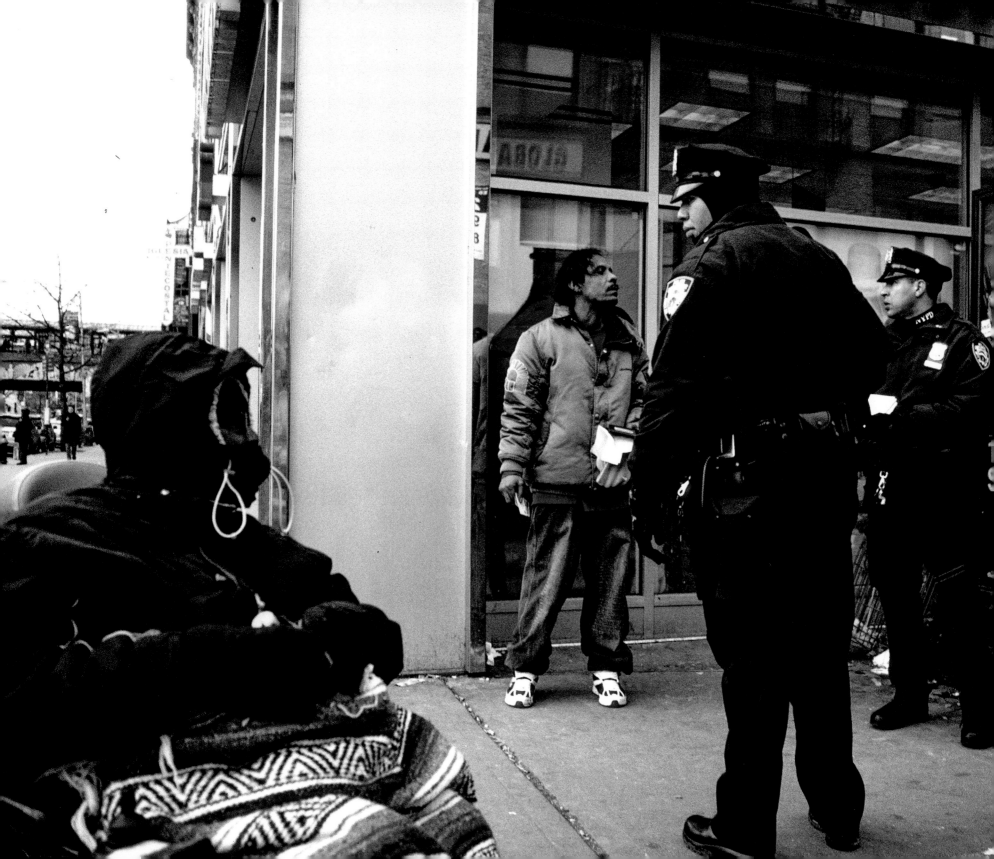

Police incident, northwest corner of East 125th Street at Lexington Avenue, Harlem, 2009

CULTURE

HARLEM'S WALLS

Graffiti, Memorials, Murals, and Advertisements

STREET GRAPHICS REFLECT the life of a neighbor-hood—its identity, struggles, aspirations, and well-being, as well as the tastes of storeowners, gang members, and individual artists. Photographers such as Aaron Siskind and Helen Levitt often included examples of graffiti in their work. Long before public statues were erected or streets renamed to honor Harlem's leaders, sports figures and artists had a presence on the walls.

Official public art murals commissioned by schools, im-ages sponsored by community organizations, or paintings planned and supervised by committees generally express the views of their sponsoring organization. Rather than photo-graphing officially sanctioned wall art, I prefer to document the personal visions of artists, working largely on their own, who are less interested in promoting morality and values.

During the 1970s, a period of dramatic economic decline and depopulation in Harlem, Harlem was at its most mili-tant. Walls of vacant buildings were home to large murals devoted to political issues such as Black Liberation, the civil rights movement, and the struggle against racial oppression.

Numerous Black Panther posters featured escaping prisoners and armed women defending their children. Stores housing Jamaican businesses displayed lions, images of Ethiopian emperor Haile Selassie, and the colors of the Ethiopian flag. Memories of the rural South found expression in hand-lettered commercial signs and in the down-home names of stores, connecting the sharecropper's farm with urban life.

Also covering the facades of vacant storefronts were posters advertising movies, concerts, and musicians. Only visible for a couple of weeks, each generation of posters was soon covered over by a more recent layer, eventually forming thick stacks of paper. Framed by the decayed remains of ruined buildings, they created three dimensional collages made up of a variety of faces, lettering styles, and colors in surprising arrangements. The results were lively, if unintended, works of street art. The rebuilding of the neighborhood brought an end to these collages, which vividly captured the film and music scene of New York.

As drug trafficking increased during the late 1980s and early 1990s, memorials to slain drug dealers became popular. Merchants and neighborhood residents dared not deface or remove these examples of street art for fear of retaliation by the gangs. In 2012 city officials and gentrifiers do not tolerate memorials to dead drug dealers along Harlem boulevards.

As middle-class families moved into Harlem, the neighborhood attracted ever greater numbers of tourists. Enormous billboards with celebrities advertising sports equipment, liquor, cars, and music companies became frequent. Over four decades, Harlem's walls reveal a shift from calls to armed struggle and political activism to commercialism. The locally created, handmade designs were replaced by mass-produced banners and billboards.

Globalization brought new images of black celebrities to Harlem. Stories of oppression and calls for revolution have vanished, replaced by an endless display of consumer products and mass entertainment. Murals and posters depicting the struggle for social justice as well as memorials glorifying the drug lifestyle were replaced by slick symbols of youth, success, and wealth. The prophets and the martyrs celebrated for their courage in the struggle for equality in the earlier murals, lining the boulevards, gave way to portraits of black rappers—Sean John, Missy, Lil Wayne, and 50 Cent —and sports figures. Many of the celebrities in these advertisements seem to be enjoying the American dream while sneering at the crowds below. Liquor advertisements are the exception here: people are portrayed next to their bottle of choice, happy, and inviting passersby to share.

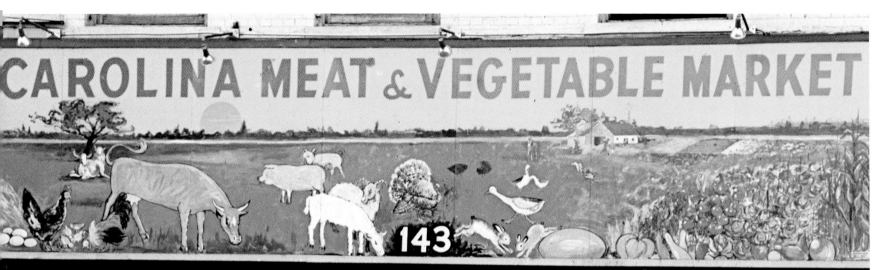

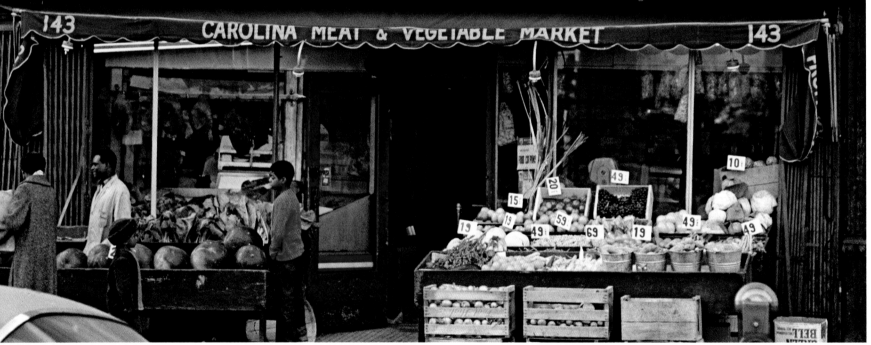

Carolina Meat and Vegetable Market, 143 Lenox Avenue, Harlem, 1970

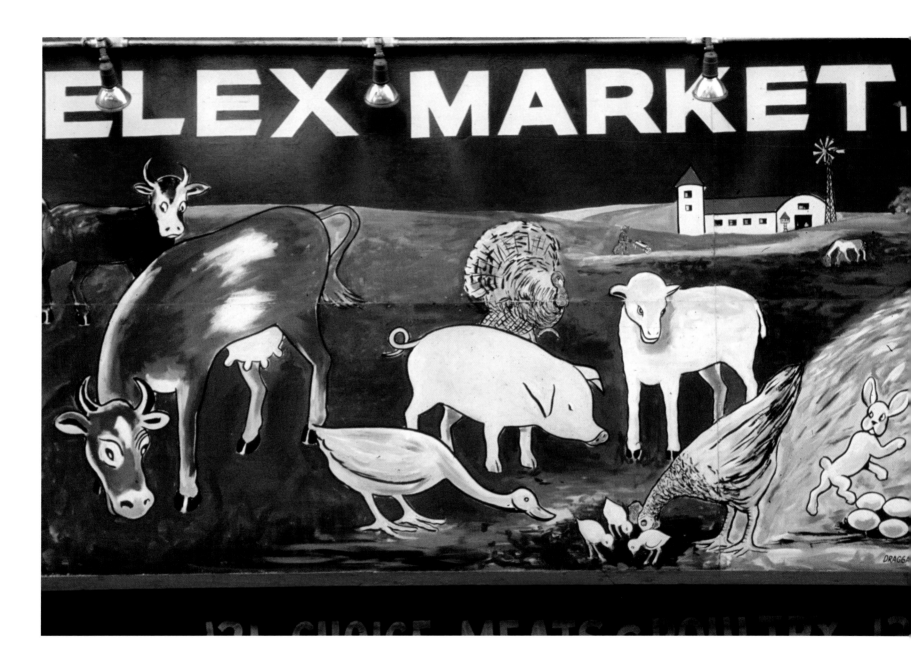

Meats and Poultry Market, Harlem, 1970 **209**

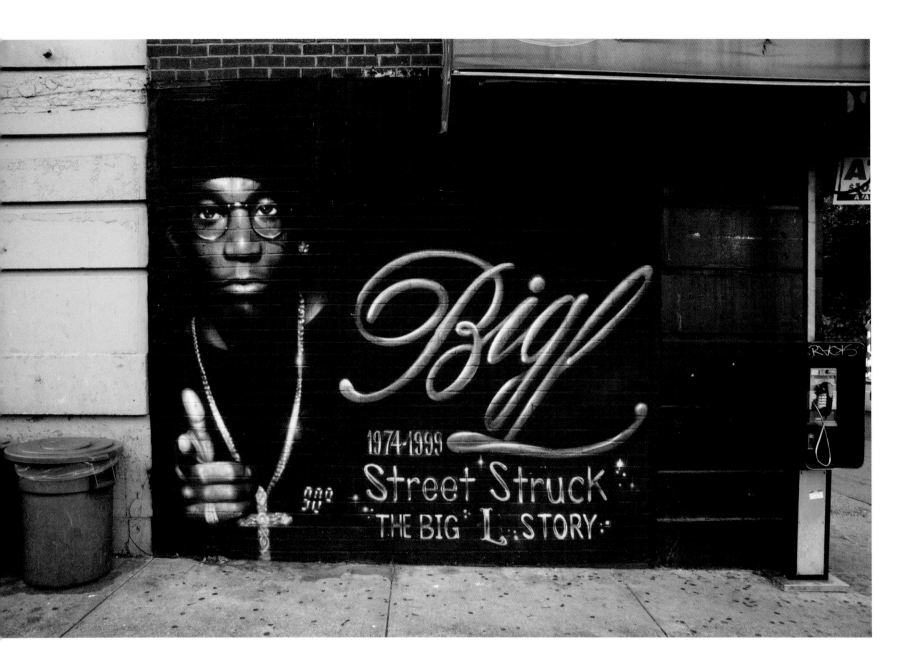

Memorial to Harlem rapper Big L, West 140th Street at Malcolm X Boulevard, Harlem, 2011

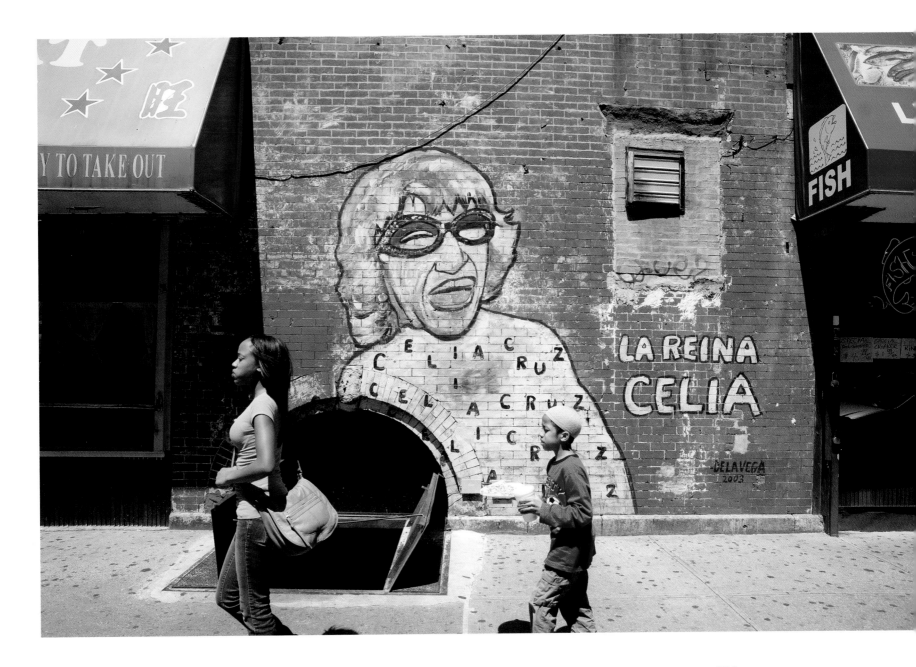

Celia Cruz memorial by Daniel de la Vega, 2003, East 103rd Street at Lexington Avenue, Harlem, 2011

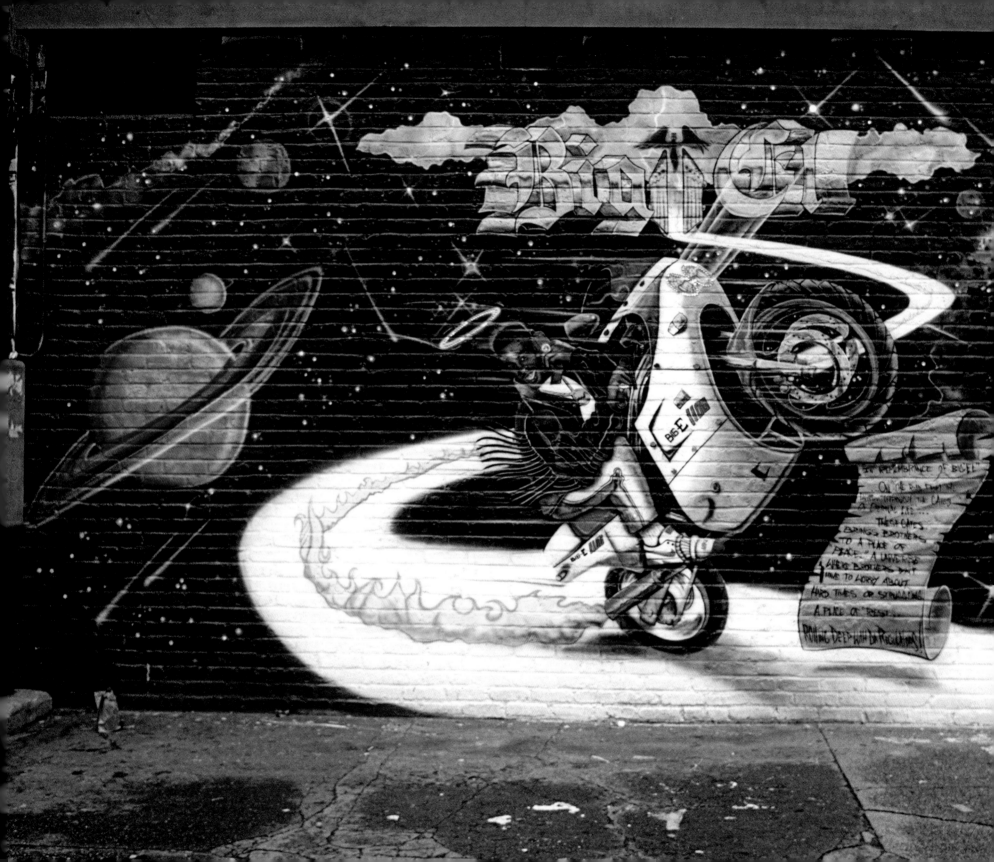

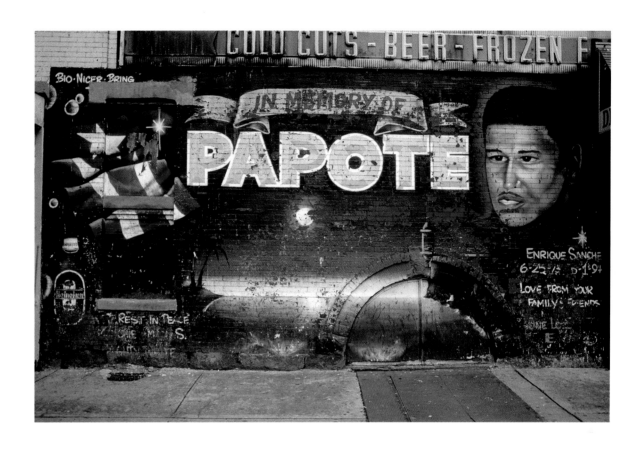

Papote's memorial was one of the longest surviving drug murals in Harlem, northwest corner of 115th Street at Lexington Avenue, 2007

Memorial mural, West 124th Street at Malcolm X Boulevard, Harlem, 1994

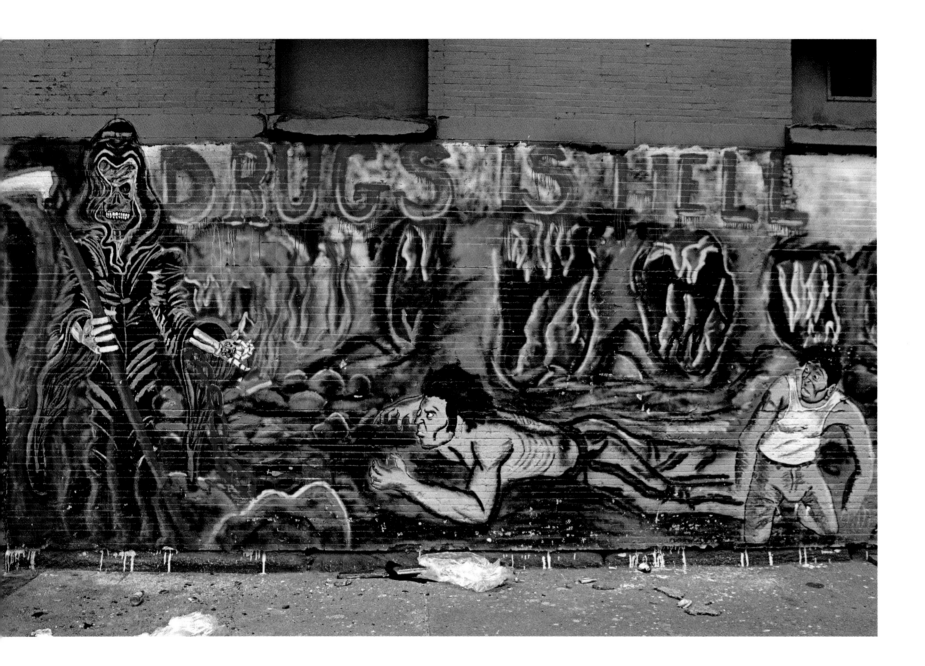

214 DRUGS IS HELL, *Second Avenue at East 118th Street, Harlem, 1991*

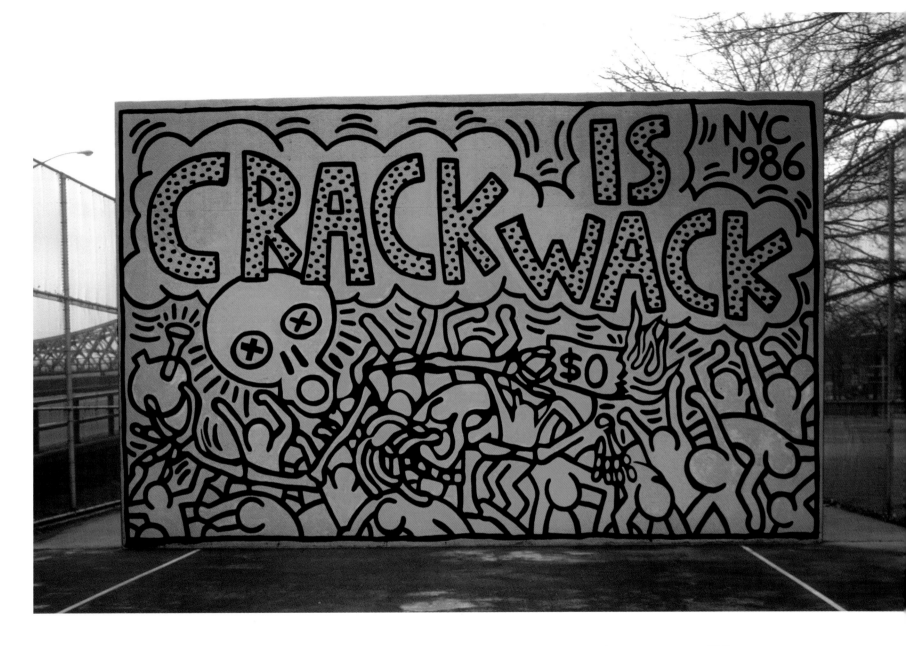

1986 crack mural by Keith Haring, Second Avenue at 128th Street, Harlem, 1991 **215**

CRACK MATA **CRACK KILLS**

ADVERTENCIA

Bajo la ley, cualquier apartamiento usado para la venta o manufactura de narcóticos podrá ser incautado y clausurado. Los inquilinos podrán ser desahuciados.

La Autoridad de la Vivienda hará cumplir vigorosamente la ley.

Usted ha sido advertido.

COMITE ANTI-NARCOTICOS

"IF YOU DEAL DRUGS, WE'LL PUT YOU OUT!"

—Emanuel P. Popolizio
Press Conference, May 25, 1988

2 Units in Projects Seized in Drug Cases

2 drug suspects & flats seized by the feds

The aim is to rid public housing of traffickers.

Marshals Seize Leases in Drug Raids

New York City Housing Authority Narcotics Task Force

 FAMOUS BLACK AMERICAN EDUCATORS

NABISCO BRANDS! **FAMOUS BLACK AMERICAN LEADERS**

FAMOUS BLACK AMERICAN ENTERTAINERS–PART 1

NABISCO BRANDS!

FAMOUS BLACK AMERICAN ENTERTAINERS–PART 2

NABISCO

NABISCO BRANDS! **BLACK AMERICAN GENERALS AND ADMIRALS**

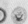

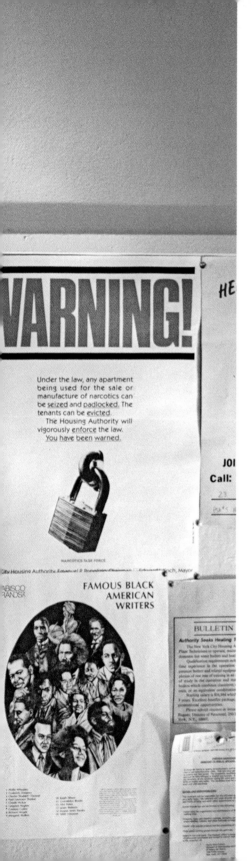

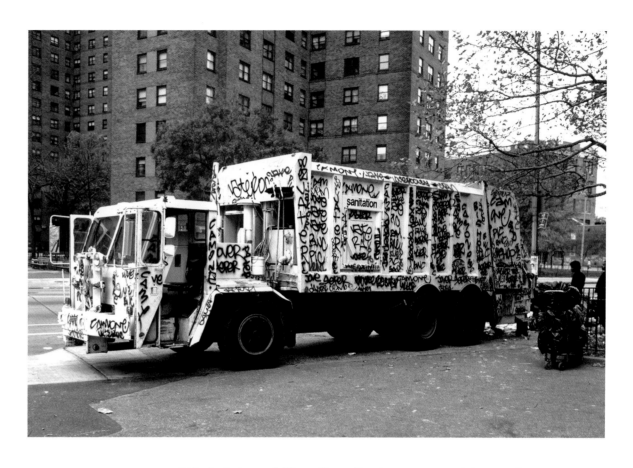

TOP *Sanitation truck, Wagner Houses, First Avenue at East 124th Street, Harlem, 1988*

OPPOSITE *Bulletin board, management office, Johnson Houses,*
East 115th Street at Lexington Avenue, Harlem, 1989

217

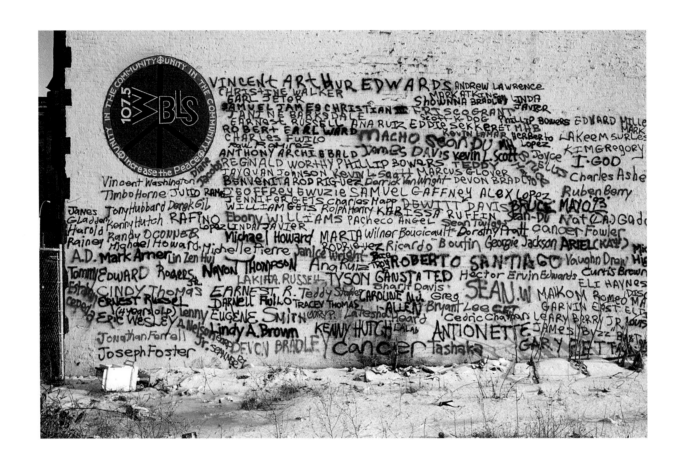

Increase the Peace Campaign, memorial wall with the names of victims of violence,
East 125th Street, between Park and Lexington Avenues, Harlem, 1994

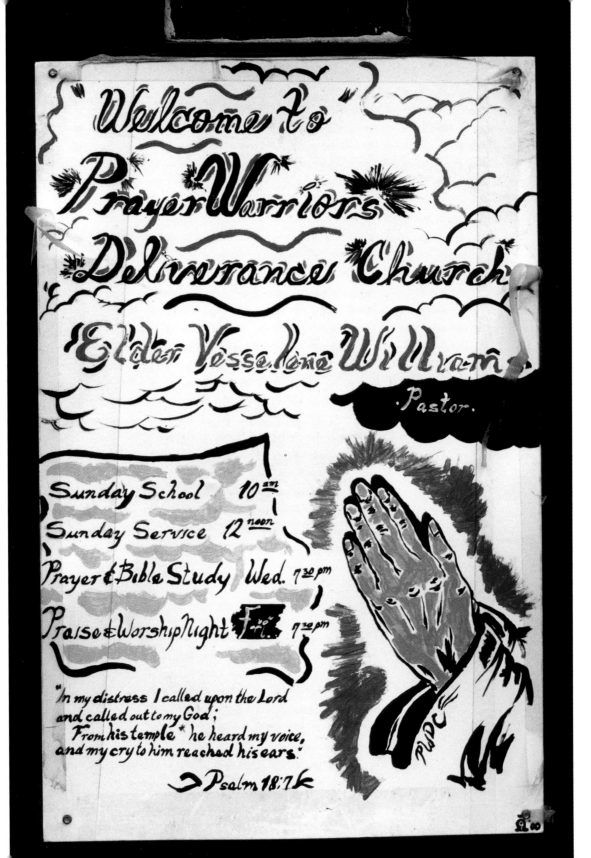

Storefront church sign, 2457 Frederick Douglass Boulevard, Harlem, 2001

219

220 *113 East 125th Street, Harlem, 1993*

113 East 125th Street, Harlem, 1994

222 *113 East 125th Street, Harlem, 1995*

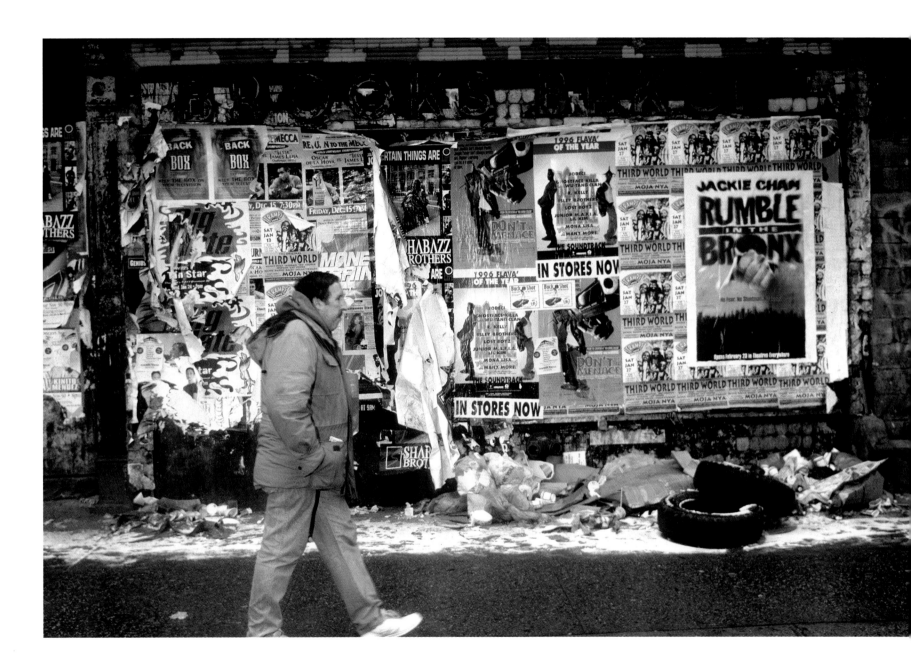

113 East 125th Street, Harlem, 1996 **223**

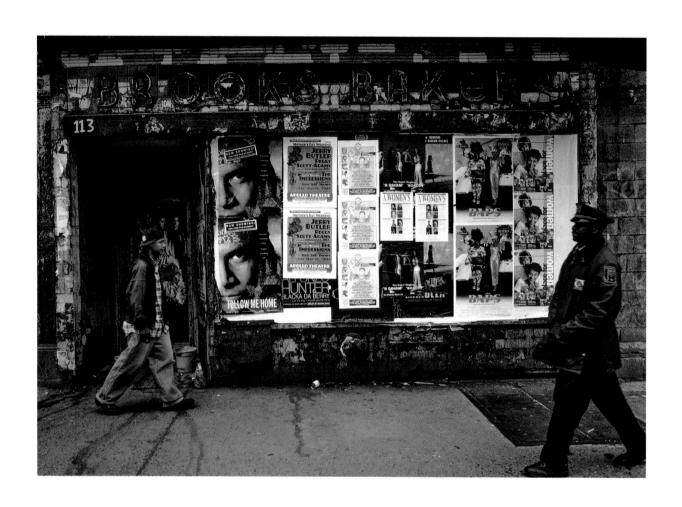

113 East 125th Street, Harlem, 1997

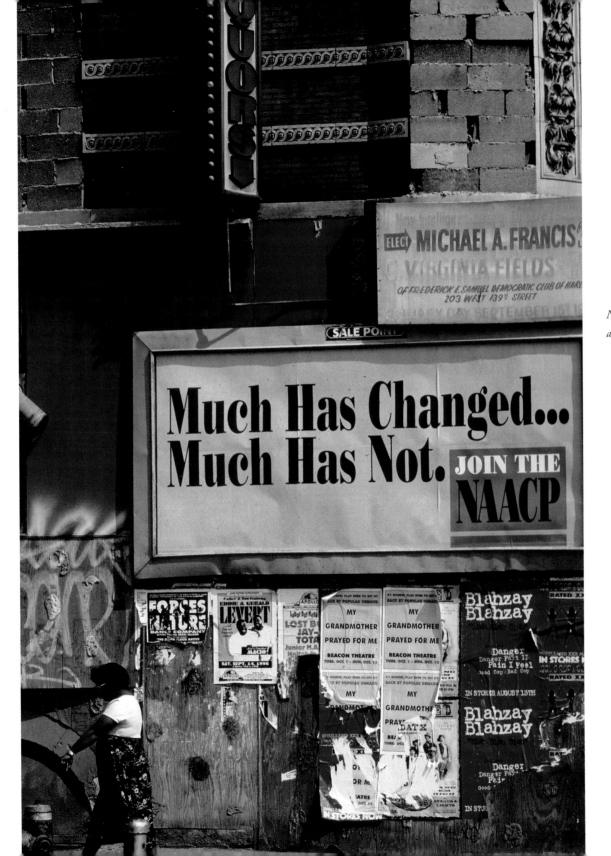

Northwest corner of Malcolm X Boulevard
at West 138th Street, Harlem, 1996

225

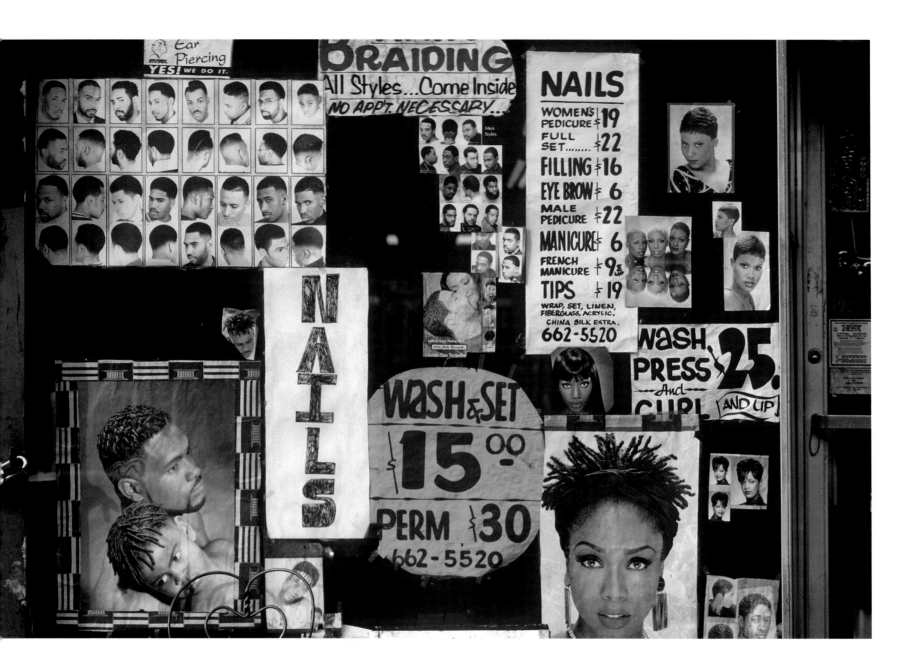

226 *357 West 125th Street, Harlem, 2001*

Angela Davis retro poster, Fifth Avenue at West 125th Street, Harlem, 2010

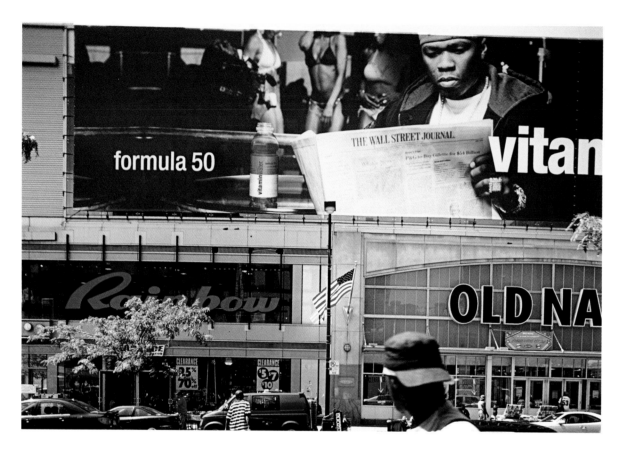

TOP *Advertising billboard featuring the rapper 50 Cent, West 125th Street by Frederick Douglass Boulevard, Harlem, 2005*

OPPOSITE *Mural of Martin Luther King Jr. by Estos, Frederick Douglass Boulevard at West 154th Street, Harlem, 2009*

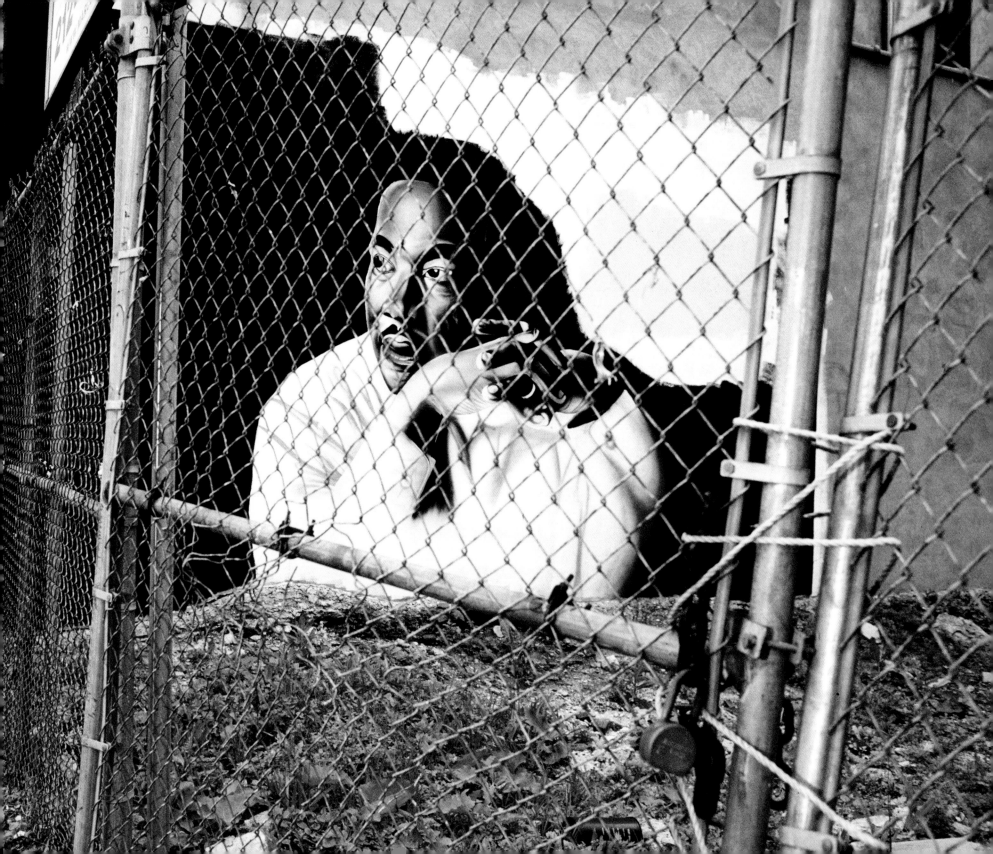

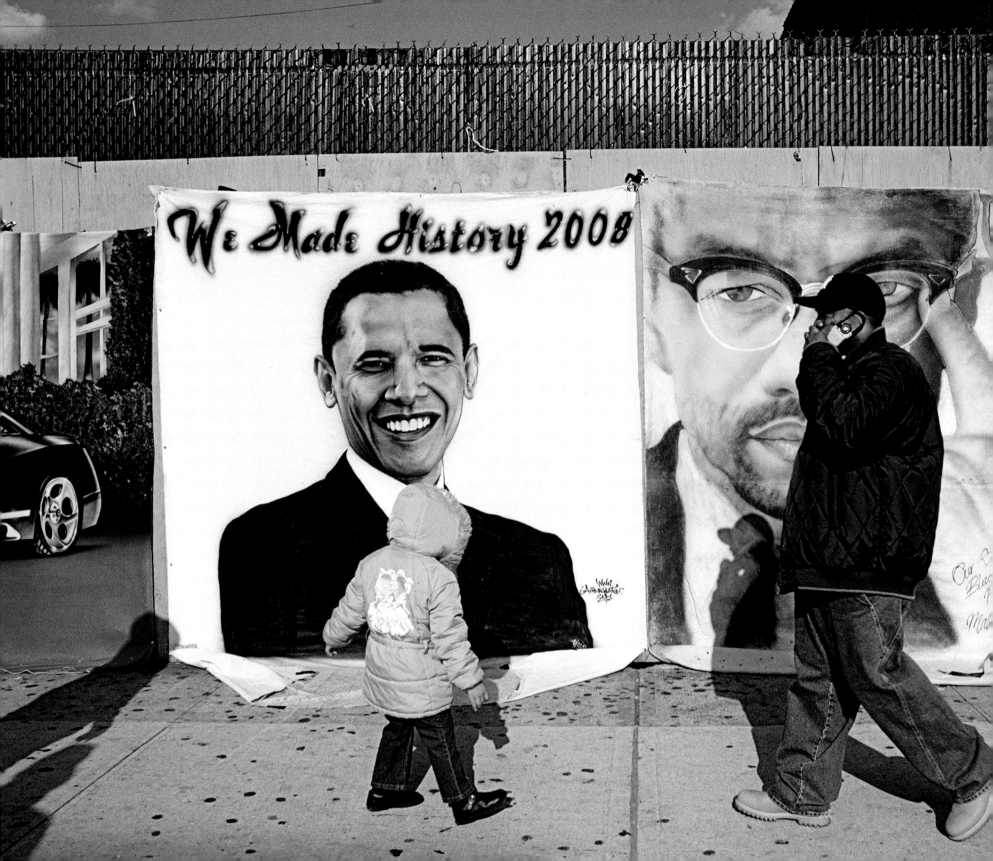

WE MADE HISTORY 2008, *253 West 125th Street, Harlem, 2009*

231

RELIGION

Raise your pants, raise your image…. Sagging, this style began in prison.

BULLETIN BOARD,
CROSSROADS BAPTIST CHURCH,
WEST 127TH STREET, 2011

BY 2010 BETWEEN THREE and four hundred churches existed in Harlem, scores of them without a fixed place of worship, renting space from established churches, meeting in hotel rooms, or conducting services in private homes. "Churches, churches and churches, Harlem seemed to be stuffed with religion," wrote Gordon Parks in his 2006 biography *A Hungry Heart*.[1]

On Sundays and religious holidays, the influence of religion in the community is particularly evident. Street evangelists preach and sing the gospel along the commercial streets and in subway cars. Choirs and ministers can be heard as one walks past churches where, according to Langston Hughes, "religion soars to a shout."[2] Beautifully dressed women and children walk to church, holding Bibles in their hands; Muslim women dressed in white sell bean pies on Malcolm X Boulevard. Many of the larger churches, such as the historically important Mother AME Zion Church, encourage

OPPOSITE *Stained-glass window with portrait of Daddy Grace, founder of United House for All People, West 124th Street at Frederick Douglass Boulevard, Harlem, 2000*

233

tourists to attend the services and donate to the church. Tourists line up on the sidewalk or ride in tour buses to hear gospel singing at some of Harlem's most famous churches. The most adventurous among them walk along the boulevards in search of a great choir.

During the great migration to Harlem only the largest and most established black congregations were wealthy enough to build their own churches. Notable among these landmark houses of worship were Saint Philip's Episcopal Church built in 1910 and the Abyssinian Baptist Church erected in 1923. Other congregations moved into buildings once occupied by other denominations or by synagogues. The majority of Harlem's congregations are small and worship in storefronts, tenements, and brownstones. Many such churches exist only for a year or two. In 1926, sociologist Ira Reid counted 140 churches in 150 blocks of Harlem, two-thirds of which he classified as being in storefronts.[3]

The Catholic Church retained a presence in Harlem even after its original Euro-American congregants moved to the outer boroughs or suburbs, catering, for example, to the many West Indians who were part of the great migration to Harlem. Indeed, by 1929 an estimated five thousand blacks attended Catholic churches.[4]

Harlem is famous, in part, because of its powerful ministers. In the late 1930s and early 1940s Adam Clayton Powell Jr., minister of the Abyssinian Baptist Church on West 136th Street, led successful boycotts of Harlem stores and private bus companies that discriminated against blacks by refusing to hire them. The motto of the boycotters was "Don't buy where you can't work." Elected to Congress in 1945, colorful and controversial, Powell represented Harlem in Washington for more than two decades.[5]

Another of these powerful ministers was Father Divine, who was, according

to Jervis Anderson, "a superstar of grass-roots religion" and one of the "great cult leaders of Harlem during the Depression."[6] Accepted by his followers as the living God, Father Divine, the evangelist of positive thinking and self-reliance, advocated for peace, a minimum wage, and the abolition of capital punishment. Many of his followers, particularly those in California, were white. He arranged free banquets for the poor, which he called Holy Communion, and organized stores where people could buy basic necessities at reduced prices. He also operated a number of inexpensive hotels, which he named Heavens, where people could stay for a week for two dollars. Father Divine gave his disciples "heavenly" names such as Hot Sunshine, Bright Star, Tree of Life, Glorious Illumination, and Precious Lamb.

Though Father Divine left no trace of his years in the neighborhood, during the Depression his stores were everywhere, advertising meals for fifteen cents, a shoeshine for three cents, coal and fresh vegetables, and all of them accompanied with a wish for peace. But in 1942 he moved the headquarters of his mission to Philadelphia, declaring that city henceforth the capital of the world.[7]

Malcolm X, a spokesperson for the Nation of Islam, was based at Harlem Temple Number 7 until he was removed in 1964 by Elijah Muhammad (for criticizing Muhammad's fathering of children with several of his teenage secretaries). Malcolm made many memorable speeches in Harlem including the celebrated "The House Negroes and the Field Negroes," which he delivered in 1961 at Michaux National Memorial African Bookstore on Lenox Avenue.[8] In 1965 Malcolm X was assassinated at the Audubon Ballroom in West Harlem, and Temple Number 7 was dynamited. Five years later, the temple was rebuilt and named after Malcolm X.[9]

In 2012 Harlem ministers no longer have the national recognition of an Adam Clayton Powell Jr. or Malcolm X. When Googling "Harlem ministers," Bishop

James D. Manning of the Blood of Jesus ATLAH World Missionary Church is first among those whose names come up. Manning, an ex-convict-turned-minister, called President Obama "an emissary of the devil," and Obama's mother "white trash." A sign outside his church on Malcolm X Boulevard later read: "Jesus is true: Obama is evil. He used the Black vote to Uncle Tom for Wall Street. I speak love & truth." Bishop James D. Manning, with his anti-Obama rants and calls to arrest Mayor Michael Bloomberg, his problems with the law, and his call for rent boycotts, echoes the career of Adam Clayton Powell Jr.[10] The signs on his church on Malcolm X Boulevard have become a tourist attraction and are constantly photographed.

In *Black Manhattan* (1930) James Weldon Johnson described churches operating in former storefronts and private residences as "ephemeral and nomadic."[11] This situation holds true today, as I have seen a number of them close down. The West Indian Prayer Warriors Deliverance Church and Little Mount Moriah Baptist Church are both gone. Baptist Temple Church, a former Hungarian synagogue, has been demolished.[12] In 2007, the Ark of Safety Fellowship Church moved from its storefront on Morningside Avenue on the corner of West 111th Street, leaving behind a sign saying "Notice: Church Closed/Moved. No more free food. This is not a drop off location for clothes and other items. No Trespassing."

I am not aware of any new storefront churches opening in Harlem since 2010. Churches where the congregation owns the building have a better chance to survive. For example, the First Haitian Church, with its painting of paradise above the altar, was still functioning in 2012. Samuel's Temple on East 125th Street, in an effort to raise funds, added commercial activities as a supplement to its religious ones. The church now sports an electronic message board announcing church news as well as offering Wi-Fi for a dollar to passersby. Church leaders also installed a cash machine at the entrance.

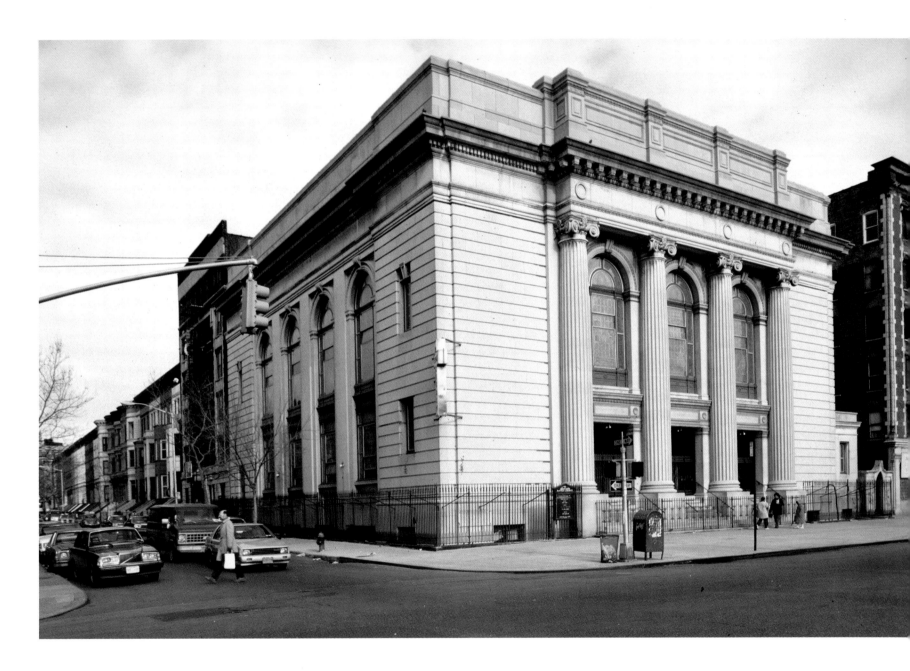

Former Temple Israel, now Mount Olivet Baptist Church, northwest corner of West 120th Street at Malcolm X Boulevard, Harlem, 1987 **237**

Salvation and Deliverance Church, detail, 37 West 116th Street Harlem, 2006

Christ Temple, detail, 405 Malcolm X Boulevard, Harlem, 2007 **239**

Christ Temple, 405 Malcolm X Boulevard, Harlem, 2012

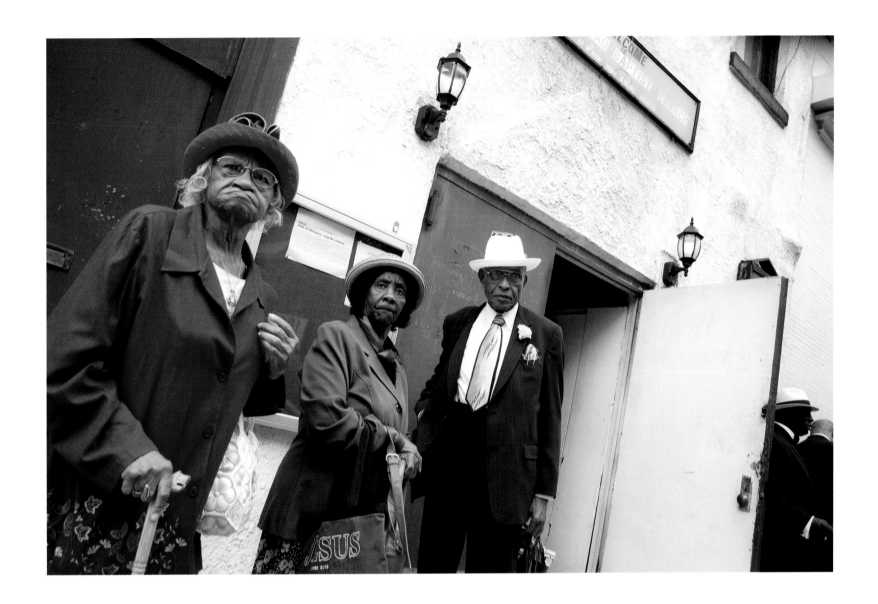

Crossroads Baptist Church, 104 West 127th Street, Harlem, 2010 \textbf{241}

Muslims praying outside the Masjid Aqsa Mosque, Frederick Douglass Boulevard south of West 116th Street, Harlem, 2012

*Malcolm Shabazz Mosque,
southwest corner of West
116th Street at Malcolm X
Boulevard, Harlem, 1983*

243

Long-gone Little Mount Moriah Baptist Church, 2553 Frederick Douglass Boulevard, Harlem, 1981

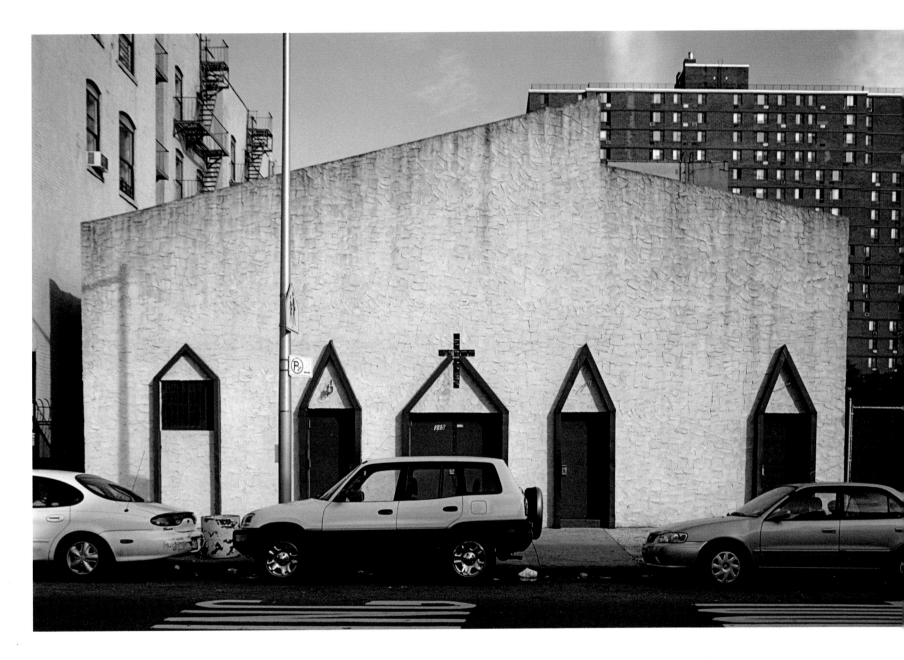

First Haitian Baptist Church, 315 West 141st Street, Harlem, 2007

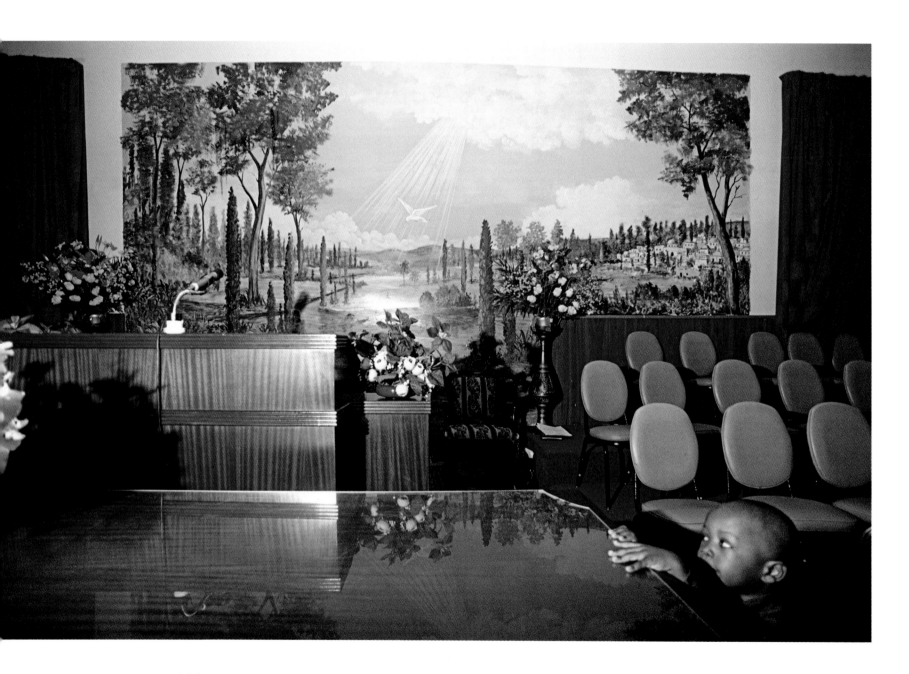

Sanctuary featuring a painting of paradise, First Haitian Baptist Church, 315 West 141st Street, Harlem, 2002

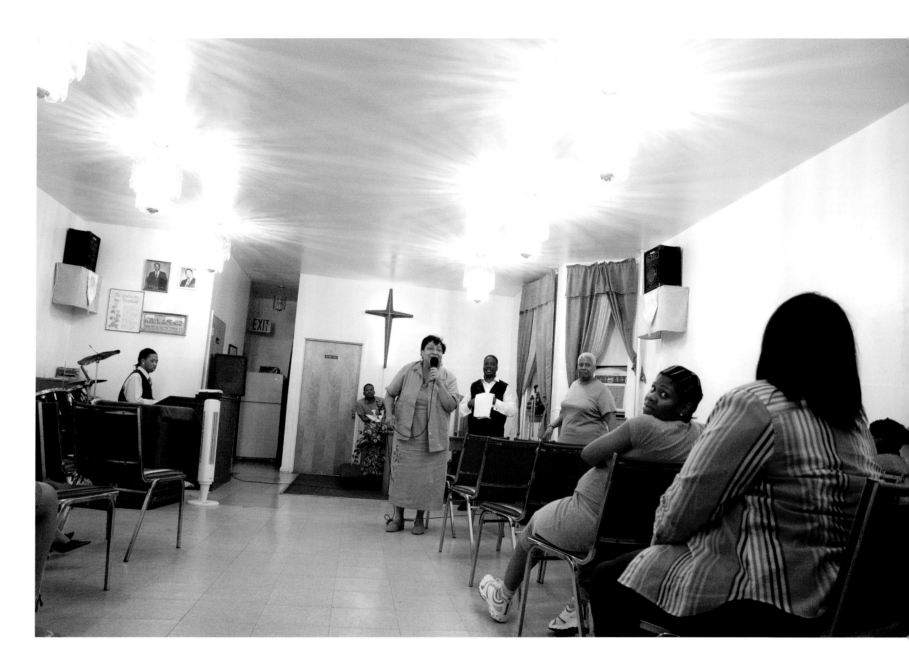

Night service, Emmanuel Church of God in Christ. This church survives in the middle of Harlem's restaurant row, southeast corner of West 118th Street at Frederick Douglass Boulevard, Harlem, 2010

247

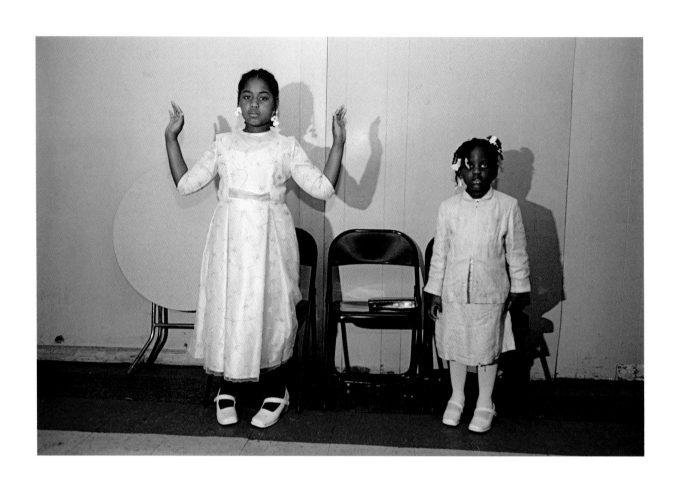

Williams sisters, Prayer Warriors Deliverance Church, 2451 Frederick Douglass Boulevard, Harlem, 2002

Minister Tyrone Max, Samuel's Temple,
75 East 125th Street, Harlem, 2010

249

Protesting Obama's visit to Harlem, Reverend
James D. Manning, Malcolm X Boulevard
at West 124th Street, Harlem, 2011

Reverend Thomas D. Johnson, Canaan Baptist
Church, 132 West 116th Street, Harlem, 2008

Reverend Manning's Atlah Church sign, West 123rd Street at Malcolm X Boulevard, Harlem, 2010

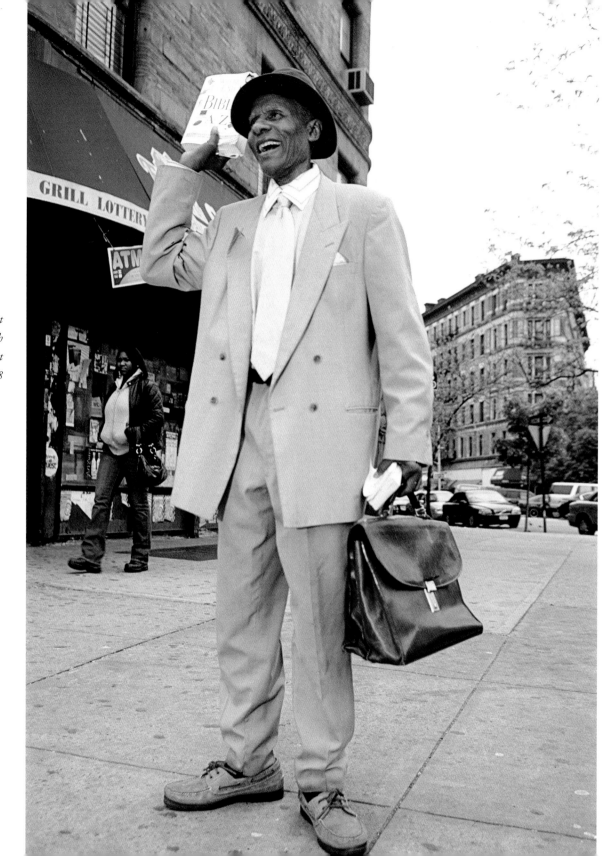

Pierre Gaspar, street evangelist widely known as "the Hallelujah Man," Saint Nicholas Avenue at West 116th Street, Harlem, 2008

252

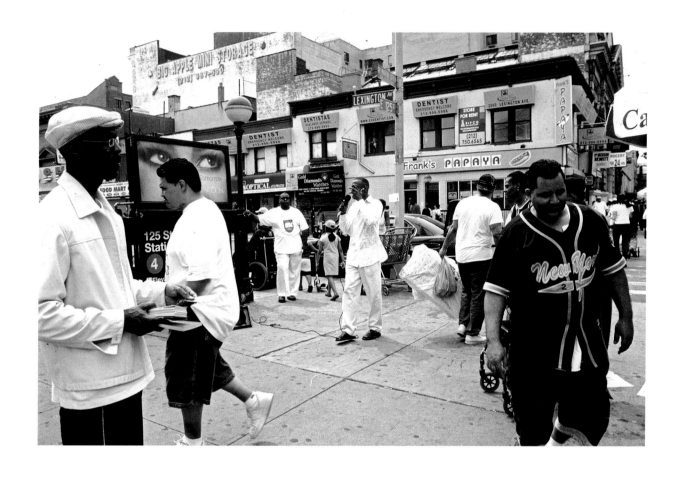

Southeast corner of East 125th Street at Lexington Avenue, Harlem, 2007

PARADES, CELEBRATIONS, AND COMMEMORATIONS

Every window that you looked at, people's heads were out, to see the Marcus Garvey parade. Most of them wanted to see Marcus Garvey and he was very well decorated, his hats, and the feathers, but he drove always in his automobile, sitting back.

<div align="right">FRANCES WARNER, 2001</div>

ALONG HARLEM'S GRAND BOULEVARDS, the neighborhood celebrated holidays and military victories, mourned the dead, and rioted during bad times.[1] Harlem celebrated Armistice Day with a massive parade in 1918. Marcus Garvey, the "Provisional Emperor of Africa," and his African Unity parade in 1920 was a phenomenal event. In 1938, residents celebrated boxer Joe Louis's defeat of German Max Schmeling in his quest for the world heavy-weight crown. In 1935, 1943, and 1964 Harlem experienced widespread rioting over police brutality, housing conditions, and unemployment.

Photographs and television documentaries about Harlem parades convinced me to attend the African American Day Parade along Adam Clayton Powell Jr. Boulevard. The event attracts groups as diverse as the Masons, the Black Panther Party, and members of the hospital unions. I saw Elks and

OPPOSITE *Puerto Rican Parade Day, 163 East 116th Street, Harlem, 2007*

Masons marching past, wearing black suits with aprons similar to those in fashion seventy years ago, like those that can be seen in *Harlem on My Mind* (the companion catalog to a controversial 1969 Met exhibition on Harlem's history). The Universal Negro Improvement Association flag was very much in evidence and portraits of Marcus Garvey were on banners carried in the parade.

Though the African American Day Parade is billed as the "largest black parade in America," great older parades were extravagant, attracted larger numbers of people, and were louder, and the crowd appeared to be in a state of frenzy. One of the best photographs of a Harlem parade is *Elks Parade, 1939* by Jack Manning, showing a crowded street, families on balconies, people sitting on fire escapes, and even men on the roofs of apartment buildings.[2] Lacking similarly flamboyant personalities, the nostalgic African American parades of the twenty-first century resemble pleasant neighborhood gatherings. They are not as colorful and do not take place as frequently as in the years before 1930 when, according to James Weldon Johnson, "No Sunday passes without several parades."

One of the most important public events in Harlem is the yearly New York City Marathon, which for a few hours brings tens of thousands of Caucasians from all over the world to an almost completely black and Latino section of Fifth Avenue. The crowd lines the streets to cheer the tired runners as they approach the end of the race shouting "Go my brothers; be strong. Let's go, let's go, let's go," or "Go daddy go," when the runner is middle aged. Every other block, people play music and give water and bananas to the runners always encouraging them to keep going.

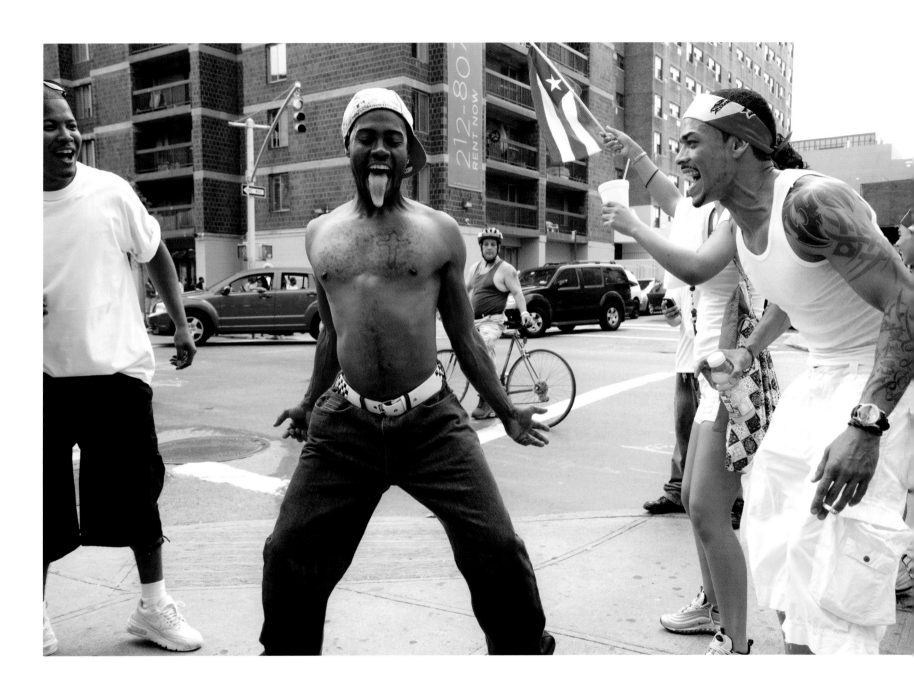

Puerto Rican Parade Day, Lexington Avenue at East 122nd Street, Harlem, 2010 **257**

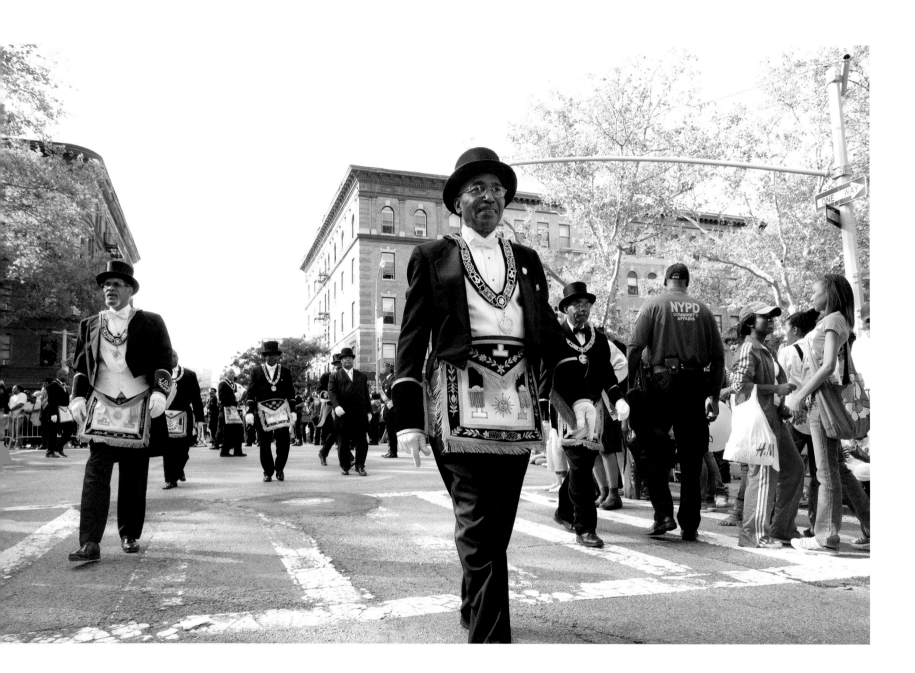

258 *Brotherhood of Grand Lodges, State of New York, African American Day Parade, West*
136th Street at Adam Clayton Powell Jr. Boulevard, Harlem, 2010

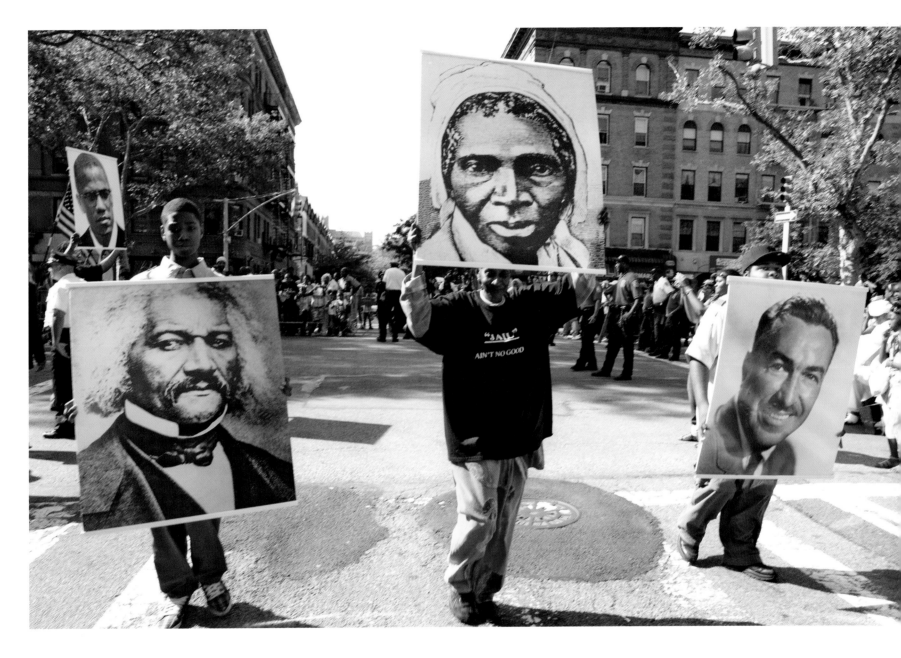

Members of the Malcolm Shabazz Mosque, African American Day Parade, West 136th **259**
Street, at Adam Clayton Powell Jr. Boulevard, Harlem, 2010

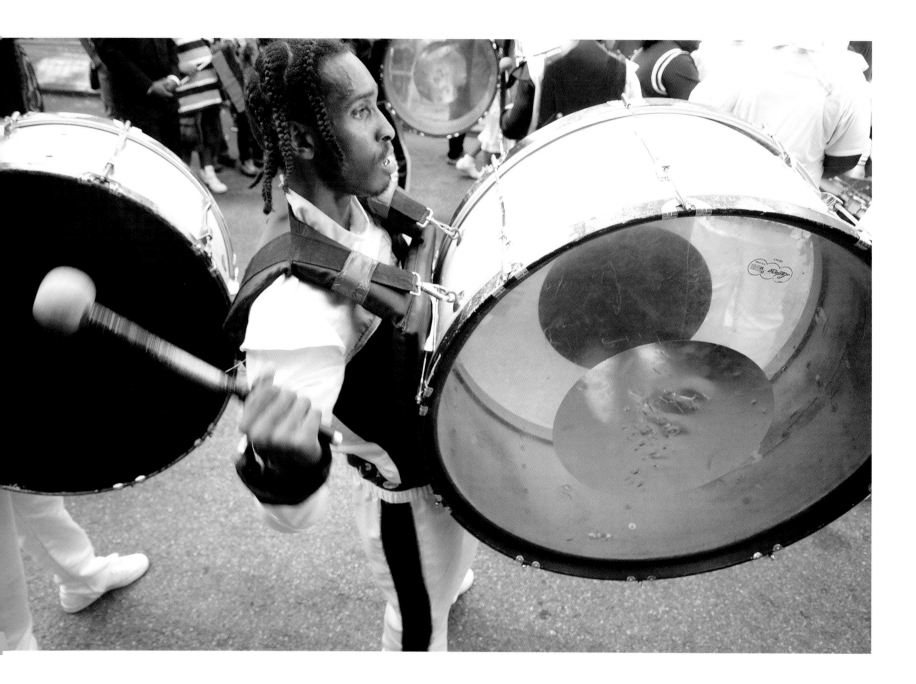

African American Day Parade, West 136th Street near Malcolm X Boulevard, Harlem, 2012

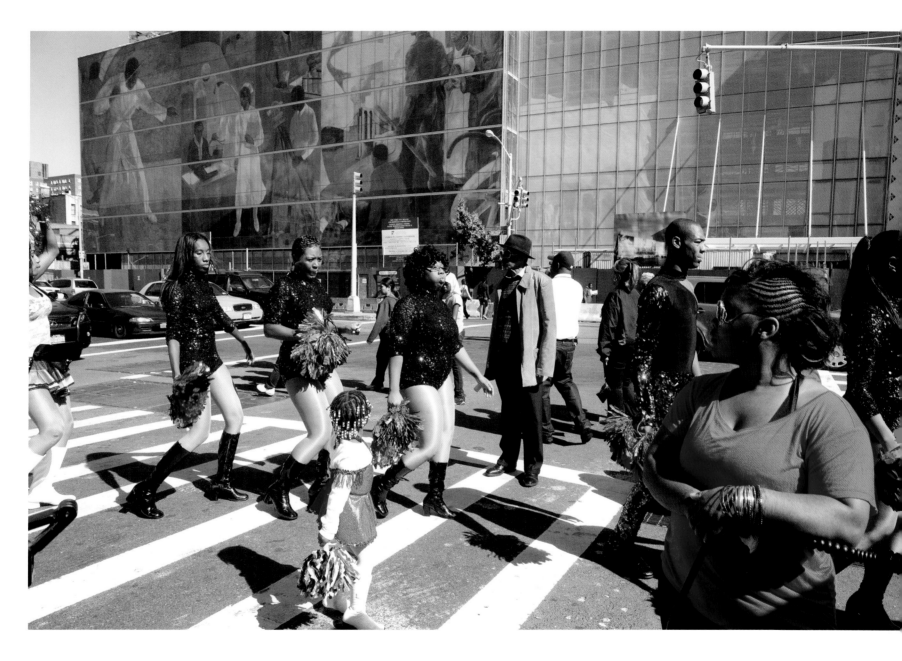

End of Harlem African American Day Parade in front of Harlem Hospital, Malcolm X Boulevard at West 136th Street, Harlem, 2011 **261**

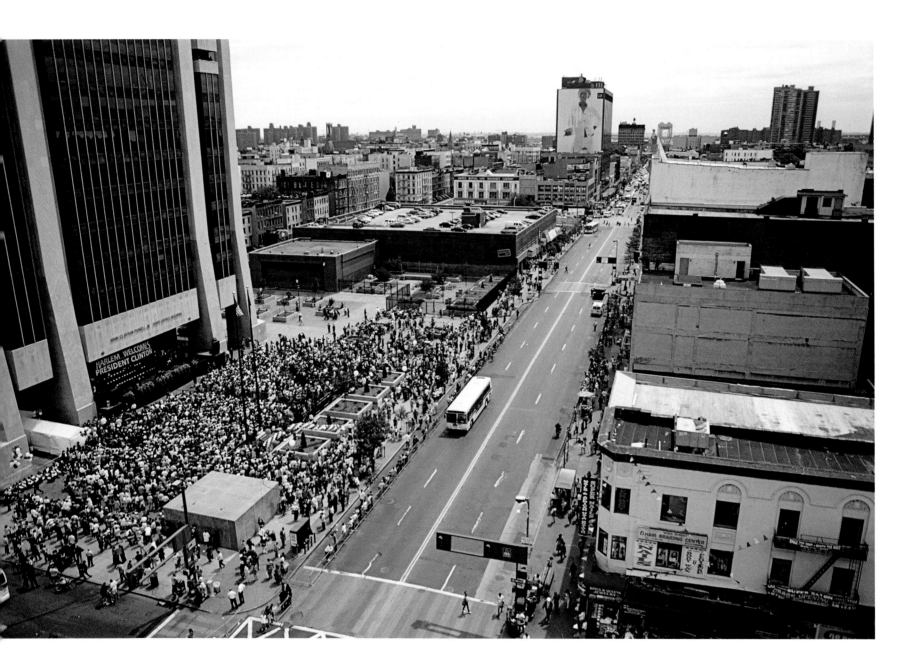

Harlem welcomes Bill Clinton, Adam Clayton Powell Jr. Boulevard at West 125th Street, Harlem, 2001

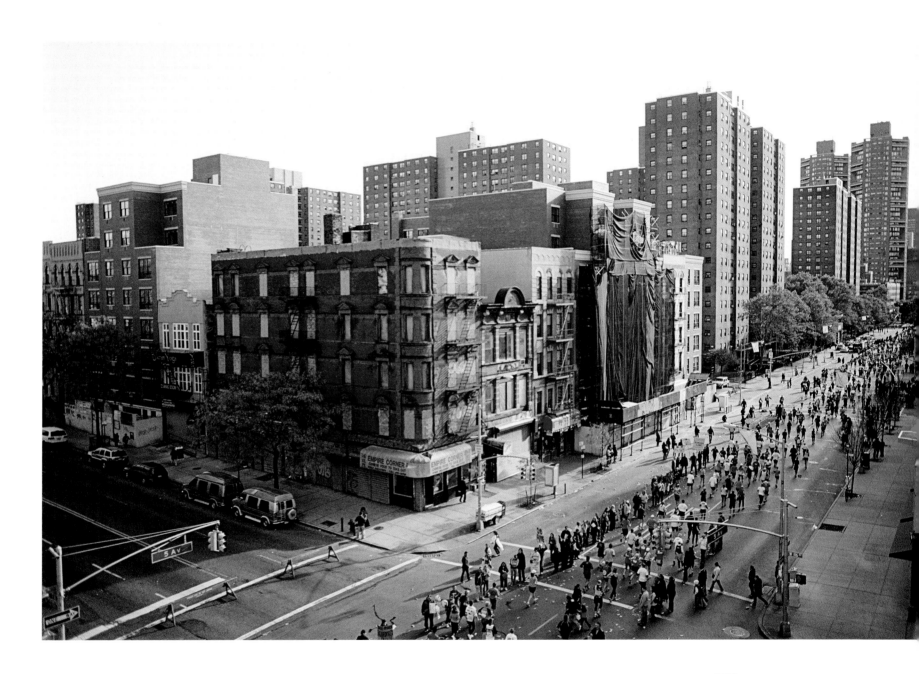

New York City Marathon, 2008, view south along Fifth Avenue from 116th Street, Harlem, 2008

New York City Marathon entering Harlem, Madison Avenue Bridge, 2010

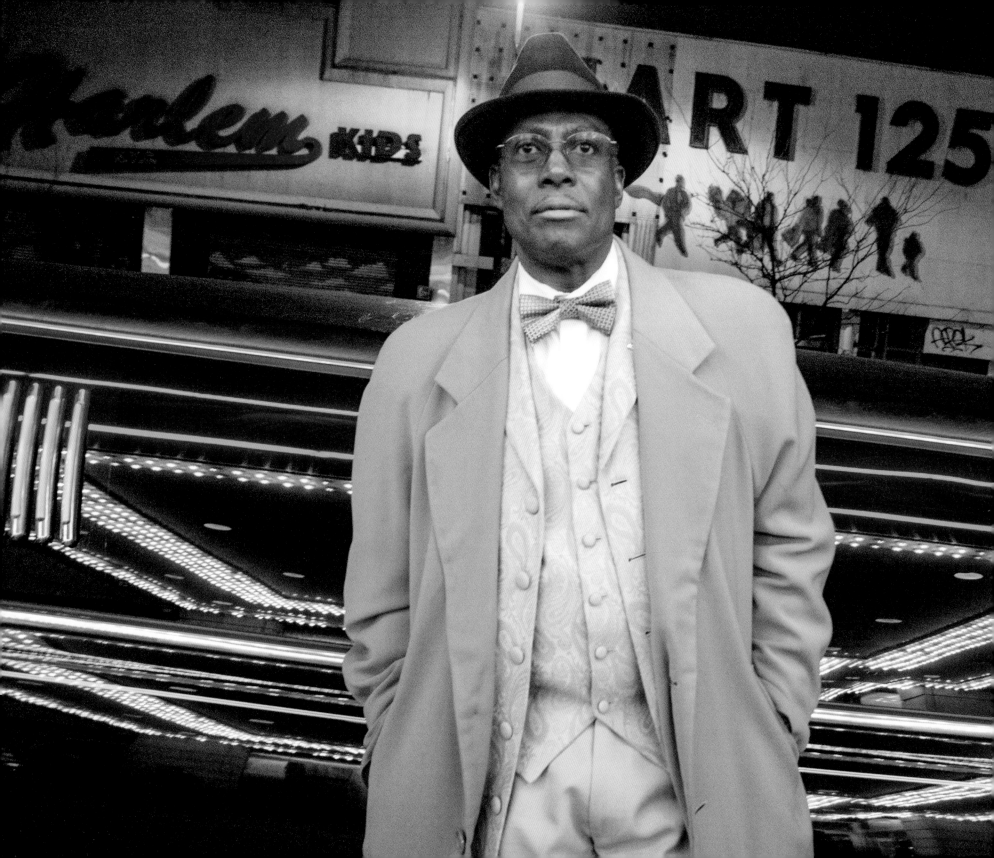

"WE PUT OUR OWN SPIN ON STYLE"

Harlem Fashions

Although our American journey has been anything but relaxed, our style has served both as a survival skill and a means of celebration.

LLOYD BOSTON, FASHION CONSULTANT, 1998

PEOPLE GO TO HARLEM TO BE SEEN, to let others know what you stand for, and to have fun. Along Harlem boulevards aggressive black youths pass by curious tourists and handicapped elderly visitors. Women wearing expressive hair and clothing styles, tourists and locals of all classes and races, stroll along the crowded sidewalks of 125th Street, 116th Street, and Malcolm X Boulevard. Not age, not physical attractiveness, not even illness gets in the way of dressing up and acting up. In New York City, a world capital of style, fashion finds its most democratic expression in Harlem.

Among the fashions encountered are tenant farmer, hip-hop, civil rights advocate, Rastafarian, pimp, black Muslim, black Jew, and African national dresses such as Malian, Senegalese, and others. Elderly men wearing suits and hats walk by young males listening to music, pants sagging. The

OPPOSITE *Dapper Sam Page, limo driver, outside the Apollo Theater, 253 West 125th Street, Harlem, 2011*

267

relaxed elegance of adults promenading along the avenues contrasts with the youngsters' aggressive and open sexuality. Elderly women dressed for church walk slowly wearing floppy hats and brightly colored dresses. On t-shirts and jackets young people celebrate fabulous rappers seldom seen in Harlem. Dressed for the occasion, those unable to walk roll in their wheelchairs. Occasionally a woman strolls by wearing a white gardenia in her hair in the style of Billie Holiday. Older men with long hair dress to look like Frederick Douglass and on the anniversary of his death, Michael Jackson impersonators stand by the Apollo Theater.

In hip-hop videos of the neighborhood, rappers are depicted at night wearing obligatory symbols: gold chains and rings. They flash wads of bills, show stacks of cocaine, and sometimes are shown holding guns. Their backdrops consist of corner stores, cyclone fences, and police cars and ambulances with lights flashing and sirens blaring. For shooting locations, artists select tenement roofs or badly lit alleys where they are shown with their "homies," walking along, dodging garbage cans. They rap "for real" in front of all-night convenience stores, in the lobbies of massive public housing projects, or sitting on the stoops of townhouses. Hip-hop videos depict the rappers' own neighborhoods. Scenes of historic and gentrified Harlem are rare.[1]

Python body, Marilyn's New York, 541 Malcolm X Boulevard, Harlem, 2012 **269**

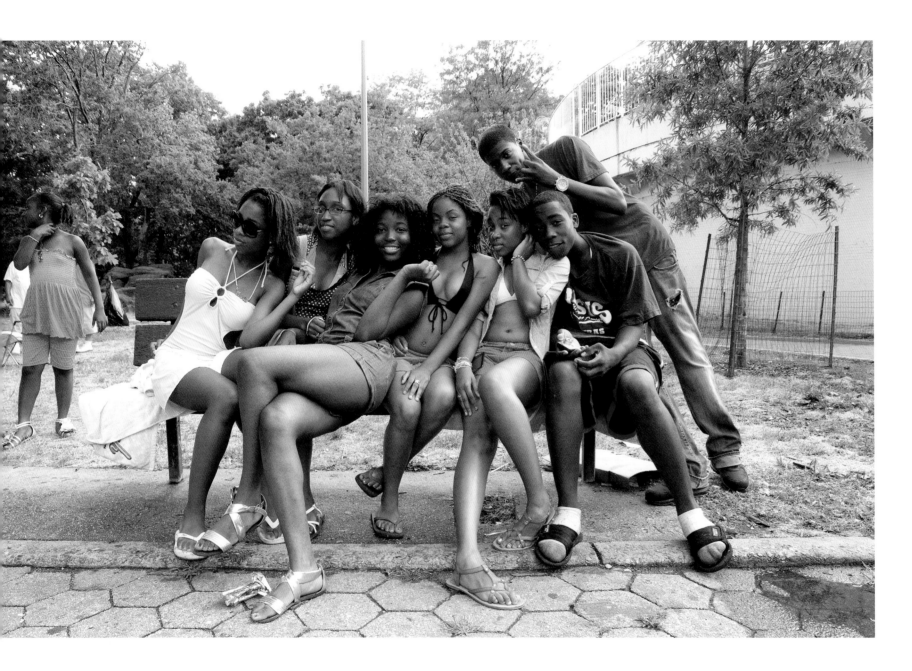

Deijah and family, Marcus Garvey Park, East 124th Street at Fifth Avenue, Harlem, 2010

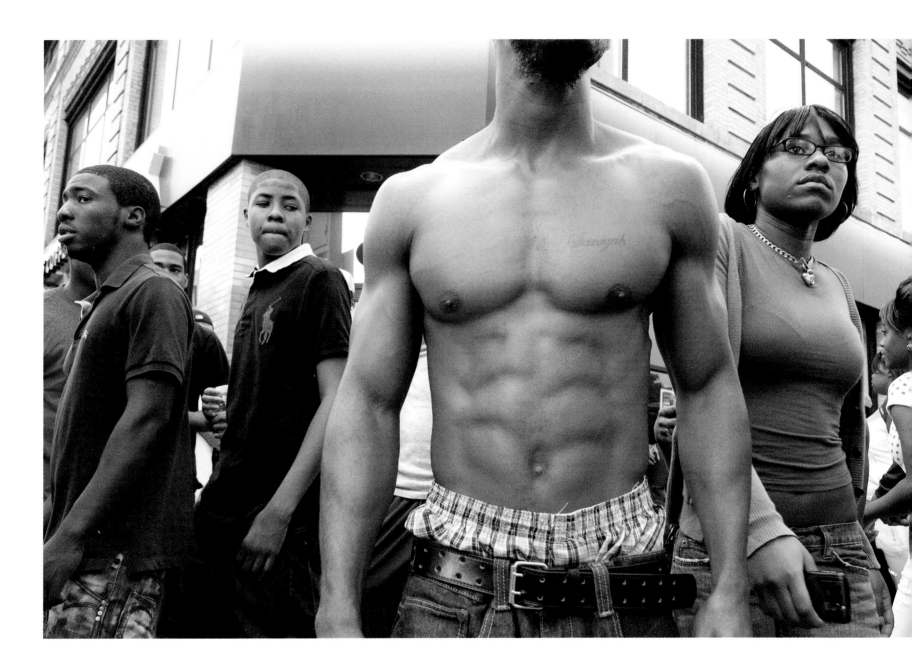

West 125th Street at Adam Clayton Powell Jr. Boulevard, Harlem, 2010 **271**

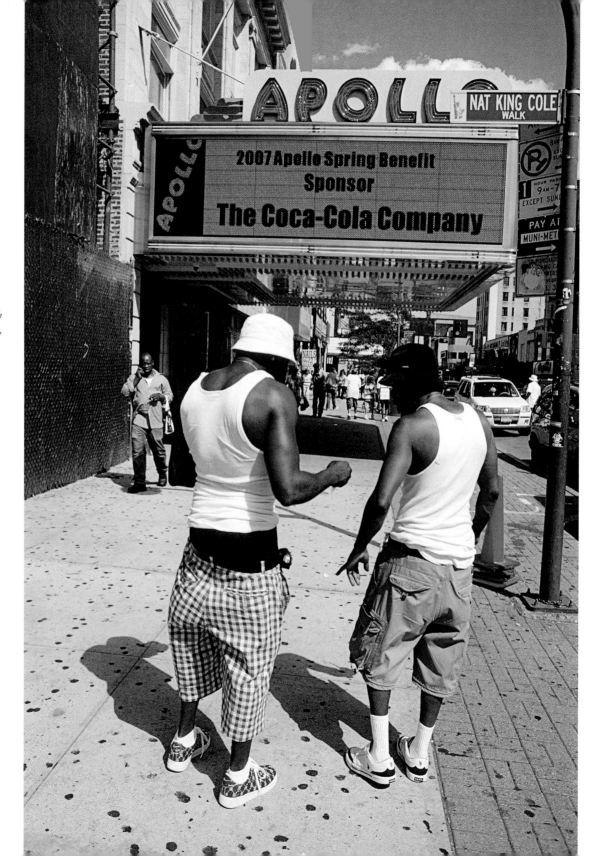

"Sagging"; view east along West 125th Street from 251 West, Harlem, 2007

272

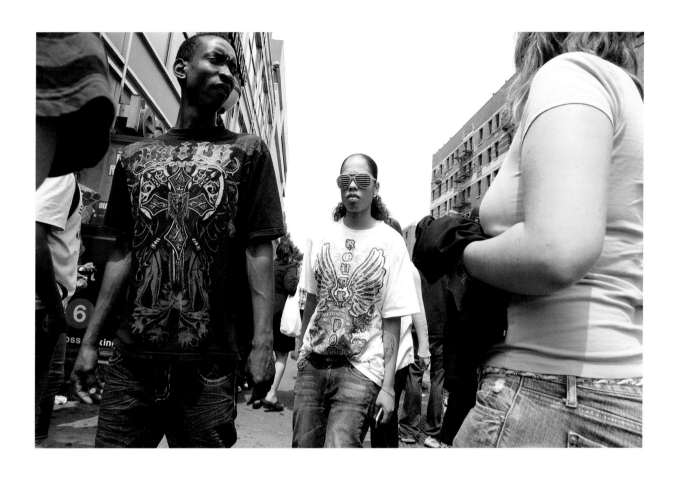

Lexington Avenue at 125th Street, Harlem, 2010

274 *Park Avenue at East 125th Street, Harlem*

The southern farmer look, East 123th Street at Lexington Avenue, Harlem, 2010 **275**

Man wearing a Jay-Z t-shirt, 253 West 125th Street, Harlem, 2011

Eddie, originally from Selma, Alabama,
Frederick Douglass Boulevard at
West 118th Street, Harlem, 1990

277

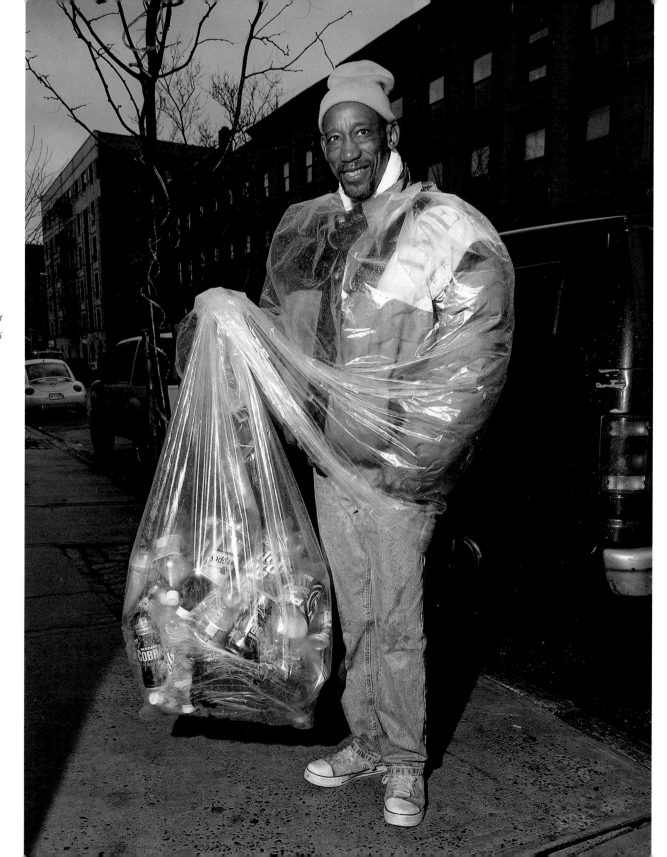

*"Bullet," East 126th Street at
Madison Avenue, Harlem, 2006*

125th Street at Adam Clayton Powell Jr. Boulevard, Harlem, 2005

Rasheedah, West 135th Street near Adam
Clayton Powell Jr. Boulevard, Harlem, 2008

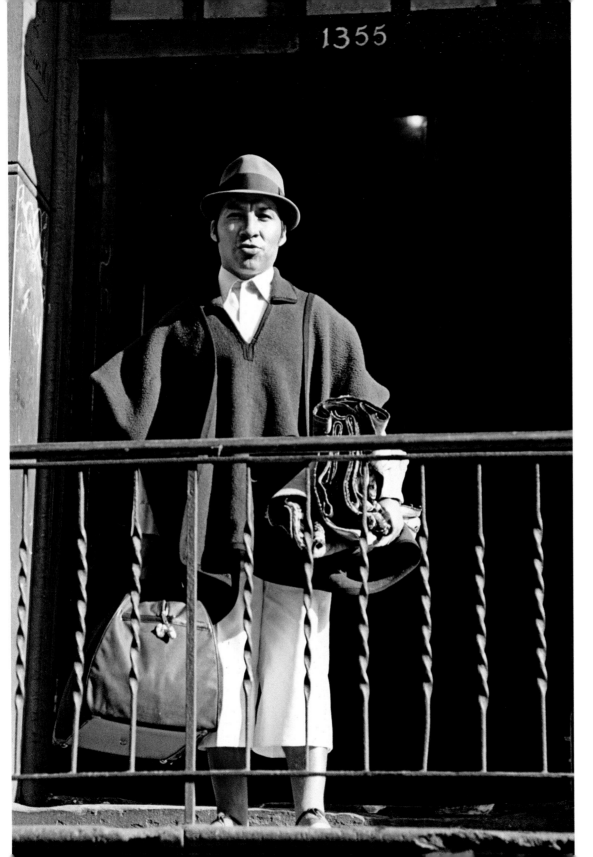

Bolivian Indian selling rugs, 1355 Park Avenue, Harlem, 1970

281

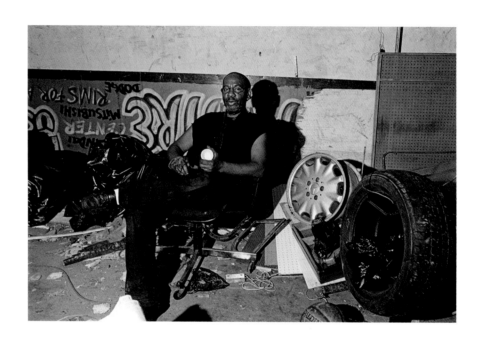

Frank Suarez, 2164 Frederick Douglass Boulevard, tire shop, now gone, Harlem, 2008

Ninety-year-old Jeanette listening to Barack Obama give the inaugural address, Senior Housing, 2177 Frederick Douglass Boulevard, Harlem, 2009

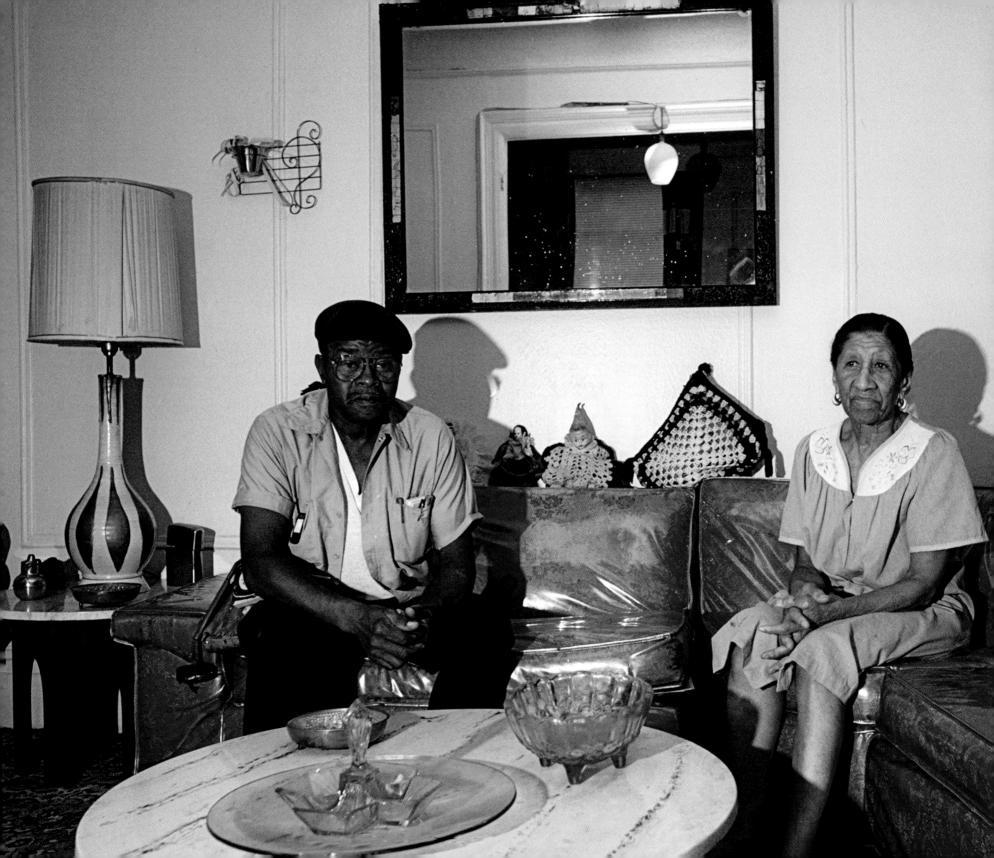

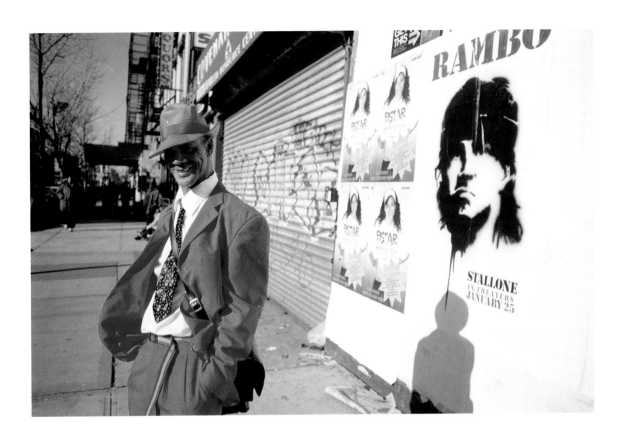

TOP *Mr. Butterfly Pin, a bulldozer operator originally
from Jamaica, 71 East 125th Street, Harlem, 2007*

OPPOSITE *Sam, building superintendent, with resident, 274 West 140th Street, Harlem, 1995*

285

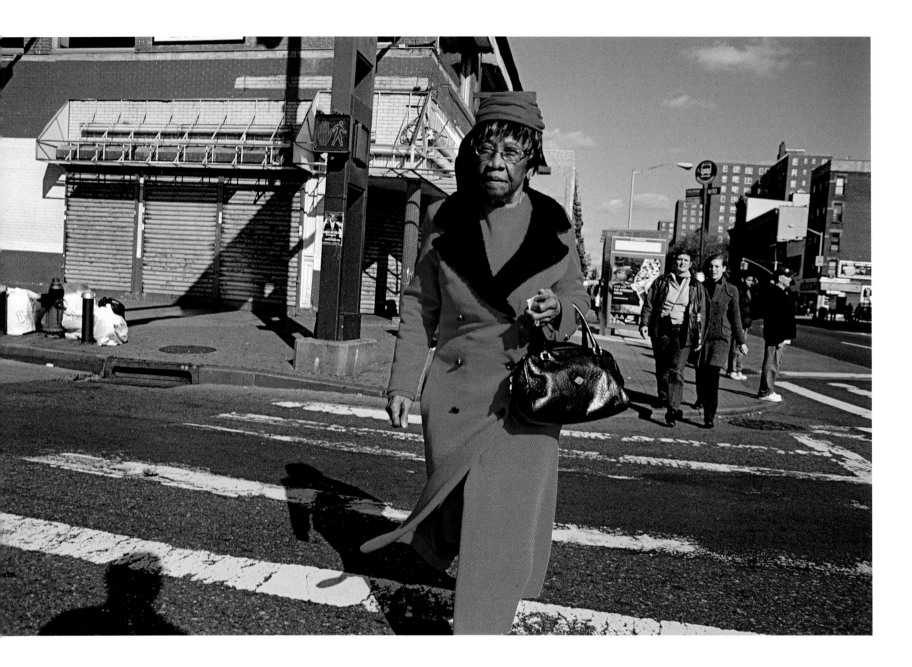

286 *Woman dressed for Sunday church, Frederick Douglass Boulevard at West 125th Street, Harlem, 2008*

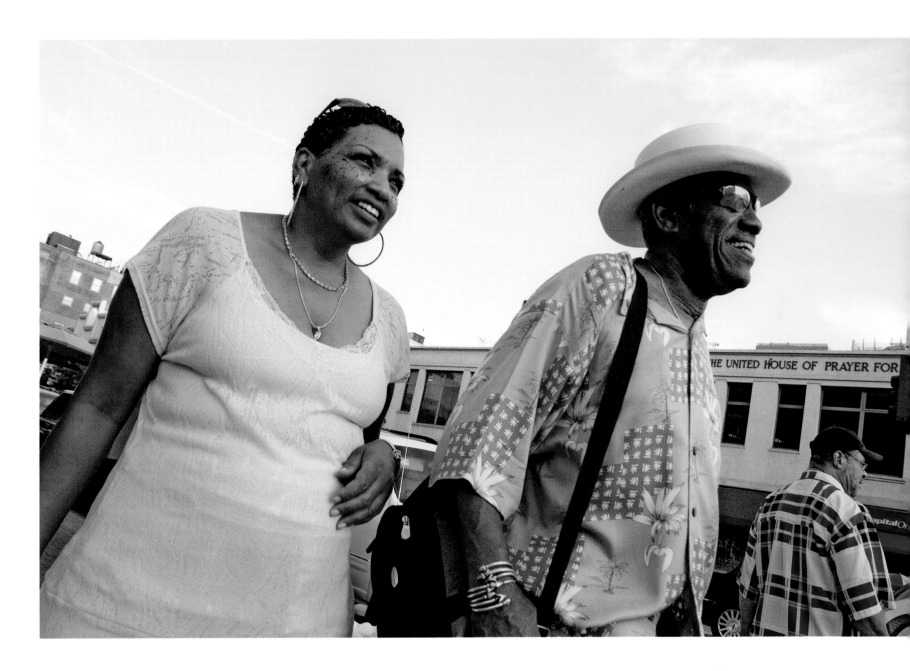

Northeast corner of Frederick Douglass Boulevard and West 125th Street, Harlem, 2010

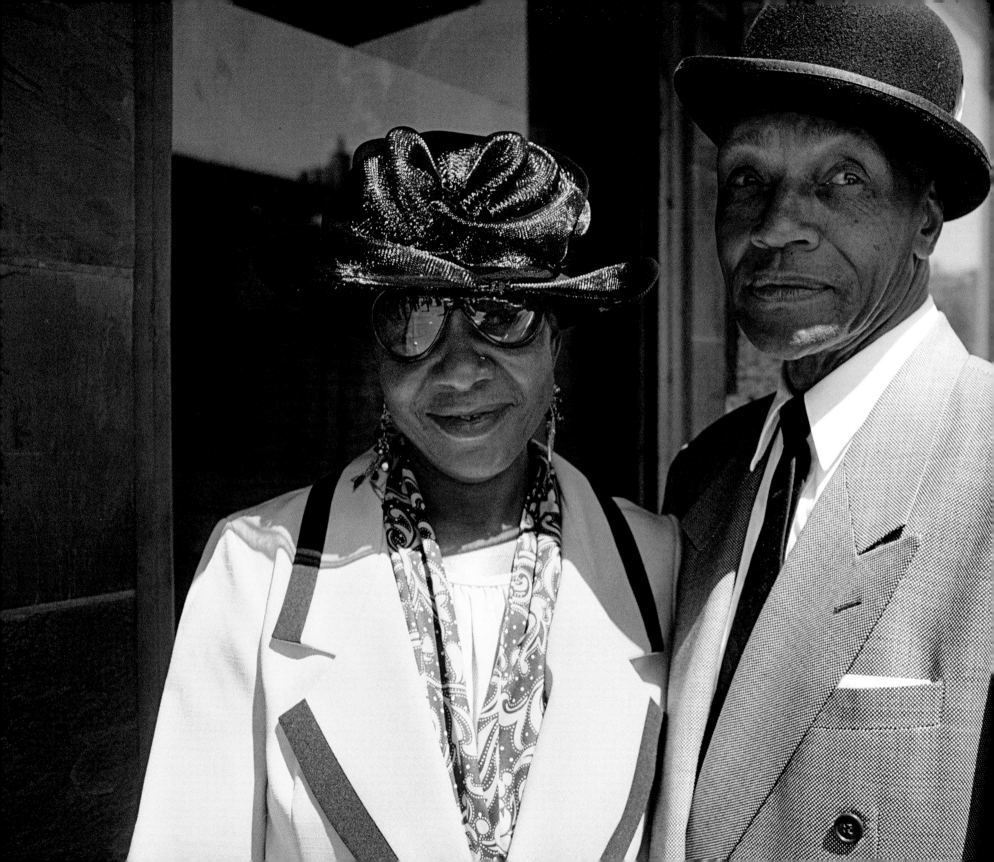

Carrie and Archie, originally from the West Indies, Malcolm X Boulevard at West 125th Street, Harlem, 2007

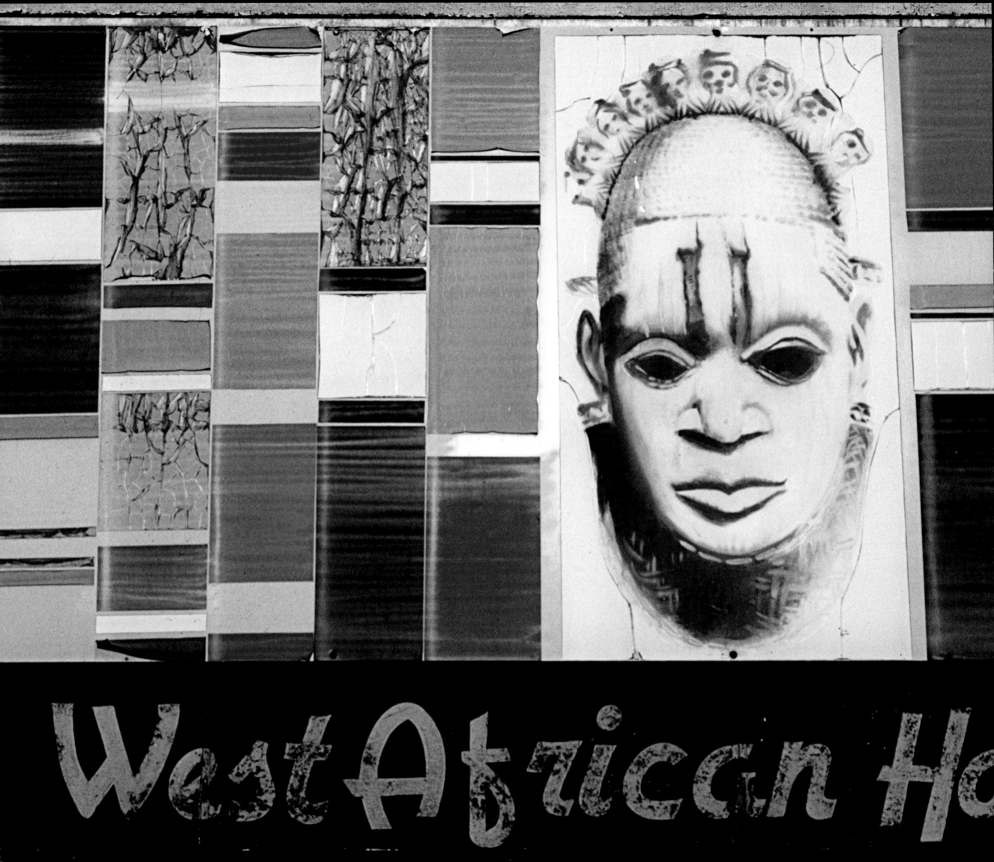

THE AFRICAN PRESENCE IN HARLEM

What is Africa to me:
Copper sun or scarlet sea,
Jungle star or jungle track,
Strong bronzed men, or regal black
Women from whose loins I sprang
When the birds of Eden sang?
One three centuries removed
From the scenes his fathers loved,
Spicy grove, cinnamon tree,
What is Africa to me?

COUNTEE CULLEN, FROM
"HERITAGE," CA. 1925

OPPOSITE *359 West 125th Street, Harlem, 2009; this mysterious sign is now covered by a barbershop sign*

WHEN I BEGAN photographing Harlem in the 1970s Africa was under colonial control. In South Africa, apartheid was official state policy. Zimbabwe was still a British colony ruled by a small white elite. Angola and Mozambique remained Portuguese colonies. As more African countries gained their independence, Harlem's connection to Africa also changed.

From the 1920s to the 1950s, Harlem was one of the world's greatest concentrations of people of African descent, widely

referred to as "the preeminent black metropolis," "a city within a city, the greatest Negro City in the world," a "Negro Mecca," "Negro Metropolis," "a Magnet." Even today, Harlem's unofficial title is "the capital of Black America." In his 1925 introduction to the anthology *The New Negro,* Alain Locke described Harlem as being—or promising to be—"a race capital."[1] This "significant and prophetic" section of Manhattan was for Locke a unique place where people of African descent coming from the Caribbean, Africa, and the United States had the opportunity to realize their full potential.

In the late 1910s Marcus Garvey, one of the most important advocates of the "New Negro," arrived from Jamaica. His goal was "to unite all people of African ancestry of the world to one great body to establish a country and absolute government of their own." For him Africa, the ancestral home for all people of African descent, was to be "one vast empire, controlled by the Negro." By the end of the 1920s some two million people in the United States and abroad had joined his Universal Negro Improvement Association headquartered in Harlem.[2]

Africa was a source of inspiration for poets Countee Cullen ("Heritage") and Langston Hughes ("The Negro Speaks of Rivers"). West Indians brought their own particular Egyptian and Ethiopian connections to Harlem. Rastafarians call Africa Zion, and painted lions, pyramids, Ethiopian flags, and images of Haile Selassie, the emperor of Ethiopia, appear on the walls of their shops and businesses.

The Michaux National Memorial African Bookstore on Adam Clayton Powell Jr. Boulevard and West 125th Street was a center of Harlem literary life, indeed perhaps the most influential African American bookstore in the country. The shop's owner, Lewis Michaux, hosted visiting African leaders and was himself a supporter of Marcus Garvey.[3] A photograph of the bookstore decorated with portraits of

African leaders and displaying the banner "Repatriation Headquarters, Back to Africa Movement" was included in the 1968 *Harlem on My Mind* exhibition at the Metropolitan Museum of Art and printed in its catalog.[4]

After 1970, immigrants from Senegal, Mali, and Burkina Faso settled around West 116th Street, an area referred to as "Little Africa." New African immigrants along West 125th Street are also very visible; here women steer potential clients toward the many braiding and nail salons nearby and men sell African soaps, oils, suitcases, folk art, and other products. This time, Africans are coming directly to Harlem from across the ocean—and of their own free will.

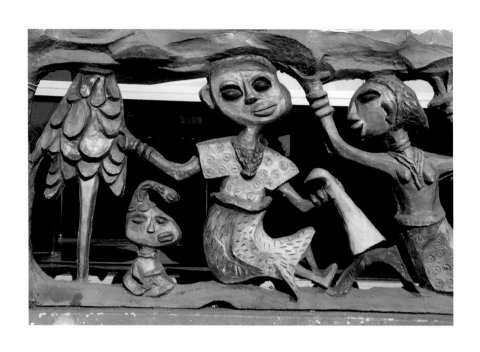

Detail of a sculpture by the Nigerian artist Adebisi Akanji Osogro, National Black Theater, northeast corner of Fifth Avenue and 125th Street, Harlem

294

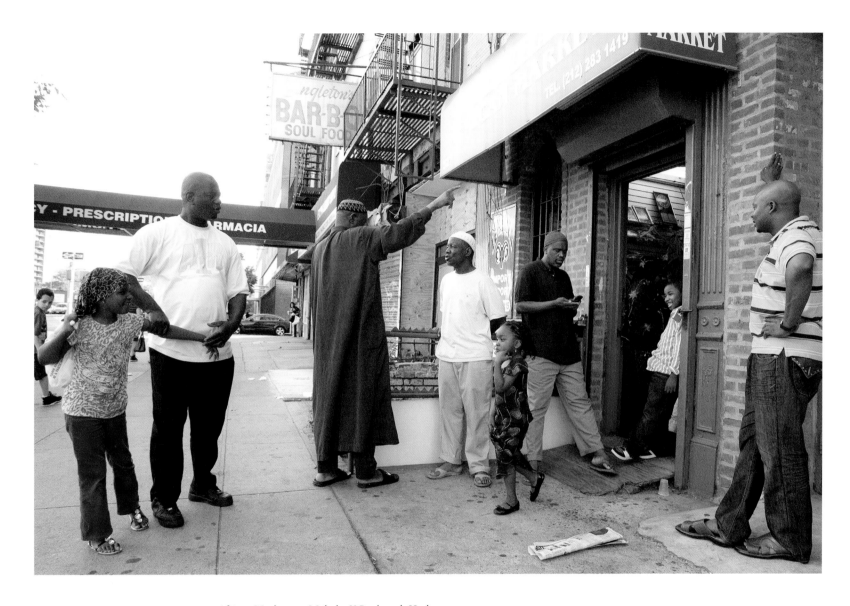

African Market, 527 Malcolm X Boulevard, Harlem, 2010

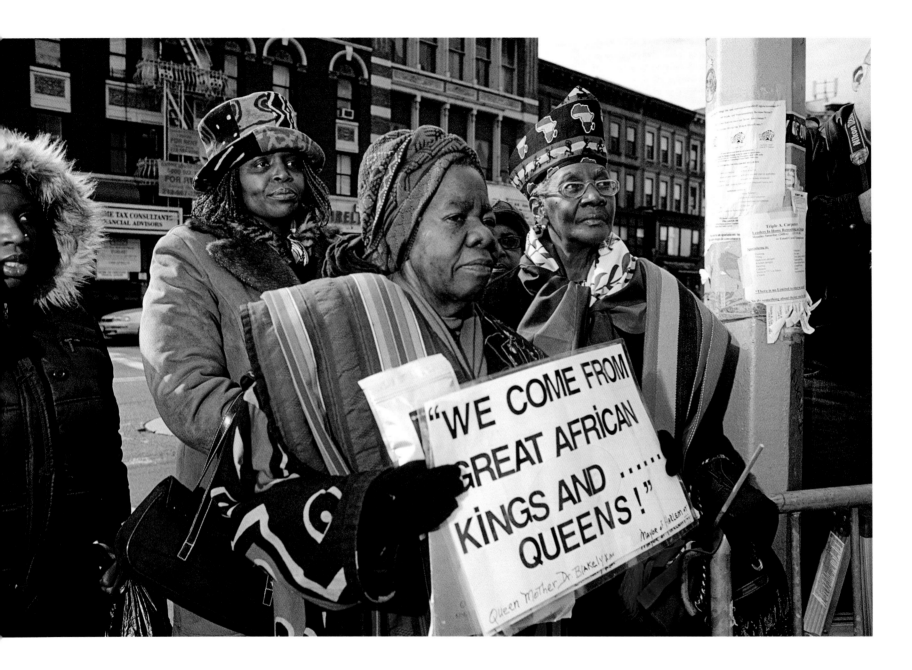

Queen Mother Delois N. Blakely, Harlem's unofficial mayor, waiting for Prince Philip at
Harlem Children's Zone, Madison Avenue at East 125th Street, Harlem, 2007

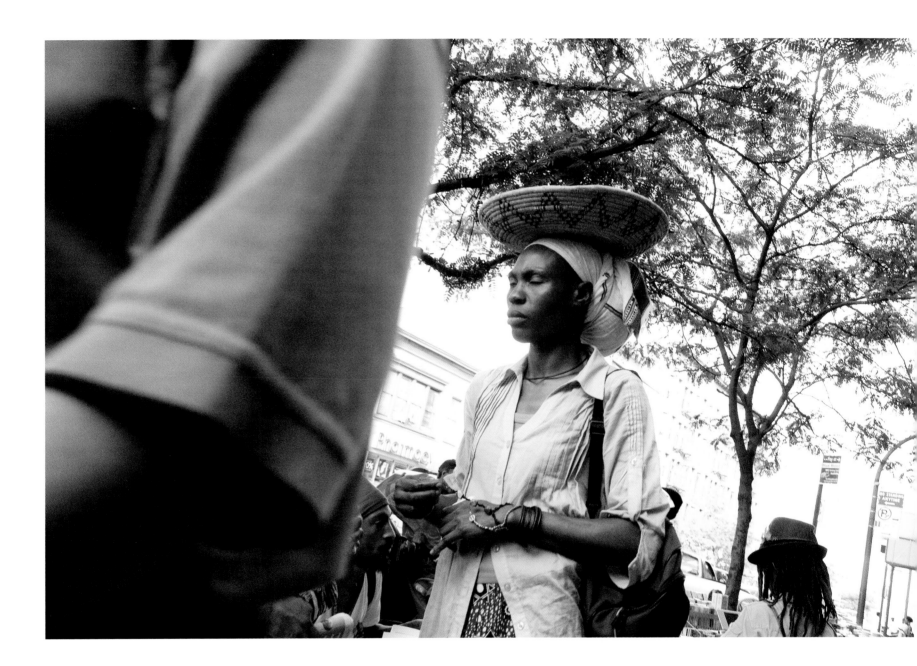

52 West 125th Street, Harlem, 2010 **297**

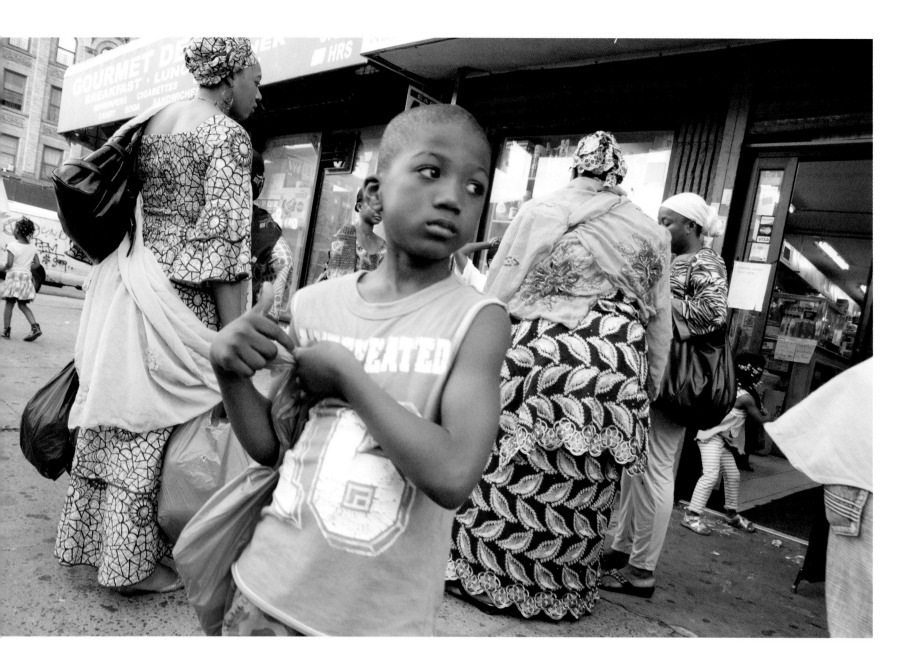

298 *Southeast corner of Frederick Douglass Boulevard and West 116th Street, Harlem, 2010*

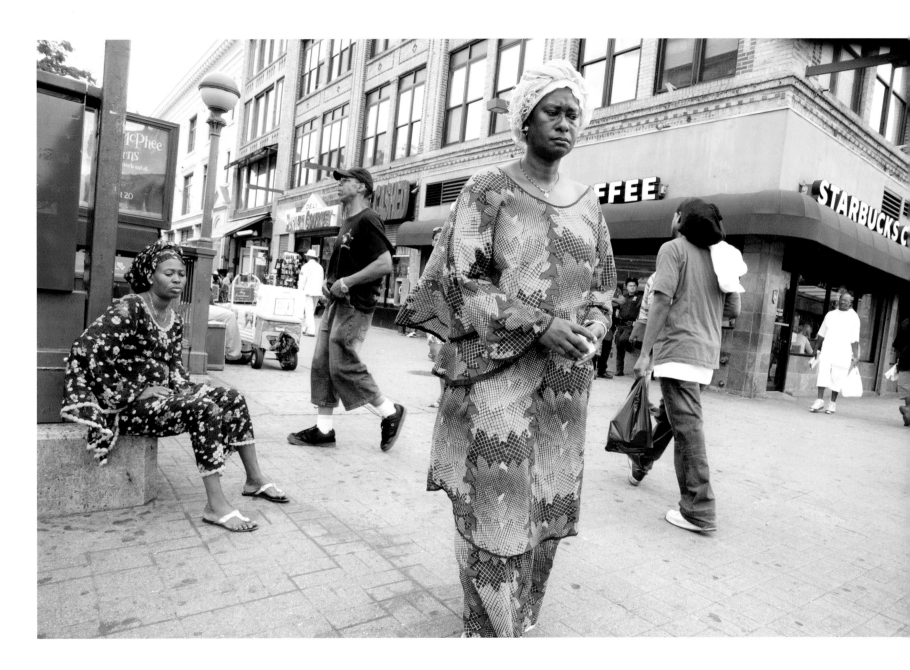

Northeast corner of Malcolm X Boulevard at West 125th Street, Harlem, 2010

TOURISTS IN SEARCH OF HARLEM'S HEYDAY

Tourists aren't coming to Harlem because they want to see the new Disney store.…. They want to see what it is about Harlem that makes it special. They will pay money to see an actual place that still exists from Harlem's heyday.

TIFFANY ELLIS, MARKETING STRATEGIST, CA. 2001

ON WEEKENDS, ALL HUMANITY appears to be walking along the wide sidewalks of 125th Street and Malcolm X Boulevard, part of a joyous parade to see and be seen. A dozen languages can be heard. Stuck in traffic, tourists look down at the crowds from the top of double-decker buses. Japanese tourists pass peddlers offering single cigarettes, pirated DVDs, and drugs. Elderly residents and disabled people cruise silently along in motorized wheelchairs. Dutch tourists emerge from what looks like a residential building, but it is in fact one of the area's new boarding houses. Spanish tourists are photographed in front of a storefront church. African women wearing robes and headgear chat in front of hair-braiding stores. Young blacks from New Jersey come to watch their relatives perform at amateur night at the Apollo. Black Muslims, men in suits, peddle bean pies along with the *Final Call,* their national newspaper.

As if they were the hosts of the celebration and the owners

OPPOSITE *231 West 125th Street, Harlem, 2007*

301

of the streets, sexy black youth show themselves off wearing baseball caps, t-shirts, sneakers, and gold chains. Shouting matches erupt, often followed by fistfights. Occasionally a pickpocket dashes toward a subway entrance to disappear into the crowd. Undercover cops make arrests in front of large crowds. Crime adds unpredictability to this large theater set. Tourists are delighted to experience a Harlem that resists Disneyfication.

Already in 1986, Harlem had the highest name recognition of any neighborhood in the entire state of New York, reports the New York State Visitor and Convention Bureau. "The most famous neighborhood in what is arguably the nation's most famous city is Harlem!" adds John J. Jackson.[1] As a growing economic force, tourism is shaping the so-called capital of black America. "More than 800,000 visitors come to Harlem each year to experience the cultural and entertainment attractions, such as art exhibitions, book fairs, and jazz festivals," according to the New York City Economic Development Corporation.[2]

Neighborhood merchants have become adept at showcasing the cult of Harlem's great past. Former speakeasies are introduced as places where Duke Ellington played and Billie Holiday sang. And even though Michael Jackson never lived in Harlem, his discovery at the Apollo Theater made it possible to add his name to the list of local celebrities. Among its visitors are those interested in Harlem's "ghetto culture." "I cannot stand these tourists that come to our neighborhood, walk around the projects hoping to find men dealing crack or whatever," says Diana Moore, age forty-seven.[3]

White tourists outnumber blacks in some well-known clubs such as the now closed Lenox Lounge. In 2000 Alvin M. Reed, the owner, complained: "It has been 100 percent white on certain nights." He could have been speaking about

the legendary Cotton Club (1923–40), which was operated mainly for white audiences. Mr. Reed feared the Lenox might have been turning into a "Harlem light joint that has no soul." Expecting to see mostly black people and experience an "authentic Harlem," tourists find themselves surrounded by other curious tourists like themselves.[4]

TOURISTS IN SEARCH
OF HARLEM'S HEYDAY

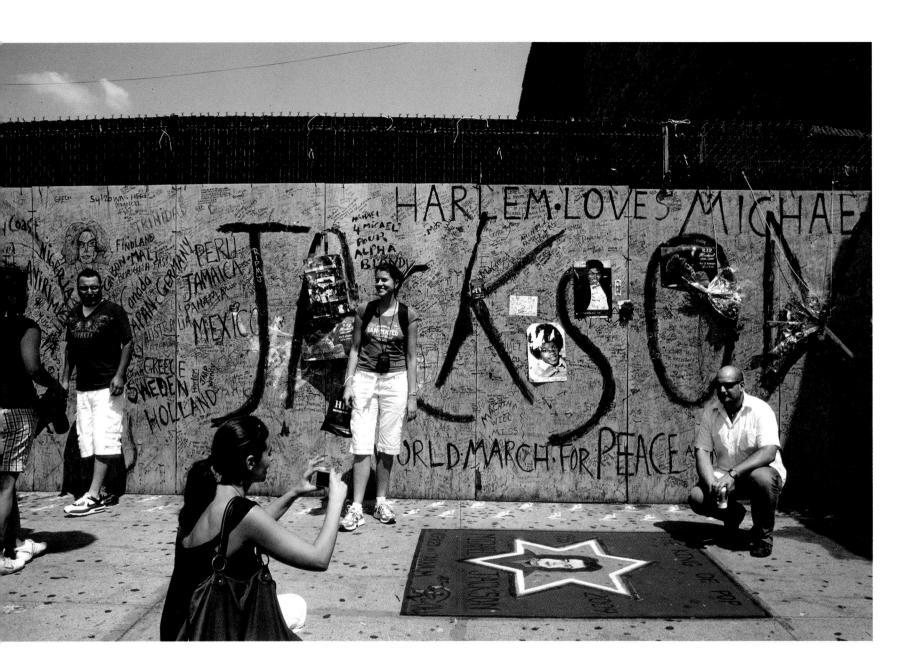

304 *253 West 125th Street, Harlem, 2009*

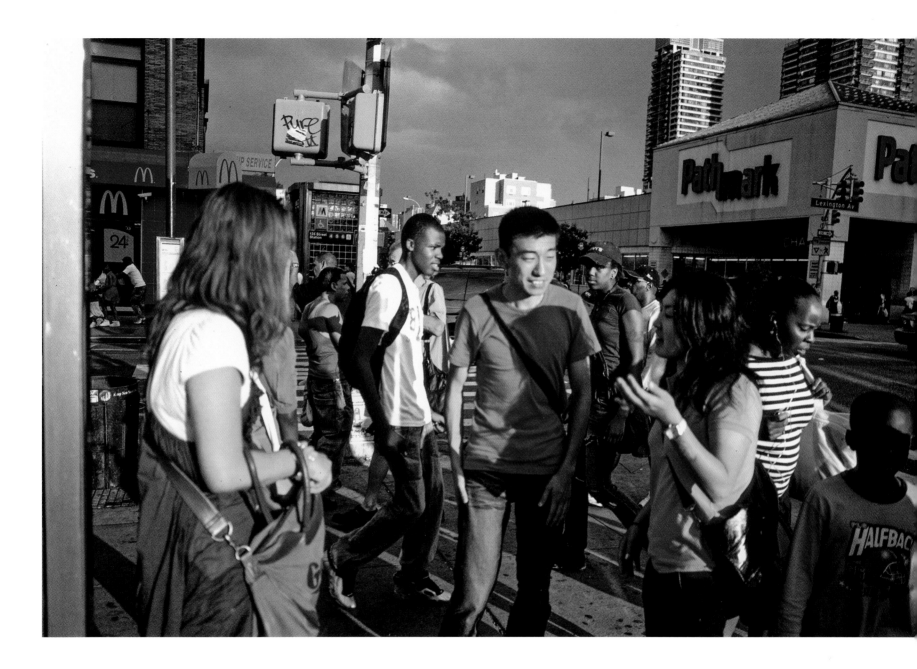

Northwest corner of East 125th Street at Lexington Avenue, Harlem, 2008 **305**

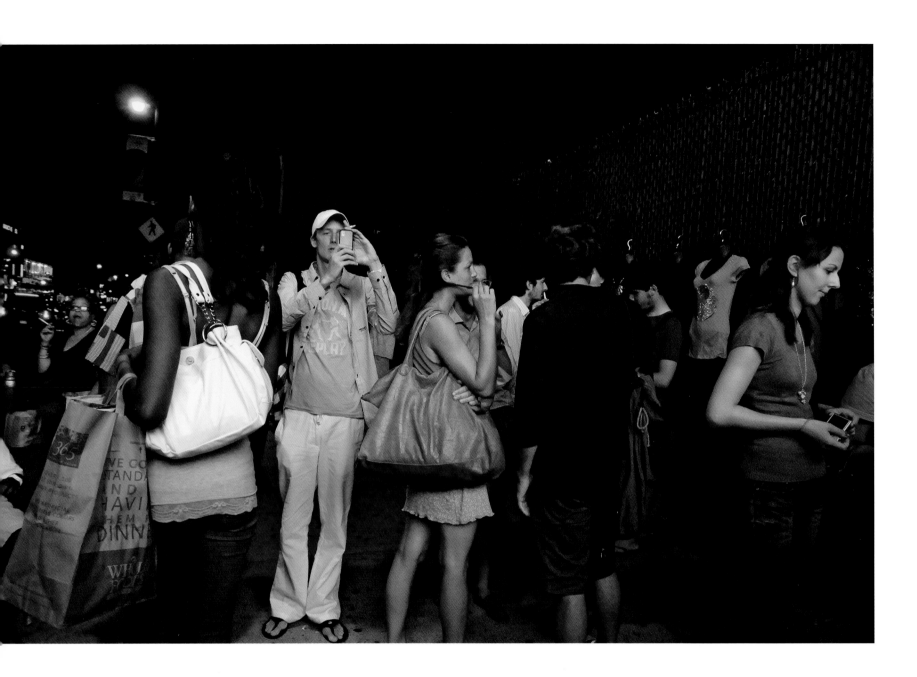

Amateur night at the Apollo, West 125th Street, Harlem, 2010

Mayor Wayne Smith of Irvington, NJ, and his entourage being photographed in front of
Reverend Al Sharpton's headquarters. 106–108 West 145th Street, Harlem, 2012

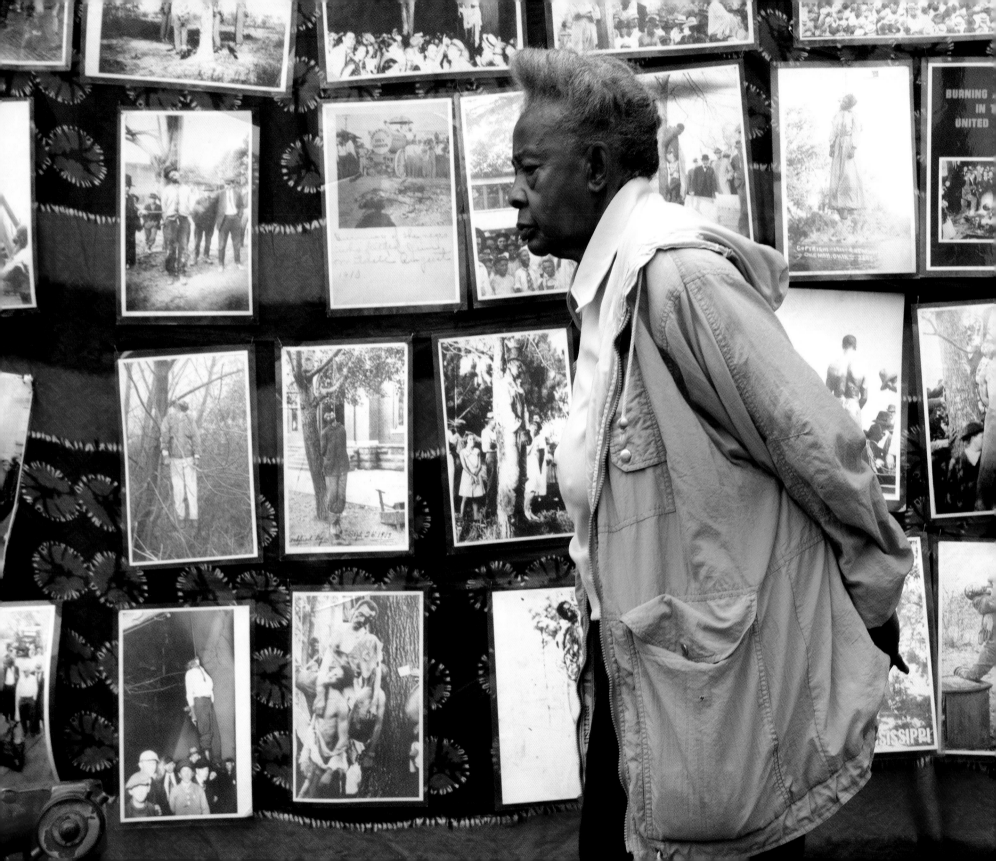

A DEFIANT ATTITUDE

Someday we are going to set this place on fire, cutting phone lines and all that movie shit.

MIDDLE-AGED BLACK MAN WALKING ALONG
MALCOLM X BOULEVARD, 2011

ALONG WEST 125TH STREET at Malcolm X Boulevard those making political statements—in rallies and parades, on murals and posters, or just ranting on their own—remind the crowds that history is not over yet and that they shouldn't forget that blacks, in the words of Claude McKay, were "Enslaved and lynched, denied a human place / In the great life line of the Christian West; / And in the Black Land disinherited."[1]

For many African Americans, the main boulevards of Harlem are places to bear witness to their history, to pay tribute to their leaders and martyrs, and to remind the world of the history of slavery and lynching. On weekends I see these mostly elderly civil rights veterans walking proudly along the avenues wearing shirts with Black Panther raised fists and "Free Mumia" pins.

In one example of such bearing witness, a block west from the Studio Museum and across the street from the

OPPOSITE *Woman walking past horrific depictions of lynchings pinned on Mart 125, a vacant storefront, 260 West 125th Street, Harlem, 2010*

Apollo Theater, activist and scientist Dr. Jack Felder set up displays, on the derelict facade of the vacant mart on 125th Street, that consisted of photocopied images, many of them taken from the 1986 book *Burning at Stake in the United States*.[2] He called his exhibit a "Black Holocaust Museum, just like the Jews." On Amazon, the book, which was produced by the National Association for the Advancement of Colored People, is described as a compilation of "journalistic accounts of five brutal human burnings that occurred during the summer of 1919 that compels readers to establish an emotional link with America's horrific past." The enterprising Dr. Felder sells that book as well another, titled *Post Traumatic Slavery Disorder: America's Legacy of Enduring Injury and Healing*.[3] A young man stands in front of these images of atrocities selling DVDs titled *Harriet Tubman*, *Sankofa*, and *Farewell to Uncle Tom*.

Currently, at a time when the neighborhood is becoming diverse and the rents rising, one finds long-time residents claiming ownership of Harlem: "We built Harlem…. We stayed when everybody left." Such residents complain bitterly, telling of friends forced to move out and adding they are afraid of being pushed out as well.

In 2012, graffiti on Fifth Avenue and 125th Street read:

TO THE GENTRIFIERS!!
HARLEM DIDN'T START WHEN YOU GOT HERE!!
HARLEM IS FOR HARLEMITES!!
—COMMUNITY FIRST!!

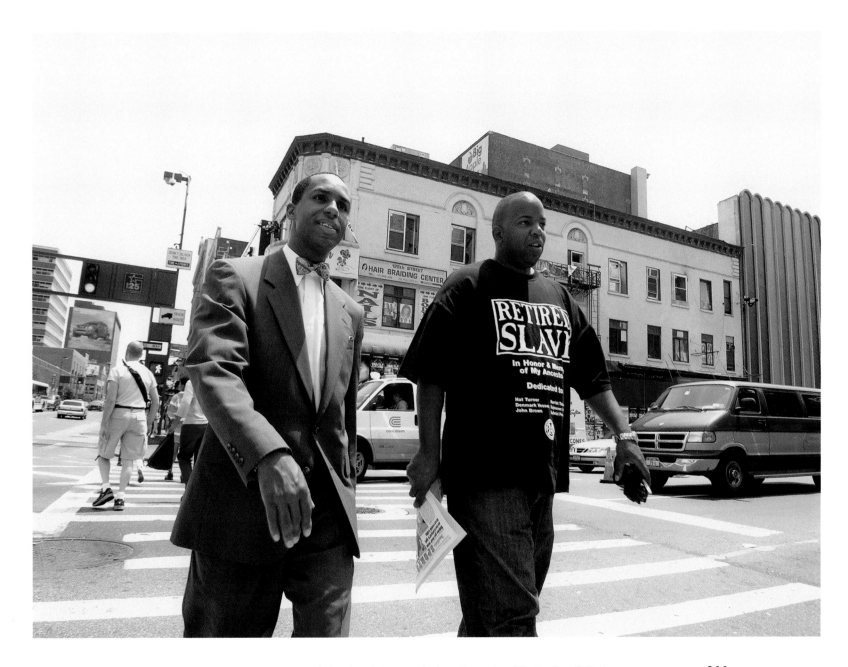

"Retired Slave," 125th Street and Adam Clayton Powell Jr. Boulevard, Harlem, 2005 **311**

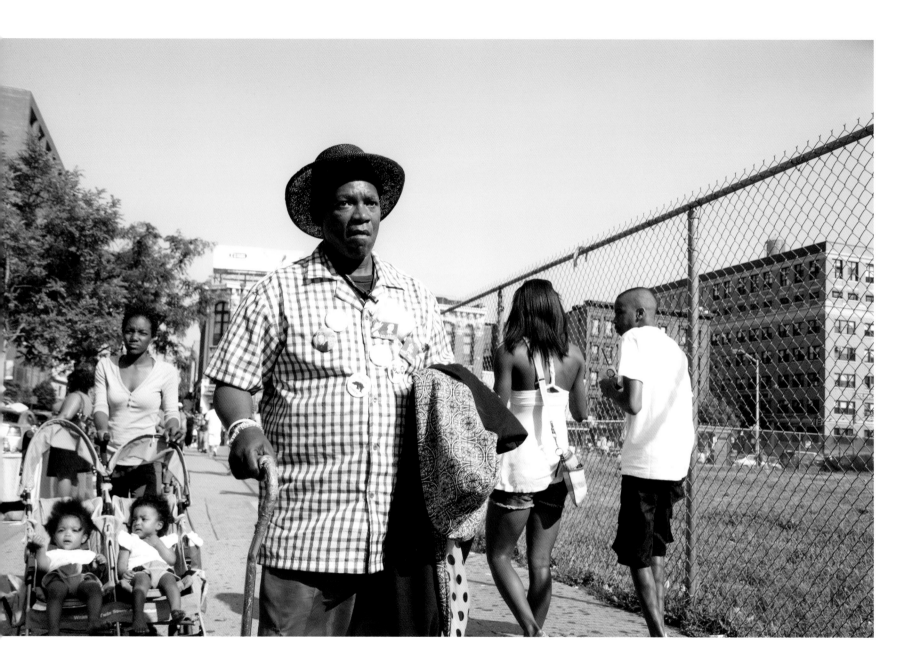

Man wearing Black Power, Elijah Muhammad, and Obama pins, southeast corner of West 125th Street at Malcolm X Boulevard, Harlem, 2010

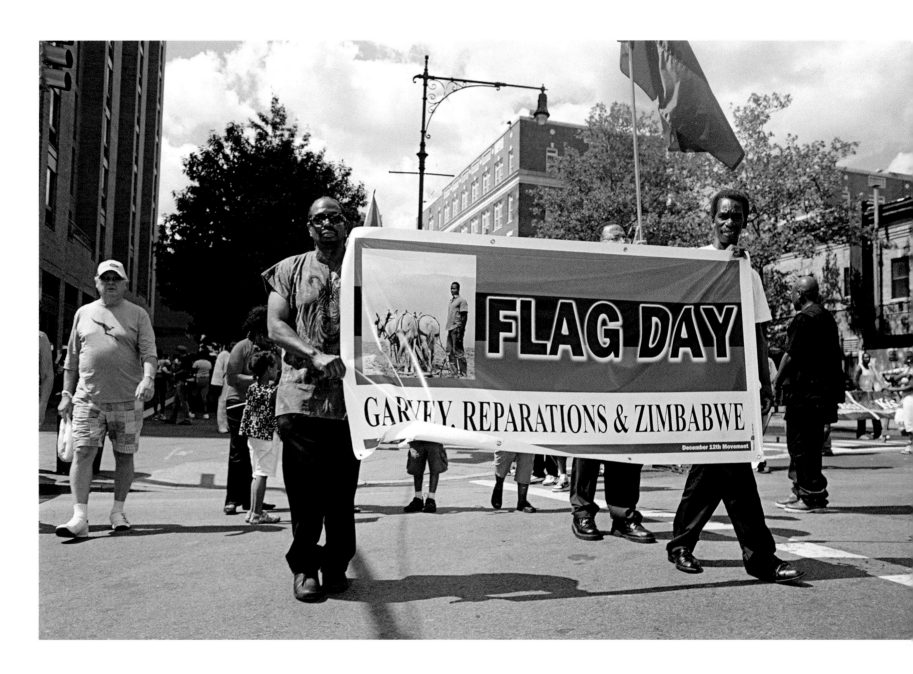

Reparations, West 135th Street at Frederick Douglass Boulevard, Harlem, 2008 **313**

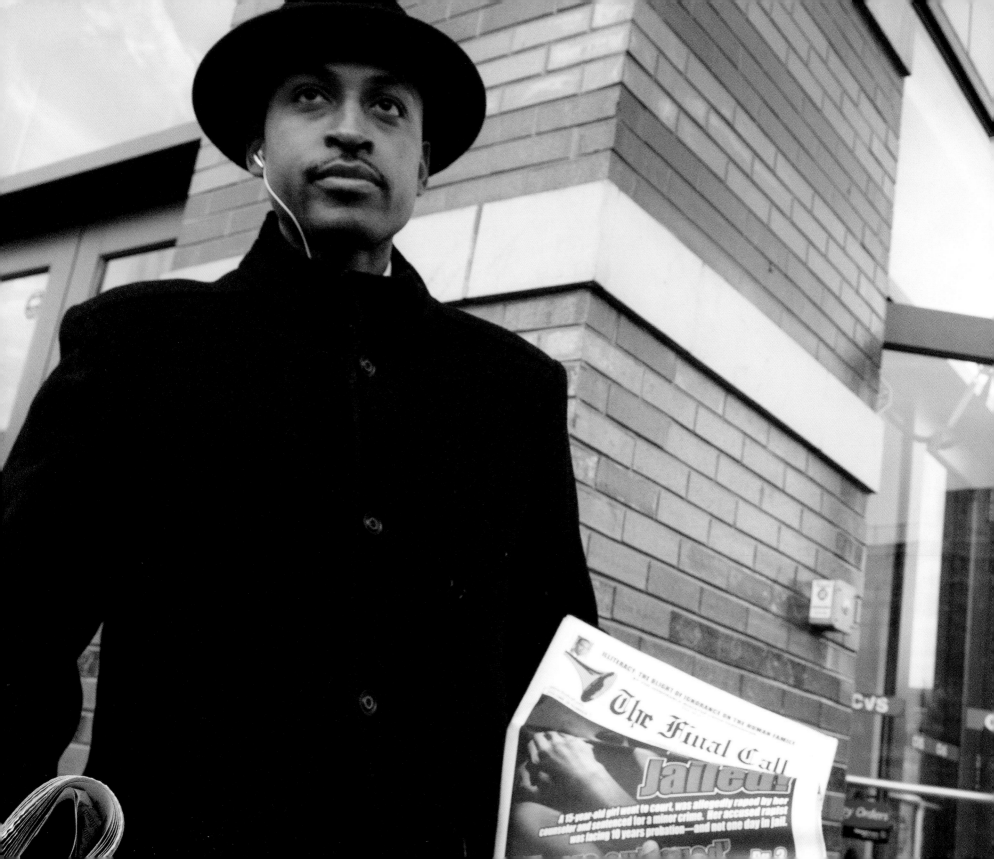

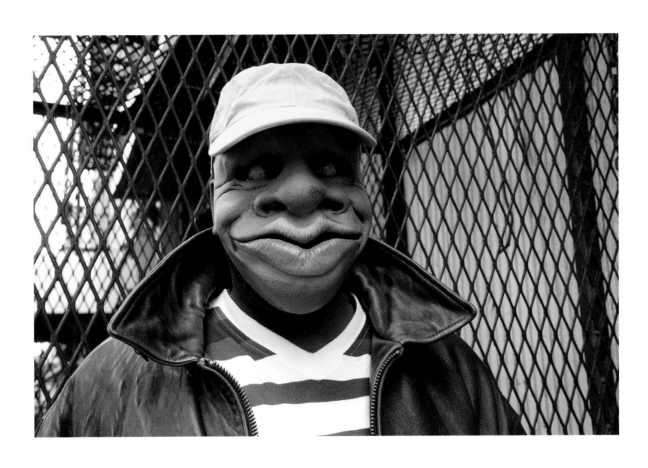

TOP *Thomas wearing a mask for Halloween. 147th Street at Seventh Avenue, Harlem, 2010*

OPPOSITE *Giving away the* FINAL CALL, *Malcolm X Boulevard at West 125th Street, Harlem, 2010*

315

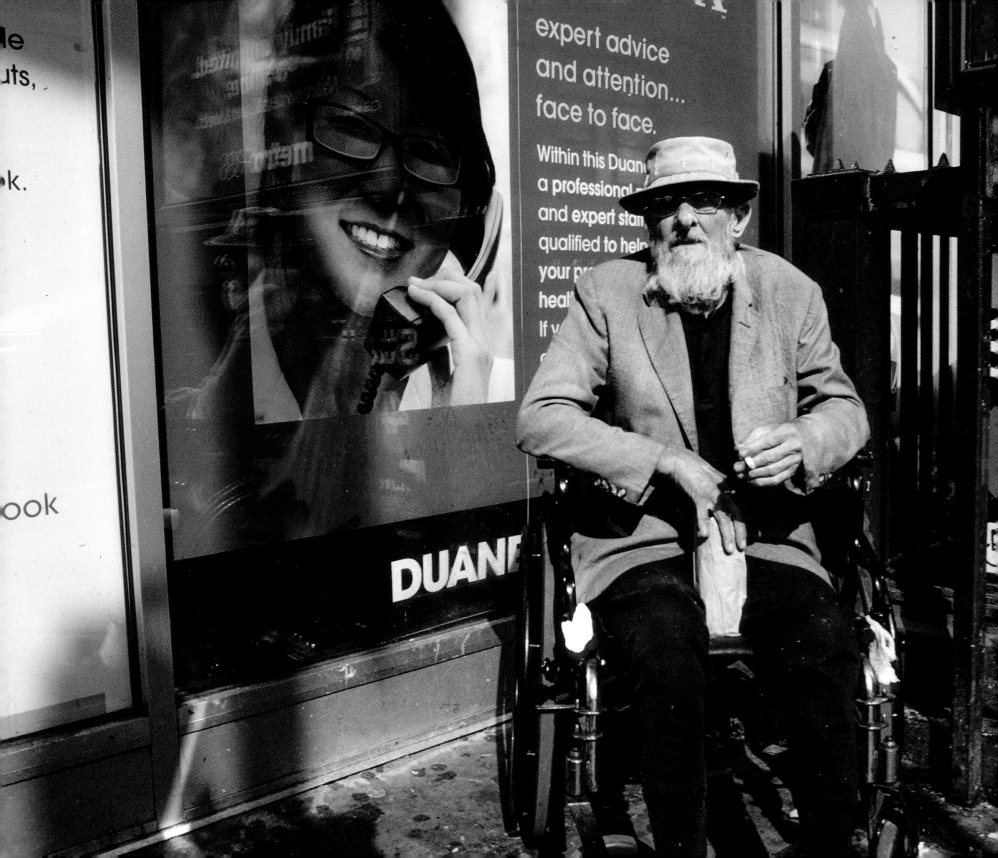

LEXINGTON AVENUE
AT EAST 125TH STREET

A Happening Intersection

THEY DO NOT SELL SNEAKERS at the intersection of East 125th Street and Lexington Avenue. Nor is this the Harlem where tourists go to get their pictures taken or where neighbors put chairs on the sidewalk and talk with each other. This is the Harlem where people who are down on their luck or are suffering from addiction congregate. Madness, fatigue, and anxiety are evident in their eyes and movements, and old-style destitution persists at this corner.

People come here for grocery shopping at the huge Pathmark supermarket, entertainment, or drugs, to access social services, or to catch the bus or subway. Most are here for a particular reason since few families live in the immediate vicinity. Some come out of necessity; others neither leave nor take anything on their way to somewhere else. Many come simply to look around and be entertained by the action on the street. Fights, arrests, illegal sales, police raids, and the crowds themselves provide the entertainment.

Among those passing by are ordinary workers shopping

OPPOSITE *Northwest corner of East 125th Street, at Lexington Avenue, Harlem, 2007*

317

at the large Pathmark, as well as down-and-out "canners" bringing their cans and bottles to the recycling station on East 124th Street, the best of its kind in Harlem. Some look like recently released hospital patients, plastic ID bracelets still on their wrists. Others are oblivious to their surroundings and carry on animated conversations with themselves. Disabled people navigate their way slowly with the help of wheelchairs, walkers, or crutches.

This intersection is a focal point of the underground economy, a place where it is possible to acquire methadone, crack cocaine, pills of all sorts, and even a "clean" urine sample to submit for a drug test at a nearby methadone program. Street vendors sell "loosies"—single cigarettes—or porno DVDs as well the *Daily News* and the *New York Post*. African women hand out cards advertising nearby hair-braiding salons; and men walk by adorned with sandwich boards advertising nearby shops buying gold and diamonds.

The intersection is also a busy transportation hub. Homeless men wait for the M35 bus to take them to Ward's Island, New York City's largest shelter. College students and tourists can get the M60 bus to La Guardia Airport. Beneath the street is the station for the number 4, 5, and 6 IRT subway lines linking the poorest communities of the South Bronx with the richest neighborhoods of the Upper East Side. This corner of New York is also particularly attractive to street evangelists, who readily find people here in need of salvation and exhort them to mend their ways.

All American cities have locations where mostly poor strangers come together and cross paths. In Los Angeles, homeless people congregate south of Fifth Street, on two desperate blocks on San Julian Street, the heart of Skid Row. Baltimore's "hot" corners are along East North Avenue. Neither are as complex as this inter-

section in New York. Unlike East 125th Street, these streets and intersections are more homogeneous, lack a strong police presence, and are not really the place for a stranger to walk alone with a camera. The corner of East 125th Street and Lexington Avenue, in contrast, is the most diverse in terms of people, activities, police, and security.

Twenty years ago the best known of these urban hot places was the block of 42nd Street between 8th and 9th Avenues, which featured prominently in Martin Scorsese's 1976 movie *Taxi Driver*. Today that area near the Port Authority Bus Terminal has been taken over by Disney Entertainment and has been domesticated, with the area losing much of its nervous energy and unpredictability.

319

**LEXINGTON AVENUE
AT EAST 125TH STREET**

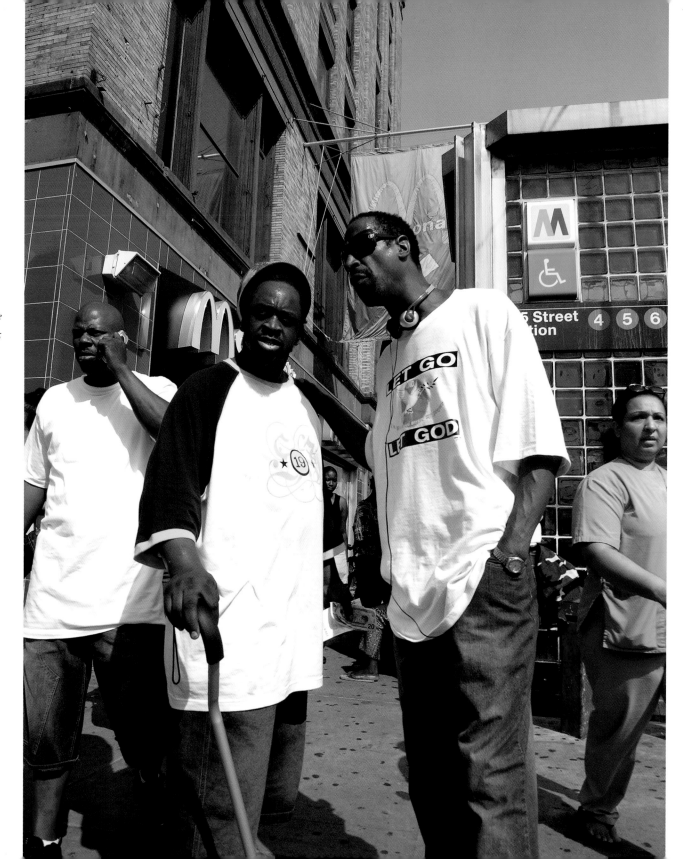

Northeast corner of Lexington Avenue and 125th Street, Harlem, 2005

320

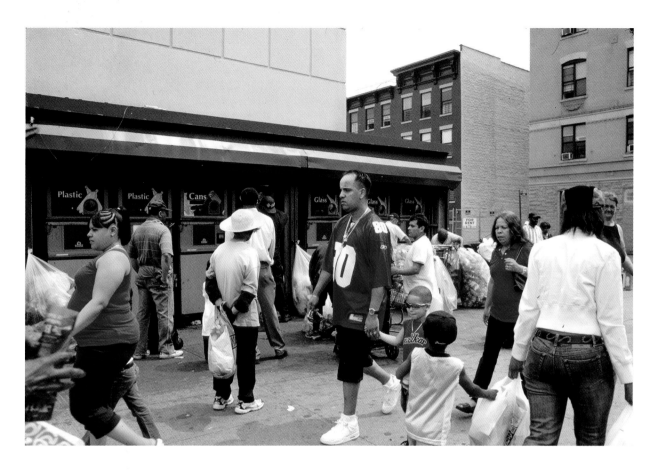

Northeast corner of West 124th Street at Lexington Avenue, Harlem, 2007

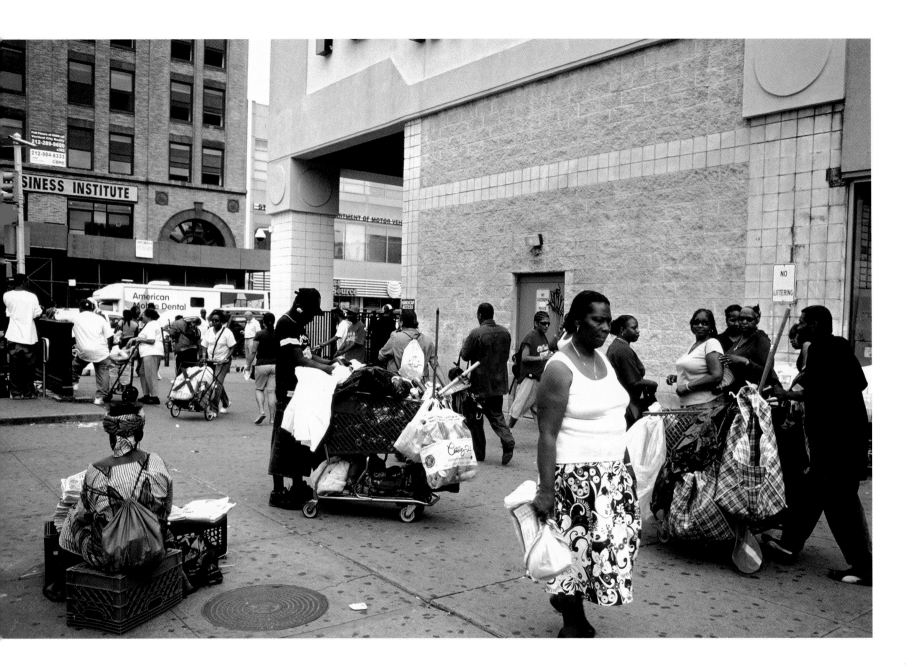

Southeast corner of East 125th Street at Lexington Avenue, Harlem, 2007

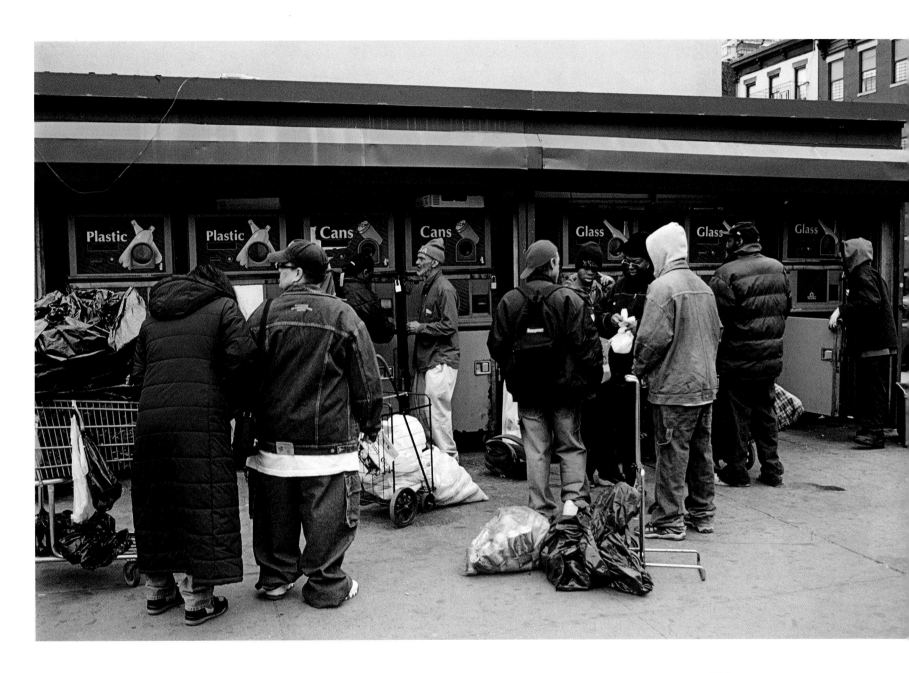

Northeast corner of Lexington Avenue at East 124th Street, Harlem, 2007 **323**

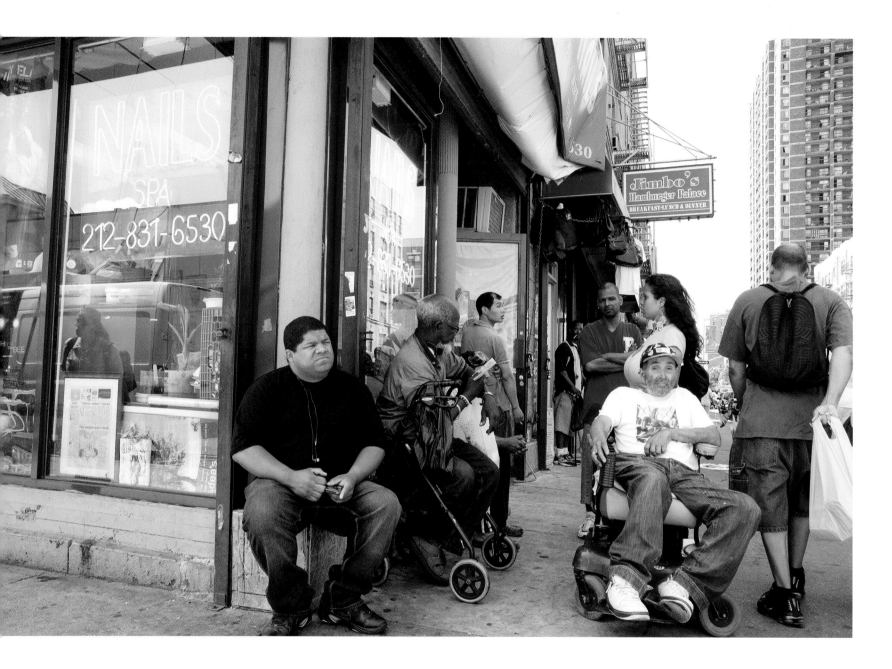

324 *Southeast corner of East 124th Street and Lexington Avenue, Harlem, 2010*

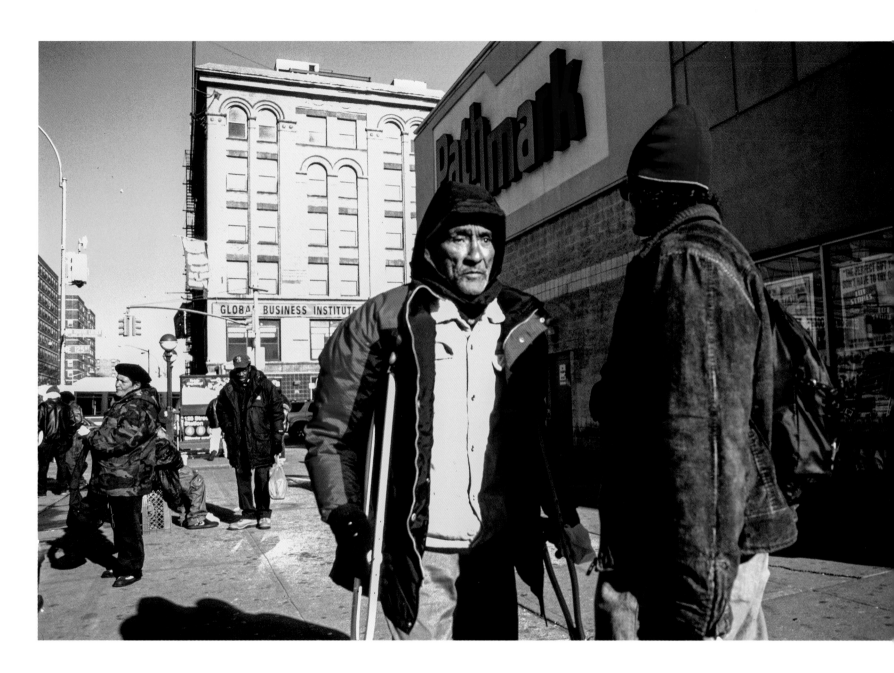

View north along Lexington Avenue from East 124th Street, Harlem, 2008

FREE FOOD

Turkeys, turkeys, they have lots of turkeys.

OPPOSITE *Evangelist Jeanette, a Bronx crossing guard, giving a sermon before serving free meals, the Baptist House of Prayer, 82 West 126th Street, Harlem, 2009*

FREE FOOD PROGRAMS LARGELY involve the poor feeding the poor. In the 2000 US census, the poverty rate in Central Harlem (Community District 11) was 35 percent and was 37 percent in East Harlem above East 116th Street (zip code 10035).[1] The most reliable sources of free food are food stamps, the school system, the food bank, and the city-sponsored senior centers where the elderly, the disabled, and children are often fed. For the other segments of the population, free food on a daily basis is difficult to find. During Thanksgiving, Christmas, and Easter, I visited churches and community centers to meet the individuals from different boroughs who had volunteered to prepare and serve free meals. Those preparing and serving the food worked in factories or as school crossing guards, housecleaners, or hospital orderlies. Sometimes they would bring their teenage children or grandchildren to help. Dinner was often

327

served after a religious service consisting of preaching and hymn singing. Some cooks, women in their eighties, came from the Bronx; they told me they had volunteered for decades and loved what they did. The long commute or old age never deterred them.

Exceptional are the youngsters, largely volunteers for the Coalition for the Homeless, who every night serve prepared food from the back of a truck that stops at Harlem Hospital, one of their feeding sites. Church-sponsored youths come from as far as Dayton, Ohio, such as the group I encountered along Lexington Avenue at East 125th Street that was steering people to a nearby bus for free soup.

"On Thanksgiving day people have to eat," explained Darrell of New Mount Zion Baptist Church in 2011 as he distributed Styrofoam containers of food out of a van parked on Lexington Avenue at East 125th Street. Members of New Mount Zion drive to areas such as Park Avenue at East 121st Street and First Avenue at East 123rd Street, where poor people congregate. When I ask Darrell where people are going to get food the next day he answers, "I don't know about tomorrow." Restaurants such as Jacob on Malcolm X Boulevard and Doug E's on Adam Clayton Powell Jr. Boulevard also offer free meals for people to take home on Thanksgiving.

In a decades-old tradition, a group organized by Sister Mary brings together people of different ages and races to serve Thanksgiving dinner to hundreds of people in front of the Grant Houses on West 125th Street. In addition, many churches and the Salvation Army give out food packages that include a turkey and all the trimmings to those who have registered in advance. At Saint Charles Borromeo Catholic Church on West 141st Street, Deacon Bedford tells those lined up, "One, one, only one. We want everybody to get something."

Not all churches are as well organized as Saint Charles Borromeo or the Salvation Army, however. In 2009, a long line of people expecting turkeys grew restless as they waited at the First Grace Baptist Church on Frederick Douglass Boulevard. One woman complained that the packages being handed out were not as promised. "They are not getting a turkey. They got no turkey. I want a turkey, they ain't got none." Not finding a turkey in his bag, a man chimed in sarcastically, "I waited seventy-five hours for some ham. Look what I got," he said, showing a package of sliced ham. Another voice could be heard yelling, "It's a scam, it's a damn scam, it is not fair." A deacon from the church advised the crowd to "come back Tuesday for the turkey."

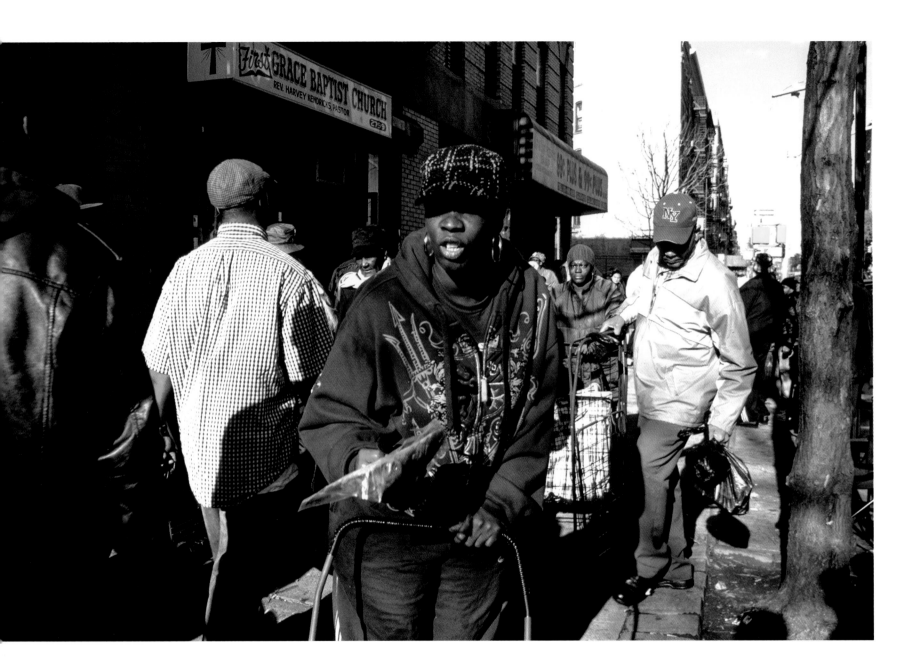

330 *First Grace Baptist Church food giveaway, 2799 Frederick Douglass Boulevard, Harlem, 2009*

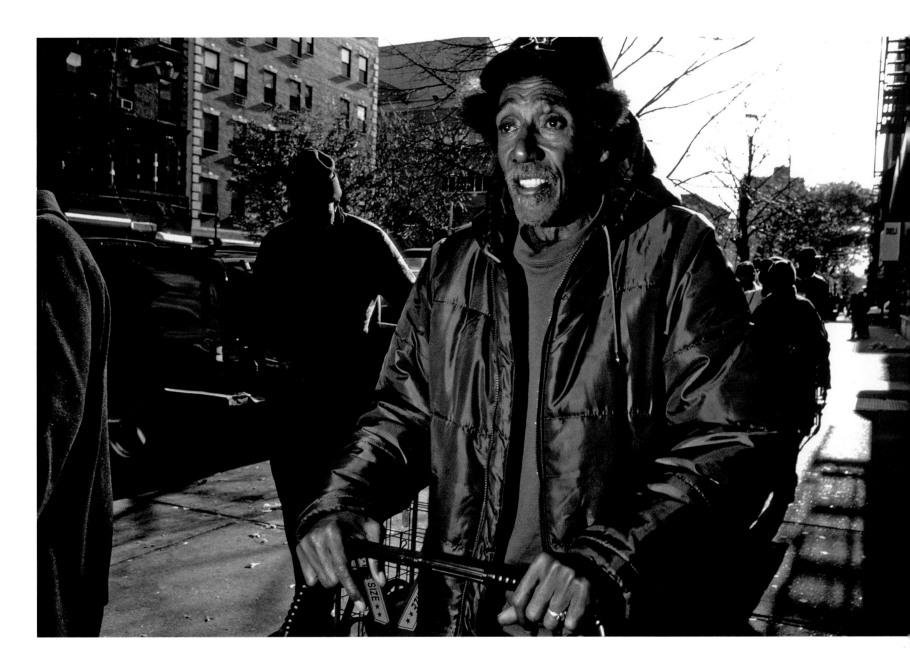

Church of Saint Charles Borromeo, free Thanksgiving turkeys and trimmings, 211 West 141st Street, Harlem, 2009　　　**331**

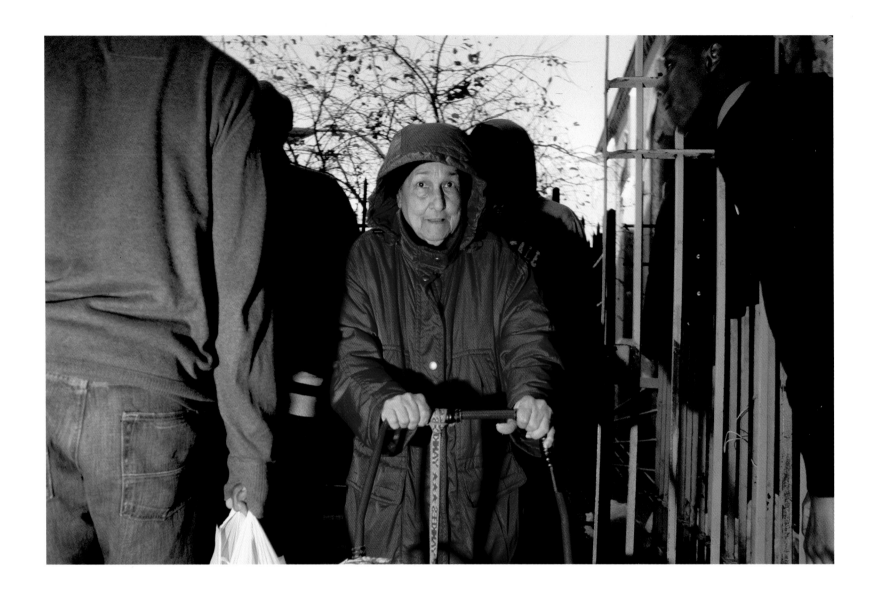

Church of Saint Charles Borromeo, free Thanksgiving turkeys and trimmings, 211 West 141st Street, Harlem, 2009

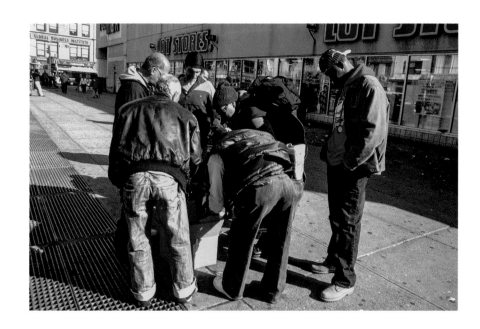

*Box from Meals on Wheels placed on the sidewalk for people to help themselves, view
north along Lexington Avenue from East 124th Street, Harlem, 2009*

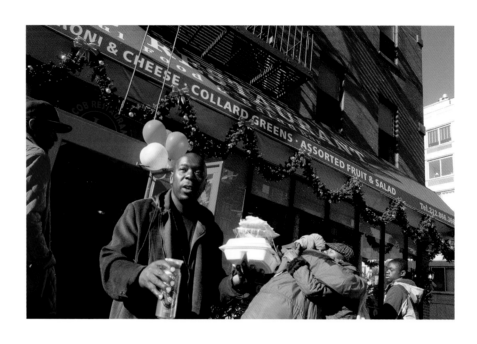

Free Thanksgiving dinner, Jacob Restaurant, 373 Malcolm X Boulevard, Harlem, 2011

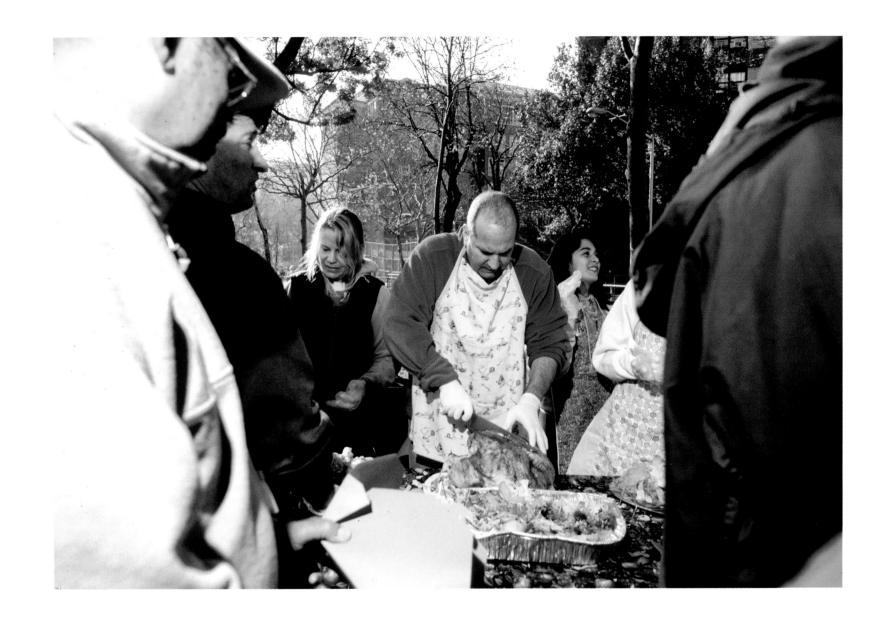

Friends of Sister Mary serving a free meal on Thanksgiving Day, West 125th Street at Morningside Avenue, Harlem, 2009 **335**

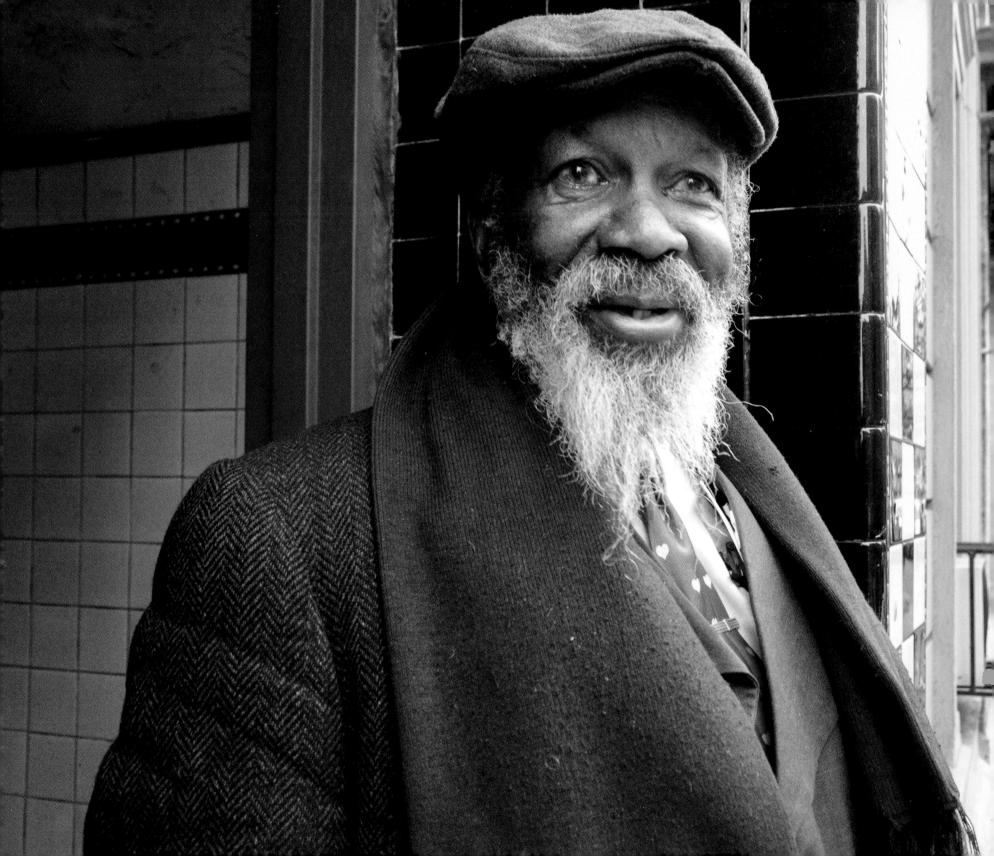

WHAT MEAN THESE STONES?

When your children ask their fathers in time to come, saying "What mean these stones?"
... These stones shall be for a memorial unto the children of Israel forever.

<div align="right">

JOSHUA 4:6–7

</div>

OPPOSITE *Reverend Watkins, West 118th Street at Adam Clayton Powell Jr. Boulevard, Harlem, 2011*

I WAS PLEASED TO MEET the retired Reverend William Watkins as I stood waiting at his doorstep on West 118th Street in 2011. I had taken a chance and approached a small elderly black man at the entrance to an apartment building, and it turned out to be Reverend Watkins. For a long time I had looked forward to speaking with this Harlem minister, journalist for the *New York Evening Press*, and purveyor of comic books. Long ago, in 1988, I had photographed his storefront in an otherwise vacant building at 1964 Adam Clayton Powell Jr. Boulevard, where he engaged in his religious, news-gathering, and collecting activities. The building was run-down, but the carefully handwritten lettering on the facade was for me a good example of a struggling business offering several different services and was typical of that time in New York's poor, minority communities. To my questions about the many Harlems now, Reverend Watkins told me, as many others had done, that the neighborhood was turn-

337

ing "multicultural." And when I asked his opinion about all the changes in the neighborhood, Reverend Watkins responded with a quotation from the Bible: "What mean these stones?"

Among Harlem's "stones" are the historical markers attached to its buildings or placed where landmarks once stood and where great events occurred. These markers remind visitors of where internationally famous places were once located and where notable people lived. For example, on one of the towers at the Polo Grounds Houses, a plaque marks the nearby location of home plate where the New York Giants played until 1957. In 2012, a terse sign commemorating Marcus Garvey was mounted on the wall of Saint Mark the Evangelist Catholic Church on West 138th Street: "On this site Mr. Marcus Garvey held his first public meeting in the United States in the year 1916." A bronze plaque at 620 Lenox Avenue marks the original location of the block-long "visually dazzling and spacious" Savoy Ballroom; another at West 132nd Street commemorates Paradise Alley, a cluster of nightclubs and cabarets described as "an inspiration to the world." Now that the Lafayette Theater is a church and the Apollo Theater is devoted to "legends," there is no "Cradle of New Stars" in Harlem.

In 1923 the *New York Times* claimed: "The unwritten law of Manhattan of those days was that white and black could not dwell side by side as neighbors."[1] But the Harlem of the twenty-first century is not a violent New York City ghetto "doomed for white occupancy." As perceptions of race have changed and as families of diverse origins and mixed races move in to the neighborhood, Harlem is reinventing itself.

Today young black men do not share the same bars and barbershops as their older brethren. Local Latinos share a very different history and sense of racial identity from African Americans; they have their own musical tastes, eat at Spanish

restaurants, and attend their own churches. Moreover Latinos represent diverse nationalities, including Puerto Ricans, Dominicans, and Mexicans. But if residents do not share the same ethnic background and have varied food, music, and religious preferences, then what accounts for Harlem's strong sense of identity?

Is today's "authentic" Harlem the dark "hood" of contemporary hip-hop artists? Or is their Harlem a re-creation of the much rougher neighborhood of their parents' generation? Many hip-hop artists present a neighborhood in their videos they claim is still "real." Yet these artists also make their contribution to the "enhanced Harlem" as their fans go north of West 130th Street along Malcolm X Boulevard to pay respect to rappers such as Big L, Doug E. Fresh, and Huddy 6.

The image of a prosperous, diverse, culturally rich Harlem is the invention of real estate developers—the promise of a multicultural neighborhood for those able to pay the high prices for condos and townhouses. This vision is manifested in upscale restaurants such as Red Rooster. *New York Times* food critic Sam Sifton wrote in 2011, "New Yorkers are accustomed to diversity on sidewalks and subways, in jury pools and in line at the bank. But in our restaurants, as in our churches and nightclubs, life is often more monochromatic. Not so at Red Rooster Harlem, which the chef Marcus Samuelsson opened in December. The racial and ethnic variety in the vast bar and loft-like dinning room are virtually unrivaled."[2]

Even as economic development and demographic changes are transforming Harlem's character, people still line up to watch the parades, sing gospel at their churches, preach on street corners, play music in the parks, get their haircuts at midnight, and pull up chairs on the sidewalk for conversation and a little dice rolling. Along commercial streets, men urge people to "check it out: tattoos, tattoos, body piercing right here."

A diverse neighborhood now, and no longer the heart of black American creativity, Harlem is in danger of becoming a "museum city." Promoted by museums and cultural institutions, city officials, businesses eager to make a profit, and hip-hop artists seeking fame, African American culture and history are still among the strongest and most persistent forces shaping Harlem today.

Living side by side in a historically black neighborhood allows everyone—blacks, whites, Latinos, and Asians—to live richer lives than if they stay in their own segregated communities. Indeed, for Harlem to remain "the most famous Black neighborhood in the world," its population doesn't necessarily have to be overwhelmingly African American.

For many, the new Harlem may mean the loss of a familiar "down-home" place, a more aggressive police presence on the street, and growing economic hardships. For others, however, the neighborhood demonstrates the evolving and ever more multicultural society of the United States.

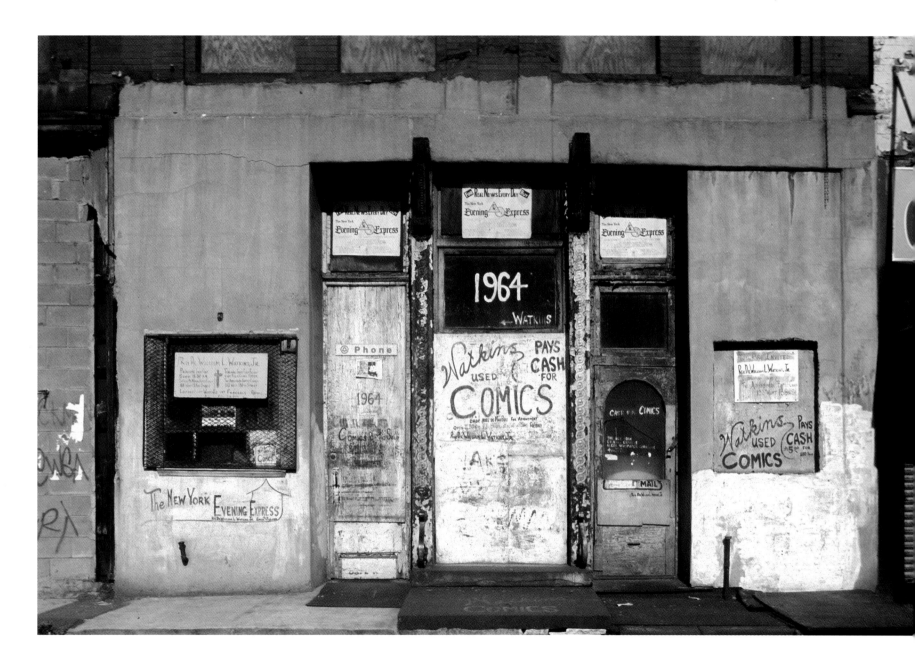

1964 Adam Clayton Powell Jr. Boulevard, Harlem, 1988 **341**

1964 Adam Clayton Powell Jr. Boulevard, Harlem, 2007

1964 Adam Clayton Powell Jr. Boulevard, Harlem, 2012 **343**

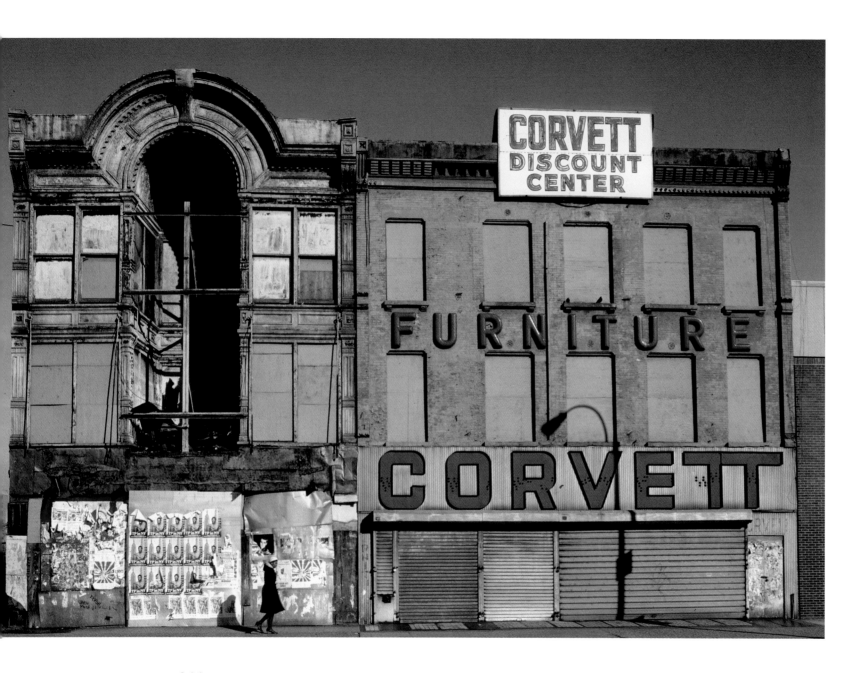

344 *167 East 125th Street, Harlem, 1980*

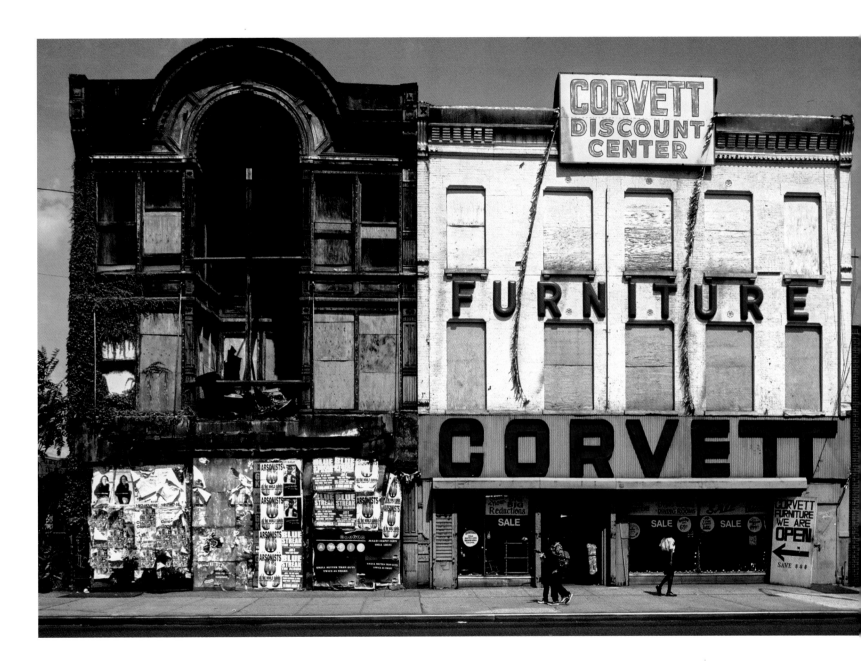

167 East 125th Street, Harlem, 1999 **345**

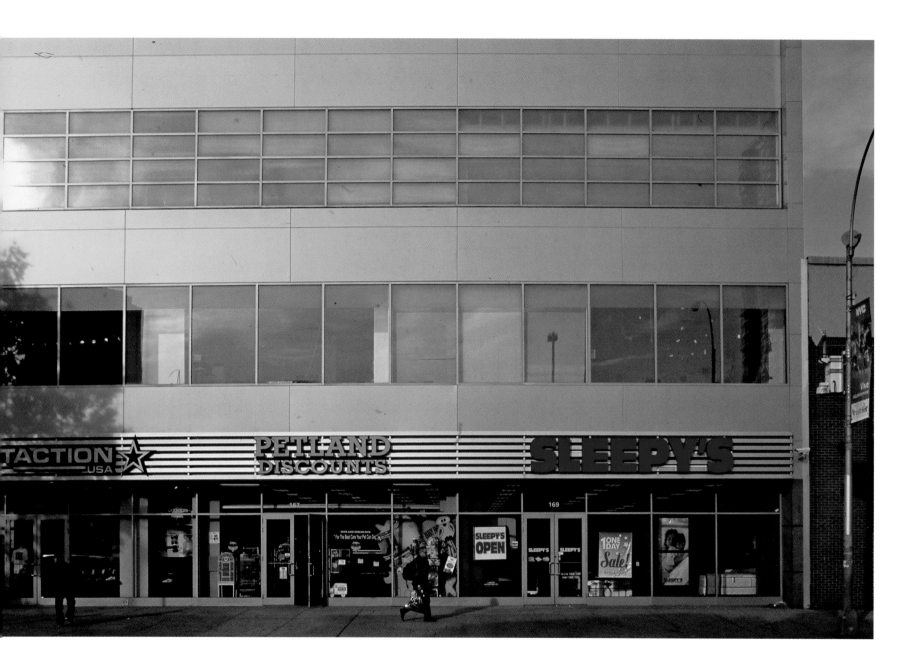

167 East 125th Street, Harlem, 2007

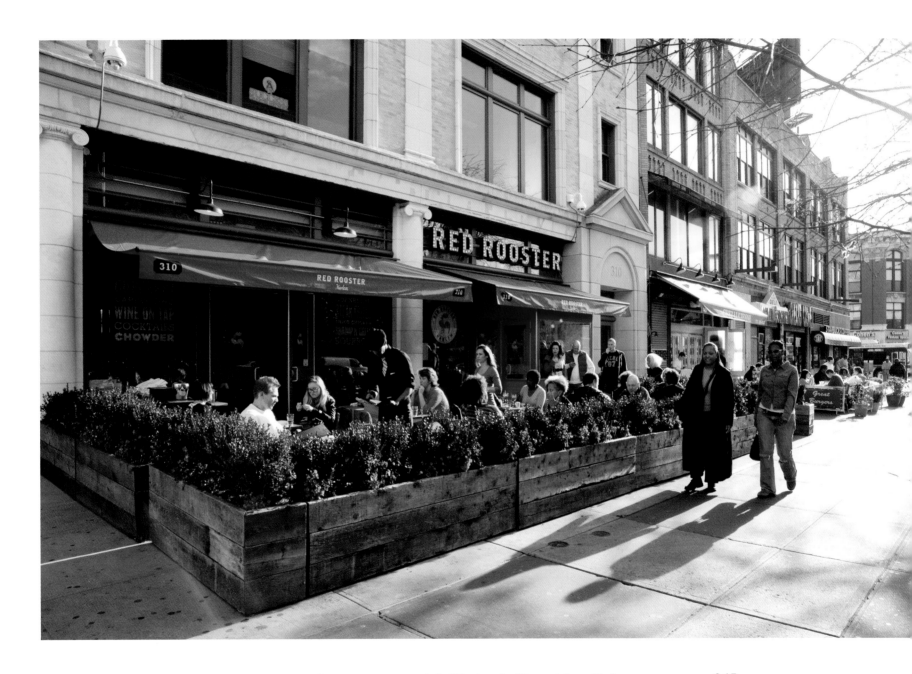

Red Rooster Restaurant, Malcolm X Boulevard at West 125th Street, Harlem, 2010

Deli, 551 Malcolm X Boulevard, Harlem, 2010

West 125th Street at Malcolm X Boulevard, Harlem, 2010

"The executioner," Apollo Theater, 253 West 125th Street, Harlem, 2011

349

AFTERWORD

IN HARLEM WANDERING
FROM STREET TO STREET

Did you take a picture of me?

Who gave you permission to take pictures?

You have to ask before you take a picture.

What are you going to do with my picture?

Where is that picture going to appear?

Don't take the picture!

You shouldn't have done that. That isn't right.

I hope you are not taking pictures around here. I hope you are not
* taking serious pictures around here.*

If you don't leave I am going to break your camera! I am hungry.

We are not monkeys in the zoo!

Get the fuck away from here!

You don't have no fucking right to take pictures of nobody!

God loves you man. Stop taking pictures of little kids. What do
* you do, you take pictures and you jerk off when you see them?*
* Who gave you permission to take pictures of me?*

You see that man going around just clicking pictures; that is very
* dangerous.*

Let me see one of these pictures somewhere and you are in trouble.

What are you taking pictures of man? Don't come back here to
* take no pictures.*

Can I see what you wrote in that yellow notebook?
If he is taking pictures, he is going to pay you!
You be careful out here 'cause the camera is expensive.
Are you a Reuters photographer?
Are you a Mormon?
Want to take my picture? My father is famous.
Thank you, Thank you. [For taking my picture]

I OFTEN ASK PEOPLE IF I can take their photograph, but sometimes what I see is so extraordinary that to stop and ask permission would break the spell. I often take a chance and press the shutter. If I am asked to leave, I leave. If someone threatens to break my camera, I move on as quickly as possible. If they say "don't take my picture," I don't. People I encounter often want to know where I'm from. "You weren't born in this country," they usually say. If a person asks where their picture is going to appear I say that I don't know. If people ask for their picture to be taken, I do and make plans to send a copy to them. These are the rules I generally follow.

I think it is best not to spell out my photographic intentions to people I encounter lest they become guarded, mistrustful, and stiff. This approach preserves the openness and spontaneity of my work. Usually it is sufficient for me just to acknowledge that I like to photograph a streetscape or a building or a sign. Unlike tourists taking snapshots, people sense I have a larger purpose. They do not know what it is, yet they sense that somehow it may affect their lives.

Most of the angry comments aroused by my documentation took place when I was carefully rephotographing buildings, not people. Among those angered were residents who thought I had no right to photograph in their neighborhood; the oth-

ers showed signs of being drunk or mentally unbalanced. I included the comments of these people because they were my first critics: I felt their comments deeply and viewed them as part of my documentation.

Two encounters took me by surprise, forcing me to be more forthcoming about what I do and compelling me to explain myself.

One Sunday in May 2007, I was rephotographing sites I had photographed more than two decades earlier. These new pictures were going to be part of my Invincible Cities website. I had a sheet of twenty older images with me so I could take the same picture from the same spot and angle as the old one. I was walking slowly to each of the sites, and generally taking my time on each of the new photographs. I would have thought it was obvious to anyone who noticed that what I was doing was harmless—including the policeman driving a van around Saint Nicholas Avenue and West 120th Street. I paid no attention to him, but as I walked toward Frederick Douglass Boulevard, the officer pulled up alongside me, got out of his van, and asked to see a picture ID. I was irritated but I did as he asked and gave him my driver's license, showed him the sheet of slides, and explained my purpose. He copied down my name and my license number. When I asked why he had stopped me, he explained that after the terrorist attacks of September 11, 2001, the police were encouraged and authorized to stop anyone without any reason and to ask for identification.

Then the policeman warned me: "I will look at this website," he said, "and see if any pictures of my children are in it, and if they are I will sue you as a pedophile. I know that any jury will support me." I responded that although most of the photographs on the website were of buildings, some of them included children. Furthermore I argued, a website documenting Harlem that did not include pictures of children would be pretty strange. I added that generations of street photographers have taken

pictures of children. The policeman was unimpressed and drove away. In the 1980s and 1990s the officer would have used my own security as an argument to discourage me. In 2007 his response was to threaten to sue me for the content of my photographs.

On another occasion, in June 2007, I was photographing a boarded-up corner building on Fifth Avenue and 132nd Street. Windows on all floors were sealed except for those of a grocery store occupying the ground floor. A middle-aged, visibly drunk man came from behind and said, accusingly, "You are an Arab, aren't you?" I replied no, but he continued, saying, "When are you guys going to start blowing up places? You are an Arab," he repeated. "Don't blow the building yet. Don't pull the cord." He proceeded to tell his inebriated friend that I was an Arab terrorist. What was strange about this encounter was that the drunk did not seem to think of terrorist activities as particularly upsetting. He was eager to see me blow up a building, along with myself, as entertainment.

ACKNOWLEDGMENTS

I HAVE BEEN DOCUMENTING Harlem for forty-two years. Along the way, I received support from friends, family members, complete strangers, and institutions such as foundations, churches, and community development corporations.

My former wife, Professor Lisa Vergara, an art historian, took me along to museums in Europe and the United States, helping me to see how great painters depicted cities. She asked questions about my work. She looked at my photographs, asking, for example, why I had cropped buildings in a particular way. She encouraged me to take what at the time seemed to be boring photos but which became most revealing when rephotographed. My father-in-law, Charles Pieroni, even though he had no reason to believe in the success of my endeavors, generously and for decades helped us financially.

At the Graduate School of Architecture Planning and Preservation of Columbia University I learned about urban design, urban history and architecture. Professors Robert Beauregard, Daniel Bluestone, Kenneth T. Jackson, and Richard Plunz all showed interest in my work and gave me opportunities to present it to the university community, thus stimulating my thinking.

James Dickinson of Rider University and Timothy Gilfoyle of Loyola University, Chicago, carefully read, edited, and commented on the text and images for this book. Many thanks to Russell Damian of the University of Chicago Press for helping with the assembling of texts, notes, and photographs and to Yvonne Zipter, also from the Press, for a careful and sensitive editing of the text.

I have spent my professional life almost completely outside of the photography mainstream, working instead with planners, architects, and American historians. I am grateful to Peter B. Hales of the University of Illinois, a photography scholar, for placing my urban documentation into the rephotography tradition.

In Harlem I was assisted by dozens of building superintendents who gave me access to roofs, by housing authority employees who spoke to me about their developments, and by people I met in elevators, bars, barbershops, and subway stations. A selection of their comments, as recorded here, forms an essential part of the text.

My Harlem work was exhibited at the New York Historical Society thanks to Louise Mirrer, the society's president, and to Marilyn Kushner, Curator of Prints and Photographs. The Harlem exhibition encouraged me to closely study my archive and plan this book.

I was fortunate to receive financial support from the Architecture and Urban Planning programs of the National Endowment for the Arts and New York State Council on the Arts and

from the MacArthur and Ford Foundations. Architect Carl Anthony, of the Poverty Program of the Ford Foundation, believed that inner-city neighborhoods deserved to be carefully documented. With the support of his program I was able to place most of my Harlem images on the Invincible Cities website and move into the digital world.

ACKNOWLEDGMENTS

NOTES

FOREWORD

1. See Camilo José Vergara, *The New American Ghetto* (New Brunswick, NJ: Rutgers University Press, 1995), 110, 114, 115.

STREET PHOTOGRAPHY OF HARLEM, EARLY 1970S

Epigraph: Alexander Garvin, "The Three Faces of Harlem," *World Order* (Winter 1967), http://www.alexgarvin.net/printPub.php?item=14.

1. The quote from Ellison can be found in the inscription on his memorial; see "Riverside Park: *Ralph Ellison Memorial*," City of New York Parks and Recreation, http://www.nycgovparks.org/parks/northernriversidepark/monuments/1946.

2. David Halle and Andrew Beveridge, "Changing Cities and Directions: New York and Los Angeles," in On-Line Working Papers Series, California Center for Population Research, UC Los Angeles, 9; http://escholarship.org/uc/item/6pk1047j.

3. Henri Cartier-Bresson, *Family, Mexico, 1934*, http://www.christies.com/LotFinder/lot_details.aspx?intObjectID=5304253.

SINCE 1977, EXPLORING HARLEM THROUGH TIME-LAPSE PHOTOGRAPHY

1. Sally Eauclaire, "Eighteen Color Photographers/Mitch Epstein, 'Common Practice,'" excerpt from *American Independents* (New York: Abbeville Press, 1987), http://www.americansuburbx.com/?s=Mitch+Epstein&submit.x=28&submit.y=9&submit=Search.

2. The quote is from Sean O'Hagan, "Why Street Photography Is Facing a Moment of Truth," *Guardian*, April 17, 2010.

3. Adam Gopnik, "Improvised City, Helen Levitt's New York," *The New Yorker*, November 19, 2001.

4. "Harlem 1980s," YouTube video, 3:58, posted by "dtoronto," August 29, 2008, http://www.youtube.com/watch?v=qU1z5SGMdQE&list=PL39E246BFBCEA684B&index=13&feature=plpp_video.

MANY HARLEMS, ONE CULTURAL CAPITAL OF BLACK AMERICA

Epigraph: Ellington, quoted in Richard O. Boyer, "Profiles: The Hot Bach—II," *New Yorker*, July 1, 1944, 26–35.

1. Donna Akiba Sullivan Harper, *Not So Simple: The "Simple" Stories by Langston Hughes* (Columbia: University of Missouri Press, 1996), 40.

2. Sam Roberts, "No Longer a Majority Black, Harlem Is in Tran-

sition," *New York Times*, January 5, 2010.

3. Clyde Haberman, "N.Y.C.; N.B.A. Hopes Transcend Hoop Hype," *New York Times*, February 10, 1998.

4. US Census Bureau, *2010 US Census Data* for tracts 216, 197.02, 218, 201.02, 220, 257 in New York County.

5. Ibid., tract 239 in New York County.

6. Haberman, "N.Y.C.; N.B.A. Hopes Transcend Hoop Hype."

7. Claude McKay, "Zeddy," in *Home to Harlem* (Lebanon, NH: Northeastern University Press, 1987).

8. Bill Egan, "Buildings and Places Linked to Florence Mills: John Joyce/Rodney Dade Funeral Chapel," Florence Mills: The Little Blackbird, http://www.florencemills.com/buildings.htm#funeralchapel.

9. Dan Charnas, "Rangel and Harlem Bid Final Farewell to Bobby Robinson," NewsOne for Black America, January 13, 2011, http://newsone.com/nation/dan-charnas-2/bobby-robinson-remembered-by-charles-rangel-and-harlem/.

10. ASAP Rocky, "Peso," YouTube video, 2:50, posted by "ASAPRockyUptown," August 10, 2011, http://www.youtube.com/watch?v=ob3ktDxAjWI.

11. Nancy Cunard, "Harlem Reviewed," in *The Politics and Aesthetics of New Negro Literature*, ed. Cary D. Wintz (New York: Routledge, 1996).

LOST HARLEM

1. "Apollo Theater Interactive Timeline, 1913–2010" by A&E Tele-vision Networks, LLC. http://www.biography.com/blackhistory/timeline/apollo-theater.jsp.

2. Timothy Williams, "Powerful Harlem Church Is Also a Powerful Harlem Developer," *New York Times* August 17, 2008.

3. New York City Department of City Planning, "125th Street, Original Proposal," presented October 1, 2007, http://www.nyc.gov/html/dcp/html/125th/125th6zp.shtml.

GLOBALIZATION TAKES OVER

1. "Contact Us/Frequently Asked Questions," McDonald's Corporation, http://www.mcdonalds.ca/ca/en/contact_us/faq.html.

2. Calvin Tomkins, "Romare Bearden," *The New Yorker*, November 28, 1977.

3. Vacation Guide advertisement, *Ebony*, June 1961, 93.

LANDMARK HARLEM AND HARLEM LANDMARKS

1. Julia Vitullo Martin, "Doing it Right: Affordable Home Ownership in Harlem" *The Manhattan Institute's Center for Rethinking Development Newsletter*, May 2005, http://www.manhattan-institute.org/email/crd_newsletter05-05.html.

2. Carey D. Wintz and Paul Finkelman, eds., *Encyclopedia of the Harlem Renaissance* (New York: Taylor & Francis, 2004), 2:678.

3. Jervis Anderson, "That Was New York: Harlem," *The New Yorker*, July 20, 1981.

4. "Apollo Theater Interactive Timeline, 1913–2010."

MEMORIALIZATION

1. Erik K. Washington, "Bartholdi's Washington and Lafayette Statue: From Paris to Harlem" *Suite 101*, http://suite101.com/article/bartholdis-washington-and-lafayette-statue-from-paris-to-harlem-a228381.

2. "Victory, World War I Black Soldiers' Memorial, Chicago," The Historical Marker Database, http://www.hmdb.org/marker.asp?marker=4683.

3. Sidney H. Bremer, "Home in Harlem," in *Analysis and Assessment, 1940–1979*, ed. Cary D. Wintz (New York: Taylor & Francis, 1996).

4. "John Rhoden, 83, Sculptor of Public Art," Obituary, *New York Times*, January 17, 2001.

5. Mark Mooney, "Ellington Statue Will Play It Solo," *Daily News*, May 5, 1995.

"SIMPLY MAGNIFICENT"

Epigraph: Steven L. Newman Real Estate Institute, "Harlem in Our Eyes: Sustaining Cultural Legacy in a Rapidly Changing Neighborhood," symposium brochure, Baruch College, City University of New York, February 23 and 24, 2006.

1. "Welcome to SoHa 118," Corcoran Real Estate Group, http://www.soha118.com/.

2. "The Lenox," MNS Real Impact Real Estate, http://thelenoxnyc.com/.

3. Sara Polosky, "Harlem Condo Emerges from Bankruptcy with Fresh Price Cuts," *Curbed* (blog), July 15, 2011, http://ny.curbed.com/archives/2011/07/15/harlem_condo_emerges_from_bankruptcy_with_fresh_price_cuts.php.

4. Herbert Muschamp, "Metaphors Rise in Harlem Sky," *New York Times*, February 18, 2004.

5. HarlemHouse, "88 Morningside in Harlem, Unveils Breathtaking Rooftop Terrace," *Harlem Condo Life* (blog), July 29, 2011, http://harlemcondolife.com/2011/07/29/88-morningside-in-harlem-unveils-breathtaking-rooftop-terrace/.

THE PROJECTS

1. New York City Housing Authority, "NYCHA Housing Developments," http://www.nyc.gov/html/nycha//html/developments/dev_guide.shtml.

2. Lewis Mumford, "Skyline: The Gentle Art of Overcrowding," *The New Yorker*, May 20, 1950.

3. "The Boutique Kalahari Apartments in New York City Real Estate Are Built With LEED Silver Standards for Healthier Living—NYC Presale Condos For Sale," *New York Apartments, Pre-Construction Real Estate, Presale NY Condos* (blog), September 5, 2008, www.condo-living-west.com/nyblog/2008/09/boutique-kalahari-apartments-in-new.html.

THE SUBWAY

1. Randy Kennedy, *Subwayland: Adventures in the World beneath New York* (New York: St. Martin's Press, 2003), 178.

2. Walter Goodman, "The Swarm of Life underneath New York," *New York Times*, August 8, 1994.

3. Michael M. Grynbaum, "For the C Trains Rickety and Rackety Cars, Retirement Will Have to Wait," *New York Times*, August 25, 2011.

4. "Average Weekday Subway Ridership," Metropolitan Transit Authority, http://www.mta.info/nyct/facts/ridership/ridership_sub.htm.

5. A. K. Thornton, "How Safe Is the New York City Subway?" NYSubway.com, http://www.nysubway.com/safety/subway-safety.html.

DEFENSES

1. Kate Taylor, "Borough President Seeks Limits on Stop-and-Frisk," *New York Times*, September 23, 2011.

2. John Leland, "A Summer Idyll, and Then Three Bullets," *New York Times*, August 12, 2011.

3. Carla Zanoni, "Walking Tours Shed Light on Surveillance Camera Use," *Columbia Daily Spectator*, September 29, 2003.

4. "SkyWatch: Surveillance as Effective Deterrence," *Homeland Security News Wire*, February 10, 2011, http://www.homelandsecuritynewswire.com/skywatch-surveillance-effective-deterrence.

RELIGION

1. Gordon Parks, *A Hungry Heart: A Memoir* (New York: Washington Square Press, 2007), 16.

2. Langston Hughes, "The Negro Artist and the Racial Mountain," *The Nation*, June 23, 1926.

3. "Digital Harlem: Everyday Life 1915–1930," University of Sydney, http://www.acl.arts.usyd.edu.au/harlem/.

4. Ibid.

5. "Adam Clayton Powell, Jr.," *Wikipedia*, http://en.wikipedia.org/wiki/Adam_Clayton_Powell,_Jr.

6. Jervis Anderson, "Harlem IV-Hard Times and Beyond," *The New Yorker*, July 20, 1981.

7. "Father Divine, the March of Times, New York 1930s," YouTube video, 6:45, posted by "FDIPPM," August 7, 2009, http://www.youtube.com/watch?v=JNLNrNxPmDA.

8. "Malcolm X on the 'House Negro' and the 'Field Negro,'" YouTube video, 1:00, posted by Paul Lee, April 18, 2009, http://www.youtube.com/watch?v=5EJSNaB_wBQ.

9. "Malcolm X," *Wikipedia*, http://en.wikipedia.org/wiki/Malcolm_X.

10. Timothy Williams, "Minister Sees Salvation of Harlem in Boycott," *New York Times*, March 28, 2008; "Harlem Minister Says Obama 'Was Born Trash,'" *Undercover Black Man* (blog), March 15, 2008. http://undercoverblackman.blogspot.com/2008/03/harlem-minister-says-obama-was-born.html.

11. Stephen Robertson, "Churches," *Digital Harlem* (blog), April 17, 2009. http://digitalharlemblog.wordpress.com/2009/04/17/churches/.

12. W. David Dunlap, "Vestiges of Harlem's Jewish Past," *New York Times*, June 7, 2002.

PARADES, CELEBRATIONS, AND COMMEMORATIONS

Epigraph: Frances Warner speaking in the film *The American Experience—Marcus Garvey: Look for Me in the Whirlwind* (PBS, 2001).

1. James Weldon Johnson, *Black Manhattan* (New York: Knopf, 1930).
2. Jack Manning, "Elks Parade 1939," *Look*, May 21, 1940. The photograph was part of "The Harlem Project, 1936–1940" and has been exhibited widely.

"WE PUT OUR OWN SPIN ON STYLE"

1. Big L, "5 Fingas of Death," YouTube video, 4:37, posted by "zarmanouch," July 17, 2007. http://www.youtube.com/watch?v=CD6n58CgXJo&feature=fvwrel; ASAP Rocky, "Peso," YouTube video, 2:50, posted by "ASAPRockyUptown," August 10, 2011, http://www.youtube.com/watch?v=ob3ktDxAjWI; Juelz Santana, "Forever Harlem," music video, 3:37, posted by "Mikey Fresh," http://vimeo.com/8561048.

THE AFRICAN PRESENCE IN HARLEM

Epigraph: Countee Cullen, "Heritage" in *My Soul's High Song: The Collected Writings of Countee Cullen*, ed. Gerald Early (New York: Anchor Books, 1991).

1. Alain Locke, *The New Negro* (New York: Atheneum, 1970).
2. "In His Own Words" in *Marcus Garvey: Look for Me in the Whirlwind* webpage, Public Broadcasting Corporation, 1999, http://www.pbs.org/wgbh/amex/garvey/sfeature/sf_words_text.html.
3. "Lewis H. Michaux," *Wikipedia*, http://en.wikipedia.org/wiki/Lewis_H_Michaux
4. Allon Shoener, ed., *Harlem on my Mind* (New York: Random House, 1968).

TOURISTS IN SEARCH OF HARLEM'S HEYDAY

Epigraph: Tiffany Ellis, quoted in David Snyder, "Crossroads at the Renny," in *Race Anthology 2000*, ed. Sig Gissler, http://www.columbia.edu/itc/journalism/gissler/anthology/Renny-Snyder.html

1. John J. Jackson, *Harlemworld: Doing Race and Class in Contemporary Black America* (Chicago: University of Chicago Press, 2003), 19.
2. "Counting Visitors to Harlem," Audience Research and Analysis, April 11, 2009, http://www.audienceresearch.com/case-studies/harlem-upper-manhattan-empowerment-zone/.
3. Sandra Ifraimova, "Tourism Growth in Harlem Comes with Pluses and Minuses," *The Uptowner* (blog), November 8, 2011, http://theuptowner.org/2011/11/08/tourism-growth-in-harlem-comes-with-pluses-and-minuses.

4. Linda Richardson, "Looking for Authenticity; Is the Jazz Really Jazz without the Locals?" *New York Times*, November 16, 2000.

A DEFIANT ATTITUDE

1. Claude MacKay, "Enslaved," in *Harlem Shadows: The Poems of Claude Mackay* (New York: Harcourt, Brace, 1922).
2. *Burning at Stake in the United States* (New York: National Association for the Advancement of Colored People, June 1919).
3. Joy DeGruy Leary, *Post Traumatic Slavery Disorder* (Milwaukie, OR: Uptone Press, 2005).

FREE FOOD

1. "10035 Zip Code Detailed Profile," City-Data.com, http://www.city-data.com/zips/10035.html.

WHAT MEAN THESE STONES?

1. "Negro Colony Growing; 150,000 in Harlem Section," *New York Times*, July 29, 1923.
2. Sam Sifton, "Red Rooster Harlem," *New York Times*, March 8, 2011.

BIBLIOGRAPHY

A&E Television Networks, LLC. "Apollo Theater Interactive Time-line." http://www.biography.com/tv/classroom/apollo-theater-timeline.

Academy of American Poets. "Walking Tour: Langston Hughes's Harlem of 1926." http://www.poets.org/viewmedia.php/prm-MID/19208.

Anderson, Jervis. "That Was New York: Harlem." *The New Yorker*, July 20, 1981.

Appiah, Kwame, and Henry Louis Gates Jr. *Africana: The Encyclopedia of the African American Experience*. New York: Basic Civitas Books, 1999.

Baldwin, James. *Another Country*. New York: Dell Publishing, 1960.

———. *The Fire Next Time*. New York: Dell Publishing, 1963.

Blair, Sara. *Harlem Crossroads*. Princeton, NJ: Princeton University Press, 2007.

Boyer, Richard O. "Profiles: The Hot Bach—II." *New Yorker*, July 1, 1944, 26–35.

Bremer, Sidney H. "Home in Harlem." In *Analysis and Assessment, 1940–1979*, edited by Cary D. Wintz. New York: Taylor & Francis, 1996.

City of New York Parks and Recreation. "Hancock Park." http://www.nycgovparks.org/parks/M034/highlights/6408.

Columbia University. "Harlem History." http://www.columbia.edu/cu/iraas/harlem/neighborhood/neighborhood.html.

Cunard, Nancy. "Harlem Reviewed." In *The Politics and Aesthetics of New Negro Literature*, edited by Cary D. Wintz. New York: Routledge, 1996.

DuBois, W. E. B. "The Talented Tenth." In *The Negro Problem: A Series of Articles by Representative Negroes of To-day* (New York: J. Pott & Co., 1903). Reprinted at http://teachingamericanhistory.org/library/index.asp?document=174.

Euclaire, Sally. *American Independents*. New York: Abbeville Press, 1987.

Golden, Thelma, Deborah Willis, Cheryl Finley, and Elizabeth Alexander. *Harlem*. New York: Skira Rizzoli, 2010.

Gopnik, Adam. "Improvised City, Helen Levitt's New York." *The New Yorker*, November 19, 2001.

Harper, Donna Akiba Sullivan. *Not So Simple: The "Simple" Stories by Langston Hughes*. Columbia: University of Missouri Press, 1996.

Huggins, Nathan. *Harlem Renaissance*. New York: Oxford University Press, 1971.

Hughes, Langston. "The Negro Artist and the Racial Mountain." *The Nation*, June 23, 1926.

Jackson, Caroline. "Harlem Renaissance: Pivotal Period in the Development of Afro-American Culture." Yale-New Haven Teachers Institute. http://www.yale.edu/ynhti/curriculum/units/1978/2/78.02.03.x.html.

Jackson, John J. *Harlemworld: Doing Race and Class in Contemporary Black America.* Chicago: University of Chicago Press, 2003.

Johnson, James Weldon. *Black Manhattan.* New York: Knopf, 1930.

Jones, Leroy. *Home: Social Essays.* New York: Akashic Books, 2009.

Kennedy, Randy. *Subwayland: Adventures in the World beneath New York* (New York: St. Martin's Press, 2003.

Larsen, Nella. *Passing.* New York: Penguin, 2003.

Leary, Joy DeGruy. *Post Traumatic Slavery Disorder.* Milwaukie, OR: Uptone Press, 2005.

Lewis, David Levering. *When Harlem Was in Vogue.* New York: Penguin, 1997.

Locke, Alain. *The New Negro.* New York: Atheneum, 1970.

McKay, Claude. 1922. *Harlem Shadows: The Poems of Claude Mackay.* New York: Harcourt, Brace.

———. *Home to Harlem.* Boston: Northeastern University Press, 1987.

Mumford, Lewis. "Skyline: The Gentle Art of Overcrowding." *The New Yorker*, May 20, 1950.

NAACP. *Burning at Stake in the United States.* New York: National Association for the Advancement of Colored People, 1919.

Osofsky, Gilbert. *Harlem: The Making of a Ghetto.* New York: Harper Torchbooks, 1971.

Parks, Gordon. *A Hungry Heart: A Memoir.* New York: Washington Square Press, 2007.

Schultz, Stanley K. "American History 102." http://telepresence.wisc.edu/ushistory/.

Shoener, Allon, ed. *Harlem on My Mind.* New York: Random House, 1968.

Tao, Dominick. "Harlem Monuments Spruced Up for Spring." *City Room* (blog). *New York Times*, June 12, 2009, http://cityroom.blogs.nytimes.com/2009/06/12/historic-monuments-aspruced-up-for-spring/.

Tomkins, Calvin. "Romare Bearden." *The New Yorker*, November 28, 1977.

University of Sydney. "Digital Harlem, Everyday Life, 1915–1930." http://www.acl.arts.usyd.edu.au/harlem/.

Van Leeuwen, David. "Marcus Garvey and the Universal Negro Improvement Association." National Humanities Center. http://nationalhumanitiescenter.org/tserve/twenty/tkeyinfo/garvey.htm.

Vergara, Camilo José. *The New American Ghetto.* New Brunswick, NJ: Rutgers University Press. 1995.

Vergara, Camilo José, and Howard Gillette. "Invincible Cities." http://invinciblecities.camden.rutgers.edu/intro.html.

Wintz, Carey D., and Paul Finkelman, eds. *Encyclopedia of the Harlem Renaissance*, vol. 2. New York: Taylor & Francis, 2004.